Picasso and the Spanish Tradition

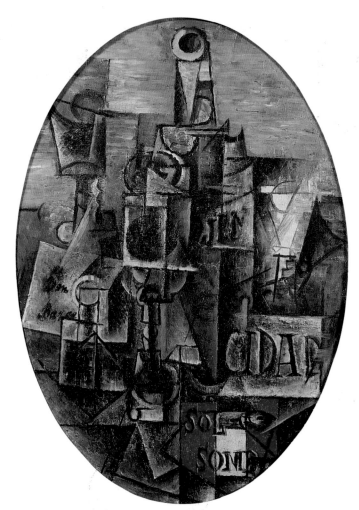

Frontispiece: Pablo Picasso, *Spanish Still Life*, Céret, May-June 1912.
Oil and Ripolin on canvas, 46 × 33 cm.
Villeneuve d'Ascq, Musée d'Art Moderne,
Gift of Jean and Genevieve Masurel.

PICASSO
AND THE SPANISH TRADITION

Edited by

JONATHAN BROWN

With contributions by

JONATHAN BROWN SUSAN GRACE GALASSI

ROBERT S. LUBAR ROBERT ROSENBLUM

GERTJE UTLEY

Yale University Press
New Haven and London

Publication of this volume has been aided by
a subvention from an endowment fund established at the
Institute of Fine Arts, New York University,
by the late Lila Acheson Wallace, co-founder
with her husband of the Reader's Digest Association, Inc.

Designed by Gillian Malpass
Printed in Singapore

Library of Congress Catalog Card No.: 96-60716

A catalogue record for this book is available from The British Library

ISBN: 0-300-06475-6

100122674 4

Contents

Contributors

JONATHAN BROWN has written many books and articles on the history of Spanish art, including *The Golden Age of Painting in Spain*, Yale, 1991. He is Carroll and Milton Petrie Professor of Fine Arts at New York University's Institute of Fine Arts.

ROBERT S. LUBAR, a specialist in modern French and Spanish art, is assistant professor at the Institute of Fine Arts, New York University. He is the author of *Divided Landscapes: Essays on Art, Culture, and Politics in Modern Spain, 1898–1939* (Yale University Press, forthcoming).

ROBERT ROSENBLUM, professor of fine arts at New York University, has often written about Picasso in articles ranging from "Picasso and the Typography of Cubism" to "War and Peace: Antiquity and late Picasso."

GERTJE UTLEY, an independent scholar, participated in the organization of *Vienna 1900* at the Museum of Modern Art, New York. In recent years she has written and lectured on Picasso's later career, the subject of her doctoral dissertation, now in progress.

SUSAN GRACE GALASSI is associate curator at The Frick Collection and the author of *Picasso's Variations on the Masters: Confronting the Past* (Harry N. Abrams, Inc., 1996).

Acknowledgments

THE GERM OF THIS BOOK was planted at the great Picasso exhibition, held at the Museum of Modern Art, New York, in 1980. After viewing it, I experienced the uncanny feeling of having seen the work of a Spanish old master lurking just beneath the surface of these seminal creations of modern art. The shock of recognition was amplified by the fact that everything I had learned or read about the artist situated him within the heroic narrative of French modernism. Indeed, it was in this context that his pictures were usually exhibited in the permanent installation of the museum.

The years passed, and thoughts of Picasso were crowded out by other pursuits, notably research on and writing and teaching about Spanish art of the Golden Age. However, in 1992, there was an opportunity to test my instinct about Picasso's involvement with the art and culture of his native land. In that year, the Spanish Institute in New York, a private, non-profit-making organization which promotes relations between Spain and the U.S.A., decided to initiate an annual symposium on Picasso. I took advantage of my chairmanship of the Fine Arts Advisory Committee to suggest "Picasso and the Spanish Tradition" as the topic for the inaugural session.

The symposium took place on 25 April 1992 and was sponsored by a generous grant from the Consul General of Spain in New York, Ambassador Miguel de Aldasoro. Arrangements were made by Dr. Suzanne L. Stratton, now Vice-President of the Institute and the coordinator of its ambitious fine-arts program. At the end of the event, the participants agreed that the results had met and perhaps exceeded our expectations and that our papers might have something to contribute to an understanding of this wellspring of Picasso's art. We decided to prepare them for publication and, along the way, invited Gertje Utley to join our group by contributing an essay on Picasso's post-war period.

In the four years since the symposium, we have extensively revised our contributions, exchanging ideas as we went along. The spirit of our cooperative venture is, we hope, reflected in this book, as well as a cohesiveness that results from the camaraderie of the contributors, all of whom work within a small area of Manhattan, with the Institute of Fine Arts of New York University at its center.

In addition to the generosity of Ambassador Aldasoro and the efficacy of Dr. Stratton, we wish to thank Professor James R. McCredie, Director of the Institute of Fine Arts, for arranging a subvention for this publication. Our

publisher, Yale University Press, has provided exemplary support and expertise in the production of the book. We thank John Nicoll for seeing promise in the project; Gillian Malpass, for managing the production and gracefully coping with the idiosyncracies of five authors, and Lucinda Collinge for deftly editing the manuscripts.

Jonathan Brown
Princeton, 9 February 1996

Preface

THE QUESTION OF Picasso's relation to Spanish tradition might seem both superfluous and perilous. His Spanish origins are a matter of fact, while his place within the "French School" is widely accepted. Libraries in the U.S.A. reflect this consensus by classifying him as a French artist. (Spaniards and Catalans, however, have never doubted that Picasso was truly Spanish or Catalan, depending on their patriotic allegiance.) Nevertheless, there is a growing awareness that this formulation is too facile and that Picasso's "Spanishness" is not a mere accident of birth or a question of spiritual osmosis.

The definition of the Spanish component of Picasso through reference to Spanish tradition is the perilous part. Tradition has become a loaded word, and its usage here requires a few lines of explanation. For writers in the past, an artistic tradition was understood as a pattern of accumulated ideas and practices. It was exemplified by recognized masters whose work served as a reference and stimulus for later generations. More recently, tradition has acquired another meaning, as an ideological construction of history, often manifested in the form of cultural myths. This definition of tradition is frequently encountered in the guise of nationalism, one of the most durable, if sometimes pernicious forms of cultural mythology. These two aspects of tradition are not necessarily contradictory. They may even be seen as complementary or mutually reinforcing, and that is how they are treated in this book.

In the opening essay, an attempt is made to define a Spanish tradition of painting as a set of responses to classicism that were developed over three centuries and epitomized by El Greco, Velázquez, and Goya, the three most universally admired of all Spanish artists. Picasso saw these stars in the heavens and aspired to reach them. By studying their works and absorbing their ideas, he established a position from which he could take an independent stance toward the history of his art.

The first twenty-five years of Picasso's life coincided with a critical moment in the development of nationalism, the origins of which are found in the earlier nineteenth century. It was in this period that nationalistic sentiment, based primarily on linguistic and ethnic criteria, emerged as a potent force in European society, and that the concept of "race," as determined non-genetically, ominously began to coalesce with the idea of nationhood.*

* E.J. Hobsbawm, *Nations and Nationalism since 1780. Programme, Myth, Reality* (2nd. ed., Cambridge, 1991), pp. 101–30.

Robert Lubar shows how the young Picasso was caught between two of the characteristic manifestations of late nineteenth-century nationalism in Spain, the Generation of 1898 in Madrid and Catalan *Modernisme* in Barcelona. Once he had arrived in Paris, Picasso's national identity was cast in yet a different mold, and he was classified by the French as a member of an (admirable) race of outsiders. According to Lubar's argument, Picasso's artistic practice at this time calls into question the visual and literary tropes through which mythic nationalism is constructed, as he sought to create a space in which he might exercise his talents. Yet, later in life, he too succumbed to the power of the ideas of nationalism and the pull of his homeland.

Until the start of the Spanish Civil War, Picasso could play with his Spanish identity to some extent. Robert Rosenblum deciphers the coded, at times unabashedly patriotic, references to Spain in still-life paintings by the artist. In addition, Picasso was able to palliate the pangs of nostalgia by periodic trips across the border. But with the triumph of Franco, this avenue was closed. The point of no return, of course, is *Guernica*, which is not dealt with in detail in this book because it is so well studied. With the victory of the nationalists, the Spain of Picasso's youth was dramatically transformed as a society and as a haunt of the artist's imagination.

Following the end of the Second World War, the question of Picasso's nationality re-emerged and was re-shaped by the cultural battles which engulfed French political and intellectual life. To his surprise, and initially to his satisfaction, Picasso was hailed as a French cultural hero by the political left. However, as we see in Gertje Utley's meticulous reconstruction of this neglected chapter in Picasso's biography, his prominence invited political attack. Picasso's Spanish identity, which had been to some extent an asset in the early 1900s, now became something of a liability. French xenophobic writers, who surfaced once the dust of war had settled, lumped Picasso with other "aliens" alleged to have contaminated the "purity" of French society and culture. Picasso opted for art instead of politics; he retreated to the south of France and sought solace in the Mediterranean life he remembered from earlier days.

This retreat to the south has long been recognized as prompted by nostalgia, at least in part. There, Picasso created a "mundillo español," a little Spanish world, inhabited by friends and visitors from Spain, and furnished with memories of a distant but still vivid childhood. Picasso's longing for Spain was frustrated of course by Franco, whose dreams and lies now ruled his homeland. But if the Spanish present was closed to the artist, the past remained a free country, and especially its artistic past, into which Picasso made occasional, feverish sorties. Susan Grace Galassi is our guide to one of the most famous of these imaginative tours of the history of Spanish art, the "Variations on Velázquez's *Las Meninas*," through which Picasso again confronted an artist who was one of his original sources of inspiration and an enduring challenge to his creative powers.

Picasso's engagement with Spanish tradition, as presented in these pages, is a

dynamic, unfolding story. Unlike the members of the Generation of 1898, who sought to identify elements of an immutable Spain, Picasso's vision of Spain continually changed during his long life. The Spain of Francisco Franco was a very different place from the Spain of Alfonso XIII; the aged Picasso had long ceased to be the rebellious, penniless youth who had gone to Paris to seek his fortune and test his powers. At some point, Spain for Picasso ceased to be a reality and became an idea, a memory, an essence at once immutable and evanescent.

Picasso took pride in being an outsider who stood somewhat apart from the myths and mores of French intellectual life. His Spanish identity, however much its construction was transformed, provided him with the counter-myth needed to resist the power of French culture and the grand tradition it professed to embody. The tension between the allure of French ideas and the compelling histories of his homeland proves to have been a crucial element in Picasso's art and thought.

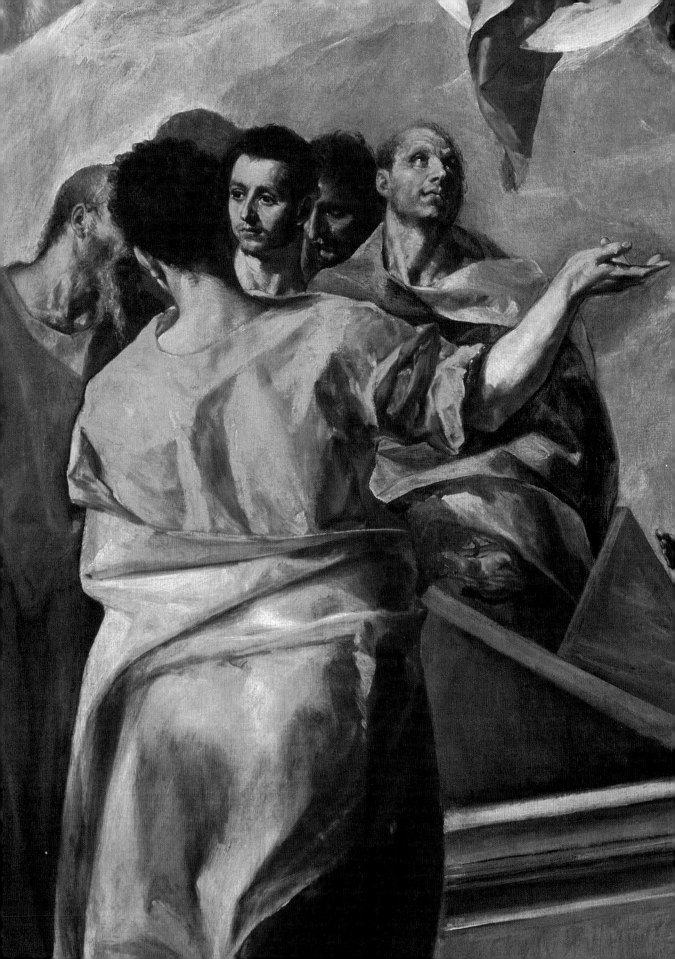

I *Picasso and the Spanish Tradition of Painting*

JONATHAN BROWN

IF PICASSO WITHOUT PARIS is unthinkable, Picasso without Madrid hardly merits a thought. The young artist lived in the Spanish capital on two occasions. From October 1897 to June 1898, he spent an apparently aimless year as a student at the Real Academia de Bellas Artes, and in January 1901, he returned for a few months to work on the publication, *Arte Joven*. From all appearances, Madrid, admittedly one of the most provincial cities of *fin-de-siècle* Europe, provided little of value to Picasso's formation, and the unhappy memories of those chilly, cheerless months have colored all his biographies. However, Madrid had one great asset that was to prove crucial to the development of Picasso's artistic imagination—the Museo del Prado. It was there that he encountered the three great past masters of Spanish painting who would continue to haunt his mind and challenge his powers—El Greco, Velázquez, and Goya.[1]

Picasso first visited the Prado in April or May 1895, when his family, en route to Málaga from La Coruña, broke the trip for a day in Madrid.[2] His father, Don José Ruiz, a mediocre academic painter, took him for a quick tour of the museum, which allowed the boy only enough time to make two small sketches after works in the collection (Museu Picasso, Barcelona). His eye was caught by Velázquez's portraits of two marginal figures at the court of Philip IV, the dim-witted jester Don Juan de Calabazas and the dwarf El Niño de Vallecas. The choice of these uncharacteristic pictures by Velázquez is telling in the light of Picasso's fascination with the theme of the outsider in works of the Blue Period.

The artist's decisive engagement with the heroes of Spanish painting occurred at the Prado during that unhappy year of 1897–98, when he suffered from poverty, loneliness, and the uninspired tutelage of the royal academy.[3] In later life, Picasso tended to minimize the extent of his immersion in the masterpieces of the Prado, but according to his companion during those months, the Argentinian painter Francisco Bernareggi, the two aspiring painters sought refuge from their professors by retreating to the museum.

We spent our days (eight hours a day) studying and copying in the Prado and at night we went (for three hours) to draw from nude models at the Círculo de Bellas Artes.[4]

1 El Greco, *Assumption of the Virgin*, detail of fig. 5.

I

Bernareggi and Picasso took great pleasure in making copies after El Greco, which was a scandalous pursuit. "That was in 1897, when El Greco was considered a menace," wrote Bernareggi. And when Picasso's father was given some of the students' replicas, his reaction was: "You're taking the wrong road."

While conservative taste may have scorned the art of El Greco, his fame had risen rapidly in advanced artistic circles during the closing years of the century. In Madrid, the spokesman of the pro-Greco movement was Manuel Bartolomé Cossío, who had been promoting his cause since the mid-1880s and who, in 1908, published the pioneering, and still-influential, monograph on the artist.[5] By 1902, however, El Greco had been admitted into the pantheon of Spanish art. This was the year of the monographic exhibition at the Prado, which was official recognition of El Greco's strange genius.[6] Thereafter, his detractors fell silent.

Picasso's first stay in Madrid coincided with the final stage of the apotheosis of El Greco, and he was swept along with the tide. More than once, he made a pilgrimage to Toledo and paid homage to El Greco's *Burial of the Count of Orgaz*, in the little parish church of Santo Tomé.[7] From then on, El Greco was a recurrent point of reference in Picasso's store of imagery.

The young artist's fascination with the other two greats of Spanish painting, Velázquez and Goya, was more in keeping with conventional taste. Both were recognized heroes of Spanish history and culture, and were the subjects of numerous publications. In 1899, public interest in Velázquez reached new heights with the celebration of the third centenary of his birth.[8] On 6 June, the Prado inaugurated a grandiose installation of his works in the most important gallery of the museum, and one week later, on 14 June, a statue of the artist was unveiled in front of the entrance on the Paseo del Prado, where it still stands. When Picasso returned to Madrid in January 1901, he could see Velázquez in all his glory.

Goya was more conspicuous still, thanks to the wide circulation of his prints.[9] The academy owned the original plates of *Los Caprichos*, *La Tauromaquía*, *Los Desastres de la Guerra*, and *Los Disparates*, and had published them in 1890–91 (sixth edition), 1876 (third edition), 1892 (second edition), and 1891 (third edition), respectively. Picasso's identification with Goya was first recognized by Miquel Utrillo in an article published in the June 1901 issue of *Pèl & Ploma*, where he referred to his friend as "le petit Goya."[10] Many years later, this sobriquet was still apt; as André Malraux observed in 1974: "Picasso spoke to me of Goya more than of any other artist."[11]

Documenting Picasso's obsession with the Spanish masters is not so difficult; evaluating their impact on his work is more demanding. It is easy, of course, to identify Picasso's appropriations of motifs and compositions from the great painters of Spain, as has been done. However, his affinity for his artistic ancestors runs deeper than borrowed poses and gestures.

The bond between Picasso and the Spanish masters has sometimes been regarded as a spiritual one. John Richardson spoke for many students of Picasso when he wrote: "El Greco would help Picasso exploit the ecstasy, anguish and

morbid sense of sin of his black Spanish faith . . ."[12] This is certainly true, but on at least one occasion, Picasso saw the connection in purely formal terms. "Cubism is Spanish in origin, and it was I who invented Cubism. We should look for Spanish influence in Cézanne. . . . Observe El Greco's influence on him. A Venetian painter but he is Cubist in construction."[13] Picasso liked to shock and mislead when he spoke about his art, although this does not mean that he is always to be mistrusted. El Greco and the other painters of Spain comprise a distinct tradition within the history of European art, one that is often acknowledged but has never been adequately defined. This tradition was assimilated by Picasso, starting in his student days in Madrid, and it provided him with a position on the margins of the mainstream of European art. By analyzing the works of El Greco, Velázquez, and Goya, Picasso could see how these great artistic forebears had criticized and interpreted the classical tradition.

By the middle of the eighteenth century at the latest, the classical tradition had become the universally accepted standard for artistic training and creation, and this makes it tempting to conceive of the history of post-medieval painting in Europe as an inexorable progress toward the triumph of the grand manner. The painters of Spain, however, adopted an independent stance towards classicism, which they regarded as an option, not as an imperative. Thus, some ignored it, others combined it with different stylistic currents and still others purposely altered or discarded it as irrelevant to their purposes. The result, which might be characterized as provincial by many upholders of the classical canon, is better defined by the term counterclassical.

The complex origins of Spanish counterclassicism can be traced to the fifteenth century. In the 1400s, Spanish painting was conditioned by two factors: the presence of innumerable examples of Flemish art and the lack of systematic interest in Greco-Roman antiquity, buttressed by the theoretical writings of Italian humanism. The consequences of these conditions are manifest in the work of Pedro Berruguete (ca. 1450–1503), the leading painter in Castile at the end of the fifteenth century.[14] Berruguete was schooled in the Hispano-Flemish tradition, but he was in Italy in the 1470s and possibly worked for Federigo da Montefeltro, duke of Urbino and patron of Piero della Francesca. By 1483 he had returned to Spain and thereafter diluted his Italianism with large measures of the Flemish style preferred by Castilian clients. This hybrid manner is evident in the *Annunciation* (fig. 2), executed around 1490 for an altarpiece in Santa Eulalia in Paredes de Nava. His idiosyncratic interpretation of Italianate elements becomes apparent when this work is compared with Leonardo da Vinci's *Annunciation* of 1478 (fig. 3), which was painted while Berruguete was in Italy.

For Leonardo, symmetry, balance, and proportion were the essential elements in producing a smoothly flowing narrative. As we know from other works, Leonardo began by constructing the perspective and then integrated the figures into the composition, adjusting their scale, and that of ancillary objects or attributes, to the surrounding space. The figures are solidly rendered and

3

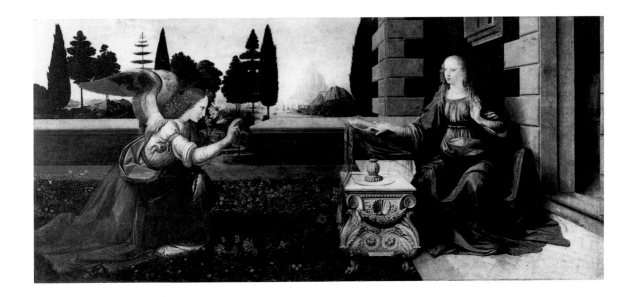

carefully shaded by a softly modulated light, which emphasizes the roundness of their forms.

The unity so carefully contrived by Leonardo was not of interest to Berruguete. He composed by what might be called an additive method, which gave equal emphasis to the main and subordinate elements. A clear, even light illuminates the scene, casting almost no shadows. Even the perspective construction seems to recede at a different angle as it moves backward in the picture. It hardly matters, because Berruguete virtually ignored the consequences of perspective for the scale of the figures, which are too large in relation to the architectural setting. The elements more consonant with medieval practice, such as the underscaled figure of God the Father hovering in the air and the scroll on which the heavenly message is inscribed, may have been stipulated in the contract, but their effect is unmistakably archaic.

By the time he painted the *Annunciation*, Berruguete's vision of Italy had grown dim. Italian classicism was the veneer of his style, not its essence, and much of it rubbed off once he re-established himself in Spain. This arms-length relationship with the stylistic mode developed in central Italy became characteristic of Spanish painters of the ensuing two centuries, beginning with the hero of Picasso's student days, El Greco.[15]

The recent discoveries of El Greco's writings leave no doubt that he had mastered the essential texts of Italian theory and begun to put them into practice during the time he spent in Italy, 1566–76.[16] His *Purification of the Temple* (fig. 4), executed in Rome ca. 1570–75, offers a repertoire of the Italian Renaissance style and even acknowledges its sources in a footnote in the lower right corner, which contains the portraits of Raphael, Titian, and Michelangelo (as well as of the artist's protector, the miniature painter Giulio Clovio).

3 Leonardo da Vinci, *Annunciation*, ca. 1478. Oil on panel, 98 × 217 cm. Florence, Uffizi.

2 (facing page) Pedro Berruguete, *Annunciation*, ca. 1490. Oil on panel. Paredes de Nava, Santa Eulalia.

4 El Greco, *Purification of the Temple*, ca. 1570–75. Oil on canvas, 117 × 150 cm. The Minneapolis Institute of Arts. The William Hood Dunwoody Fund.

However, immediately upon his arrival in Spain in 1576, the artist began to formulate a critique of the classical style that informed his work for the rest of his life.

One of his first commissions in Toledo was a series of three altarpieces for the convent church of Santo Domingo el Antiguo.[17] (The group was intact until 1904, although some of the paintings have been sold since.) In the center of the major altarpiece was the *Assumption of the Virgin* (fig. 5), the largest, most complex work painted by the artist up to that time. While the rich, vibrant colors are indebted to Titian, and the large, powerful figures, to Michelangelo, the composition, with its flattened perspective, is almost a rebuke to a central tenet of Renaissance painting.

Wherever possible, El Greco countered the retreat into space by eliding the contours of figures meant to be seen in the middle ground with those displayed in the foreground. For instance, the head of the massive apostle in the left corner appears almost to brush against the head of the figure to his right, seen full-face (fig. 1). In the sky, the head of the angel to the right floating behind the Virgin Mary appears to be wedged under her outstretched arm. Most extraordinary is the handling of the sarcophagus: the mouth is tipped up and abruptly stops as it reaches the middle ground. The lid of the tomb is reduced to a triangular protrusion, resembling a shark's fin, which seems to be floating in an indeterminate space. The aggressive distortion of this inanimate detail is

6

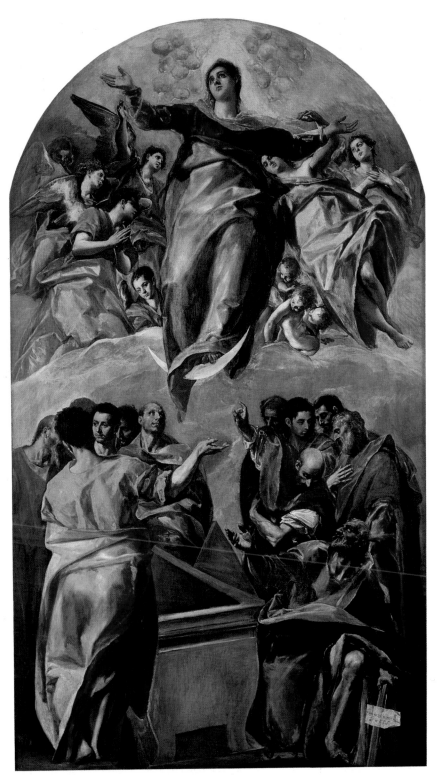

5 El Greco, *Assumption of the Virgin*, 1577. Oil on canvas, 401 × 229 cm. The Art Institute of Chicago. Gift of Nancy Atwood Sprague in memory of Albert Arnold Sprague, 1906.99.

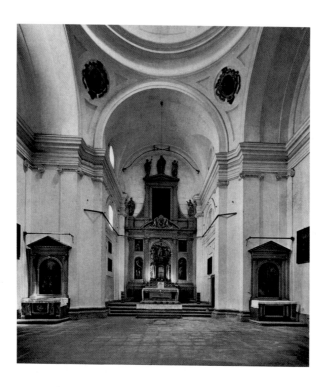

6 Main chapel, Santo Domingo el Antiguo, Toledo.

as arresting as the blade-like melon in the foreground of *Les Demoiselles d'Avignon*.

El Greco's writings on art reveal his profound mistrust of geometry as a means to attain artistic perfection. However, his repeated insistence on limiting the illusion of depth has a second, functional explanation. The *Assumption of the Virgin*, like most of the artist's large-scale works, was intended for an altarpiece. As a view of the interior of Santo Domingo shows (fig. 6), altarpiece paintings had to be carefully composed for visibility and legibility, even in a small space like that of this Toledan church. The solution, which was followed by El Greco and virtually every Spanish painter of the Golden Age, was to deploy large-scale figures along the frontal plane of the picture. In these circumstances, the illusion of depth became unnecessary, if not undesirable, and thus was minimized or eliminated.

This tactic is employed, of course, in the painting of El Greco most admired by Picasso, the *Burial of the Count of Orgaz* (fig. 7), executed in 1586–88 for the decoration of the funerary chapel of Gonzalo de Ruiz, count of Orgaz.[18] However, it is not only this characteristic that distinguishes the picture from Italian paintings of the epoch; it is also the bold differentiation between an observed and an imagined reality. The canvas is divided into two zones, one terrestrial, the other celestial. In the lower half, El Greco displayed his extraordinary, if often overlooked, mimetic capabilities, which are evinced in the painstaking execution of the richly embroidered vestments of the saints lowering the dead knight into the grave, in the damascened armor of Gonzalo de Ruiz, and

7 (facing page) El Greco, *Burial of the Count of Orgaz*, 1586–88. Oil on canvas, 480 × 360 cm. Toledo, Santo Tomé.

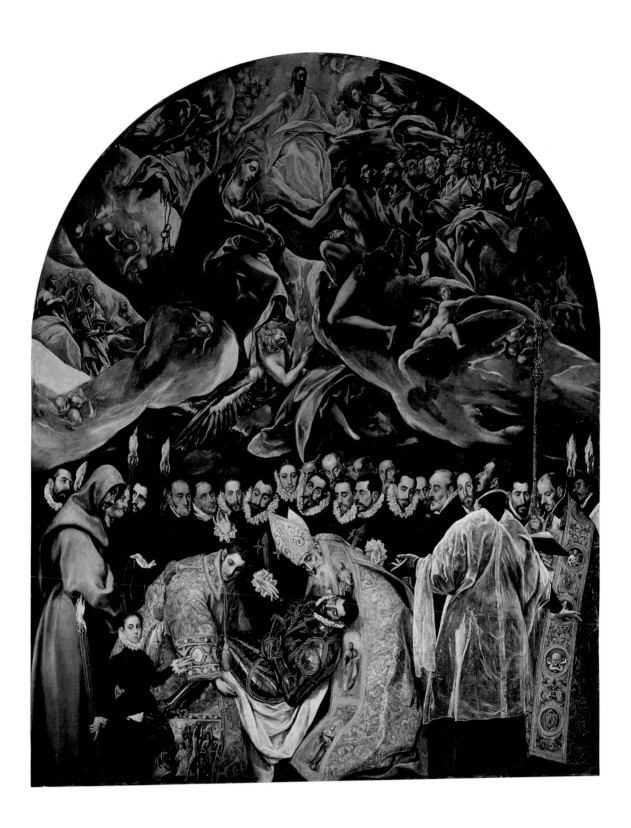

especially in the gauzy, translucent dalmatic worn by the parish priest at the right.

In the space above the portrait gallery of Toledan worthies, El Greco abandoned realism for the exaggerated, anti-classical style he used to depict the supernatural. Here figures assume gigantic proportions, changes in scale are sudden and drastic, light is brilliant and icy, clouds are compressed into irregular, plate-like shapes streaked with white and gray. For Catholics of the late sixteenth century, the *Burial* was a ringing declaration of the efficacy of good works for the salvation of the soul; for a budding, restless young artist at the end of the nineteenth century, it was the demonstration of the power of a great painter to reproduce and remake reality in one composition.

El Greco's imaginative transfigurations of the visible world are again evident in the *View of Toledo* (fig. 8), executed around 1600. Here the landmarks of the city are subjected to daring manipulations.[19] It is well known that El Greco transferred the location of the cathedral from the center of town to the eastern quarter, and that he altered the topography by exaggerating the height of the hill upon which the city is built. Less obvious but more exciting is the way he undermined the illusion of depth. Employing the same approach as in the *Assumption of the Virgin*, El Greco sought to make the eye return to the front plane of the picture. This is most conspicuous in the sinuous tree in the lower right foreground, the foliage of which merges with the trees farther back on the other side of the River Tagus. Or, to take a second example, the underbrush in the lower left, nearest the viewer, is made to seem continuous with a greensward in the middle distance. A winding trail, leading to the farthest reaches of the landscape, ends at the turbulent sky which, however, seems to hover over the buildings in the middle distance. While the tension between surface and depth is much more radical in the landscapes of Cézanne, El Greco's *View of Toledo* proves that Picasso's comparison of the two painters was not merely capricious.

The counterclassicism of Velázquez, like that of El Greco, is founded on a systematic critique of the presuppositions of Renaissance classicism. Although their artistic experiences and careers were different in many respects, they shared an interest in exposing and exploiting the artificial constructs of Italianate picture-making. The earliest works by Velázquez, done in Seville before his move to the court of Philip IV in 1623, reveal an artist who has been schooled in pictorial conventions which depart significantly from the classical norm. In the *Adoration of the Magi* (fig. 9), which was executed for an altar in a Jesuit church in 1619 (that is, only five years after El Greco's death), he used a naturalistic rather than a Mannerist idiom. However, the compositional principles are similar in both artists' works—large figures are crowded together in the foreground and a notional landscape, comprising a tree or two and a distant hill, is wedged into a corner of the canvas. That said, the lack of space in the composition is offset by the powerful, rough-hewn personages, who belong to a different breed from the ethereal, abstracted figures of El Greco.

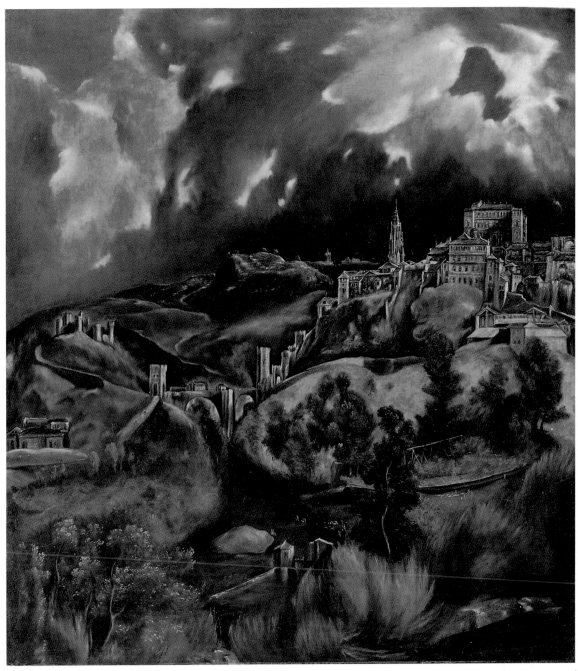

8 El Greco, *View of Toledo*, ca. 1600. Oil on canvas, 121 × 109 cm. New York, The Metropolitan Museum of Art. Bequest of Mrs. H.O. Havemeyer, 1929. The H.O. Havemeyer Collection.

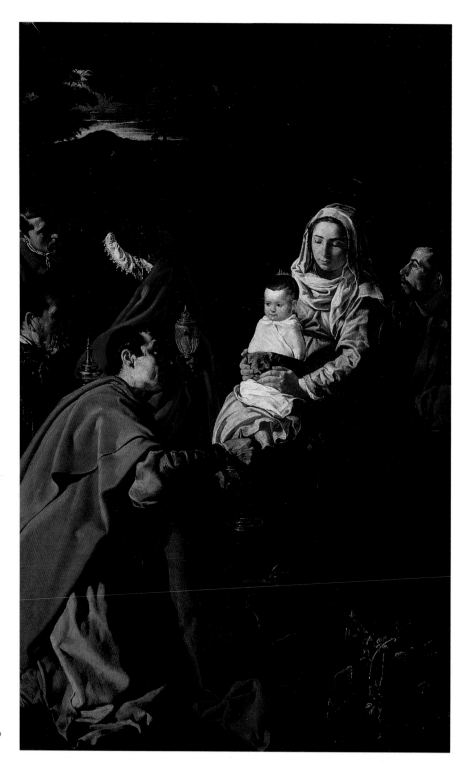

9 Diego de Velázquez,
Adoration of the Magi,
1619. Oil on canvas, 204
× 126 cm. Madrid, Museo
del Prado.

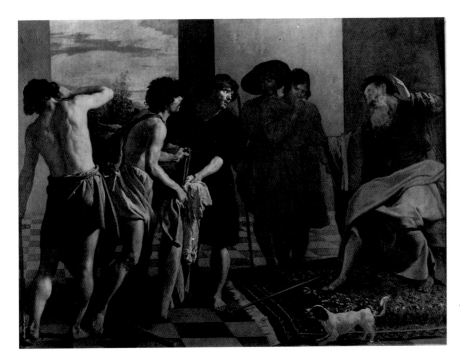

10 Diego de Velázquez, *Joseph's Bloodied Coat Brought to Jacob*, 1630. Oil on canvas, 217 × 285 cm. El Escorial.

Ten years later, Velázquez painted the *Feast of Bacchus* ("*Los Borrachos*"), which surprisingly can be described in almost the same terms as the *Adoration*. However, soon after completing this work in the spring of 1629, Velázquez traveled to Italy and spent several months in Rome, where he immersed himself in the grand manner and became a master of the classical style. In one of the pictures executed in Rome, *Joseph's Bloodied Coat Brought to Jacob* (fig. 10), the artist displayed his newly minted Italian style. Sculpturesque figures, properly scaled to a correct perspective construction, display their emotions through sweeping gestures and animated expressions. The palette is richer, the shading more subtle. Velázquez had dedicated hours and hours to the study of Raphael and Michelangelo, and now he could rival the Italians at their own game.

Yet for the rest of his career, Velázquez turned his classicism off and on, as if it came from a faucet instead of an unstoppable wellspring of inspiration. For instance, perspective would not have been regarded as an indispensable part of picture-making by a painter trained in Seville in the 1610s. Thus, Velázquez does not hesitate to forego a rational illusion of space in *Pablo de Valladolid* (fig. 11), which was executed in the 1630s. When Edouard Manet saw the picture in 1865, he immediately perceived what Velázquez had accomplished and wrote that the portrait was "perhaps the most astounding bit of painting ever done." His words succinctly describe the amazing vitality and originality of the picture: "The background disappears; it is only air that surrounds the good man, all dressed and alive."[20] A comparable portrait of a young man painted by Domenichino around 1603 (fig. 12), with its carefully plotted spatial illusion

11 Diego de Velázquez,
Pablo de Valladolid, 1634–
35. Oil on canvas, 209 ×
125 cm. Madrid, Museo del
Prado.

12 Domenichino,
A Young Man, 1603. Oil
on canvas, 69 × 56 cm.
Darmstadt,
Grossherzoglich Hessisches
Landesmuseum.

and studied pose, helps to demonstrate the radical denial of depth engineered by Velázquez.

And yet, twenty years later, Velázquez created *Las Meninas* (fig. 97), which has one of the most evocative illusions of space ever devised. In this painting, however, Velázquez suborns another convention of the grand manner, narrative clarity, and leaves gaps in the story which have proved wide enough to accommodate numerous interpretations.[21] If the meaning and purpose of the picture were clear to the painter and his patron, Philip IV, they have long since been displaced by the elliptical presentation of a drama with no apparent text.

Velázquez's confrontation with the classical tradition reached the maximum

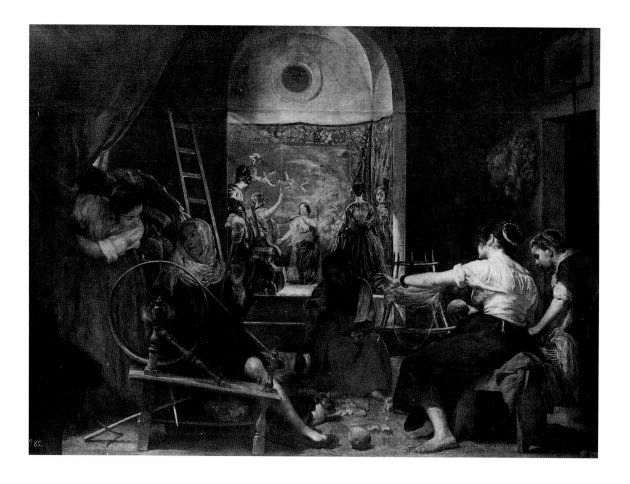

13 Diego de Velázquez, *Fable of Arachne*, ca. 1658. Oil on canvas, 170 × 190 cm. Madrid, Museo del Prado.

intensity in his mythological works. In depictions of subjects based on antique sources, the use of the classical style required no explanation or justification; it was an obvious way to proceed. However, for a counterclassicist, it was the obvious place to attack, and this is what Velázquez did in the *Fable of Arachne* (fig. 13), painted around 1658.[22] The first convention he dispensed with was the equation of perfect human form with antique sculpture, and next was a setting evocative of ancient architecture. After stripping the garb of antiquity from his painting, Velázquez took another, bolder step—he relegated the principal action to the background. There, represented in small scale, Minerva transforms the Lydian weaver Arachne into a spider as punishment for boasting that she was greater at the craft than the goddess herself. The story from Ovid's *Metamorphoses* is represented in such an indirect way that the true subject was forgotten for almost three hundred years, and the picture came to be understood as the visit of noblewomen to a tapestry factory. Even today, scholars cannot agree on whether the figures in the foreground, the spinners, represent an earlier phase of the story, when Minerva appears in the disguise of a weaver, or whether they are simply members of Arachne's workshop, or personifications of certain virtues.

16

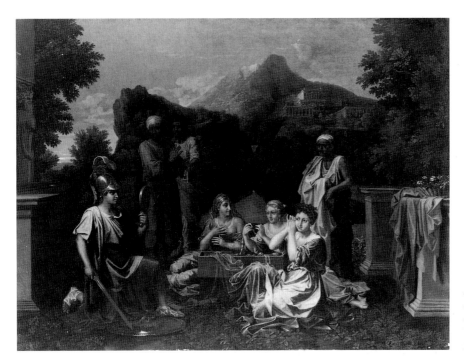

14 Nicolas Poussin, *Achilles among the Daughters of Lycomedes*, 1656. Oil on canvas, 100 × 133 cm. Richmond, Virginia Museum of Fine Arts.

Obviously, the shock value of the *Fable of Arachne*, that is, the shock of seeing a tale from Ovid presented as a commonplace event, has long since worn off. However, perhaps some of the impact may be restored by comparing it with an orthodox example of seventeenth-century classicism, Poussin's *Achilles among the Daughters of Lycomedes* (fig. 14), painted within a year or two of Velázquez's masterpiece.

By the time that Francisco de Goya, the third great master of counterclassicism, began his career, the grand manner had at last been implanted in Spanish soil. In 1752, the Real Academia de Bellas Artes de San Fernando was founded, and in time it became the official promoter of the neo-classical style. (The Academia de San Fernando was the last but one of the major European art academies to be established; only the Royal Academy in London is later.) Initially, the academy's teachings were directed by the Late-Baroque master Corrado Giaquinto, but by 1780, when Goya became a member, the pedagogical program was under the influence of Anton Raphael Mengs, who had been first painter to the Spanish court from 1761 to 1776 (with a five-year absence between 1769 and 1774).

Goya's reception piece for the academy reveals his ambivalent stance toward the doctrine and discipline of neoclassicism. As required by the occasion, *Christ on the Cross* (fig. 15) is a display of the artist's talents as an academic draftsman, and compared with works in his more familiar, sketchy manner, it looks quite convincing. Departures from the norm are apparent only when it is juxtaposed

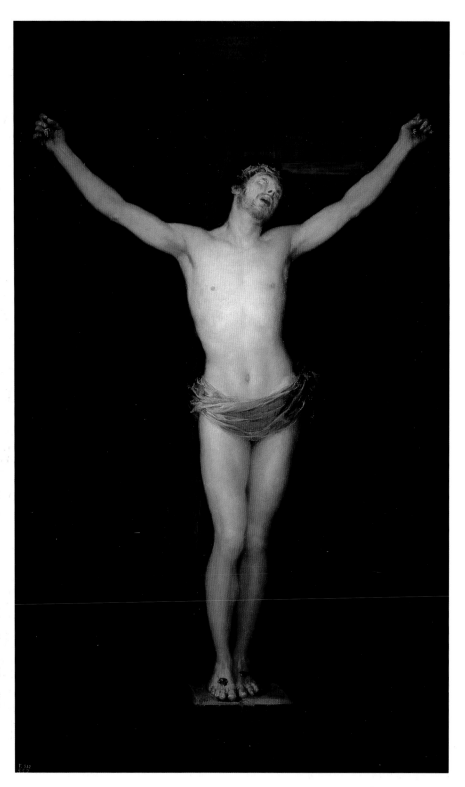

15 Francisco de Goya,
Christ on the Cross, 1780.
Oil on canvas, 255 ×
153 cm. Madrid, Museo del
Prado.

16 (facing page) Anton
Raphael Mengs, *Christ on
the Cross*, 1761–69. Oil on
panel, 198 × 115 cm.
Aranjuez, Palacio Real.

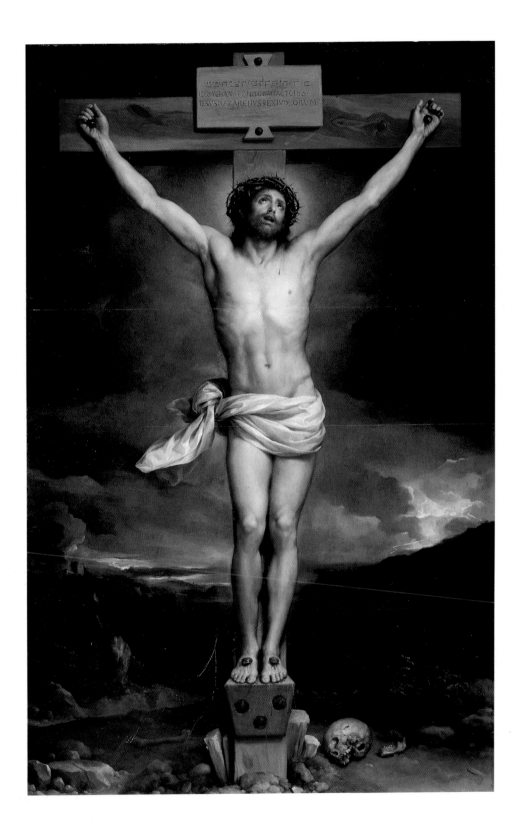

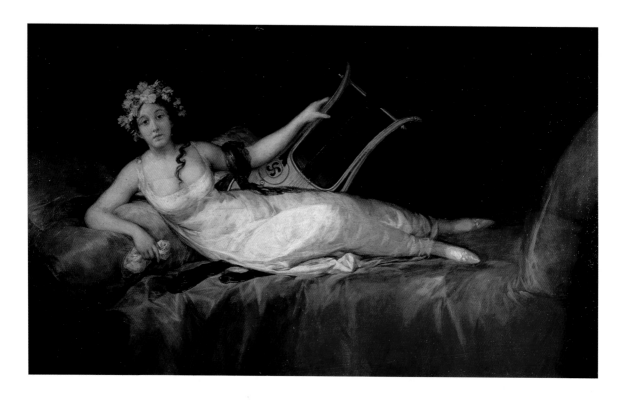

17 Francisco de Goya, *Marquesa de Santa Cruz*, 1805. Oil on canvas, 130 × 210 cm. Madrid, Museo del Prado.

with a work on the same subject painted by Mengs for Carlos III in the 1760s (fig. 16). Mengs, a confident master of figure drawing, emphasized the skeletal and muscular structure beneath the surface of Christ's tautly stretched skin. As a consequence, his Christ stands firmly upright on the cross, still able to support his weight despite the agony of martyrdom, while the Christ of Goya is modeled with an almost feminine softness and seems to sag limply on the cross. Goya's picture is effective in its way, but that way is not neoclassicism. In fact, the composition employed by Goya has venerable precedents in the Spanish Golden Age. It was invented by Francisco Pacheco and imitated by his pupil, Velázquez (Prado) and by Francisco de Zurbarán (Chicago, Art Institute), among others.[23]

Twenty-five years after *Christ on the Cross* was painted, a second wave of neoclassicism arrived in Madrid from France, and Goya, catering to the fashion for the style among the Spanish aristocracy, once again was obliged to work within its parameters. His portrait of the marquesa de Santa Cruz (fig. 17), executed in 1805, inevitably recalls Jacques-Louis David's *Mme Récamier* (1800; fig. 18), a picture in fact seen by the marquesa's mother during a sojourn in Paris in 1801.[24] It is immediately clear that Goya's version of neoclassicism is not entirely orthodox. He eschewed the careful perspectival construction and the smoothly modulated light effects employed by David and, as a result, the work seems warmer and less restrained. The figure of the marquesa is brought forward

20

in the pictorial space and turned in the direction of the viewer, while a stronger, more powerful light emphasizes the richer tonalities used by Goya.

Goya's revisionary interpretation of neoclassicism eventually hardened into a conviction that this style was inadequate to express the tumult and disorder which attended the political collapse of the old regime. He first gave voice to his beliefs on 14 October 1792, when he addressed a letter to the vice-protector of the academy, forcefully attacking the central tenet of the neo-classicists—that Greco-Roman art was the model of perfection.

> What scandal it is to hear nature despised in favor of Greek statues by those who know neither one nor the other and are not conscious of how the smallest part of nature overwhelms and amazes those who know most. What statue or pattern of one is there which is not copied from divine nature? However excellent the artist who made the copy, can he fail to proclaim that, when it is compared with nature, one is the work of God and the other of our miserable hands? Will not anyone who attempts to set aside and improve nature, rather than seek what is best in her, fall into a reprehensible and monotonous manner of painting like plaster casts, which is what has happened to all who have conscientiously followed this course [i.e., of not observing nature].[25]

A new style was needed to express a new view of the world, and this was what Goya set out to devise.

Goya's letter seems to posit a turn toward Romantic naturalism, but this was

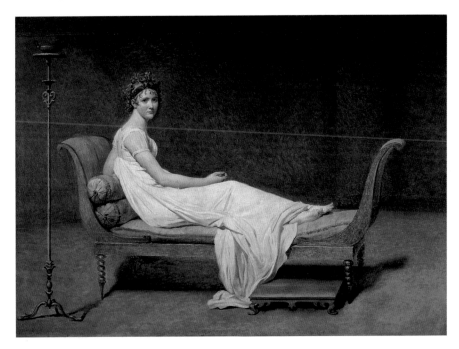

18 Jacques-Louis David, *Mme Juliette Recamier*, ca. 1800. Oil on canvas, 174 × 224 cm. Paris, Musée du Louvre.

19 Francisco de Goya, *Unos a otros*, plate 77 of *Los Caprichos*. New York, The Metropolitan Museum of Art. Gift of M. Knoedler and Co., 1918 (18.64 [77]).

not the course he followed. Instead he found an unlikely source of inspiration, the satirical prints of France and England. The vernacular idiom of these ribald works, which were circulating widely in Spain by the late 1780s, offered an escape route from classicism, and Goya took it.[26] Thus began his revolt against the tyranny of the grand manner that had dominated European painting since the Renaissance. He first essayed this style in *Los Caprichos*, published in 1798 (fig. 19). Fearful of reprisal by the Inquisition, Goya quickly withdrew the prints from sale and thereafter took his new style underground, confining its use to sketchbooks while continuing to produce society portraits and other commissioned works.

It was only after the Napoleonic invasion of 1808 and the tumultuous events which racked Spanish society in the aftermath that Goya brought his new art into the open. The *Third of May, 1808* (fig. 20), painted in 1814, for all its strategic distortions of history, has the excited, emotional edge of an eyewitness account. This sense of spontaneity and immediacy was not within the compass of the classical style and Goya, now armed with an alternative aesthetic, discarded classicism without hesitation.

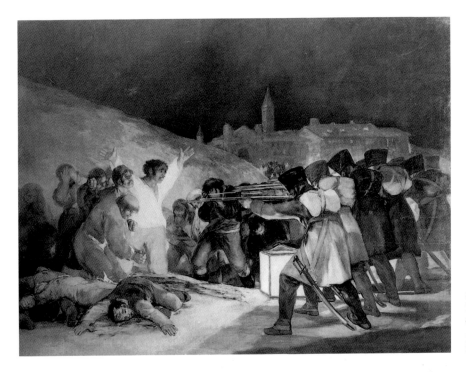

20 Francisco de Goya, *Third of May, 1808*, 1814. Oil on canvas, 266 × 345 cm. Madrid, Museo del Prado.

Goya mined this new vein of artistic expression until the end of his life, although more intensely in private works than in public ones. A culmination was reached in the enigmatic series of etchings, *Los Disparates*, created between 1816 and 1823 but not published until 1864, when eighteen of the twenty-two plates were issued by the royal academy. Compositions such as *"Disparate desordenado"* (fig. 21) and the *Woman Seized by a Horse* (fig. 22) are among the first works that convincingly give form and voice to the urgings of the subconscious.

The tradition of Spanish painting absorbed by the young Picasso thus offered a venerable alternative to academic classicism. However, he was not the first to experience its liberating power. The influx of Spanish painting which came to Paris after the end of the Napoleonic era had already aroused the keen interest of French painters and critics.[27] This tide reached a crest in 1838, when Louis-Philippe placed on view the collection of 446 canvases which had been gathered in Spain by his agent, Baron Isidore Taylor.[28] One critic, writing just after the opening of the so-called Galerie Espagnole in the Louvre, cogently summarized the reaction of the French to this virtually unknown school of painters:

It is truly something marvelous and unexpected, this sudden appearance of so many masterpieces which reveal an entirely new language that explains, no less well than the plays of Calderón and Lope de Vega, a neighboring country we still hardly know.[29]

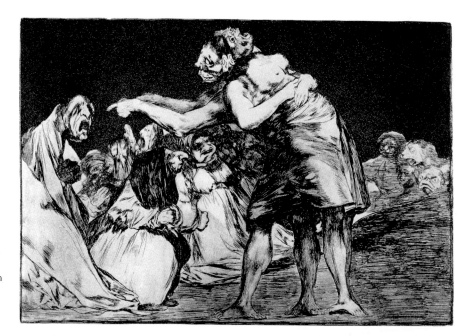

21 Francisco de Goya, *Disparate desordenado*, from *Los Disparates*. New York, The Metropolitan Museum of Art, Harris Brisbane Dick Fund, 1924 (24.30.8).

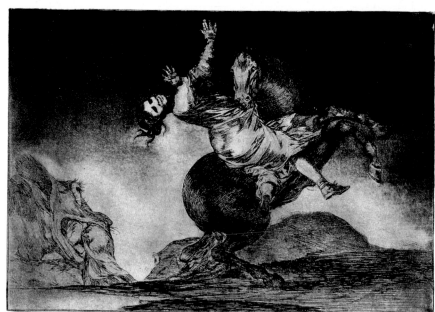

22 Francisco de Goya, "*El caballo raptor*", from *Los Disparates*. New York, The Metropolitan Museum of Art, Harris Brisbane Dick Fund, 1924 (24.30.11).

This pictorial language may have been entirely new to the French, but it was Picasso's mother tongue. El Greco, Velázquez, and Goya were to him what Poussin, David, and Ingres would have been to a French painter. However, Picasso's relationship to the Spanish masters was dynamic and complex, changing as his personality changed during the course of his life. In an early work

such as the *Burial of Casagemas* (1901; Musée d'Art Moderne de la Ville de Paris), Picasso ironically turned to the *Burial of the Count of Orgaz* for inspiration, whereas in creating the *Démoiselles d'Avignon* of 1907, he audaciously exploited the profound, counterclassical implications of El Greco's *Apocalyptic Vision* (New York, Metropolitan Museum of Art).[30] The young Picasso studied the bullfight paintings and prints of Goya, which he later passionately re-worked when he painted *Guernica* (1937). Velázquez, the first of the Spanish masters to catch Picasso's eye, returned to haunt his imagination in his later years, when his thoughts turned increasingly to the land of his birth. The variations on *Las Meninas*, discussed in chapter five below by Susan Grace Galassi, show Picasso completing the circle of his lifelong engagement with his artistic ancestors.

The art of Picasso and the three masters of the Spanish tradition intersect at many places. However, his debt to El Greco, Velázquez, and Goya is not limited to borrowed motifs, gestures, and compositions. By an accident of birth and a design of the intellect, Picasso adhered to a tradition of painting that was inherently skeptical of artistic authority. Writers have often commented on Picasso's purposeful manipulations of the tenets of classicism.[31] Like the three Spanish masters, he regarded the classical style with a mixture of respect and irreverence. As the starting point of European art, classicism had to be mastered, but this mastery could never be allowed to enslave. The tradition of counterclassicism exemplified by El Greco, Velázquez, and Goya, each the most original artist of his age, inspired and instructed Picasso, who sought and earned the right to be considered their peer.

2 Narrating the Nation:
Picasso and the Myth of El Greco

ROBERT S. LUBAR

URING HIS SUMMER SOJOURN of 1909 in Horta de Ebro with
Fernande Olivier, Picasso informed his patrons Gertrude and
Leo Stein that he was planning a trip to Madrid and Toledo. "I would be very
happy to go," he wrote, "it's been a long time that I've wanted to see Greco
again. . . ."[1] Although the trip appears to have been cancelled,[2] the letter reveals
the artist's sustained interest in the art of El Greco at the time of Cubism.
Picasso had studied paintings by El Greco on at least three occasions: during a
brief visit to the Prado with his father in April or early May of 1895; while a
student at the Real Academia de Bellas Artes in Madrid from October 1897 to
June 1898 (during which time he also made several visits to Toledo), and on the
occasion of his sojourn in Madrid in the winter and spring of 1901.[3] Following
his second visit to the Spanish capital, Picasso produced a series of sketches
with caricatures of El Greco heads. In one drawing of circa 1899 (fig. 23), his
identification with the Greek-born artist was particularly strong. Inscribing the
page with the words "Yo, el Greco" beneath one of the heads, Picasso simulta-
neously paid homage to a venerable Spanish painter and declared his position as
El Greco's legitimate heir.[4]

Picasso's dialogue with El Greco at the time of Cubism has been the subject
of considerable discussion, most recently in relation to the genesis of the
Demoiselles d'Avignon (fig. 24). In 1987, Rolf Laessoe and John Richardson
independently proposed a new source for the *Demoiselles* in El Greco's *Apocalyptic
Vision* (fig. 25), previously known as *The Opening of the Fifth Seal*.[5] Laessoe,
pursuing an observation Ron Johnson had made in 1980,[6] noted formal affinities
between the two paintings in figural types and positions, in the triangular
entrance to the pictorial space, in the angularity of the draperies, and in the tight
compression of the visual field.[7] Moreover, Laessoe posited an iconographical
connection. Arguing that in 1907 El Greco's canvas was in the Paris home of
Picasso's friend Ignacio Zuloaga,[8] and that it was originally thought to be a
fragment of a larger panel representing "Sacred and Profane Love," Laessoe
pointed to a related theme in a preparatory sketch for the *Demoiselles* (fig. 26), in
which a sailor and a medical student enact a drama of carnal versus intellectual
knowledge in a brothel.[9]

23 Pablo Picasso, "*Yo, el
Greco*", ca. 1899. Ink on
paper, 31.5 × 21.8 cm.
Barcelona, Museu Picasso.

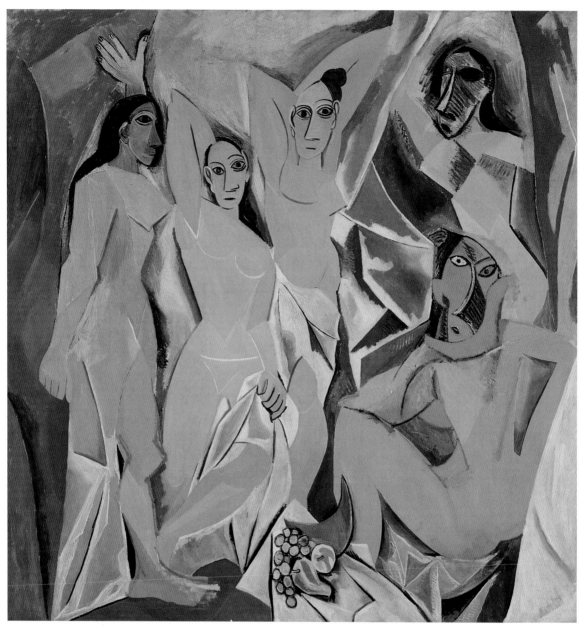

24 Pablo Picasso, *Les Demoiselles d'Avignon*, 1907. Oil on canvas, 243.9 × 233.7 cm. New York, The Museum of Modern Art. Acquired through the Lillie P. Bliss Bequest.

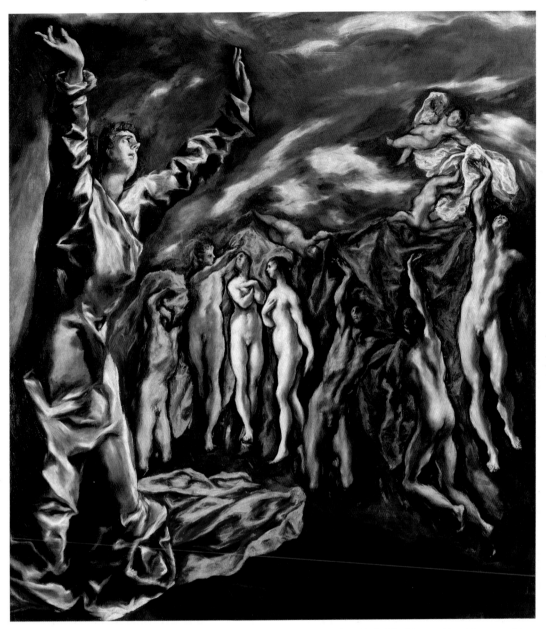

25 El Greco, *Apocalyptic Vision*, 1608–14. Oil on canvas, 225 × 193 cm. New York, The Metropolitan Museum of Art. Rogers Fund, 1956.

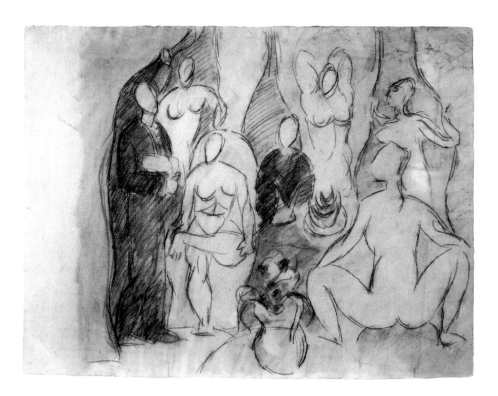

26 Pablo Picasso, study for *Les Demoiselles d'Avignon*, 1907. Basel, Öffentliche Kunstsammlung Kupferstichkabinett. Gift of the artist.

Even before Laessoe's article appeared, John Richardson had marshalled considerable evidence to substantiate a connection between the *Demoiselles* and the *Apocalyptic Vision*, going so far as to suggest El Greco as a missing link in the development of Cubism. Taking his cue from Picasso, Richardson quoted a much later statement by the artist to Romauld Dor de la Souchère:

> Cubism is Spanish in origin, and it was I who invented Cubism. We should look for Spanish influence in Cézanne. . . . Observe El Greco's influence on him. A Venetian painter but he is Cubist in construction.[10]

Thus positioning Cubism and the art of El Greco outside the Renaissance tradition of perspectival illusionism, Richardson concluded: "Cubism was Spanish to the extent that it emanated from El Greco, and from one painting in particular." Indeed, Richardson's entire discussion was an attempt to re-situate Picasso's art within the context of Spanish painting. Following Picasso's lead, Richardson constructed his genealogy of Cubism on the basis of formal affinities between the art of Picasso and El Greco. In so doing, he followed an argument that had gained currency in French formalist criticism of the 1920s, particularly in the writings of Picasso's friend, André Salmon.[11]

It can also be argued, however, that the *Demoiselles d'Avignon* secures its meanings in opposition to the concept of a unitary national tradition. Robert Rosenblum, for example, has positioned the *Demoiselles* in a venerable history of nineteenth-century representations of prostitutes, courtesans, and odalisques

30

that spans national frontiers, extending from Goya's *Naked Maja* and Manet's *Olympia*, to Delacroix's *Women of Algiers* and Ingres's *Turkish Bath*.[12] Along with this tradition of women in suggestive poses, we may in turn cite representations of bathers—another category of nudes—and admit Cézanne into Picasso's visual archive.[13] Art-historically speaking, then, Picasso overlays visual and temporal referents.[14] As William Rubin has observed, Picasso so effaces his sources in the preparatory sketches for the *Demoiselles* through a process of continual elaboration and transformation, that it is difficult even to speak of a precise dialogue with past art in the final painting.[15]

These preliminary remarks indicate that an extended consideration of Picasso's relation to art history and his uses of visual tradition is in order. It is my contention that Picasso denies rather than confirms a stable aesthetic discourse of cultural nationalism in *fin-de-siècle* French and Spanish art. Locating the *Demoiselles* within a wider field of cultural criticism, I want to suggest that Picasso does not merely compete with his predecessors formally, but calls into question historical and temporal constructions of national visual traditions through a practice that is also textual. The bodies of the five demoiselles constitute the site where this practice is negotiated. As Picasso elides and overlays signifiers of cultural tradition in French and Spanish art, national history is not so much written, but unwritten, pulled apart. Picasso's "ladies" inhabit the space where multiple and contradictory texts converge.

<p style="text-align:center">* * *</p>

Picasso's conception of time is central to his dialogue with national history and tradition. If history is the writing of the past, in the *Demoiselles* Picasso insists upon anchoring the viewer in the immediate present. In the contracted space of a *maison close*, vision joins its object in the bodies of five prostitutes. There is no retaining wall to arrest the forward movement of these "ladies"; nothing contains the demoiselles as they press against the picture plane.[16] In place of woman as protector of the hearth, mother of the nation, and personification of eternal spring, Picasso's aggressively sexualized nudes transgress the boundaries of bourgeois respectability and shake the moral highground of the nation.[17] In a direct, confrontational address that forbids contemplative immersion, the five nudes engage the viewer, who has here assumed the position of a (presumably) male client, in a voyeuristic drama of seduction and repulsion. At every level, Picasso arrests movement into depth at the surface of the picture, returning us to the intense hold of the gaze: there is no erotic mystification here, no escape from the blinding stare of the Medusa.[18] This is particularly true in the case of the two demoiselles on the far right, who wear expressions which André Salmon likened to "masks almost entirely freed from humanity."[19] Conjuring images of the West's colonial "other" and violent primitive sexuality,[20] they block the viewer's passage into the symbolic space of a transcendent and timeless sensuality.[21]

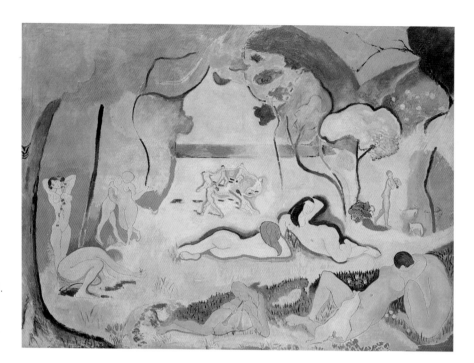

27 Henri Matisse, *Le Bonheur de Vivre*, 1905–06. Oil on canvas, 174 × 238 cm. Merion, Pennsylvania, The Barnes Foundation.

The broad implications of Picasso's challenge are immediately evident if we consider the "horizon of expectations"[22] in French culture for paintings of the female nude. Here it is instructive to examine another work of avant-garde transgression in relation to the *Demoiselles*—Matisse's *Bonheur de Vivre* of 1905–06 (fig. 27), which Picasso had ample opportunity to study at the home of Gertrude and Leo Stein.[23] Matisse's *Bonheur* largely secures its meanings within French painting, with sources ranging from Poussin and Ingres,[24] to Cézanne, Manet, Monet, and Gauguin. In this way, as James Herbert has argued, Matisse's painting bridges a temporal span between the eternal Golden Age represented by the Latinate *grande tradition* and the art of the Republican present.[25] Practicing what Herbert calls a "temporal compromise,"[26] Matisse refigures the body-politic of contemporary France—robust, transcendent and, essential to the operations of nationalism, natural. Locating his practice within the tradition of the *paysage composé*, Matisse suspends his eternal present in the domain of the symbolic; his conception of time corresponds to the structure of myth.[27]

In contrast, Picasso aggressively disrupts mythical temporality. He opens a fissure in the discourse of nationalism as he simultaneously dislocates tradition and dismantles the aesthetic codes mediating the relationship between the nation and the *éternelle féminin* in French painting. The term "discourse" has a particular meaning here as it relates both to language and, to borrow a phrase from Paul de Man, "the rhetoric of temporality."[28] As Picasso abandoned his initial allegorical conception for the *Demoiselles*, he transferred its erotic and

thanotopic content to formal relationships.[29] In so doing, he radically altered the signifying structure of the painting. As the allegory was progressively emptied, the formal signifiers of the painting began to circulate in a wider, and less secure, field of meaning, attaching themselves to multiple concepts simultaneously (a *maja*, Spanish art, a bather, the *grande tradition*). If the *Demoiselles d'Avignon* has consistently thwarted efforts toward a unitary interpretation, it is because Picasso's aesthetic operations de-center meaning. Within the organic space of the symbolic,[30] Matisse posits, but in the end does not deliver, a unified subject/object relation. He simultaneously establishes an organic image of the body in nature, and disfigures that relationship through spatial discontinuities and unstable gender identities.[31] This movement in and out of the symbolic constitutes his most radical act. Picasso, however, goes a step further. The rhetorical mode and temporal structure of the *Demoiselles* correspond more closely to irony, understood by de Man as a division of "the flow of temporal experience into a past that is pure mystification and a future that remains harassed forever by a relapse within the inauthentic."[32] Picasso seems to deny that a lost organic unity can ever be recovered in the future; the *Demoiselles d'Avignon* defeats all efforts at synthesis, holding the viewer prisoner in an anxious present.[33] If Matisse can still envision the unified space of myth, Picasso collapses it from within.

Picasso's contemporaries immediately recognized the transgression. Although their comments are often contradictory—hearsay passed on by second and third parties[34]—they consistently register expressions of shock, confusion, and dismay. One published response is, however, illuminating. In "The Wild Men of Paris," which appeared in New York in May 1910,[35] Gelett Burgess recalled his visits to the studios of Matisse, Braque, Derain, and Picasso, among others. The article is frequently cited as the first instance in which a photograph of the *Demoiselles* was published, although its real interest lies in the author's astute critical observations. In the account of his meeting with Picasso, Burgess referred to the artist's "monstrous, monolithic women"; he characterized his paintings as abominable affronts to "nature, tradition, decency"; and he described Picasso himself as a devilish iconoclast who delights in his "crimes." Although it is not clear if his remarks were specifically directed toward the *Demoiselles*, Burgess's essay sheds considerable light on the extent to which Picasso challenged Fauve "cultural unities."[36]

But it must be stressed here that Picasso does more than invert the *grande tradition* and the authority of a French national art. Interpreting Picasso in relation to French art ultimately diminishes the historical weight of his transgressive act. It must also be emphasized that Picasso disrupts the rhetorical and temporal structures that allowed myth to operate in the construction of national artistic tradition(s) in Spain. To argue this point is to focus on language as the site where cultural ideologies are held, reproduced, and finally naturalized as myth;[37] it is to examine the political and literary status of cultural representations as figures of a particular kind of speech, and the ways in which those representations are secured in painting and in criticism. In order to expose this

process—to demythologize it—I want to return to El Greco, but not to a specific painting—tracing, as does Richardson, a formal teleology that culminates in Cubism—or to biographical data. Picasso's special identification with El Greco invites a different kind of analysis, one that may help to articulate his attitude toward tradition and modernity within a historically-defined cultural process. To this end, I want to examine the El Greco "myth" in *fin-de-siècle* Spanish criticism as a means to enter into and disturb the discursive formations of the Spanish tradition. This approach will enable us to chart the operations through which a range of cultural unities was forged in a country which, unlike France, lacked any semblance of an ideological center on the question of nationalism. Picasso's contemporaries in *fin-de-siècle* Barcelona and Madrid participated in culturally distinct processes of national identity formation. Through their various attempts to define tradition and give it form, conflicting nationalist discourses entered the art and art history of Spain. The *Demoiselles d'Avignon* is heir to this process.

* * *

Jonathan Brown and José Álvarez Lopera have studied the critical fortunes of El Greco in the nineteenth and early twentieth centuries.[38] Beginning with the first recuperation of El Greco in France with the opening of Louis-Philippe's short-lived Galerie Espagnole in the Louvre in 1838, and the publication of Théophile Gautier's *Voyage en Espagne* in 1843, the artist was transformed into the paradigmatic Romantic hero: a rebel, an individualist, and an outsider to Spanish art. By the 1860s and 1870s, El Greco was in turn repositioned as a formal innovator and an audacious colorist whose experiments forecast those of Delacroix and the Impressionists.

Nowhere was El Greco's status as a forefather of modern art more insistently emphasized than among Picasso's circle in *fin-de-siècle* Barcelona. The journal *Luz* used the word "precursor" to identify El Greco's relationship to modernism's spirit of renovation, cosmopolitanism, and innovation in its first issue of 15 November 1897,[39] an epitaph Miquel Utrillo again used in his 1906 monograph on the painter:

> Celebrated in his days, in ours, and without doubt in those to come, his works can aspire to the serene immortality of those who constantly remain modern.[40]

The theme of El Greco's modernity signaled an exhortation to the cosmopolitan youth of Picasso's generation.[41] On at least one occasion, Picasso appears to have used imagery derived from his studies after El Greco to construct his own bohemian persona as a worldly artist and as a member of the Catalan avant-garde. This was around 1899–1900, by which time the artists, writers, and poets who frequented the Quatre Gats café in Barcelona had become deeply interested in El Greco's art and in the cultural criticism it generated. In a revealing caricature, Picasso adapted the elongated proportions of the Greco

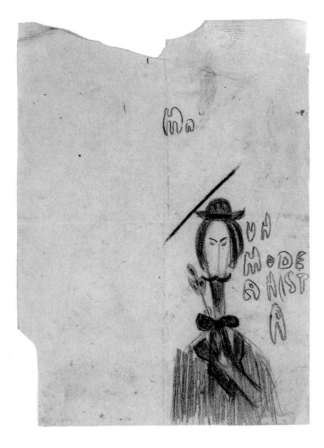

28 Pablo Picasso, *"Un Modernista"*, ca. 1899–1900. Conté crayon on paper, 22 × 15.9 cm. Barcelona, Museu Picasso.

heads for an image of a typical "Modernista" (fig. 28). Given Picasso's identification with the Mannerist artist and his close involvement with the Quatre Gats circle, a network of complex relations with El Greco and the bohemian milieu of Barcelona is established in his work.[42]

These observations suggest that Picasso's response to El Greco was not simply visual; it was also textual, mediated by specific cultural tropes. For Picasso's colleague Santiago Rusiñol, co-founder of the Quatre Gats, El Greco was "the modernist man of his time," a genius unrestricted by national frontiers, a man of the world.[43] Like Picasso, Rusiñol projected his own image as a painter and writer onto El Greco, emphasizing above all his artistic independence, violation of academic canons and, within the context of Rusiñol's own involvement with Symbolism, El Greco's exploration of the imaginary.[44] Indeed, shortly after Rusiñol acquired two works reputedly by El Greco from his friend Ignacio Zuloaga in 1892–93,[45] the canvases were ceremoniously paraded through the streets of Sitges, a coastal village south of Barcelona, and installed in Rusiñol's house-museum, El Cau Ferrat, amidst great fanfare.[46] Four years later, in August 1898, a monument to El Greco was unveiled in Sitges. In the absence of historical documentation of the painter's physical appearance, the press

described the monument by the sculptor Reynés as a moral portrait. The dedication speech edified El Greco as a son of all humanity.[47]

Taken as a whole, the interpretative paradigms operative within El Greco criticism shed light on the social foundations of Catalan *Modernisme*. What mattered was not the work of El Greco, historically tied to the Castilian rather than to the Catalan milieu, but the model of an unbroken chain between past and present—the linkage of tradition with progress and modernity. The El Greco "myth" provided highly mediated symbols that affirmed the interests of the Catalan bourgeoisie within a broad process of social engineering, cultural retrieval, and national identity formation. The insistence upon El Greco's timeless appeal as an innovator—and thus his modernity—was ideological; lifted outside of a precise historical moment, El Greco's art—or rather the El Greco myth—articulated the political and social aspirations of an emergent middle class actively engaged in the process of constructing a hegemonic Catalan cultural nationalism. As a symbol of progress, El Greco represented a convenient kind of found tradition, malleable enough to shape the needs of the present.

This linkage of tradition with a progressive and cosmopolitan conception of modernity[48] was not, however, an exclusive practice among Catalan artists and intellectuals. In a similar way, the El Greco myth was called upon to mediate cultural discourses outside of Spain. In 1908 El Greco was one of three artists to be represented in a room of his own at the Salon d'Automne in Paris.[49] As the Salon *livret* emphasized:

> The rehabilitation and glorification of El Greco is quite recent. The taste for the new has assisted it and perhaps, beyond that, the advent of Cézanne and the posthumous exhibitions of Van Gogh have helped the public assume the perspective necessary to understand an artist who was untroubled by the desire to please.[50]

Once again, El Greco's position in history is defined in relation to the needs of the present overlaid upon the immediate past—in this instance, filtered through Van Gogh and Cézanne, both of whom had recently been honored with memorial retrospectives at the Salon. That transgression and innovation could be absorbed into the discourse of tradition was underscored by the joint retrospectives of Ingres and Manet at the 1905 Salon d'Automne, both of whom Picasso would incorporate into his historical archive, the *Demoiselles d'Avignon*.

* * *

Picasso's layering of visual texts to construct a fractured historical narrative is evident in his life-long exploration of the practice of variation. His quotations from several, often antithetical, traditions in a single work frequently involve an operation of displacement that resists fixed meanings.[51] Moreover, his variations may be thought of as "sub-versions," exposing the latent content beneath the original source,[52] as in a 1903 variation after Manet's *Olympia* (fig. 29).[53] Here,

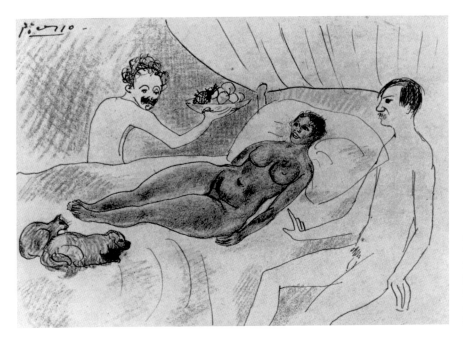

29 Pablo Picasso, *Manet's "Olympia" Attended by Sebastià Junyer Vidal and Picasso*, 1903. Pen and colored crayon on paper, 15 × 23 cm. Private Collection.

as Susan Grace Galassi has shown, Picasso competes with Manet at his own game of historical quotation by layering additional sources in Italian, French, and Spanish art onto this modernist icon. In an ironic reversal, Picasso undermines the complex confrontation between viewer and woman-as-commodity that is the social and psychological center of Manet's painting (Picasso's companion Sebastià Junyer-Vidal assumes the position of the servant), just as he reconfigures the body of Olympia as a voluptuous black Venus, the colonial signifier of "savage," unbridled sexuality.[54] Presiding over the scene is Picasso, who appears in the foreground in the position of Olympia's fictive patron, recalling Cézanne's send-up of Manet's masterpiece in his *Modern Olympia* of 1874. A later addition, judging by the contour lines of the pillow and the scale of the figure, Picasso appears to intrude upon the space of historical quotation, unable to make contact with the nude and, in the process, to take full possession of the modernist tradition that she embodies. He remains an outsider.

Picasso's caricature registers a dual sense of resistance and anxiety concerning assimilation, appropriation, and the authority of tradition that many Spanish artists of his generation experienced. If the Parisian art market held out the promise of international public recognition, it exacted a tribute that threatened to displace Spanish artists from indigenous cultural practices or, conversely, insisted upon remaking what was perceived to be their "native" character. Indeed, Picasso was immediately identified as a "Spanish" painter in Paris, and thus experienced first hand the process through which the market negotiates in national identity as a cultural commodity.

30 (right) Pablo Picasso,
*Picasso i Junyer surten de
viatge*, 1904. Ink and
colored pencil on paper, 22
× 16 cm. Barcelona,
Museu Picasso.

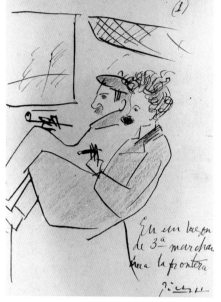

31 (far right) Pablo
Picasso, *Picasso i Junyer
arriben a la frontera*, 1904.
Ink and colored pencil on
paper, 22 × 16 cm.
Barcelona, Museu Picasso.

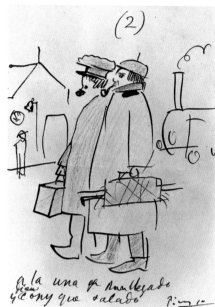

Attesting to this condition, Picasso drew a commemorative broadsheet (*auca*, in Catalan) to celebrate his fourth and definitive trip to Paris in 1904 in the company of Junyer-Vidal. The broadsheet recounts the story of two unknown painters who leave Spain to seek fame and fortune in Paris. As the narrative unfolds we follow the two friends as they leave Barcelona in a third-class wagon. ("En un vagón de 3a marchan hacia la frontera") (fig. 30). After changing trains at the border ("a la una han llegado y dicen cony que salado") (fig. 31), they continue onto Montauban, where they make a brief stop ("Y llegan a Montaulvant liados en el gaban") (fig. 32). In the fourth frame (fig. 33), we encounter Picasso and Junyer-Vidal upon their arrival in the French capital, identified by the silhouettes of Notre Dame and the Eiffel Tower in the distance ("A las nou del dematí llegan por fin a Paris"). These touristic site markers of Parisian culture past and present are charged with meaning, as they underscore the conceptual distance of Paris as the capital of modern art for Picasso and his circle in Spain. To be sure, Picasso's narrative is inscribed within a discourse of cultural difference. Although the fifth frame has been lost, a likely sequence for the narrative would involve Picasso and Junyer-Vidal searching for lodgings, or hawking their wares among dealers, before the triumphant moment of financial success in the sixth frame. Here, in a spectacular denoument, Junyer-Vidal is rewarded for his efforts by none other than Durand-Ruel (fig. 34) who, as Picasso somewhat cynically informs us, "gives him a lot of dough" ("lo llama Duran-Rouel y le dá muchos calé"). Surely, Picasso's *auca* is an ironic commentary on the vicissitudes of success for outsider artists. The inscriptions, written in both Catalan and Castilian, underscore Picasso's bi-cultural status, first as an

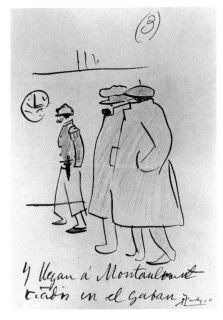

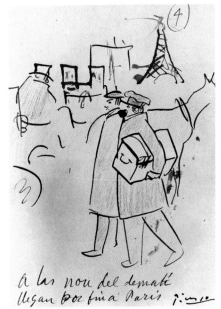

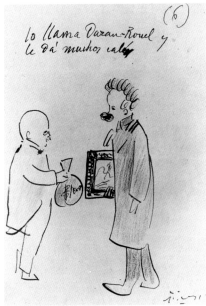

32 (above left) Pablo Picasso, *Picasso i Junyer arriben a Montauban*, 1904. Ink and colored pencil on paper, 22 × 16 cm. Barcelona, Museu Picasso.

33 (above right) Pablo Picasso, *Picasso i Junyer arriben a París*, 1904. Ink and colored pencil on paper, 22 × 16. Barcelona, Museu Picasso.

34 (left) Pablo Picasso, *Junyer visita Durand-Ruel*, 1904. Ink and colored pencil on paper, 22 × 16 cm. Barcelona, Museu Picasso.

Andalusian in Barcelona, and then as a Spaniard in Paris. Within the framework of these shifting cultural identities, we are asked to ponder the question of Picasso's relation to the Parisian art market: How will it receive him? Will he, too, be rewarded? If so, on whose terms?

Picasso was acutely aware of his outsider status in Paris, just as he was sensitive to the demands of the market, which had a voracious appetite for

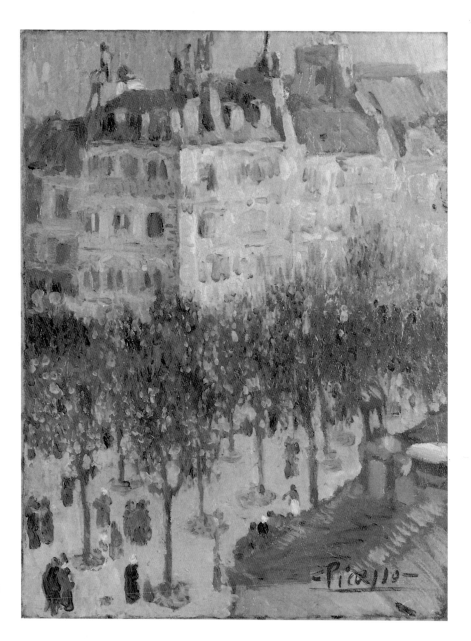

35 Pablo Picasso,
Boulevard Clichy, Paris,
1901. Oil on canvas, 61.5
× 46.5 cm. Private
Collection.

"things Spanish." Durand-Ruel had sent Ricart Canals, Picasso's friend from
Barcelona, back to Spain on two occasions to paint "typical" subjects.[55] And
Picasso himself had arrived in Barcelona for the first time in October 1900 with
some of his most "marketable" paintings of bullfighting scenes. This strategy
proved successful; the dealer Berthe Weill soon acquired three pastels through
Pere Manyac, who had taken Picasso's work on consignment.[56]

Even when his paintings and pastels explicitly treated Parisian subjects, as in
his views of the Boulevard Clichy (fig. 35) and the café-concert Le Divan

36 Pablo Picasso, *Le Divan Japonais*, 1901. Watercolor on paper, 33.5 × 49.5 cm. Private Collection.

Japonais (fig. 36), both of 1901, French critics continued to underscore Picasso's Spanish racial temperament. Félicien Fagus characterized Picasso's exhibition with the Basque painter Francisco Iturrino at the Vollard gallery in May 1901 as a "Spanish invasion," emphasizing the "profound family resemblance" among the new generation of Spanish painters.[57] Nonetheless, his review did not merely traffic in ethnic and national stereotypes. Just as Gustave Coquiot would describe Picasso as a Baudelairean "painter of modern life" in his review of the Vollard exhibition,[58] Fagus emphasized Picasso's sources in Manet, Van Gogh, and Toulouse-Lautrec, among others. Positioning Picasso between modern art and "the great ancestors" (identified neither as French nor Spanish), Fagus insisted, "the men from across the Pyrenees must no longer feel themselves foreigners: the qualities which bring success with them are collateral to ours; we are both Latins. . . ." With great insight, Fagus underscored the mutability of national artistic frontiers, as the example of Manet ("whose painting is a little Spanish") attested.[59]

A year later, in his review of Picasso's work at the Berthe Weill Gallery, Fagus was more explicit:

All of these Spanish artists . . . have temperament, race, and individuality, each one in perfect control of a personal garden, very personal and at the same time closely related to the neighboring garden. They do not have their great man yet, the conquerer who subsumes and remolds all, makes everything start from him, who shapes an unlimited universe. They remember to advantage Goya, Zurbarán, Herrera; are stimulated by Manet, Monet, Degas,

Carrière, our Impressionists. Which one—the time is ripe—will become their Greco?[60]

Responding to contemporary interpretations of El Greco as a heroic individualist who came to define a Spanish national art from the outside, Fagus emphasized the idea of tradition as an intellectual construct operating within a process of historical invention.[61] By extension, Picasso was identified as the protean outsider who would enter the body-politic of French art and reconfigure its anatomy.[62]

Where, then, was Picasso to be located? Facing up to the inherent ambiguities in securing a national tradition, French critic Charles Morice approached the problem from a different perspective. Responding in December 1902 to a group show of Picasso, Ramón Pichot, and two French artists at Berthe Weill's, Morice observed:

> these four artists, two French, two Spanish, have brought together their latest works. French; Spanish? Is this quite true? No. All four are citizens of Montmartre! Land of their desire, atmosphere of their labors and of their ambitions, of their art.[63]

Morice's comment was precise. Montmartre, so intimately associated with bohemian culture, had become the archetypal site of social interaction for the avant-garde: a physical and conceptual space in which differences among classes and nations could temporarily be effaced precisely because they were acted out and contained in cafés, music halls, and cabarets throughout the quarter. As T.J. Clark and Jerrold Seigel have argued, the avant-garde seized upon the inherent instability of bohemia as the site of shifting social hierarchies, and internalized it into its aesthetic practices.[64]

For Picasso, however, the bohemian milieu of Montmartre carried additional associations: it was a place where he could escape the authority of a unitary national tradition. This is important, because Picasso did not enter the world of bohemia without considerable cultural baggage, having inherited specific attitudes about Montmartre from his contemporaries. Miquel Utrillo had described the quarter in 1890:

> Montmartre possesses a peculiar physiognomy. Its inhabitants think and work in a distinct manner from the rest of Parisians; its serpentine little streets and alleys inspire other images than those evoked by the ostentatious central avenues. . . . It incites certain philosophies unknown to the human whirlwind which is born, lives, and dies, drowned between the interminable parallels of eight-floor apartment houses which form the inextricable network of modern Paris.[65]

Yet Utrillo's experiences of Montmartre were distinct from Picasso's. For Utrillo, Montmartre provided a model of international, cosmopolitan culture. In bohemia, to paraphrase Jerrold Seigel, he could test the boundaries of bourgeois

life without challenging the deeper assumptions of his class. Utrillo participated in a broad project of cultural and national regeneration that was intimately linked to the political and economic aspirations of the Catalan bourgeoisie, which asserted its position at the helm of contemporary Catalan society. In 1897, when Utrillo helped his friends Pere Romeu, Santiago Rusiñol, and Ramón Casas found the Quatre Gats café in Barcelona, he modeled it on Rudolphe Salis's Chat Noir in Montmartre.[66] To be sure, both locales appealed to a bohemian, cosmopolitan, and international clientele. But there was also a clear national agenda at the Quatre Gats. The neo-Gothic architecture of the café symbolically negotiated the reconciliation of tradition with modernity (fig. 37), specifically with reference to Catalonia's national efflorescence in the middle ages, just as the interior decor, which included a collection of indigenous ceramics (fig. 38), served to emphasize Catalonia's cultural patrimony. Here, on the frontiers of bohemia, history and culture were enlisted to construct a coherent model of Catalan nationalism that was tied to a broader project of bourgeois political hegemony.

Although Picasso had celebrated his first one-man exhibition at the café in 1900, *his* bohemian milieu in Paris involved a different kind of temporal and cultural synthesis. The physical site was the Lapin Agile, a "rustic" establishment that Picasso and his circle began to frequent in 1904, as a period photograph documents (fig. 39). Three large sculptures dominated the back wall of the café: a cast of Apollo with a lyre, a plaster Javanese relief, and a Crucifixion by the artist Walsey.[67] The presence of the three objects suggests an archive of visual traditions, but in contrast to the Quatre Gats café, there is no overarching structure of meaning that would enable one to locate these disparate objects historically, stylistically, or in terms of a national tradition.

John Richardson has suggested that Picasso may have obliquely responded to the Javanese relief in his *Boy Leading a Horse* of 1906 (fig. 40).[68] If so, Picasso layers cultural meanings, as Cézanne's *Bather* of 1885 (fig. 41) may also be present in his conception. So too, perhaps, is El Greco's *St. Martin and the Beggar* (fig. 42), which Richardson has identified as another source for Picasso's painting. The point is that Picasso so transforms his raw materials that specific cultural referents are difficult, if not impossible, to fix. A year and a half later in the *Demoiselles d'Avignon*, Picasso pushed this practice further in his very choice of subject-matter. Although the *Demoiselles* represents the consolidation of his cultural subterfuge, there is already a hint of this practice in 1905. In the photograph of the Lapin Agile a self-portrait by Picasso of around 1904–05 seated beside Germaine Florentin (paramour of his ill-fated friend Carles Casagemas) and the café's colorful proprietor, Frédé (fig. 43), hangs on the back wall. If the photograph is read discursively, the promixity of the portrait, the relief, and the sculptures is telling. For the group self-portrait identifies the café as a particular kind of social space, a theater of difference in which Picasso, in his role as subject and object of the representation, performs an elaborate cultural masquerade. In this framework, the photograph suggests that world history and

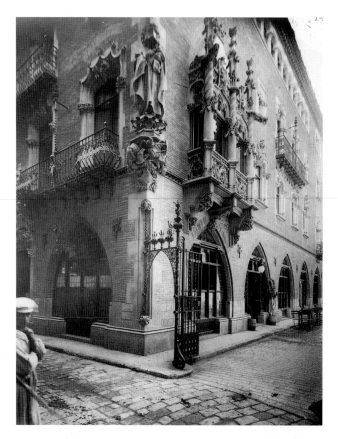

37 Exterior view of Casa Martí, Barcelona, ca. 1900.

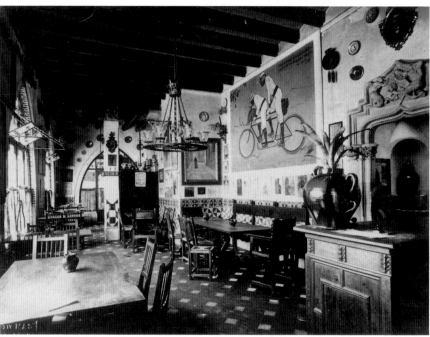

38 Interior of Casa Martí, Barcelona, ca. 1899.

civilization are Picasso's personal domain, so much raw material to be processed and reconfigured. Picasso redefines the meaning of national history and collective memory by bending artistic tradition to his individual will. Although this attitude toward tradition is not without precedents in nineteenth-century art, Picasso's implicit acknowledgment that tradition is a temporal and cultural construct speaks volumes about his historical consciousness and his sense of place in the world.

* * *

Critics have long commented on the Nietzschean character of Picasso's individual act of will, with its emphasis on creation as a sum of destructions, and its challenge to a historicized culture.[69] Ron Johnson was among the first scholars to link Matisse's *Bonheur de Vivre* with Picasso's *Demoiselles* in this regard, noting that Picasso's painting "is in many ways a Nietzschean reversal of the theme, substituting mockery, destructiveness, and tragedy for happiness."[70] For Nietzsche, however, the notion of destruction did not exactly signify a historical

39 Interior of the Lapin Agile, Paris, ca. 1905.

45

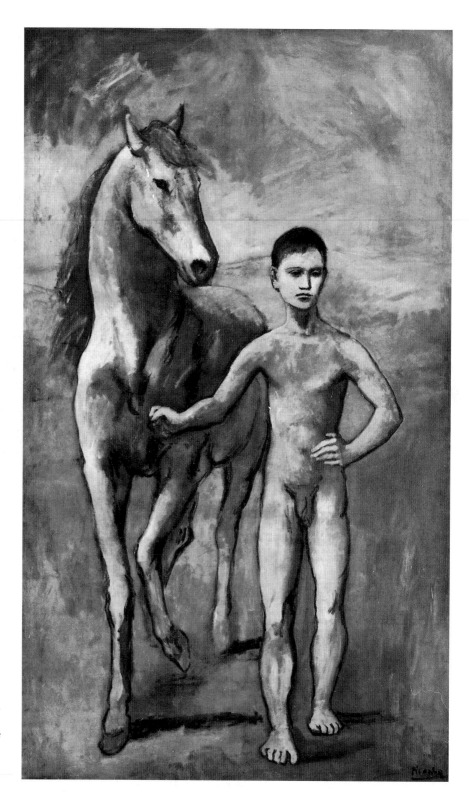

40 Pablo Picasso, *Boy Leading a Horse*, 1905–06. Oil on canvas, 202.6 × 131.3 cm. New York, The Museum of Modern Art. The William S. Paley Collection.

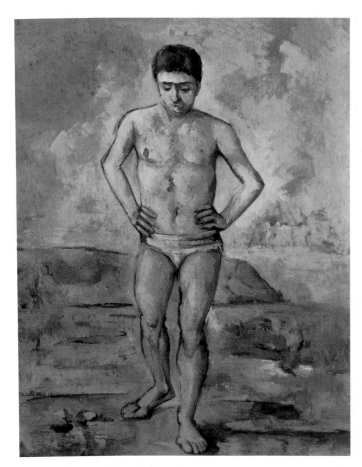

tabula rasa; rather, tradition was to be salvaged from the realm of archaeology and repositioned in relation to a lived present. This was surely the aspect of Nietzsche that most appealed to Picasso's contemporaries in Spain.

Nietzsche's writings permeated the cultural and intellectual atmosphere of the circles in which Picasso traveled, first in Barcelona, subsequently in Madrid. The literary journal *Arte Joven*, published in Madrid in the spring of 1901 under Picasso's artistic direction, served to foster close ties among artists and intellectuals in the two cities, who were jointly committed to a project of social and cultural regeneration.[71] References to Nietzsche, as well as advertisements for Spanish translations of *The Birth of Tragedy*, appear throughout the journal, which ceased publication after five issues.

If, however, Picasso and his contemporaries interpreted Nietzsche's will to power as an individual act in defiance of an anachronistic culture, one that uniquely qualified the specially endowed creator to lead the masses forward in a process of cultural renewal, within the context of the anarchist movement in Spain they also recognized that the idea of an intellectual aristocracy did not

41 (above left) Paul Cézanne, *Bather*, ca. 1885. Oil on canvas, 127 × 96.8 cm. New York, The Museum of Modern Art. Lillie P. Bliss Collection.

42 (above right) El Greco, *St. Martin and the Beggar*, 1597–99. Oil on canvas, 193.5 × 103 cm. Washington, D.C., National Gallery of Art. Widener Collection.

43 Pablo Picasso, *Au Lapin Agile*, 1904–05. Oil on canvas, 99 × 100.3 cm. New York, The Metropolitan Museum of Art, The Walter H. and Leonore Annenberg Collection, Partial Gift of Walter H. and Leonore Annenberg, 1992 (1992.391).

justify social retreat or, worse, political oppression.[72] In the wake of the Spanish-American War and the ensuing National Disaster, the Nietzschean task necessitated nothing less than a reinvention of the concept of the nation within a broad project of social regeneration.[73] As the salutatory statement of *Arte Joven* attests, culture would assume an important role in this process of national affirmation:

> We do not intend to destroy anything: our mission is more elevated. We come to build. The old, the out-moded, the worm-eaten will collapse by

themselves. . . . Virgil, Homer, Dante, Goethe, Velázquez, Ribera, El Greco, Mozart, Beethoven, Wagner—they are the eternally youthful; the more time passes, the greater they become. They grow rather than perish, and as long as the world exists, so too will they: they are immortal.[74]

Other editorial notes and articles in *Arte Joven* proclaimed that a gratuitous rupture with the past was as antithetical to this "project of regeneration" as was maintaining the status quo.[75] As Picasso's friend and co-editor of the journal, Francisco de Asís Soler, explained, "On the ruins of a people that has fallen from its vices, we are entrusted to build a great and noble people, enamored of Work, Art, and Science."[76] Seizing upon the inauguration of the bullfighting season as a pretext to launch a biting indictment of a stagnant, provincial, and anachronistic Spanish society, Soler lamented:

> We don't want to redeem ourselves. We erect new bull rings instead of creating schools; we joke, we always laugh, we enjoy ourselves at all times, and we don't try to regenerate industry, commerce, and agriculture, which are on their last legs. . . .
> We have lost everything: dignity and shame.
> Fine, be that way my countrymen! Follow your path, come to the bullfights and satisfy your cruel instincts watching blood flow. . . .[77]

Youth would lead the struggle to regenerate Spain not by turning away from tradition, but by recognizing what was most vital, authentic, and universal in tradition. The bohemian youth of Madrid that Picasso portrayed in his drawings for *Arte Joven* (fig. 44) is endowed with a unique historical mission; its art is the outward sign of spontaneous renewal and freedom from social conventions.[78] As Miquel Utrillo, writing in June 1901 for the Catalan journal *Pèl & Ploma*, explained, "In Madrid, Picasso and the writer Soler founded the journal *Arte Joven*, which circulated widely from the first number, just because of this taste for renewal, evident in the drawings of the young Andalusian painter. . . ."[79] Three years earlier, Utrillo had elaborated on this position in an editorial for the Catalan journal *Luz*, forecasting *Arte Joven*'s statement of intent:[80]

> Those of us who spontaneously grouped together around *Luz* are young people, and in that fact we place our strength and hopes. Our desire is to impress our ideas upon the minds of youth who are able to produce now, tomorrow, later, and always. . . . Not relying solely on our own resources, we also count on the decided support of youthful spirit—of all those who aspire to the youth of Art, as life declines, as it happened with Puvis de Chavannes, Whistler, Degas, Burne-Jones, William Morris, Wagner, and the Goncourts. These and many others found the true fountain of youth rejuvenating themselves more and more by means of Art—as the years distanced them from the arduous times of youth.[81]

44 Pablo Picasso, *"Bohemia madrileña"*, 1901. Charcoal on paper, 32.5 × 30.5 cm. Published in *Arte Joven*, No.2. Private Collection.

This same attitude of a youthful, athletic vitality tied to social regeneration also informed Utrillo's interpretation of El Greco in his 1906 monograph.

A series of carefully constructed binarisms are present in the generational criticism that fills the pages of *Luz* and *Arte Joven*: progress/stagnation; provincialism/cosmopolitanism; innovation/academicism; and most importantly, tradition as creative renewal versus tradition as inert formalism. Through the pairing of these concepts, artists, writers, and intellectuals in Barcelona and Madrid attempted to secure the identity of a modern Catalan and Spanish nation. Their dual project of regeneration and criticism of Spain's provincial torpor and social and cultural enervation is echoed in another key text of the period: *España negra*.

As with Asís Soler's invectives against bullfighting culture—precisely the clichés that mediated Picasso's entry into the French art market—Darío de Regoyos's *España negra* focused on the crisis of Spanish national decline. Comprising a text by the Belgian Symbolist poet Emile Verhaeren and illustrations by Regoyos (fig. 45), *España negra* appeared in serial form in *Luz* over the course of November and December 1898.[82] Its publication immediately followed Regoyos's exhibition at Els Quatre Gats in November of that year. The selection of Regoyos (who had befriended two of the café's proprietors—Santiago Rusiñol and Ramón Casas—in Paris in 1890) for the inaugural exhibition at Els Quatre Gats is indicative of the cosmopolitan orientation of the café, as the painter had close contacts with advanced artists, writers, and poets in Paris and Brussels.[83]

45 Darío de Regoyos, cover of *España negra*, 1898.

Regoyos's internationalism, essential to the members of the Quatre Gats group, was stressed in a review of his exhibition by Utrillo in *Luz*, in which his activities were briefly chronicled.[84]

But there was also another Regoyos to whom the Catalan public was introduced in 1898: the painter of "Black Spain." In 1888 Regoyos and Verhaeren had traveled throughout the Basque country in search of the poet's preconceived vision of the nation. For decades, Spain had been a subject of considerable fascination for avant-garde artists, poets, and historians (particularly in France), who would profoundly shape the image that Spaniards constructed of their own nation, just as the "otherness" of Spain served to reinforce French cultural unities.[85] The country Regoyos and Verhaeren describe in *España negra* is characterized by images of death, cruelty, superstition, ignorance, and religious fanaticism. Many of the drawings were included in the Quatre Gats exhibition,[86] thereby underscoring Regoyos's position as a critic of a traditionalist Spain, and fashioning a clear ethical posture for his contemporaries to adopt in the project of cultural renewal.

When *España negra* appeared in book form in Barcelona a year later, Regoyos added a postscript:

> Without doubt Verhaeren was correct ten years ago in seeing our fatherland as a country that is a friend to death. . . . If this artist came to Spain today, he would find us even more dead than in his last trip. His notes seem to have been written in this year of sad memories, 1898.[87]

The reference here to the National Disaster of 1898 was more than casual, as the need to reform a traditionalist and backward Spanish society was felt with particular urgency in Catalonia, which lost its foreign markets in Cuba and the Philippines in the Spanish-American War, and whose capital city of Barcelona drew large numbers of the physically and emotionally scarred *repatriados* upon their return from the devastating military campaigns abroad.

<div style="text-align:center">*　*　*</div>

While the Catalan response to the colonial disaster brought to the fore the economic and political crisis in relation to the growing momentum of an integral Catalan nationalism, Castilian and Basque intellectuals elevated generational criticism to the status of a literary genre. The leitmotifs of their criticism are: a general loss of faith in the ruling elites of Spain; a profound disillusionment with the dream of industrial progress in the wake of Spain's economic crisis of the 1880s;[88] a biting condemnation of the nation's poverty and underdevelopment, international isolation, and cultural parochialism; and a pronounced commitment to educational reform and moral regeneration. Spain is in its current predicament, they argued, because the nation has allowed itself to be misled by false ideals and corrupt politics. For the writers of the so-called "Generation of 1898"[89]—Miguel de Unamuno, Angel Ganivet, José Martínez Ruiz (Azorín), Ramiro de Maeztú, Antonio Machado, and Pío Baroja—the "problem of Spain," of which the colonial disaster was viewed as a symptom rather than a cause,[90] is the crisis brought on by a nation alienated from its innate spirit and authentic character, which they identified with Castile. Even for Unamuno, who espoused strong socialist convictions early in his career, the essence of Spain is not to be found in political history and social relations, but rather in the *castizo*—loosely translated as "authentic tradition"—a metaphysical concept that exists outside of history. As national essence, the *castizo* is intrahistorical and transtemporal.[91] For those intellectuals who came of age with the colonial disaster, the "national personality" of Spain and the *notas constantes* of the nation were essences more apt to inform art and literature than political and economic history. In coming to terms with its deepest spiritual self, the writers of the Generation of 1898 insisted that Spain would discover what was simultaneously unique and universal in its national personality. The quest for self-knowledge was the necessary first step toward the solution of Spain's moral and material crisis; a recognition of the immutable character of the Spanish people, expressed in their art and literature, would be the basis for the physical and metaphysical regeneration of the nation.

Ernest Gellner has analyzed the ways in which culture has functioned histori-cally as a barometer of nationalism in the modern world.[92] He has examined the phenomenon of "cognitive centralization," the process through which a "high" culture (in the normative sense of a great tradition to which all groups can claim a connection) functions as a mechanism for forging national unity. Modern industrial societies, predicated on constant growth, innovation, and social mobility, are inherently unstable; a universal "high" culture, common language, and standardized educational system are necessary to secure the identity of the nation. It is not, as Gellner insists, that nationalism imposes homogeneity on industrial society; rather, "it is the objective need for homogeneity which is reflected in nationalism."[93] Only when the historical and social agents that give rise to the modern concept of a national tradition are recognized can the uses of the concept become a reasonable object of study.[94]

The normative function of a universal, high culture existing beyond historical contingencies should immediately alert us to the mythical—and as we shall see ideological—character of the Generation of 1898's nationalist agenda. This is not to say that Unamuno, Maeztú, Pío Baroja, and Azorín were indifferent to the plight of the urban and rural poor in Spain. Their pessimism is colored by the weight of social injustice. In the writings of Unamuno in particular, there is clear evidence of economic thinking, although it remains weak. However, by the turn of the century a growing conservatism can be detected in Azorín's rejection of the social utility of art, and in Unamuno's and Maeztú's emphasis on the spiritual malaise of Spain. The exhortation to an authentic Spanish tradition by members of the Generation of 1898 is the inverse of concrete action.

To be sure, the idea of the *castizo* as national essence is inherently problematic, inasmuch as the status of the *notas constantes* of the Spanish tradition exists (only) in relation to a precise historical moment. In the end, the exploration of art as a manifestation of the collective genius of the Spanish people served to articulate a group identity and write the nation's history: the *castizo* was a rhetorical device, a figure of speech. Beyond particular contingencies of class and political ideologies, the Generation of 1898 imagined the nation as a commu-nity of individuals sharing a common literary and artistic tradition.[95] Thus language, in the highly mediated forms of literature and cultural criticism, became the privileged medium of historical memory and national regeneration for the Generation of 1898, the structure through which the identity of the *castizo* was negotiated and a national myth inscribed.[96]

* * *

The critical construction of the El Greco myth (as well as the art-historical recuperation of Velázquez) provides an excellent opportunity to investigate the historical consciousness of the Generation of 1898, and to articulate more clearly Picasso's relation to the Spanish tradition as a textual dialogue. Brown and Álvarez Lopera have observed that the positioning of El Greco as bearer of the

spirit of Castile was not exclusive to the Generation of 1898 (the interpretation appears in an 1869 essay on El Greco by the French critic Paul Lefort).[97] El Greco criticism was marked by a complex network of exchanges between French and Spanish writers in the period under study, culminating in a passionate exaltation of the artist's Castilian spirit by none other than Maurice Barrès.[98] Nevertheless, the characteristic view that "in spite of his origins [El Greco] knew how to interpret better than anyone the natural genius of the Iberian race"[99] had particularly wide currency in Spain. A foreigner working in direct contact with the Castilian soil, the argument proposed, El Greco purified his art and spirit. In so doing, he came to define a national tradition. Manuel Cossío expressed this position succinctly in an important essay entitled "El Greco, Velázquez, and Modern Art," originally published in 1907 and reprinted a year later in his ground-breaking monograph on the artist:

> He found a world that was new to him, one that only his foreign eyes could perceive in high relief, eyes that always fathom something more, something more typical, something which perhaps escapes the eyes of natives who have never left the land. And this new world could be translated only by a spirit like his, a spirit of another race and of another people, one that was not dulled by the daily contemplation of this environment. This painter, a foreigner like the architects and sculptors who came to Spain and who were assimilated by the local art, this painter is the one who was most in tune with our country. Everybody agrees that he is a genuine representative of our country, and that he should be treated like a Spaniard. Some are assimilated by art, whereas El Greco scorned art and artists and was himself the giver of art to Spain—a genuinely national art—because he was immersed in the totality of the land and the race, immersed in nature and in that which is human. Fleeing from the immediate and the concrete he searched for the one thing that in art, as in all else, *makes us free*: that which does not perish.[100]

In such writings, El Greco's position as bearer of the soul of Castile was "revealed." Essential to this version of the El Greco myth, which strategically downplayed the artist's considerable debts to Italian art,[101] was an emphasis on the mystical, form-giving character of the Castilian landscape. To this end, Cossío articulated the ethical principles of the Institución Libre de Enseñanza (in whose journal his text initially appeared). A liberal organization established by Francisco Giner de los Rios in 1879, the Institución sought to redeem the country's national spirit through a global project of educational reform. In a program of excursions to remote regions of Castile, the members of the Institución sought clues for national identity and continuity in the land itself. A series of conceptual links were forged between the physical and metaphysical realities of the nation, between science and the national personality, and between ethics and aesthetics. In this way, the Institución advanced the idea that art and literature provided keys to the psychology of the nation, a discourse that was heavily indebted to Hippolyte Taine's cultural determinism.[102]

Cossío's analysis is also important in another light. In his essay on Velázquez, El Greco, and modern art Cossío employed modern historiographical methods to map the critical reception of El Greco through history. Emphasizing the fortunes of the painter in the nineteenth century, however, Cossío lacked the historical distance to criticize his own argument, which ultimately assumed a dominant position in the interpretation of the painter. In identifying El Greco's *castizo* character, Cossío forged a temporal synthesis grounded in the metahistorical and teleological concept of artistic origins.[103]

As all historical discourses are negotiated through figures of speech that are set within specific temporal structures,[104] it is useful to examine the character of the *castizo* as a cancelling out of what Walter Benjamin referred to as "homogeneous, empty time"; that is, the historicist conception of temporal progression marked by clock and calendar.[105] In the writings of Unamuno and Ganivet, the structural axis "tradition/modernity" is collapsed, as the authors insist that tradition simultaneously informs, and is formed by, the present.[106] As José Ortega y Gasset wrote of Azorín's conception of time: "It is not the past that feigns presence and actuality, but the present that surprises itself as something that has already passed, as being a has-been."[107] But this temporal conception has broader implications, for as it collapses historical time it also sacrifices the present. The problem comes to the heart of the concept of the *castizo*—of authentic tradition—as a retrieval of the past by the present or, more to the point, the inscription of the past within a redemptive future. This simultaneity of past and future in a deferred present is a curiously messianic conception of time, but clearly not in the sense of Benjamin's view of history as "time filled by the presence of the now [*Jetztzeit*]."[108] In contrast to his materialist project, which aims to explode the continuum of history in order to redeem the present and the past in their full revolutionary potential,[109] the idea of the *castizo* suspends the present in a metaphysical void. As the spirit of national redemption, the *castizo* is transcendent.[110]

We have already observed how the idea of an immutable Spanish tradition renewing itself with every generation was repeatedly emphasized in articles and editorials that appeared in *Arte Joven*. Azorín and Pío Baroja, two of the journal's contributors whose literary achievements helped to define the spirit of the Generation of 1898, demonstrated a keen interest in Spanish painting, investing in the metaphysical ideal of cultural continuity and cyclical renewal.[111] For Azorín, "the Castilian pictorial genius, which is first defined in Theotocopuli [El Greco], continues to form with the next generation, until it achieves splendid efflorescence in the palette of D. Diego Rodríguez de Silva Velázquez."[112] For Pío Baroja, the conception of time as the organic continuity of tradition was even more pronounced:

> Velázquez represents the maxium development of certain pictorial qualities in the work of El Greco. Titian gave rise to El Greco, perhaps less of a painter, but more exalted and poetic in feeling the spirit of the Castilian plains; from

46 Diego de Velázquez, *Equestrian Portrait of Prince Baltasar Carlos*, 1634–35. Oil on canvas, 210 × 175 cm. Madrid, Museo del Prado.

El Greco comes Tristán, more of a painter but less of a poet. In its final hypostasis, Tristán becomes Velázquez.[113]

When the ideal of national cultural continuity and authenticity is in turn applied to painting, the question one must ask is whether one can represent the *castizo*, or whether the *castizo* exists only through its status as representation; that is to say, as language? The following description of Velázquez's court portraits (fig. 46) in Aureliano de Beruete's 1898 monograph on the painter is illuminating:

In the background of Velázquez's landscapes, the tones are always gray, bluish, and cold. They conform to the natural, and are inspired by sites the artist could contemplate from the very windows of the Palace or El Escorial, where his responsabilities as Courtier always brought him. These landscapes are unique in that the sun never directly illuminates objects and, as a result, the shadows aren't accentuated, in contrast to what actually occurs under the effects of the resplendent Castilian sun. Delicate clouds move in the sky, interrupted here and there by patches of blue. Everyone who knows the various aspects of the landscape of Madrid's environs . . . will clearly understand that Velázquez, impressed by these effects, has seen in all this a

background, both original *and* artistic, for the austere models of his portraits.[114]

If we now examine the textual description and the portrait in relation to a *View of Guadarrama* (fig. 47) of around 1900 by Beruete, who was also a celebrated landscape painter, the author's circular reasoning becomes apparent. In aligning himself with Velázquez formally (the Guadarrama *sierra* appears in the background of the princely portrait), Beruete locates himself within the Spanish tradition. But here we must identify that tradition as something written in 1898 and given form around 1900. The past is constructed to fulfill the needs of the present, with an emphasis on the intrahistorical constants of the Castilian landscape as the site of the *personalidad nacional* of the Spanish people and their art.[115]

Thus, to the extent that the *castizo* cannot be formed, or reduced *to* form, it functions primarily as a trope within a wider cultural discourse. Although it cannot be internally verified as a method of historical criticism, it retains its historicity within the framework of the Generation of 1898. In this respect, it is more useful to view the concept of authentic tradition as an ideological practice negotiated through language, and to set it in relation to the historical "sacrifice" of the Generation of 1898.

Cultural historian Robert Wohl has made an important distinction between "generationism" as an idea founded on a common doctrine or dogma, and "generationism" as a concept that sets and investigates a group's social position in relation to history.[116] In Wohl's definition, a generational identity is a function of historical consciousness under and in relation to determined circum-

47 Aureliano de Beruete, *View of the Guadarrama Mountains*, ca. 1900. Oil on canvas, 66.5 × 100 cm. New York, The Hispanic Society of America.

stances; it is a means of conceptualizing society and one's position in society "to mobilize people for cultural and political purposes."[117] For a generational consciousness to emerge, there must be a sense of rupture, of discontinuity, from previous generations. As a form of collectivism, a generational consciousness negotiates its identity through temporal rather than socio-economic terms.[118] In this sense, all historical generations view themselves as sacrificed, caught between a nostalgia for a lost past and a utopian faith in the prospects of the future.[119]

Following Wohl's position that the generational concept serves to organize hegemonic movements,[120] it must be observed that in *fin-de-siècle* Spain the role of the intellectual in this process was paramount. Although the Russian concept of an intelligentsia is not easily applied to Spain, Renato Poggioli's description of "a class created on the margin of (or over) the other classes" remains valid.[121] It was, in fact, the writers of the Generation of 1898 who first identified the intellectual as a member of a new "class" positioned at the forefront of political and social reform. But this does not imply that traditional class ties were severed. As a new social category, the intellectual vanguard may operate on the margins of organized politics and on the fringes of bourgeois society, but it is "not so much proletarian as proletarianizing."[122] Its posture remains elitist.[123]

These observations serve to position the social activity of the intellectual of the Generation of 1898, and to define the particular spaces in which he moved. Despite the often biting indictment of industrial society in the writings of Azorín and Pío Baroja (and which some historians have insisted are expressed in Picasso's Blue Period depictions of beggars, prostitutes, and social outcasts[124]), the construction of history that informs the search of the Generation of 1898 for the true identity of Spain diverts attention away from conditions in the historical present. By leveling the differences within groups and among classes, this process all but precludes meaningful social criticism.

Gellner's analysis of the emergence of modern nationalism in industrial society is relevant here,[125] as the Generation of 1898 formalized the link between culture and polity at a time of acute economic and political crisis. As suggested above, the literary production of the Generation of 1898 registers a profound disillusionment with the dream of social progress in Spain. The idea of an immutable, authentic tradition at once serves to stabilize the radical social changes brought on by industrial expansion, and to register an expression of outrage and resistance. To be sure, much of the social criticism of the Generation of 1898 vividly highlights the marginalization of groups and individuals, poverty, and social injustice. But in the end, and with increasingly reactionary implications,[126] the voice of protest of the Generation of 1898 was muted by a retreat into the intrahistoric mystique of the *castizo*. In this contradictory relationship between social criticism and nationalist mythology we can begin to grasp the profound ambivalence of the Generation of 1898 in relation to its historical moment, condemning precisely what the class consciousness of its

authors reproduces. The intellectual individualist anarchism of writers like Pío Baroja and Azorín, at once an indictment of Spanish society, and an appeal to a future Golden Age (which, however, never fully escapes a certain nostalgia for a lost past), is an outward sign of this ambivalence.

Clearly, it is not my intention to offer a critique of the literary accomplishments of the Generation of 1898, but rather to investigate the terms of its historical consciousness in relation to the internal contradictions of its ideology. These contradictions are revealed in a critical (re)reading of the El Greco myth. We have seen how historical writing on El Greco inhabited different social spaces in Catalonia and Castile. In Catalan interpretations, the El Greco myth articulated the interests of the progressive, educated middle class in the nascent project of an integral Catalan nationalism. In this incarnation, El Greco was not the "form-giver" of the *personalidad nacional*, but the cosmopolitan "man of the world," the precursor of Impressionism. The themes of creative freedom, modernity, and individualism that inflected Catalan criticism were political and economic leitmotifs articulating the interests of the industrial bourgeoisie and white-collar professionals without apology, whereas the inherent contradictions in the concept of the *castizo* register a profound anxiety among Spanish intellectuals toward the social and economic regeneration of the nation. In both cases, however, the El Greco myth inhabited class-specific formations of nationalism; its social territory, the bohemian spaces of Barcelona and Madrid, was not neutral. Picasso, who moved between the two cities just as the El Greco myth reached its apotheosis in Catalan and Castilian cultural criticism, was in a position to respond to its discursive and social formations. In the space between the two Grecos, Picasso marked his position as a unique historical subject.

* * *

John Richardson concluded his essay on Picasso and El Greco by quoting Picasso's famous remark to André Malraux, that the *Demoiselles d'Avignon* represented his first "exorcism picture" following his encounter with African tribal art at the Musée de l'Ethnographie in Paris.[127] Richardson suggested that the idea of exorcism as an apocalpytic *tabula rasa* might also shed light on the El Greco "source" and, as we have seen, underscore the Spanish origins of Cubism.[128] Using the El Greco myth as a critical point of entry to deconstruct the identity of the nation, I would argue that rather than affirming a stable discourse of artistic origins, Picasso's practice calls into question the ideological and rhetorical structures through which national identities were constructed in *fin-de-siècle* Spain. Acutely aware of his outsider status as an Andalusian in Barcelona and as a Spaniard in Paris, Picasso viewed artistic nationalism with a critical eye from a mobile perspective. In juxtaposing traditional, modernist, and exotic signifiers in *Les Demoiselles d'Avignon*; in disrupting the temporal, rhetorical, and ideological constructions through which the discourse of nationalism was secured in French, Catalan, and Castilian art and art criticism, Picasso

brought into focus the object of a true historical criticism—the writing of history. For Picasso neither preserves nor destroys tradition in the bodies of his demoiselles. He oversteps boundaries, overlays past on present, and, in the process, explodes cultural myths. Writing in 1911, the Cubist critic Roger Allard located Picasso's "violent personality . . . resolutely outside the *French* tradition."[129] Had he extended his observations to Picasso's critical interpolation of artistic tradition in Spain, he would have approached a fuller understanding of the ways in which Picasso inverted the body-politic of the nation as he wrote history in the present tense.

3 *The Spanishness of Picasso's*
 Still Lifes

ROBERT ROSENBLUM

THERE WAS ONCE A TIME when modern art, especially the kind
that pushed away from the historical past and toward a new
epoch of abstraction, could be viewed as a sort of visual esperanto, transcending
not only the palpable and visible facts of the terrestrial world but also national
boundaries. In the domain of new architecture, this Utopian dream, in part an
optimistic product of the First World War's devastating proof of the conse-
quences of nationalism, was even dubbed "The International Style," on the
occasion of the Museum of Modern Art's landmark exhibition of 1932; and such
visions of a totally new and universal pictorial language that might be compre-
hensible to all people and nations fired the global community of young artists
and architects determined to leave behind the bewildering diversities and enmi-
ties of national traditions. But by the late twentieth century, coincident with a
welling revival of nationalism and ethnic differentiations, whether in the new
independence of the three Baltic states or the separatist movements in Spain and
Canada, we have become attuned once more to discerning the national flavors
that, for instance, have begun to locate Mondrian's pure rectilinear order as
rooted in Dutch soil or Malevich's extraterrestrial icons as emanating from a
Russian heritage. And in the far less lofty domain of twentieth-century still lifes,
in which specific, earthbound objects must play major roles, such national
inflections have similarly become more conspicuous, even within the relatively
abstract lingua franca of Cubism. It is not only a matter of what is placed on a
table top, but also the still life's visual character, which often registers as clearly
as do foreign accents in spoken language. A still life by Stuart Davis, which
might include such industrial objects as a light bulb or a salt-shaker, instantly
produces a noisy and brash American inflection, especially *vis-à-vis*, say, a still
life by Ben Nicholson, whose English accent comes through not only in the
almost whispered nuancing of muted color and frail geometries but in the
occasional selection of mugs, vases and other pottery from a discreet repertory of
regional handicraft traditions. And when we see a bounty of melons or pineap-
ples rendered in tropical hues by the Mexican Rufino Tamayo, we intuitively
place its origin in Latin America. Our recognition here of national differences is
on precisely the same level as our immediate perception of, say, the distinction

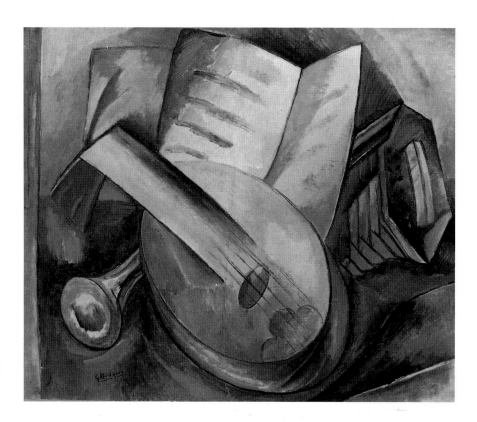

48 Georges Braque, *Musical Instruments*, 1908. Oil on canvas, 50 × 60 cm. Collection M. and Mme Claude Laurens, Paris.

between Dutch and Flemish seventeenth-century still lifes, as revealed in the tidy, cool, and immaculate precision of Willem Kalf's arrangements of precious glassware and fruit versus the robust, cornucopian sprawl of Jan Fyt's profusions of dead game and vegetables.

So it is that in terms of style, subject, and emotions, Picasso's identity as a Spanish rather than as a French or universal artist has become ever more apparent in recent decades, despite the ingrained habits of librarians and encyclopedists to classify him under "France." From the spring of 1904, when, at the age of 22, he decided to settle in Paris for good, until 8 April 1973, when he died in Mougins, Picasso lived in France as a displaced Spaniard who would allude in countless ways to the culture that had initially nurtured him south of the Pyrenees. As a child in Málaga and La Coruña and as an adolescent in Madrid and Barcelona, his formative experiences encompassed the height and breadth of the Iberian peninsula as well as a regional variety that extended from Andalusia, Galicia, and Catalonia to the Castilian capital itself. Thereafter, the holiest Spanish trinity of great masters—El Greco, Velázquez, and Goya—constantly haunted his figural inventions, whether he dealt with the suicide of a Catalan friend, Carles Casagemas; the hallucinatory vision of a brothel parlor in Barcelona's red-light district; the bombing of the Basque capital, Guernica; or the corpses photographed in a Nazi concentration camp. And in the ostensibly less

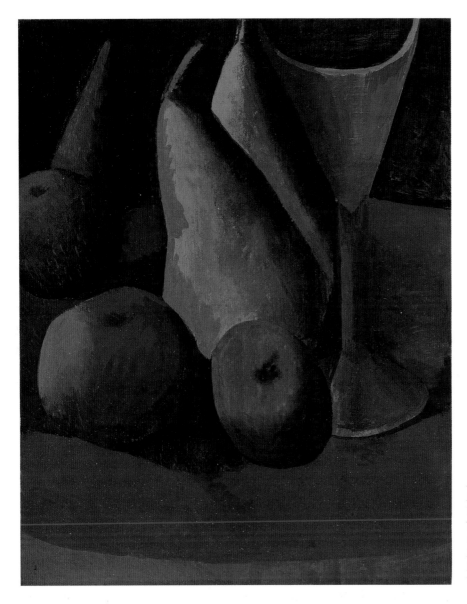

49 Pablo Picasso, *Still Life with Fruit and Glass*, Paris, autumn 1908. Tempera on panel, 27 × 21.1 cm. New York, The Museum of Modern Art. Estate of John Hay Whitney.

ambitious and less emotionally wrought territory of still lifes in two and three dimensions, Picasso, for some seventy years, would equally reveal, in a dazzling variety of overt and covert ways, his affinities to Spain. Not only did he perpetuate pictorial traditions that the seventeenth- and eighteenth-century masters of Spanish still life, from Sánchez Cotán to Meléndez, had defined; but by willful choices of objects, words, and even colors, he could disclose, sometimes obviously, sometimes cryptically, his continuing allegiance to his Spanish birthright. It is this question, the Spanish accent, both loud and subtle, of the master's still lifes, that I hope to explore here.

63

A convenient point of entry into this expansive theme might juxtapose two still lifes, one by Braque (fig. 48) and one by Picasso (fig. 49), both painted in autumn 1908, the year in which they began their joint adventure in creating the language of Cubism. In the Frenchman's emblematic arrangement of criss-crossing musical symbols—a mandolin leaning against an open score, and the bottom of a woodwind instrument (probably a clarinet) balanced by the top of a concertina that the artist himself played—we quickly sense, despite the newness of this early Cubist language of strongly modeled objects that begin to be absorbed and disembodied by their neighbors, the presiding ghost of earlier still-life paintings, especially those by Chardin. Always a point of authoritative reference for French nineteenth-century still-life painters, Chardin's art was particularly topical in 1908, the year after he was given an important retrospective in Paris.[1] Even more specifically, one of his occasional efforts at an allegorical still life, the Louvre's *Attributes of Music* (fig. 50), may well have triggered Braque's own attempts to balance the unsettling innovations of early Cubism with a simplified, heraldic allegory of music that recalls in many details—the mandolin, the sheets of music, the wind instruments—Chardin's venerable prototype.

Chardin, in fact, may well have inspired Picasso's *Fruit and Glass*, which, in its selection of a wine glass and three pears, repeats a component of one of the master's simpler still lifes in the Louvre (fig. 51).[2] To further such French connections, Picasso's painting can also be related to Cézanne and Henri Rousseau.[3] Yet for all its allusions to French sources, Picasso's modest still life evokes more deeply a Spanish pictorial dynasty. Much as Braque's still life seems to perpetuate the tradition of Chardin, Picasso's seems to reinvent the style of Spain's eighteenth-century counterpart to the French master, Luis Meléndez. Picasso's unusually emphatic modeling of three apples, three pears, and a wine glass not only intensifies the extreme contrast of light and shadow, but gives each of these inanimate objects an obdurate individuality that, one by one, demands equal attention. We find this kind of visual structure in many of

50 (below left) Jean-Baptiste-Siméon Chardin, *Attribute of Music*, 1765. Oil on canvas, 91 × 1.45 cm. Paris, Louvre.

51 (below right) Jean-Baptiste-Siméon Chardin *Pears, Walnuts, and Glass of Wine*, ca. 1760. Oil on canvas, 33 × 41 cm. Paris, Louvre.

52 Luis Meléndez, *Still Life: Oranges, Watermelons, a Jar, and Boxes of Sweetmeats*, 1760. Oil on canvas, 47 × 34 cm. Madrid, Museo del Prado.

Meléndez's still lifes, where, say, the rounded volumes of melons, oranges, and jars are all so insistent that each object appears to fight for a foreground position in a space far too shallow to contain it, proclaiming its immediate, palpable presence (fig. 52). Meléndez's pictorial order, like that of his Spanish predecessors, is a far cry from the subtle, harmonious integration of disparate objects in a Chardin still life, where a diffuse, atmospheric light and a stable hierarchy of near and far, large and small, create a peaceful community in which the parts are subordinate to the whole.[4]

Another Picasso still life painted earlier in 1908 can insist still more forcefully on this sense of hard, material fact, now presented in the rudimentary equation of a bowl versus a bottle, each distilled to its basic volume (fig. 53). Such a tug of war again has familiar resonances in earlier Spanish still lifes. For instance, one of 1621 by Juan van der Hamen displays not only the somber, earthy palette and the stark luminary contrasts of the Picasso, but the intractable geometries of the individual objects, whether the spheres of the terra-cotta honey pot and the glass jar of cherries, or the stacked cylinders of the wooden boxes of marzipan (fig. 54).[5] Like Picasso's bowl and jug, these discrete

65

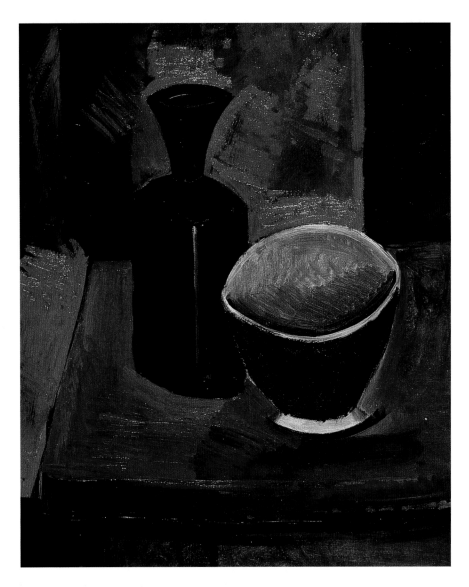

53 Pablo Picasso, *Green Bowl and Black Bottle*, spring-summer 1908. Oil on canvas, 61 × 51 cm. St. Petersburg, The Hermitage.

forms stubbornly maintain their singularity, refusing to be subsumed in an all-embracing fusion that might threaten the assertive presence of each component.

That we can quickly intuit the Spanish character in such works, whether by Picasso or by Meléndez, is a response that extends to the work of other Cubists of Hispanic heritage working in early twentieth-century Paris. The stark, tenebrist modeling and spare arrangements of Juan Gris's earliest Cubist still lifes of 1910–12, for example, have been repeatedly associated in the literature with the somber colors and lucid austerity of Spain in general and of Zurbarán in particular;[6] and even the Cubist still lifes painted by the Mexican Diego

54 Juan van der Hamen y León, *Still Life with Sweets*, 1621. Oil on canvas, 37.5 × 49 cm. Granada, Museo de Bellas Artes.

Rivera during his Paris sojourn (1909–20) often reveal the same solemn character.[7] Moreover, within this visual terrain, a complementary kind of Spanish trait may be discerned, namely, a penchant for chromatic extremes that, on the one hand, may veer toward a dark, funereal palette of grays, browns, and blacks, intensified by sharp white light; and on the other, to fiesta colors of a riotous, folkloric variety, a duality, as it were, between the sacred and the secular.[8] This is especially apparent at one point in Gris's work, moving, as it suddenly does in 1913, from a Zurbaránesque palette of earthly renunciation to a full spectrum of garish synthetic hues, whose acidic collisions of blues and purples, reds and oranges often evoke the popular pageantry of the bullfight posters and costumes that appear in his work at the same time and that were surely inspired by his summer sojourn with Picasso in the Pyrenean hill town of Céret, where these expatriate Spaniards could enjoy the spectacle of the *corrida*. On 11 June 1913, Picasso even slipped over the border into Spanish Catalonia in order to attend a bullfight in Figueras, returning later that week via Gerona.[9]

For Picasso, this was actually the third consecutive summer sojourn in Céret, whose proximity to Spain could extend culturally, if not geographically, to the town of Sorgues, near Avignon, where he had easy access to the bullfights at Nîmes. There, in July 1912, he also frequented the visiting bullfighters, and in a letter to Braque, describing his new painting of an *aficionado*, signed himself, "Picasso, artiste-peintre espagnol."[10] It was, in fact, during that summer, first at Céret and then at Sorgues, that Picasso began to reintroduce explicitly Spanish

motifs in his work and to counter the monkish grays and browns of Analytic Cubism with a startling intrusion of shrill commercial hues—livid pinks, violets, yellows—that may well reflect the bullfight spectacles he witnessed on southern French soil and that surely triggered many memories of Spain.

Such a reading of the polarized extremes of color explored by Gris and Picasso may be mere speculation, but there can be no question about the overtly Spanish symbolism of the colors included in the appropriately titled *Spanish Still Life* (fig. 55), which undoubtedly dates from his May–June 1912 sojourn in Céret, a fitting locale for this eruption of Spanish identity.[11] Putting aside for the moment the proliferation of Spanish words in this oval canvas, it is the tripartite red-yellow-red heraldry of the Spanish national colors that arrests our attention in the lower right quadrant, flatly and stridently interrupting the webbed, complex darkness of the Cubist still life above. Only weeks or months before, working in Paris, Picasso offered a symbolic assertion of French nationalism through color in a trio of still lifes that include a propagandistic brochure on military aviation, whose cover chauvinistically sported the red, white, and blue stripes of the French flag as a background for the slogan, "Notre avenir est dans l'air".[12] This "tricolorism," as Linda Nochlin has described it,[13] would continue to penetrate his work, whether during the war years, when he would again include the French flag in specifically patriotic contexts, or into the early 1920s, when the tricolor often invaded his palette in more subliminal Francocentric ways.[14] In 1912, however, this blatant French flag-waving was rapidly countered by what may now be called a Spanish "bicolorism" of red and yellow, as if Picasso, once again close to the Spanish border in Céret, were reasserting his national loyalties. Moreover, this is subtly affirmed by the almost camouflaged presence in the *Spanish Still Life* of a long, horizontal paint brush or pen that pierces the heraldic red-yellow-red field like a sword in the flank of a bull,[15] as if Picasso were inventing a new symbolic signature that proclaimed, "I am a Spanish artist," the very phrase he would use to sign a letter to Braque the following summer.[16]

That bicolored field, in fact, is to be identified as a ticket to the bullfight, painted in the hard opaque commercial colors of Ripolin, which gives it all the more startling a prominence.[17] It is a blatantly Spanish motif that also figures in another still life from the same May–June 1912 sojourn, usually subtitled, after the inscription on the painting, *Fêtes de Céret* (fig. 56).[18] Here is yet another red-and-yellow striped emblem behind another bullfight ticket, now marked in French, *Entrée aux arènes*, a color chord that is less conspicuous than in the *Spanish Still Life*, for it is painted in oils rather than Ripolin, and may well have faded over the decades. More dimly visible at the right, behind the inscription, "Fêtes de Céret," is yet another national symbol, now not the Spanish, but the Catalan flag,[19] with its four red stripes on a yellow field, perhaps a response to some decorative bunting from the local festivities that Picasso witnessed just north of the Spanish border.

The intrusions here, in the midst of a somber Cubist palette, of the intense,

55 Pablo Picasso, *Spanish Still Life*, Céret, May–June 1912. Oil and Ripolin on canvas, 46 × 33 cm. Villeneuve d'Ascq, Musée d'Art Moderne. Gift of Geneviève and Jean Masurel.

56 Pablo Picasso, *Still Life: Fêtes de Céret*, Céret, May–June 1912. Oil on canvas, 27 × 41 cm. Basel, Private Collection.

sun-drenched red and yellow of the Spanish (and Catalan) national colors may at first have only the local significance of recording the strong Spanish inflection of this French Pyrenean border town, but it is a color chord that, in fact, permeates in obvious and subtle ways much of Picasso's art, not to mention that of his compatriot, Joan Miró, who not only included, on several occasions, Spanish and Catalan flags in his work, but who at times even restricted the entire palette of a painting to red and yellow.[20] In Picasso's case, the use of the Spanish national colors is a recurrent choice, whose Mediterranean brilliance of hue not only contrasts to the typical palette of Braque but whose Spanish associations undergo a characteristically vast range of metamorphoses. So it is, for example, that the harlequin costume in both versions of the *Three Musicians* (1921), worn by a figure persuasively identified as the artist's symbolic self-portrait,[21] is in a red-and-yellow diamond pattern. And even more cryptic examples of Picasso's projection of a Spanish personal identity may be found in many works of the early 1930s that involve him in a sexual dialogue with his new mistress, Marie-Thérèse Walter. Pitchers in still lifes of 1931 are often a solar yellow, at times with hot red highlights, suggesting an inanimate surrogate for a swollen-chested male who dominates a cornucopia of smaller fruits and table objects;[22] and in the *Girl before a Mirror* (1932), the wallpaper itself, with its heraldic harlequin pattern, becomes red and yellow behind the figure, as if the artist were

70

claiming for his own Spanish persona the domestic territory in which his lover resides.[23] Similarly, even the upholstery of the chairs in which Marie-Thérèse falls into the deep abandon of sleep, often glows with red and yellow, as if Picasso, in the guise of furniture, were engulfing his beloved.[24] On other, more public levels, too, these colors proclaimed Spanish identity in still lifes related to the Spanish Civil War. In the 1938 *Still Life with Red Bull's Head* (fig. 57),[25] this grotesque animal trophy, mounted on a black rod, is flayed to a bloody red pulp, which, in turn, is countered by vivid yellow accents that even define the "whites" of the red eyes. And in a still more overtly nationalistic way, the painted memorial to the Spaniards who died for France during the Second World War, a canvas Picasso completed in 1947,[26] mixes both the French and Spanish national colors, shifting back and forth between the intricate tricolor tassels that decorate the bugle to the bolder display of the French flag whose identity, thanks to the strong field of red surrounded by a yellow border, also takes on a Spanish accent appropriate to the victims it honors (fig. 58).

Of course, it was not only color that Picasso could use to assert his origins, but

57 Pablo Picasso, *Still Life with Red Bull's Head*, 26 November 1938. Oil and Ripolin on canvas, 97.8 × 119.5 cm. New York, The Museum of Modern Art. Gift of Mr. and Mrs. William A.M. Burden.

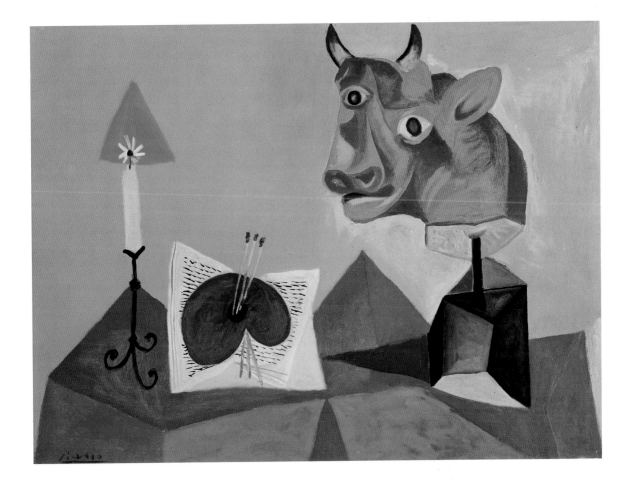

71

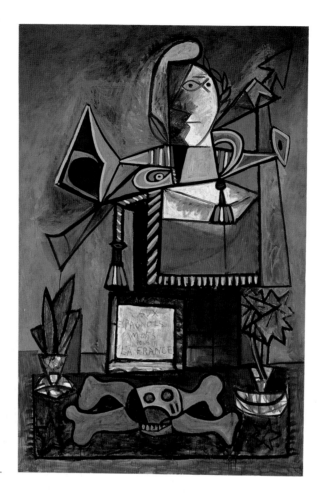

58 Pablo Picasso,
*Monument to the Spanish
Dead*, 1945–47. Oil on
canvas 195 × 130 cm.
Madrid, Museo Nacional,
Centro de Arte Reina Sofía.

also language and the very choice of objects he included in his still lifes. It is telling that in the 1912 *Spanish Still Life*, the bullfight ticket is inscribed "*Sol y sombra,*" that a fragment of a letter to his father (Don . . .) in Barcelona (Barc . . .) makes a sly appearance, and that the rest of the painting proliferates with Spanish words that, in the preparatory drawings,[27] are even more abundant. For here, Picasso has hispanicized the French components of his Cubist still lifes, substituting for such Parisian publications as *Le Journal*, *L'Intransigeant*, or *Le Matin*, the Barcelona newspaper, *La Publicidad*; and replacing the drinks from the Parisian cafés—Pernod, Armagnac, Vieux Marc—with such a Spanish alcohol (*aguardiente*) as Ojén, whose actual printed label includes this anisette's place of origin, Málaga, the artist's own birthplace. And in the drawings, even the announcement of the bullfight, *Corrida de Toros*, is added to this Spanish lexicon.

Before Cubism, too, Picasso's still lifes could disclose in multiple ways his Spanish roots. In Paris, in 1901, he painted a virtuoso still life that would be

included the following year in his first one-man show at Berthe Weill's gallery (fig. 59), a painting that Adrien Farge's catalogue essay described as "luxurious" and as revealing a "passion for color."[28] Apart from the red-and-yellow intensity of the fruit and flowers here, which pervades everything from chrysanthemums and oranges to apples and a lone red pepper, there is the telling inclusion, in the lower right, of a mug with a folkloric peasant figure painted on it, a ceramic that may be identified as coming from a turn-of-the-century revival of Catalan popular crafts, known as *azulejos de oficios* (or in Catalan, *rajoles d'oficis*), and fostered by Picasso's compatriots in Barcelona, Santiago Rusiñol, Xavier Nogues, and Ramón Casas.[29]

An even more assertive choice of an explicitly Spanish object is found in works that were executed, appropriately, during one of the many summer months Picasso would spend in the Pyrenees before the outbreak of the First World War, in this case in Gósol, on Spanish soil, in 1906. In several still lifes,[30] the dominant object is a *porrón*, a commonplace drinking vessel in Catalonia, which is held firmly by the handle so that the liquid can stream out of a spout

59 Pablo Picasso, *Still Life (La Desserte)*, Paris, 1901. Oil on canvas, 59 × 78 cm. Barcelona, Museu Picasso.

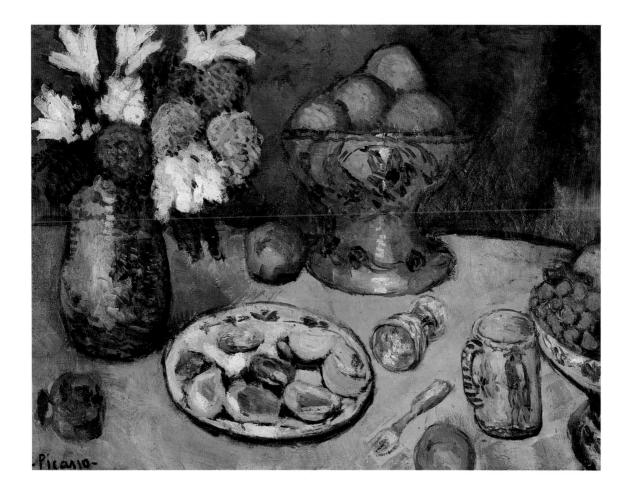

73

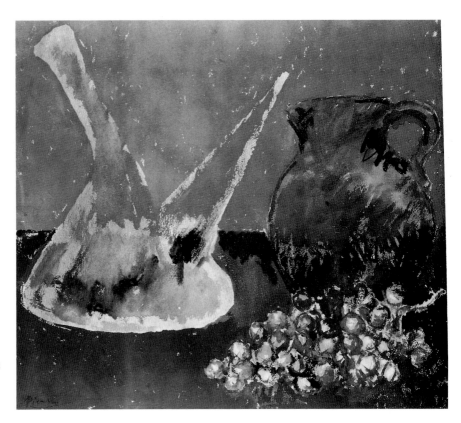

60 Pablo Picasso, *Porrón, Pottery Jug, and Grapes*, Gosol, summer 1906. Gouache and watercolor on paper, 32.5 × 37.5 cm. European Private Collection.

tilted downward into an open mouth (fig. 60). Its bold presence here proclaims a Spanish identity, just as in more subliminal ways, its phallic character, especially vis-à-vis the other, more rounded still-life objects, imposes on this inanimate terrain a kind of macho domination. In fact, the *porrón* as a still-life component would reappear in far more obviously sexual contexts in two major paintings of female nudes from 1906–07.[31] In *The Harem* of 1906, where Picasso resurrected the cloistered space and indolent postures of Ingres's *Turkish Bath*, a lone male figure appears in the right foreground (fig. 61). Languid but hyper-musculated, he seems also to have evolved from one of the French master's harem nudes, his feminine source subliminally confirmed by his diminutive genitals. But the large and erect *porrón* he grasps in his left hand more than compensates for these female origins, and gives him a Spanish identity that almost transports the painting from a Near Eastern erotic fantasy to a contemporary brothel scene in Spain.

That subject, of course, would soon be amplified in the *Demoiselles d'Avignon* (fig. 24), whose very title alludes to Spain, being in part a reference to a street, the Carrer d'Avinyó, in Barcelona's red-light district.[32] In one of the preparatory drawings for the *Demoiselles*, the still life in the middle of the brothel parlor features a *porrón*, whose central placement in the composition evokes the theme

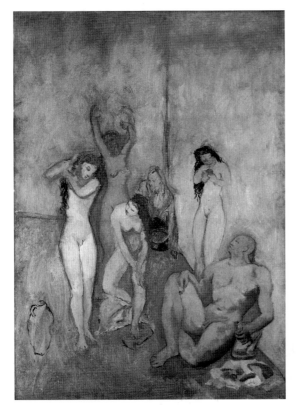

62 (above) Pablo Picasso, study for *Les Demoiselles d'Avignon*, March 1907. Carnet no. 3, 29r. Graphite pencil on beige paper, 19.3 × 24.2 cm. Paris, Musée Picasso.

61 Pablo Picasso, *The Harem*, early summer 1906. Oil on canvas, 154.3 × 109.5 cm. The Cleveland Museum of Art. Bequest of Leonard C. Hanna, Jr., 1958.45.

of virility in a particularly Spanish guise (fig. 62). The still life, however, was finally placed at the center of the bottom edge of the painting, mimicking the equally unstable placement of the still life in Ingres's *Turkish Bath*.[33] The *porrón* has now vanished, but the upward thrust of the table corner and, above all, of the melon slice seems to have absorbed its phallic energy. Yet even without the *porrón*, this new still life may also have Spanish references. The incisive crescent shape of the melon, especially when placed directly below the central whore who appears to hover above us in a shattered blue sky, recalls one of the most familiar Catholic images of Spain, the airborne Virgin of the Immaculate Conception, floating on a crescent moon, an image depicted many times by, among others, El Greco (fig. 5) and Murillo.[34] It now seems probable that the *Demoiselles* was partly inspired by El Greco's *Apocalyptic Vision*, then owned by the Spanish painter Ignacio Zuloaga, and might be read as a blasphemous retort to its Catholic theme. In fact, John Richardson, in discussing this source, even called Picasso's new vision "the apocalyptic whorehouse."[35] This heresy may be compounded further by the desanctification of the most Spanish of Virgins, who now appears in a brothel not over a crescent moon but over a fleshy slice of melon that would rise to its sexual goal. As long ago as 1946, the ever-astute Alfred H. Barr, Jr. pointed out the *Demoiselles'* general affinity to El Greco's "compact

63 Pablo Picasso, *Still Life with Liqueur Bottle*, Horta de Ebro, August 1909. Oil on canvas, 81.6 × 65.4 cm. New York, The Museum of Modern Art. Mrs. Simon Guggenheim Fund.

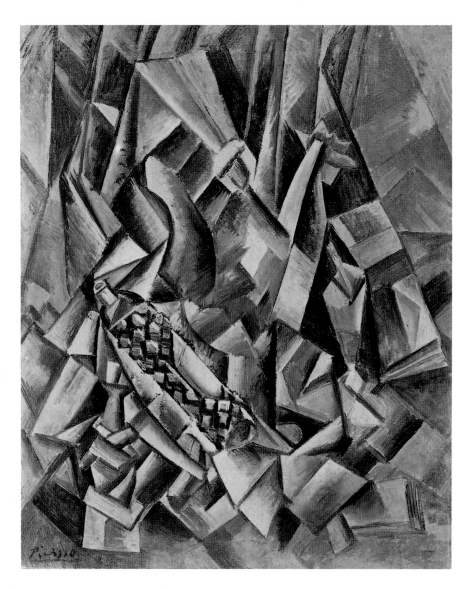

64 Bottle of Anis del Mono.

figure composition and angular highlights" by illustrating the lower, terrestrial zone of the master's early *Assumption* (1577).[36] But the affinities may be far closer than that, since not only does the upward, heavenly thrust of the sarcophagus lid reappear in the piercing angle of the table corner that forms an explosively unstable base for Picasso's still life, but El Greco's oblique crescent moon, with its slicing, airborne energy, may be reincarnated as the gravity-defiant wedge of pink melon. It turns out, in fact, that in the two years between the time of its exhibition in the Prado (1902–04) and its acquisition by the Art Institute of Chicago (1906), this very painting was visible in Paris, chez Durand-Ruel,[37] the gallery frequented by Picasso and any other aspiring artist concerned with

modern French art. In view of Picasso's early attraction to El Greco's elongated, saintly anatomies and quasi-Cubist splintering of forms in compressed spaces, the timing could not have been better. And given Picasso's background of both Catholic piety and anti-clericalism (reinforced in Paris by his friend Alfred Jarry's sacrilegious jokes),[38] it may well be that the still life in the *Demoiselles* reveals, especially to a Spaniard, the most unholy of messages, an Assumption in a brothel.

But such subliminal and heavenbound references to Spain in Picasso's still lifes can again be rooted more firmly to some of the ordinary objects that play a role in his Cubist work, objects that for decades had been misidentified or rendered invisible by Cubist camouflage. An early case in point is a famous still life of 1909 (fig. 63), which was once thought to be composed of generic tabletop objects but which now might well be retitled *Spanish Still Life*,

65 Pablo Picasso, *Bottle of Anis del Mono, Wine Glass, and Playing Card*, Paris, late 1915. Oil on canvas, 46.3 × 55.2 cm. Detroit Institute of Fine Arts, Bequest of Robert H. Tannahill.

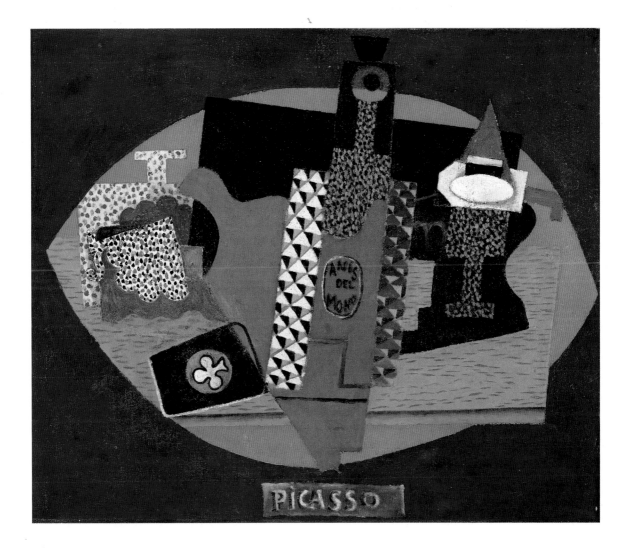

prophesying as it does the painting of May–June 1912. Tellingly, this earlier still life was painted in September 1909, just before Picasso returned to Paris from Horta de Ebro, the remote Catalan hill town where he had spent the entire summer. The diamond-patterned cylindrical object that tilts across the lower left was for years identified as a tube of paint or as a siphon, and the large object above it was virtually ignored; but in 1971, sixty-two years after it was painted, Picasso, by means of a little drawing, explained to William Rubin exactly what was represented.[39] The two most prominent objects turn out to reflect the Spanish milieu in which he had reimmersed himself that summer, namely, a bottle of Anis del Mono (fig. 64) and, in the upper center, a *botijo*, that is, another Spanish drinking vessel like a *porrón*, but in this case, one in the form of a ceramic rooster with a ringed handle on its back. Such a *botijo*, incidentally, can also be found later, in 1917, in one of Miró's Barcelona still lifes,[40] which, like Picasso's, often feature Spanish motifs, such as a caged pet bird (a recurrrent theme of Picasso's) or a pasted fragment of the local newspaper, *La Publicidad*, which Picasso had also referred to in his 1912 *Spanish Still Life*. As for the bottle of Anis del Mono, whose harlequin-like decorative faceting appears in 1909 as an almost clandestine symbol of Picasso's Spanish identity, this brand of "monkey's anisette" would soon appear in overtly legible form in the work of other Cubist artists of Hispanic heritage living as expatriates in Paris. In 1913, it turns up, clearly labeled, in a still life by Diego Rivera[41] and in 1914, Juan Gris pasted almost the entire label, with its old-fashioned illustration of a simian drinker (the monkey of the brand name), onto one of his Cubist tabletops.[42] And farther afield, the Uruguayan painter Rafael Barradas, working in Barcelona and Madrid in 1918, included fragments of the words *Anis del Mono* in his "vibrationist" compositions, panoramic urban images of contemporary signage.[43] As for Picasso, bottles of Anis del Mono continued to make overt and covert appearances in both two and three dimensions, with greatest complexity in a pair of still lifes of 1915, one carpentered and one painted (fig. 65).[44] In both, the bottle is easily identified by its diamond pattern, which in turn recalls the harlequin costume that, in the same year, often led a new, surrogate life as the artist's alter ego. In the painting, whose abundance of funereal black may allude to the fatal illness of his mistress, Eva, who was to die on 14 December of that year,[45] this bottled symbol of Spain becomes more Spanish still by the red, yellow, and black dots that appear to bubble within it, and by a further metamorphosis that turns it into one of the many rigidly upright guitars, most Spanish of instruments, in Picasso's musical inventory. For here, the diamond patterns expand sideways, suggesting the greater width of a guitar; the cork becomes the guitar's bent and tilted neck; and the identifying label, which has been relocated and transformed from its actual source, is now inscribed on a central oval shape that recalls the configuration of a guitar's soundhole.

For Picasso, the guitar, of course, was the king of Cubist musical instruments, as well as being a ubiquitous presence in both his pre- and post-Cubist work. As a symbol of Spain, it is so obvious as almost to go unnoticed, and plays a no less

frequent role in the work of Juan Gris, who, already in 1906, used a guitar as a symbolic vignette in his pre-Cubist illustrations to a volume of poetry, *Alma América, Poemas Indoespañoles*, by the Peruvian author, José Santos Chocano.[46] Its isolation by Picasso as a virtual emblem was conspicuous in 1912, when the guitar became the fundamental motif for his adventurous new assembled sculptures (fig. 66); and it may even be that some of the inventive play of solids and voids in these metal constructions was inspired by the guitar-shaped tin cake molds that could be found in Hispanic kitchens,[47] much as he would later, in 1951, transform tin dessert molds into bronze flowers.[48] And of course, the anthropomorphic potential of the guitar, already elaborated in the erotic fantasy, *La Psicología de la Guitarra* that appeared in the April 1901 issue of the short-lived Madrid periodical, *Arte Joven*,[49] to which Picasso contributed many illustrations, recommended it especially to a quick-change magician who could sometimes recreate it as a female nude (in Spanish popular culture, playing a guitar is often equated with love-making) or as a more stiffly geometric male presence that might even be another one of Picasso's alter egos, a point borne out by the fact that in the New York version of the *Three Musicians* (1921; fig. 121), the red-and-yellow harlequin, identifiable as a symbolic self-portrait, plays a guitar.

66 Pablo Picasso, *Guitar*, winter 1912–13. Sheet metal and wire, 77.5 × 35 × 19.3 cm. New York, The Museum of Modern Art.

Be that as it may, two *papiers collés* of 1912 and 1913 presenting upright guitars and newspapers almost symbolize the artist's double nationality. In one of November 1912, the anthropomorphic guitar is joined to *Le Journal* (fig. 67), but in another of similar format from the following spring, the newspaper prominently displayed is *El Diluvio*, from Barcelona, which suddenly replaces the usual French clipping with Spanish, and reasserts the Spanish character of the neighboring guitar (fig. 68). That association goes back as well to earlier Spanish still-life traditions, especially *trompe l'oeil* paintings that presented popular stringed instruments upright, hanging on walls, such as one by Pedro de Acosta of 1755 that balances a guitar and a mandolin (fig. 69), a pairing, incidentally, that Picasso would also use for a major still life of 1924.[50] And it might be mentioned too that the Spanish *trompe l'oeil* tradition occasionally featured the deception of open musical scores fixed to a flat wall,[51] a trick Picasso often recreated in a more up-to-date Cubist paradox by pasting a real sheet of music behind the invented fiction of a cut-paper guitar.

In terms of musical instruments, yet one more Spanish still-life component may be introduced here as a recent resolution to a problem that has long nagged those scholars of Cubism who seek to identify with maximum precision the elusive objects depicted. Until the 1990s, in fact, many Cubist still lifes were thought to include clarinets; but this traditional identification hardly corresponded to the frequently visible double-reed at the end of this mysterious woodwind, a contradiction that I once thought might be explained by identifying it as an oboe rather than a clarinet.[52] This puzzle, however, was finally solved by Lewis Kachur,[53] who indisputably identified the cylindrical, double-reeded woodwind that floats about Cubist tabletops as a *tenora* (fig. 71), a folkloric

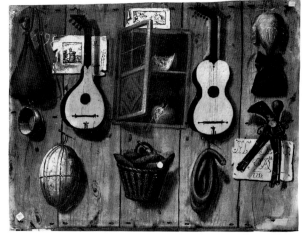

67 (above left) Pablo Picasso, *Guitar, Sheet Music, Glass*, Paris, November 1912. Pasted paper, gouache, and charcoal on paper, 48 × 36.5 cm. San Antonio, Texas, Marion Koogler McNay Art Museum. Bequest of Marion Koogler McNay, 1950.112.

68 (above right) Pablo Picasso, *Guitar*, Céret, 1913. Pasted paper, charcoal, ink, and chalk, 66.4 × 49.6 cm. New York, The Museum of Modern Art. Nelson A. Rockefeller Bequest.

69 (left) Pedro de Acosta, *Trompe l'oeil*, 1755. Oil on canvas, 92 × 124 cm. Madrid, Real Academia de San Fernando.

instrument played in Catalonia and even turned into poetic memory by Picasso's Bohemian colleague Max Jacob. Given its presence in a painting by Picasso executed in the summer of 1911, during his first sojourn in Céret, a painting traditionally mistitled *Man with a Clarinet* (fig. 70),[54] it may well be that Picasso acquired a *tenora* there and brought it back to Paris as a kind of Proustian

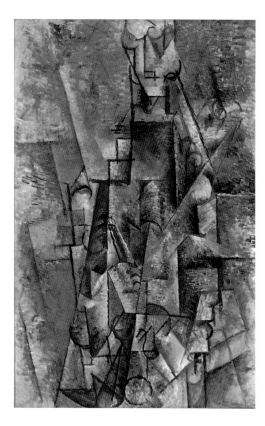

70 Pablo Picasso, *Man with a Tenora*, autumn 1911. Oil on canvas, 105 × 69 cm. Lugano, Collection Thyssen-Bornemisza.

madeleine, a memento of the flavor of Spain and Catalonia that he had once again tasted during a Pyrenean summer. And now that we know this object's identity, we may also savor in these once almost illegible still lifes the presence of the culture Picasso brought back to Paris with him from his native country and even shared with his French colleague Braque, who also included the *tenora* in several Cubist still lifes.[55]

In his selection of still-life objects of specifically Spanish identity—newspapers, bullfight tickets, written and printed words, drinking vessels, musical instruments, liquors—Picasso, while paired with a French artist in Paris, stealthily compiled an inventory of national souvenirs within the presumably supranational langauage of Cubism. Like the mother earth that Antaeus had to touch to keep his strength, these memories kept Picasso in contact with his roots south of the Pyrenees. But on far more dramatic levels, too, another strongly Spanish trait would permeate his still lifes as well as the whole of his art, namely, the recurrent presence of death, whether in symbolic or overt guise. The *memento mori*, of course, was familiar to all of Western still-life painting, but it should be emphasized here that the Spanish interpretation of this universal theme often had its own particularly grim inflection. A comparison of two seventeenth-century *Vanitas* still lifes, one by the Dutchman Harmen Steenwyck and the

71 Detail of a *tenora*, showing double reed. From *Burlington Magazine*, April 1993, p. 254, fig. 4.

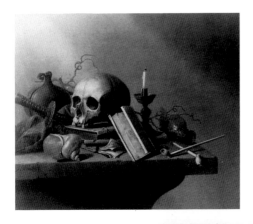

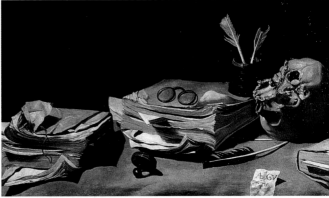

72 (above left) Harmen Steenwyck, *Vanitas Still Life*. Oil on panel, 37.5 × 38 cm. Leiden, Museum De Lakenhal.

73 (above right) Anonymous, Madrid School, *Vanitas Still Life*. Oil on canvas, 49 × 83 cm. Madrid, Private Collection.

74 (right) Antonio de Pereda, *Vanitas Still Life*. Oil on canvas, 31 × 37 cm. Zaragoza, Museo Provincial de Bellas Artes.

other by an anonymous Madrid painter (figs. 72, 73),[56] offers at first glance the same lugubrious display of a death's head found among such symbols of human learning and activity as books, quill pens, eye-glasses, a candle. But at second glance, we see in the Spaniard's work how the skull is grotesquely decomposed, creating, along with the disarray of the books, the impression of the grisly contents of an opened tomb, disclosed amidst the intense light-and-shadow contrasts familiar to Spanish tenebrism. And in another seventeenth-century Spanish still life by Antonio de Pereda (fig. 74),[57] a stark trinity of skulls above a small watch that ticks our lives away, the grisly disorder of sepulchral reality and the startling proximity of the foreground cranium are even more gruesome, especially since two of the skulls are not even given the minimal decorum of an upright placement but are explored from below, revealing eerily unfamiliar aspects of these crumbling human relics.

Of course, Cézanne, too, could stake a strong claim upon this gloomy tradition, and his own many variations upon the *vanitas* theme were surely as well known to Picasso as his more emotionally neutral still-life objects. Already in

the morbid territory of his youth in the 1860s, Cézanne had introduced skulls into his still lifes; but it was not until his final decade, perhaps partly prompted by his mother's death in 1897, that they would reappear, usually as the only object in a still life, forcing an unmitigated confrontation (fig. 75).[58] Nevertheless, Cézanne's scrutiny of this traditional motif and studio prop, whether set up as one, two, three, or four skulls, manages to absorb the blank frontal stare of death into a more serene, engulfing pictorial order, transforming the tough, intractable presence of a skull into a vibrant weave of translucent paint or watercolor that almost seems a triumphant assertion of life and art rather than a *memento mori*.[59] Responsive as he was to Cézanne, Picasso must have lodged the French artist's skulls deep into his own imagination, but remained a Spaniard in his own reading of this universal theme.[60]

Even during the epic years of Cubism, from 1907 to 1914, when Picasso's inventory of table objects seldom introduced disturbing emotions, the *vanitas* still life could make a sudden appearance, reminding us of how death could strike even within art's ivory tower, much as Juan de Valdés Leal, in the seventeenth century, could produce the thunderclap apparition of a skeleton *in ictu oculi*—in the blinking of an eye.[61] In the best-known example, the Hermitage's *Still Life with Death's Head* of 1907 (fig. 76), it may even have been the death of Cézanne in 1906 (and his three memorial exhibitions that followed in 1907) which occasioned this vision of a skull as a disarming intruder in the sensuous confines of an artist's studio, although later deaths (those of Alfred

75 Paul Cézanne, *Three Skulls*, 1902–06. Pencil and watercolor, 47.7 × 63 cm. The Art Institute of Chicago.

83

76 Pablo Picasso, *Still Life with Death's Head*, autumn 1907. Oil on canvas, 115 × 88 cm. St. Petersburg, The Hermitage.

Jarry on 1 November 1907 and of Picasso's friend and fellow painter in the Bateau-Lavoir, G. Wiegels, a suicide on 1 June 1908) have also been suggested, explanations that might argue for the painting's later date.[62] But even if read as a painted obituary, this still life, with its volcanic eruption of slashing planes and heated colors, also points towards the lethal undertow of the *Demoiselles d'Avignon*. The conjunction here of the hard, bone-yellow skull with the soft reflection in the mirror above of a painted pink-and-blue nude echoes one of the traumatic themes of the *Demoiselles*, that is, the association of sexual pleasure with the risk of venereal disease. Indeed, the frightening black hollows of the beckoning, frontally aligned nasal cavity and of the disquietingly asymmetrical eye sockets strip to the bone the fearful stare of the most hideous and threatening of the "demoiselles" at the lower right.

Whatever triggered this revival of the *vanitas* still life in 1907, and the possible reasons are by no means mutually exclusive, thoughts of death seemed to be put in abeyance by the vital, forward-looking energies that went into the invention of Cubism, at least until the winter of 1913/14, when death reappeared as a papery gray mask on a table top that also features more familiar Cubist still-life components—a snippet of *Le Journal*, whose concealed vowels,

O and U, are wittily supplied by the skull's eye sockets (to which the carat-shaped nasal cavity points),[63] and two guitars (fig. 77). Made even more grotesque by its crown of dark gray hair, this planar, Cubist skull may be related, as Jean Sutherland Boggs has suggested,[64] not only to the death of Picasso's father on 3 May 1913, but to his illustrations for Max Jacob's neo-Catholic fantasies about a certain St. Martorel, who had once been cloistered in the monastery of Santa Teresa in Barcelona and who would die struggling to enter Jerusalem. And it might be added, given the painting's date and the war news that was often included in Picasso's newspaper clippings of 1912–14, that the skull here also casts its grim shadow across the front-page historic events reported by *Le Journal*. Be that as it may, the unexpected face of death on a Cubist table top otherwise animated by a seductive variety of colors and textures creates an eerie shock that strikes an alien, Spanish note within the milieu of Parisian Cubism.[65]

But if skulls play only rare and unexpected cameo roles in Picasso's Cubist still lifes, they would move to center stage during the years of the Second World War, when his table tops often became a theater of death. With grimly appropriate public and private timing, this kind of *memento mori* began to appear in January 1939, a month when the news from Barcelona included not only that of his mother's death there on the 13th, but of the city's surrender to Franco's armies on the 26th.[66] The darkness spread, and until 1945, the profusion of skulls, both human and animal, in Picasso's still lifes reflected the slaughters that had already begun to be a major subject for him with the outbreak of

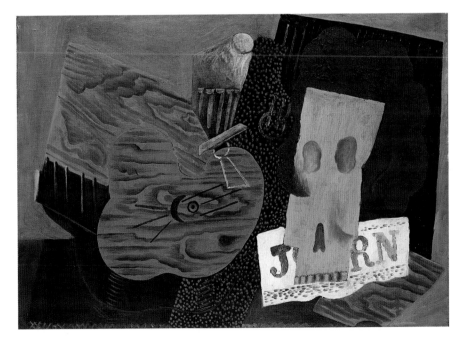

77 Pablo Picasso, *Guitar, Skull, and Newspaper*, Paris, winter 1913–14. Oil on canvas, 43.5 × 61 cm. Villeneuve d'Ascq, Musée d'Art Moderne.

78 Pablo Picasso, *Death's
Head*, ?1941. Bronze, 25
× 21 × 31 cm. Paris,
Musée Picasso.

the Spanish Civil War. In the 1930s, bulls' heads, a familiar symbol of Spain, were often represented as fleshy or flayed sculptures or in humanoid form as minotaurs, but soon after the fall of Barcelona and Madrid in January 1939, they quickly became bone. For the duration of the war and beyond, these horned skulls turned Picasso's still lifes into a graveyard for Spain.

Nevertheless, this reign of death soon became not just a question of mourning for Spain, but of an all-pervasive sense of death's triumph, much as *Guernica*, initially triggered by a tragedy tied to a specifically Spanish time and place, swiftly became a universal apocalypse, echoing back to archetypes like the *Massacre of the Innocents* and *Death on a Pale Horse* as well as to paintings of modern historical disasters, whether by the Spaniard Goya or the Frenchman Delacroix.[67] For Picasso, death's specter could appear without warning even in domestic confines rather than in the prisons, air raids, battle fields, and concentration camps of the war years. Two anecdotes about his ultimate distillation of death's visage, the bronze-and-copper sculpture Leo Steinberg described as "indestructible ore, all core and no crust,"[68] are telling (fig. 78). In 1941 (which suggests an earlier date for this *memento mori* than the usual one given, 1943[69]), Pierre Malo, visiting the artist's studio, noticed to his shock that the sponge-bowl in the bathroom had been replaced by this terrifying skull, which needs no base from which to exert its awesome power; and in June 1943, visiting Picasso's

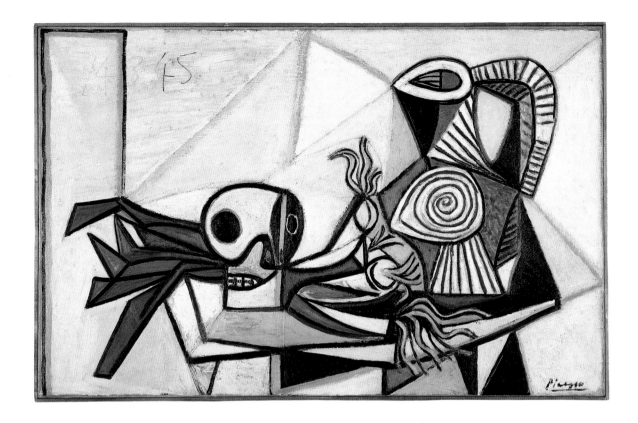

studio for the first time, Françoise Gilot was startled to find it lying on the floor near a door, a grisly variation of a doorstop.[70] Such an abrupt intrusion of death into daily life recalls the way the Spaniards used to place signs with skull and cross bones at those points on their highways where fatal automobile accidents have occurred—a safety precaution, to be sure, but one with the morbid resonances Picasso could create even from a kitchen still life.

As in seventeenth-century *vanitas* still lifes, the pleasures of the table could also be darkened by the shadow of death, so that Picasso, with his usual metamorphic magic, could turn that symbol of low-class, earthy food—the leek—into not only a reminder of the austere cuisine of France under the Occupation, but the image of death itself. Often, he would include several leeks in an X-shaped pattern under a human skull, making this humble vegetable recall the crossed tibia that complete the familiar emblem of the entire skeleton as a skull and cross bones (fig. 79),[71] an emblem he would later use in his painted memorial for Spaniards who had died for France. Moreover, as Gilot pointed out, the French slang phrase, "manger les poireaux par les racines," that is, to be dead and buried, eating leeks from the roots up, adds another grim layer to this unexpected *memento mori*.[72] And during these Occupation years of starvation and mass murder, one of Picasso's recurrent themes, the display of living or dead animals on a table top, as if they were sacrifices in a pagan or Christian ritual,

79 Pablo Picasso, *Still Life with Skull and Leeks*, 14 March 1945. Oil on canvas, 73 × 116cm. The Fine Arts Museums of San Francisco, Museum purchase, Whitney Warren, Jr. Fund, in memory of Mrs. Adolph B. Spreckels, Grover A. Magnin Bequest Fund, Roscoe and Margaret Oakes Income Fund, and Bequest of Mr. and Mrs. Frederick J. Hellman by exchange, 1992.1.

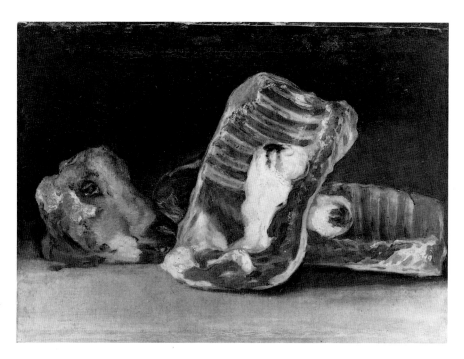

80 Francisco de Goya,
*Still Life with Pieces of Rib,
Loin, and a Head of Mutton*,
ca. 1808–12. Oil on
canvas, 45 × 62 cm. Paris,
Louvre.

proliferated with a gruesome intensity matched in Western still life only by the
strewn animal corpses—fish, rabbits, sheep, birds—that Goya painted during
the Napoleonic occupation of Spain, bloody recreations of his *Disasters of War* on
butcher's-shop counters and kitchen tables.[73] Of these, the Louvre canvas of a
severed sheep's head beside its two hacked rib cages is specially relevant (fig. 80).
Already in 1925, Picasso had registered it obliquely in his *Still Life with Ram's
Head*, in which the Goyesque severed head is the disquieting centerpiece in a
Surrealist conjunction of disparate objects, including a scorpion fish gasping for
breath;[74] but on 6 October 1939, a month after France and Great Britain
declared war on Germany, he resuscitated Goya's slaughtered sheep far more
literally, adding, in the gaping jaw bones, the visual equivalent of the animal's
screaming death throe (fig. 81).[75] This single horror quickly became collective.
Eleven days later, Picasso painted three sheep skulls, their raw red flesh still
clinging to their bones (fig. 82).[76] Although memories of Cézanne's pyramids of
human skulls may also be discerned here, it is again to Spanish precedent that
we must turn for anything comparable to this head-on confrontation with not
only the physical horror of death, but the total indignity with which the relics
of once living things can be treated. Here, not only is Goya evoked, but also such
a seventeenth-century still life as Pereda's trio of human skulls, peered at from
disrespectfully odd angles and also imposing themselves larger than life—or is
it death?—in the foreground (fig. 74).

As for the sacrificial, quasi-religious aspect of these slaughtered sheep, which,
according to Dora Maar, Picasso kept in his studio as wartime food for his dog,[77]

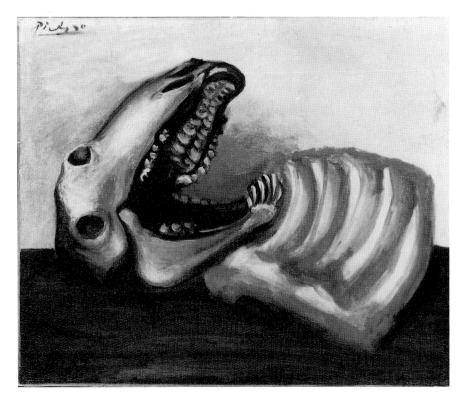

81 Pablo Picasso, *Sheep's Skull*, Royan, 6 October 1939. Oil on canvas, 50 × 60 cm. Private Collection (formerly Stanley Seegar).

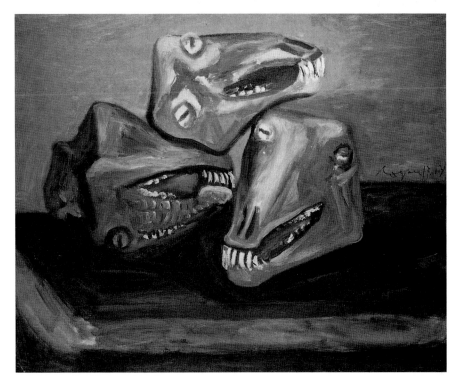

82 Pablo Picasso, *Three Sheep's Skulls*, Paris, 17 October 1939. Oil on canvas, 65 × 89 cm. Geneva, Galerie Jan Krugier, Collection Marina Picasso (Inv. 12961).

83 (above) Attributed to Giovanni Battista Recco, *Still Life*. Oil on canvas, 108 × 87 cm. Amsterdam, Rijksmuseum.

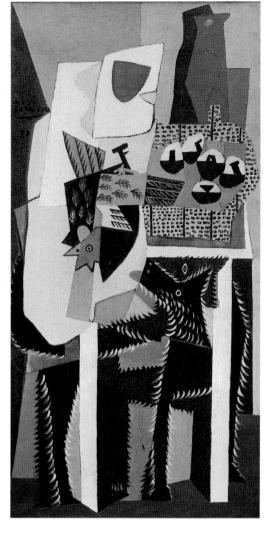

84 (right) Pablo Picasso, *Dog and Cock*, Paris, 1921. Oil on canvas, 155 × 76.5 cm. New Haven, Yale University Art Gallery.

there is, as usual, a Christian undercurrent here that often runs through even the most ostensibly secular of his works. Memories of symbolic sacrificial lambs become more explicit in his 1943 bronze of a man with a grave expression carrying a helpless sheep by the legs,[78] an image that reverberates through classical and Christian prototypes, including Zurbarán's still life of a lamb bound for slaughter, which weds a butcher's shop to the Catholic liturgy.[79] Birds, too, are often presented by Picasso as if on sacred altars, especially cocks, which, together with a bowl to catch the blood, can run a wide spectrum of associations, from the narrative of the Crucifixion to more primitive cult rituals. Already in a still life of 1921, a cock, whose open round eyes suggest it is still twitching with the last spasms of life, is secured to a kitchen table next to five eggs, while a wolf-like dog, lurking below, further threatens the helpless crea-

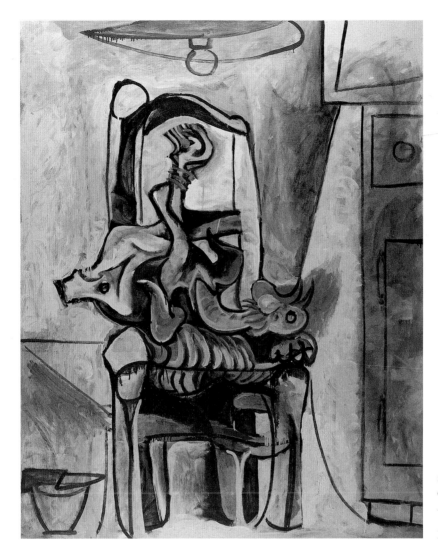

85 Pablo Picasso, *Trussed Cock*, Mougins, 24–27 April 1962. Oil on canvas, 162 × 139 cm. Collection B. Ruiz-Picasso.

ture with his outstretched tongue (fig. 84).[80] This is a Spanish version, so to speak, of Chardin's *Buffet* of 1728, in which a far more benign dog is lusting not after a terrified captive animal, but after a teasing parrot, safely out of reach, and an elegant display of oysters and fruit on a sideboard. One is reminded, too, of a seventeenth-century still life, once attributed to Velázquez (fig. 83),[81] in which a pair of painfully alive, trussed chickens on a kitchen table await their death below a pair of slaughtered birds and an array of eggs, the whole suggesting, like Picasso's, a life cycle that, in human hands, becomes a death cycle. In fact, such images of trussed birds, also echoing Goya's lethal still life of a plucked turkey wrenched brutally upward in the ugliest posture of death, kept reappearing in Picasso's still lifes, reaching a chilling climax in late April 1962 (fig. 85).[82] Working with the grisaille palette that, as in *Guernica*, evokes death and

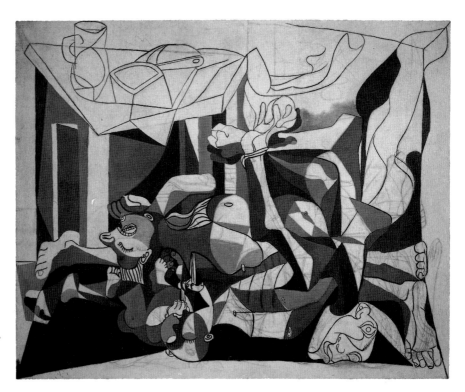

86 Pablo Picasso, *The Charnel House*, 1944–45. Oil and charcoal on canvas, 199.8 × 250.1 cm. New York, The Museum of Modern Art.

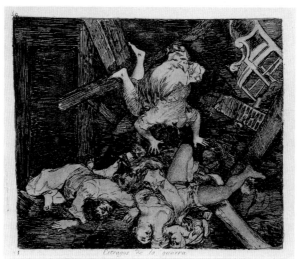

87 Francisco de Goya, *Ravages of War*, etching from *Disasters of War*. New York, The Metropolitan Museum of Art, Purchase, Rogers Fund and Jacob H. Schiff Bequest 1922 (22.60.25 [30]).

mourning, Picasso painted a trussed and plucked cock turned on its back, its bound legs upright, on an altar-like chair. Directly above is a ceiling lamp, whose centrally placed light bulb recalls its malevolently surveillant prototype in *Guernica*. Almost unnoticeable at the lower left are the ritual cup and knife for the blood, which seems to have been totally drained from this skeletal painting

92

that, rather than a domestic still life, becomes a prison cell with a tortured corpse under an interrogation light.

As a gruesome testimony of human slaughter, this dead bird evokes harrowing memories of Picasso's *memento mori* of 1945, the *Charnel House*, in which a trio of human cadavers—man, woman, and child—litter the floor and a helpless pair of trussed hands rise upwards to a kitchen still life of pitcher and casserole, incompletely painted and bone dry in their emptiness (fig. 86).[83] The bitter equation of human and animal carcasses and the treatment of corpses as if they were merely debris defiled by human conquerors now transforms the conventional category of still life into a triumph of death so evil that the reality of the concentration camps whose photographic documentation initially prompted this painting can be glimpsed. Again, Goya can provide a grim preview of this confounding of ordinary garbage with what was once alive but is now dead. In *Ravages of War*, a plate from Goya's *Disasters of War*, whose records of wanton slaughter and dismembered human corpses echo the still lifes of brutalized animals he painted at the same time, we are forced to peer into a ditch where both inanimate furniture and the once animate bodies of men, women, and a child are being thrown together indiscriminately in a hideous pile (fig. 87). Like the *Charnel House*, it gives a particularly agonized inflection to the Romance language term for still life—dead nature or, as the Spanish say, *naturaleza muerta*.

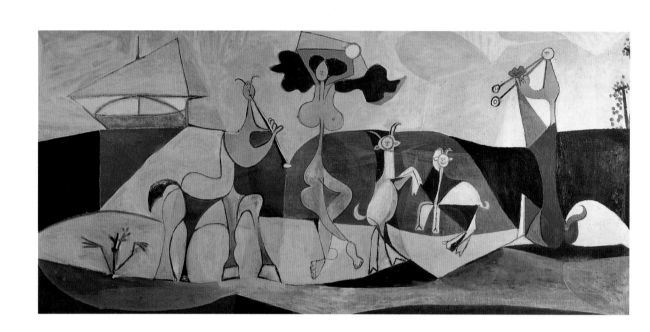

Picasso and the French Post-war "Renaissance": A Questioning of National Identity

GERTJE UTLEY

IN THE SUMMER OF 1946, while vacationing in the south of France with his new love, Françoise Gilot, Picasso was offered the opportunity to work in the seclusion of the Château Grimaldi, in Antibes, an ancient fortress which housed the local collection of antiquities. There, between August and November, Picasso produced a corpus of paintings and drawings, which are known collectively as the Antipolis series, after the ancient Greek name of this Mediterranean town.[1] Ancient Greek mythology formed the conceptual background for those playful scenes of frolicking nymphs, fauns, and centaurs, which are the subject of the central painting of the series, *La Joie de Vivre*, and of many of the related paintings and drawings (fig. 88). Pondering the appearance in his work of this cast of characters, Picasso claimed that living on the shores of the Mediterranean had always filled his imagination with the mythical creatures which have haunted the collective unconscious of those shores since pre-classical antiquity.[2] And he further observed that works of art tended to be born of contingencies of time, place, and circumstance.[3] In this case, the elements of all three are known to us in considerable detail, and allow us to reconstruct not only how they engendered the proliferation of ancient Mediterranean imagery in his paintings and drawings in Antibes, but also how they contributed to Picasso's retreat from Paris to the south of France.[4]

On the face of it, those idyllic visions of a pre-cultural Arcadia are easy to understand. They obviously express the exhilaration about new love, impending fatherhood, and new-found freedom after years of war and occupation (fig. 89). The scenes of simple pleasures on the beach have also been identified with the spirit of *vacances payées* and with *la fête de l'Huma*, the yearly games and festivities organized by the communist daily *L'Humanité*. And while the title *La Joie de Vivre* almost certainly pays tribute to Matisse's arcadian *Bonheur de Vivre* of 1905–06,[5] the appearance of faun and centaur and of a classicizing vocabulary of form and line in the Antibes corpus is also clearly indebted to the inspiration Picasso had received from his recent involvement with the mythologizing fables, *Dos Contes*, written by his long-deceased friend, the Catalan poet

88 Pablo Picasso, *La Joie de Vivre* (*The Joy of Life*), also called *Antipolis*, 1946. Oil on fibercement, 120 × 250 cm. Inscribed: *Antipolis 46*. Antibes, Musée Picasso.

95

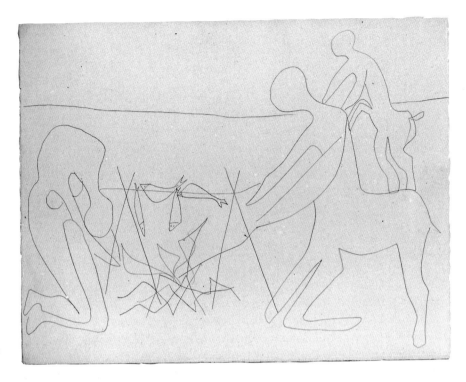

89 Pablo Picasso,
*Centaurs and Woman
Grilling Fish*, Antibes,
6 November 1946.
Graphite on white wove
paper, 51 × 66 cm. Paris,
Musée Picasso.

Ramón Reventós.[6] It seems to me, however, that more complex issues are at play as well.

On various occasions in his long career, Picasso had entertained a dialogue with classicizing forms and mythological subject matter. Recent scholarship has illuminated aspects of this dialogue by relating its appearance and reappearance in Picasso's oeuvre to cultural and socio-political currents.[7] This approach seems to me particularly justified in the period immediately following the Second World War, when Picasso's decision to join the French Communist party only weeks after the liberation of France invites a consideration of the political context. Furthermore, much of the socio-political as well as cultural discourse of the time can be established from the study of contemporaneous Picasso criticism. Insofar as much of this material, which we shall examine below, is found in Picasso's personal archives, and was assembled at his request, and since—as we know from James Lord—Picasso actually read the press-clippings, we can be certain that he was fully informed about the debates which swirled around his art.[8] Indeed a connection (if not a causality) can be posited between the effect of this discourse on Picasso and his decision to retreat to the "neutral" territory of the Mediterranean.

Picasso's return to the Mediterranean and to its myths coincided with a raging polemic in the French press over whether his work should be interpreted as the epitome of French art and French values or whether it was to be considered as foreign and the exemplification of all that was prejudicial to the development

and reputation of French culture. The debate on the Spanishness of Picasso's art and personality and his place within the so-called *"tradition française"* in art had earlier engaged authors, friends, and critics such as Gertrude Stein, Wilhelm Uhde, and Jean Cocteau.[9] James D. Herbert has asserted that only after the Second World War was Picasso finally embraced by the art establishment and situated in the pantheon of French artists.[10] Although there is evidence in support of this argument, there was by no means a consensus on this question. In fact Picasso's extraneousness to the French tradition, and the perception by some critics that his art represented a danger to the integrity of Western civilization, was never before debated with such acrimony.

The polemic was symptomatic of the prevailing conception of France's exalted role within a manichaean worldview; many French saw the nation as civilizing healer of a disintegrating and morally corrupt post-war society, and some even viewed France as a stalwart defender of the Western classical tradition against the cultural or physical onslaught of "barbarian invaders" from the "Orient," as we will see below. France, painfully aware of its diminished role in the international political arena, was obliged, as never before, to defend its cultural hegemony and what it saw as its civilizing mission in the world. In the heat of this debate Picasso became the target of a new, heightened nationalism, which was born of a feeling of powerlessness, bordering on paranoia, and was attended by xenophobia, a focus on the core of what it meant to be French, and a reaffirmation of the enduring values of *la grande tradition française*.

Historically, French political discourse has often taken place in the cultural arena. Yet never before had the discussions of politics and art been more confusingly entangled than during this period, when the emotions aroused by the issues of occupation and collaboration were still raw. Rarely has art criticism been more loaded with political content. The historian Tony Judt has observed that while there is a tradition in France for intellectuals to posit themselves as arbiters of the nation in questions of politics, ethics, and culture, it was precisely in those post-Liberation days that direct political discussion was avoided. Political debate was instead channeled into the writings on literature, philosophy, and art, but rarely was it so subtly expressed as to escape public attention.[11] According to Martin Brionne, writing for *Esprit* in early 1945, the nation was so profoundly shaken that it was not able to make the distinction between political events and adventures of the mind and in art.[12]

The critical writing about Picasso was a particularly effective forum in which to play out old animosities and ideologies, and its discourse was intimately linked to the most sensitive political issues of the day. As a writer in *L'Eclair* in February 1946 complained: "Our amiable colleague *La Nation* maligns us in an article in which it unloads all its ammunition in a curious blend of painting, 'les trusts,' *L'Aurore, L'Époque*, the Vatican, Pétain, 'Portuguese fascists,' Clément Vautel, Camille Mauclair, and Goebbels's propaganda, because we have, apparently, spoken badly of Picasso."[13]

While nationalism and the attendant retreat to the comfort of traditional

values and forms of expression were shared by the right and left of the political spectrum, attitudes about Picasso's place within that tradition differed.[14] Whereas the Communists—at least in the early post-war days before sectarianism and the return to socialist realism—tended to portray Picasso as the foremost representative of French painting, and endeavored to anchor his image to the venerable lineage of the French tradition, more conservative critics took aim at Picasso's status as outsider. They considered his art not only as foreign but even detrimental to the values of that tradition. The better-known writers on Picasso, such as Louis Aragon, Paul Eluard, André Verdet, Jean Cassou, and Michel Leiris, were sympathetic, if in varying degrees, to the French Communist party. Their works consequently offer only a partial, if intellectually and artistically more astute, view of the attitudes toward the artist at the end of the Second World War. In sifting through Picasso's personal archives we come face to face with some of the lesser-known voices of a more conservative bent.

At the dawn of post-Liberation France, Picasso's French bona fides, what André Fermigier has called his "naturalization file," was stronger than ever.[15] By refusing to leave France during the ordeal of defeat and occupation and by remaining in Paris when many French modernists had fled to the south of France or even to America, Picasso had been hailed at the war's end as one of the foremost citizens of a newly liberated Paris. In the words of Brassaï and Louis Parrot, Picasso had become "the symbol of regained freedom" ("le symbol de la liberté retrouvée").[16] His much publicized membership in the French Communist party, which was announced by the Communist daily *L'Humanité* on 5 October 1944, imbued Picasso with the spirit of the Resistance and therefore of France itself.[17] Although the Communist role in the underground may not have been quite as glorious and certainly not as immediate as claimed, they had nevertheless played the most active part in the Resistance, and it was among their ranks that the heaviest casualties were suffered. To build on their resulting post-liberation prestige and to bolster their position in the reconstruction of France, the Communists decided to exploit Picasso's authority both as a magnet for their recruitment campaign directed at intellectuals and as validation of their claim to be the party of the French cultural *Renaissance*.[18] They realized that, in order to give maximum resonance to Picasso's membership in the party, they had to reassert his ties with France and its traditions; in other words they had to surround Picasso with an aura of Frenchness and provide him with the credentials of *francité*.[19]

The first maneuver in this campaign was an obviously concerted effort to provide Picasso with a visible role in the civil life of the nation. He was given a prominent position at the head of celebrations connected with the Liberation. He was seen at public meetings and leading delegations to honor the victims of the Fascist occupation.[20] And Picasso was asked to draw the frontispiece for the volume that the poets and writers of the Resistance offered in homage to Charles de Gaulle.[21] *L'Humanité* proclaimed him "Picasso, grand peintre français,"[22] and his oeuvre was exhibited repeatedly, not only in the context but even as a

paradigm of French art. Picasso was also offered the honorary presidency of the Front national des arts after the death of Maurice Denis.[23] Through their control of this organization and its offshoot after 1945, the Union des arts plastiques, the Communists exerted a considerable hold on an important part of the French art scene.[24] For a short while after the Liberation, the Communists were in fact in charge of the Département des Beaux Arts, which was part of the Ministry of Education.[25] Before 1944 Picasso had never shown his work in a museum in France; now he began to participate in exhibitions such as *Art Français Contemporain*, held at the Palais du Luxembourg in July 1946, and in the traveling exhibition of the same title, which had been organized by the Union des arts plastiques. He also occupied a prominent place in the exhibition *Art et Résistance* in the spring of 1946 and took part in government-sponsored exhibitions aimed at promoting the prestige of French culture abroad, notably the controversial *Picasso and Matisse* exhibition at the Victoria and Albert Museum in London in December 1945.[26] When the Musée National d'Art Moderne re-opened its doors in 1946 under the direction of Jean Cassou, a self-proclaimed fellow traveler of the Communist party, its focus was on French art.[27] Picasso was among the artists asked to contribute to the collection.

Picasso also supported initiatives by the Communists to narrow the gap between art and the public through educational projects such as the *Encyclopédie de la Renaissance Française*.[28] And he was closely connected to the Communist-inspired cultural center, Maison de la Pensée Française, where he exhibited repeatedly.[29] In the eyes of the French Communists, Picasso was not only to become a French painter, he was to become the painter of all the French. To facilitate his accessibility to a wider audience, a series of public lectures was held, which endeavored to position Picasso within the French pictorial tradition. Jean Cassou in a lecture entitled, "C'est tout l'esprit français qui anime et explique la peinture française" ("It is the essence of French spirit that inspires and defines French painting"), placed Picasso firmly within the purest lineage of the *tradition française*, and, by associating him with the *Avignon Piéta* (Louvre) and with David and Ingres, identified him as the heir of the spiritual, socio-political, and aesthetic values of that tradition.[30] In describing the arabesques of Ingres's linear distortions of the human body, he provided the pedigree for the bodily deformations in Picasso's work.[31]

Picasso's position as honorary president of the Front national des arts drew him into the painful process of *épuration*, the post-Liberation purge of alleged collaborators.[32] It appears that the meeting, at which the list of artists to be purged was drawn up, took place in Picasso's studio and under his presidency. The letterhead of the committee, the copy of a letter to the Préfet de Police, and several newspaper reports on the meeting confirm this information.[33] In presenting Picasso as an arbiter of French morality, the Communists touched a sensitive nerve which was bound to provoke reactions. Léon Gard, for example, was outraged at the "infamy" that a foreigner should be allowed to judge Frenchmen

on their home territory.[34] The suggestions of the Comité d'épuration (Purge Committee) carried little weight with the government, but the Front national des arts did have its say in the organization of that year's Salon d'Automne. Planned during the Occupation, the Salon opened its doors on 6 October 1944 as the Salon de la Libération without the artists who had been singled out by the Purge Committee. While paragons of French art such as André Derain, Maurice Vlaminck, and Aristide Maillol were denied the right to exhibit, Picasso was honored with a special presentation of his oeuvre, a rare distinction for a foreign artist.[35]

In one of the most striking demonstrations of this potent mix of art and politics, the Communist party chose to announce that Picasso had joined its ranks the day before the opening of the Salon. In the words of one critic, this turned the *vernissage* into a political demonstration.[36] While the Communist press, including *L'Humanité*, *Les Lettres Françaises*, and *Ce Soir*, promoted both events with the expected fanfare,[37] a veritable revolution broke out in the exhibition itself. The so-called "scandale du Salon d'Automne" was in the best tradition of "la bataille d'Hernani" and the reception accorded to the *Sacre du Printemps*. Paintings were taken off the walls, viewers wanted their money back, and out in the street an *auto-da-fé* was staged with reproductions of Picasso's paintings.[38]

Opinions were divided as to the political or artistic motivations for the revolt. Inasmuch as Picasso had chosen to exhibit a survey of his work of the prior six years rather than a retrospective of earlier paintings and sculpture, it is possible that the reaction was provoked by the aesthetic shock of a totally unprepared public, or by young hotheads of the École des Beaux Arts, who revolted against an art totally at odds with the precepts of their academic education. However, in published criticism, reference to the "agonizing hideousness" of Picasso's work led instantly to prejudiced observations on nation and race.[39] The references to Picasso's work as "immoral," "degenerate," and a "danger to French art" which appeared in *Nouvelle Jeunesse*, for example, revived memories of Fascist rhetoric on art.[40] It may not be surprising that Picasso's prominence in the national political arena and the exploitation of this situation by the Communists would provoke reaction. What is striking, though, is the bitterness of this polemic and the nature of the discourse. With its repeated reference to nationalism, race, and tradition, much of the writing echoes the cultural attitudes expressed under the Nazis, at a time when the wider implications of those attitudes should have been painfully clear.

It is plausible that, just as left-wing writers had suspected, political considerations were partly responsible for the virulence of the reaction among the public. However the rebuttals by Picasso's champions made the underlying political tenor of the polemic unmistakably clear. Responsibility for the unrest was attributed by these writers to the survival of the "Nazi virus" among reactionary elements, and parallels were drawn to Nazi brutality and the pillaging of Jewish stores during the German occupation.[41] The strongest indictment

of the revolt appeared in *Les Lettres Françaises* in a statement by the Communist-dominated Comité National des Écrivains which was signed by many of the leading names associated with the Communist party. Ostensibly a defense of Picasso and his right to artistic freedom, it was in fact a scathing attack on what was labelled "clearly an act by the enemy," a "vestige of the intimidation tactics experienced under Nazi occupation."[42] The rebuttal, with its strong rhetoric reflected the Communist party's politics and, more specifically, the editorial policies of *Les Lettres Françaises*, which exploited the polarized post-war climate to claim the role of "custodian of the memories of the occupation," and to support its assertion that communism offered the only viable alternative to fascism.[43]

This manichaean view of politics as applied to the cultural sphere provoked protests by those who objected to being called collaborators "just because [we are] not *picassistes*."[44] Issues of collaboration and resistance were frequently entangled in discussions on art. While André Lhote identified Picasso with the spirit of the Resistance, Germain Bazin asked why it was that "collaborators" were only to be found among the Fauves and Realists.[45]

Incomprehension of Picasso's art was, however, certainly at the origin of some of the criticism. In particular the liberties Picasso took in representing the human figure were seen as "obstinately inhuman" and consequently as inherently un-French, in "blatant contradiction with the lineage of the French tradition in art."[46] The public was said to reject as incompatible with French art those "*pantins* [puppets] with two eyes on the same side of the face, the ear on the navel and the breast on the chin."[47] Even Fernand Léger is quoted as having commented in front of a painting by Picasso: "three eyes, two mouths, this is Spanish torture and not French art."[48]

A major complaint among Picasso's critics was that he was "not even French" and that therefore his art was not only unfit to represent French culture at home or abroad, it was seen as prejudicial to France's prestige in the world.[49] The critic of *Toujours Paris* objected that a Spaniard should be presented as the greatest French contemporary painter, as the epitome of all the qualities of French art.[50] After the *Picasso and Matisse* exhibition at the Victoria and Albert Museum, Picasso was declared an unworthy ambassador of French art.[51] In 1947, Léon Gard declared bluntly in *Apollo* that "the art presented abroad as French is not French art."[52] The same xenophobic spirit led to outcries of "La France aux Français" by visitors to the Picasso exhibition at the gallery Louis Carré in July 1946, and to complaints that Georges Braque, a French painter after all, did not receive the same attention as Picasso in post-war France.[53]

To emphasize better the alien nature of Picasso's art, critics stressed repeatedly the "national essence" of native painters such as Matisse, Braque, or Bonnard, who, in the elegance, harmony, and intelligence of their compositions, embodied the inherent qualities of French perfection.[54] Aragon wrote of Matisse in 1947, that it was time to appreciate that he was not only from France, but that he was *la France*.[55] It was this debate that prompted an exasperated George

Besson to write, "I do not know whether Picasso is Spaniard, Italian, Patagonian, Jewish, or Catholic Christian or Protestant. I do know that he is Picasso. And I never asked myself the question: is his oeuvre French, Spanish, Judeo-Masonic, or Soviet?"[56]

Discussions on Picasso's art frequently led to wider considerations of the volatile issues of nation and nationalism and of race and racism.[57] In his article, "L'explication raciale" ("The Racial Explanation"), Léon Degand denounced the contemporary obsession with wanting to create a national French art, which he saw as destined to be little more than the illustration of prejudice. He cautioned in particular against the undue importance given to hereditary factors in art and recalled the consequences of such thinking under the Nazis.[58]

The debate reached a climax in the writings of Waldemar George, which brought the controversy to a new level of national and even international attention.[59] The vehicle was a polemical exchange with Georges Huisman, former director of the Beaux-Arts, which appeared in *Opéra* in 1946. Under the heading "The art of Picasso is not French," George had questioned whether Picasso, whom he named "Cubism's illegitimate father," should be called upon to represent "the genius of France." In George's eyes, Picasso's art not only committed "a crime against man," it undermined the whole tradition of French painting, and by extension, of Western civilization. This attack prompted a response by Huisman, published two weeks later and entitled: "Mais si, Picasso est un peintre français" ("But, of course, Picasso is a French painter").[60]

George's attack on Picasso represented a dramatic *volte-face*. The one-time editor of *Amour de l'art* and founding editor of *Formes* had been an early champion of Cubism. However in the late twenties he became a virulent reactionary in matters of art, a notably zealous defender of the figurative tradition.[61] The xenophobic character of his post-war writings reminded his respondents of Nazi doctrines, and they immediately signaled the dangers lurking in such rhetoric.[62] Huisman was emphatic on this point: to "pretend that Picasso is not French is tantamount to excluding, as was done during the times of Hitler and Pétain, those painters and sculptors of the School of Paris who came from the four corners of Europe to look for inspiration in Montmartre or Montparnasse . . ."[63]

Waldemar George shared in fact many of the cultural concepts of Nazi ideology. As Lhote pointed out in an article entitled, "Quand les 'collaborateurs' se font critiques d'art" ("When Collaborators Turn into Art Critics"), George, in the early years of the Occupation, had been an outspoken advocate of the cultural ideologies of Fascist Italy, and had expressed the aspiration that France should follow its example.[64] George's diatribes recall Vlaminck's famous article of 1942 in *Comœdia*, in which, heedless of the potential danger for the target of his indictment, he had accused Picasso of having dragged French art into a deadly impasse. Vlaminck, who had been a post-war target of the *épuration* for his cozy relationship with the Germans during the Occupation, did not hesitate, during an interview in January 1947, to repeat his polemic against "ce métèque." Once

again he attacked Picasso as a foreigner, using the racially charged word "métèque," which alludes in no flattering way to East European origins and semitism.[65]

This reference to the Eastern, or the Oriental, as the enemy of Western civilization was one of the recurring themes in Picasso criticism.[66] According to his critics, the artist was "the evil spirit of Western art," whose paintings expressed the demonic and apocalyptic qualities of "Oriental bestiaries from the times of the barbaric invasions."[67] Already in the early 1930s, Waldemar George had accused Picasso of being out of touch with the "constants of European art, through which the white race ensures its identity and survival in history."[68] Now he reiterated his opinion that Picasso was an "Oriental" and, as such, a threat to Europe's millennial struggle to free itself from the degrading stronghold of oriental and barbaric cultural aggression.[69] A strong proponent of the civilizing mission of France, George believed that this mission was incarnated in the classical, humanist tradition of French art, the only bulwark against the threat of degenerate Oriental influences.

George was certainly not alone in his obsession with what he saw as the threat of Eastern cultural invasions to the Western humanist tradition of realism, nor was he the only one to characterize non-French ideas and practices as barbaric. In fact, these strident voices were loud enough to reach the ears of the Assemblée Nationale, which scheduled a debate on the issue on 18 September 1946.[70] Among those who shared George's paranoia about the decaying influence of this so-called orientalizing trend was Bernard Dorival, chief curator of the newly reopened Musée National d'Art Moderne, who stressed in particular the role of Spain and of the Eastern European countries in unleashing the flood of Oriental influences which threatened to engulf Occidental culture and precipitate "the crisis of the Occident." He, too, when speaking about Picasso, mentions the seductive abstract refinements of "this Oriental."[71]

James D. Herbert has pointed to the paradox presented by the Spanish origins of Picasso. Although Spain borders on what the French called the "latin sea" (the Mediterranean), its links to Arabia, the Orient, and even the Slavic East were constantly stressed.[72] This supposed resemblance between the Slav and the Spaniard was again underscored by Lucien Farnoux-Reynaud in his review of Picasso's exhibition at the Galerie Carré.[73] The rather confused allusions to the mythical concept of the "Oriental" are supported by reference to the cliché of the multi-ethnic roots of Spain, and its mingling of African and semitic influences.[74] And they were fed, no doubt, by memories of the civil war in Spain, which the Right in France had perceived in terms of a fight between the European, Christian civilization, and barbarism, between the Latin Occident and Asiatic bolshevism, and between spirituality and materialism.[75] Historically, anti-Soviet or anti-Communist connotations could certainly resound in the orientophobic discourse. Yet in the days before the escalation of the Cold War, the term "Orient" as used in art criticism was more likely to relate to the non-figurative trends that were seen to have entered Western art through the

gateway of Picasso's Spain, and had proliferated in the art of the School of Paris painters.[76] It was also associated with the emotional excesses of expressionistic currents imported by the School of Paris painters, which by some were labelled as "those barbaric invasions," which had overrun Montmartre and Montparnasse in the earlier years of the century.[77] The term "Orient" could be applied to whatever seemed strange and foreign, and was usually construed as the corroding "other," which was in conflict with the values of the French tradition. At times these writings make it seem that the "Orient" was everything that lay outside the classicizing "corridor" of the French tradition, which ran from the present through France's glorious eighteenth and seventeenth centuries and the Italian Renaissance back to its origins in Rome and ancient Greece. This view echoes Napoleon's famous notion that Africa begins south of the Pyrenees, and more recently, Dorival's expressed belief that the idea of pure painting could have developed nowhere but in the area bordered by the Alps, the British Channel, the Rhine, and the Pyrenees.[78]

Much in this rhetoric recalled the strongly xenophobic and anti-semitic criticism directed at the School of Paris in the 1920s and '30s.[79] While not everybody equated the very existence of this school with a spirit of conspiracy and francophobia, as Waldemar George had done in a famous set of articles in 1931,[80] its foreign character was frequently stressed. It was argued that "this internationalization of a civilization and its settling in one location were the first signs of its decadence."[81] In no way does the veneer of French culture that may have attached to painters of the School of Paris entitle them to claim "gallicization."[82]

Modernism in its abstract and expressionistic forms—what George had denounced as the "prefabricated spirit" and the "gregarious spirit of the Slavic Orient"—was considered anathema to the precepts of the French humanist tradition in art. Abstraction was perceived to violate the values of the French figurative legacy and was mistrusted because of its association with the mechanical and technological. A coded, esoteric language, it collided with the neo-humanist ambitions of the post-war era. Expressionism, on the other hand, did not conform to the canon of harmony and balance to which French art aspired.

The incompatibility of expressionism with the essence of the French nature and its inherent foreignness were the focus of twin articles in the same issue of *Art Présent* in early 1945 by two of the foremost writers in the field, and of an exhibition organized by Waldemar George in 1947, *Some Jewish Painters and the Pathetic in Art*.[83] In his article, "Existe-t-il un art expressionniste en France?" ("Is there Expressionist Art in France?"), German Bazin ascribed all manifestations of expressionism in the art of young French painters such as Francis Gruber and André Marchand, for example, to foreign influences. In his eyes, the northerner Van Gogh was the source of all the ills, displacing French lyricism by an art of violence. However, the true influx of "those painters of violence" was attributed

to the "exodus of Slavs and Israelites." According to Bernard Dorival's article, "Existe-t-il un expressionism juif?" ("Is there a Jewish Expressionism?"), those were the elements responsible for the all-pervasive presence of the "corrosive" and "morbid," "of vice and death," which were to be found in "Jewish expressionism." Whereas examples of the French expression of drama and emotion were deemed to embody human dignity, Picasso and other practitioners of this alien expressionism were criticized for their highly subjective imagination, and the "monsters" and "construction games" it engendered. This was not what the world expected from France, but rather an "active and militant humanism."[84]

What was at stake was the future of the humanist tradition in art. Most attacks on Picasso were aimed far beyond the limited field of art criticism. Authors such as Waldemar George, Jean Loisy of *France Catholique*, or René Domergue writing for *L'Aube* perceived Picasso's art, and in particular his treatment of the human figure, as an assault on the humanity of mankind, and by extension, on the whole of Western civilization.[85] What they and others, including Claude-Roger Marx, insisted on was the need for a new humanism.[86] Huisman, in defending Picasso's position as "peintre français," had claimed this humanism for France precisely for the hospitality offered by the nation to scores of foreign artists in search of France's celebrated relationship between liberty and art.[87] Waldemar George had a narrower conception in mind. In his definition of "néo-humanisme" espoused in 1934, he had advocated the "retour à l'homme," an anthropocentric return to a focus on the human being, by which he meant a return to the figurative tradition in art, a tradition that reached from Roman frescoes to Raphael, Poussin, Claude, and the Italian paintings by Corot.[88] Part of the success of humanism in post-war France (which for thinkers like François Mauriac, Georges Cogniot, and Roger Garaudy alike, was the humanist country *par excellence*) resided precisely in that it lent itself to such multiple interpretations.[89] In the specific context of post-Liberation France the strong resurgence of neo-humanism as the major ideological tendency also had urgent political implications; according to Michael Kelly's study on the subject it became "the ideological framework within which to reconstruct the political unity of the French nation," from "humanisme chrétiens" to "humanisme marxiste," it was "the language of restoration, recovery, and reconciliation."[90]

After the war many French were convinced that only through the firm commitment to its humanist tradition could France fulfill its civilizing mission, a vocation nobody seems to have doubted.[91] French art was "one of the last barriers of a humanist and Christian civilization."[92] Pierre-Henri Simon writing in *Le Monde* put it this way: 'the people of the world expect from us a lesson in humanism, an example of health." Stressing the need to choose France's spiritual representatives with care, he too believed that it was of greater urgency to send Poussin and Corot abroad than Picasso and Matisse.[93] One of the aims of neo-humanism was to crystallize the essence of the language and values of the "tribe."[94] This corresponded to the national obsession with *francité*—an

emphasis on French identity endowed with moral superiority—and coincided with a heightened need for cohesion, uniformity, and national reconciliation, characteristic of periods following intense historical upheaval.[95]

This emphasis on the civilizing mission of France and the rhetoric of exclusion, defining the "self" by rejection of the "other" in all its manifestations, are the very hallmarks of nationalism.[96] By no means limited to the right of the political spectrum, this new nationalism addressed unresolved attitudes in response to events of the recent past. The memory of the defeat of 1940 had given birth to what Alfred Grosser had so appropriately called a "nationalism of humiliation."[97] Morally and physically in ruins at home, deprived of a role in deciding the future of the world at Yalta and Potsdam, and confronted by the first signs of the disintegration of its overseas empire, France grew painfully aware of its diminishing political importance on the international scene. Whereas in 1944, at the dawn of Liberation, sixty-four percent of the French still believed in France's rightful position among the superpowers, this assumption had been inverted only five years later.[98] French intellectuals found little comfort in the notion that France be content with its self-assigned position as the "smallest of the great nations," in the words of François Mauriac.[99] Consequently, France's pre-eminence in the intellectual sphere and particularly in the arts became a subject of particular urgency.[100] However, even here France saw its hegemony threatened by the rise of New York as the international capital of the arts. While some tried to disregard the importance of this development, others like Aragon and George Cogniot warned of "cultural imperialism," and the "Marshall Plan of the mind".[101] This apprehension about foreign influence on its home territory was also largely responsible for France's antagonism to modernity.[102]

Modern art and thought were indeed not reconcilable with the tenors of this discourse, the xenophobic and racist tenants of which were clearly a heritage from Pétainist rhetoric and the cultural discourse of the far-Right.[103] There was instead a strong desire to reconnect with those qualities identified with the "national genius," which were assumed to be a constant striving for perfection, moral truth, and harmony expressed in a realist idiom. This return to an authentic national tradition had taken on particular urgency during the Occupation, when it was pursued by Right and Left, Vichy supporters, and the Resistance alike.[104] The so-called pure lineage of the French tradition is, however, less a chronicle of the history of French art than a deliberate construct of periods and artists that are believed to embody those qualities of harmony and order desired to represent the French temperament. Reason and sensibility, balance and harmony, measure and quality of execution were seen as essential components of pure painting and could be fostered only in France, the custodian of the classical Greek humanist legacy.[105] The paragons of that lineage were Poussin and David, Ingres and Corot, Puvis as well as, among more recent artists, Maillol and Derain.[106] It was an irony of history that the latter two painters, who among the contemporaries best represented this tradition,

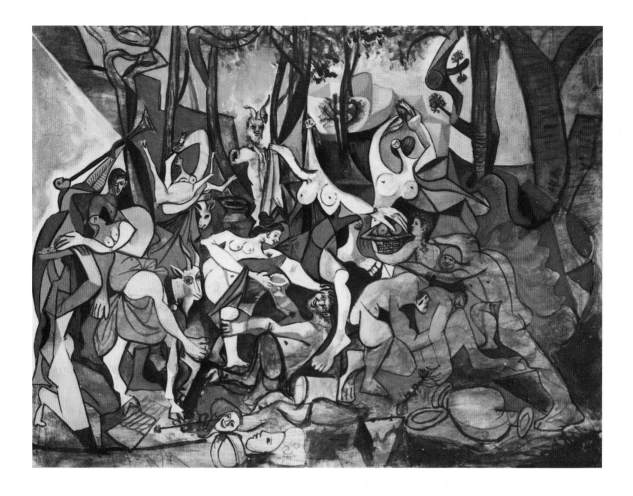

had been compromised by their contacts with the Germans during the Occupation.[107]

Although recent scholarship has shown that a return to classicism does not necessarily depend on a climate of nationalistic ideology or reflect reactionary tendencies,[108] its reappearance in post-war France, in the discourse of the Right and Left alike, is clearly rooted in nationalistic ideas of *francité*, and in the desire to anchor the conception of French identity and values in the classicizing traditions of the Latin Mediterranean heritage. As Waldemar George had stated in his review of the Salon de la Libération, it was only by claiming its rightful heritage as the legitimate descendant of ancient Greece and Rome, that France could triumph once again over the dark forces of the Orient and Asia.[109]

Like his critics from the political Right and Left, with whom he shared a deep post-war disillusionment with technology and the modern world, Picasso longed for the comforting values of an art anchored in tradition and for the untainted purity of forms of expression from the dawn of civilization. In 1944, he had confided to the English poet John Pudney that he believed the times were

90 Pablo Picasso, *Bacchanal*, after Poussin, 24–28 August 1944. Watercolor and gouache, 30. 5 × 40.5 cm.

ripe for "a more disciplined art, less unconstrained freedom."[110] This thinking
may have been what led Picasso during the very days of the liberation of Paris,
in mid-August 1944, to engage in a dialogue with Poussin, the paragon of
French classicism, in painting a gouache and watercolor after the French mas-
ter's *Bacchanal* (fig. 90).[111] However, while his politically and artistically con-
servative critics aspired to a return to tradition as ordained by the academic
codes, Picasso once again bent tradition to his own needs. His signature on the
following statement by Courbet is a fitting comment on this: "J'ai traversé la
tradition comme un bon nageur passerait une rivière: les académiciens s'y sont
tous noyés".[112]

In the Antibes series Picasso's apparent search for the comforting roots of
ancient Mediterranean civilization and for the essential purity of a pre-cultural
Arcadia differs from the *retour aux sources* in Greco-Roman classicism which
Picasso's detractors promoted. Classical elements are indeed introduced in the
emphasis on line over color, the frieze-like arrangement, and pyramidal figure
compositions of many of the paintings and drawings, and some of the drawings
recall in their format, and by their figural disposition in space, the metopes of
the temple of Zeus at Olympia (fig. 91). Moreover, Picasso clearly alluded to
sources in the Greek past of those shores, as he inscribed the ancient name of
Antibes, Antipolis, on the back of his painting *La Joie de Vivre* and on a drawing
of the series.[113]

In order to speak of the Antipolis series as classical one has to consider that
transgression has always been an integral part of Picasso's dialogue with classi-
cism.[114] In the post-Second World War era this tendency was reinforced by the
need to distance his classicism from more reactionary manifestations such as the
classicism of Maillol, who in person and through his art, had been too closely
associated with the Nazi ideology and occupation. Furthermore, we must
address the changing notions about classicism itself. No longer tethered to the
academic tradition, it may still suggest references to past art, but no longer
exclusively to Greek and Roman models.[115] Most importantly, Winckelmann's
ideals of perceiving ancient Greece and its forms of artistic expressions as a world
of Apollonian beauty and harmony—infused with qualities of "noble simplicity
and quiet grandeur"—have been seriously undermined by Nietzsche's concept
of the dichotomy between Apollonian and Dionysian drives and their necessary
co-existence in the process of creation.[116] According to this principle, the
Apollonian striving for beauty and reason in Greek art and tragedy was but a veil
thrown over the wild and reckless frenzy and devastation of Dionysian energies.
This widened concept of the classical, which rendered largely obsolete the
conventional view of classicism as being antithetical to the avant-garde, per-
vades much of Picasso's classical work.[117]

It is clear that Picasso's return to classicism in the Antipolis series does not
find its inspiration in the art of fifth century Athens, but rather in models of pre-
classical antiquity. The simple, playful linearity of the drawing is closer to the
forms of archaic Cycladic art.[118] Cycladic art also provided the most frequent

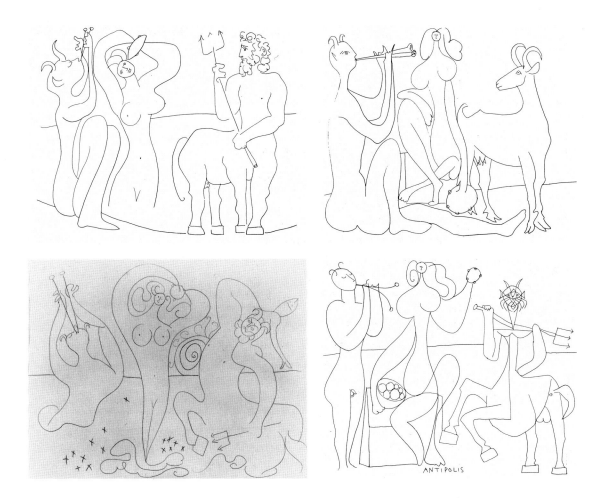

models for Picasso's ceramic oeuvre, which constitutes an important part of his artistic *élan* during the years 1947–49 in Vallauris. His work in this medium was instrumental in revitalizing the ancestral local industry and reflected contemporary discussions on the traditional Mediterranean values of that craft. At a time when "all trust in the machine age and in the technological society had been fiercely undermined," the vernacular values and handmade qualities of ceramics were celebrated as part of the national nostalgia for a pre-mechanical, pre-industrial age.[119]

A similar current of nostalgia inspired Picasso's pastoral scenes of fauns, nymphs, and centaurs in Antibes. Picasso refers not only to Matisse's painting *Le Bonheur de Vivre* but to the entire tradition of Golden Age representations. Far from suggesting utopian visions of future societies as, for example, Paul Signac had done in his painting *L'Age d'Or*, Picasso's escapist fantasy of a purer existence at the dawn of civilization belongs to what H. Hubert had called a "myth of origin."[120] However, just as Matisse had done in *Luxe, Calme et Volupté*,[121] Picasso subverted the neat classification of Golden Age representations and conflated

91 Pablo Picasso, *Antibes* series, October–November 1946. Graphite on white wove paper, each 51 × 66 cm. Antibes, Musée Picasso.

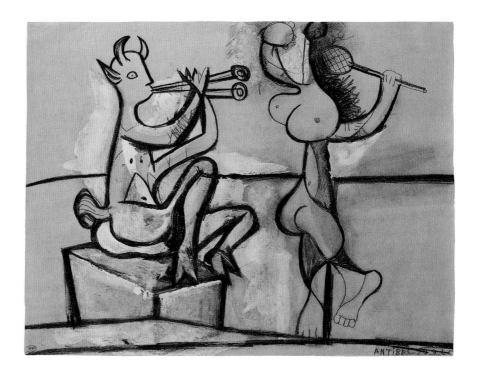

92 Pablo Picasso, *Faun and Dancer*, Antibes, 24 September 1945. Black pencil and gouache on a print proof. Paris, Musée Picasso.

this retreat into a mythical antiquity with joyful affirmation of the here and now of seaside fun and games with his new love. Among fauns and centaurs, Françoise Gilot, recognizable by her flowing hair and full breasts, part Dionysian maenad with tambourine, part modern vacationer with tennis racket, is the only modern intruder who enters this atavistic conception of escape from history (fig. 92).

The centaur and his mythical friends describe, however, more than one side of this *retour aux sources*. Classical revivals since Winckelmann had depended on the myth of the return to the original purity of the primitive. In the mid-1940s they belonged to a general revival of interest for all forms of primitive art. (It should also be noted that the Paleolithic cave paintings at Lascaux had been discovered only a few years earlier, in 1940.) This is what Jean Gras had seized upon when speaking of Picasso's return to the "archetypal utterances of human art." In his review of the Antibes paintings for the *Liberté de Nice* Gras compared them to primitive masks in the Musée de l'Homme in Paris.[122] Charles Étienne admired Picasso for just that capacity to play the role of the primitive and the child without renouncing what he calls "one of the most prodigious poetic and artistic adventures of the era. . . ."[123]

This conflation of the roots of civilization in ancient cultures and of the childlike under the concept of primitivism was characteristic of the period. Picasso, whose interest in many forms of archaic and tribal art is well known, had also repeatedly commented on his interest in the art of children and had

visited both exhibitions of children's art that were shown in Paris and in the south of France in 1945 and 1946. Those pre-rational manifestations of art were seen as unsullied by the devastating effects of the technological society and afforded access to the spiritual.

In the winter of 1945/46 Picasso worked on a sequence of lithographs in which he gradually metamorphosed a rather beefy specimen of a naturalistic bull through a progressive process of simplification, condensation, and abstraction into the pared down representation of its essential core, into the "delineation of pure spirit" (fig. 93).[124] In the culminating image of the series Picasso combined the concentrated spirituality of prehistoric art and the directness of expression, which he identified with the "genius of childhood." Irving Lavin posits that in this process of condensation and refining to essentials Picasso has coalesced two conceptions of history: "one cultural and rooted in a pre-rationalistic spiritual state of society, and the other psychological and rooted in the pre-sophisticated mental state of the child."[125] A similar *modus operandi* appears in the Antipolis series.

Although during that winter (1945/46) of intense graphic creativity Picasso produced three other series of lithographs, following a similar path from complexity to simplification, the bull series stands out. It may be no coincidence that the protagonists of those exercises, in which the dual strains of the archaic and the purity of childhood creativity intermesh most successfully, are the bull in this series and the centaur in Antibes, both incarnations of Picasso's self-identification (fig. 94). The bull, Spanish emblem *par excellence*, played out an iconographic role for Picasso in many bullfights and amorous encounters, and during the 1930s, had appeared in the guise of the Minotaur, the most powerful of the artist's alter egos. In Picasso's artistic vocabulary the bull, the Minotaur, and, as we shall see, the centaur are intimately linked to his memories of Spain and attest to the personal implications of the representation.

Having spent most of his adult life in France, actively involved in the country's cultural ferment, Picasso must have been painfully struck by the attacks in the press, which accused his art of being alien and therefore prejudicial to the reputation of French culture and the integrity of Western civilization.[126] We know how intent Picasso was to be recognized as part of the history of Western tradition.[127] Caught between the French Communists' annexation of his image as representative of their position—what they called *la Pensée Française*—and the denigrating rhetoric of his conservative critics, who wanted to exclude him from the pantheon of French art, Picasso was led to confront issues of national identity and cultural lineage.

It is therefore no coincidence that the two sources most closely related to the genesis of Picasso's Arcadian vision in Antibes derive from the two cultures which defined his emotional, intellectual, and artistic heritage, and carried consciously nationalistic connotations. The classicism and the presence of Dionysian ecstasy, suggesting the fragility of earthly love and happiness under an apparent Apollonian calm in *La Joie de Vivre*, are revealed in its debt to

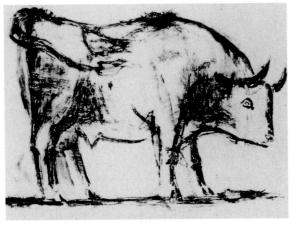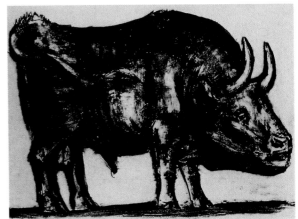
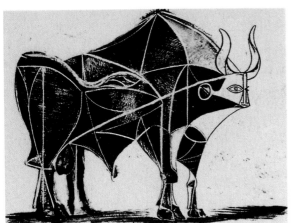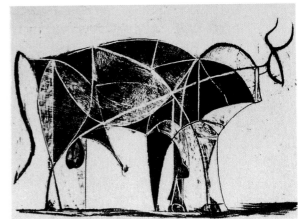
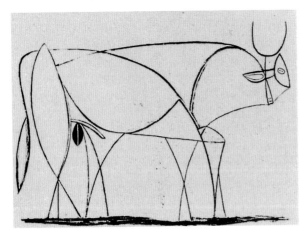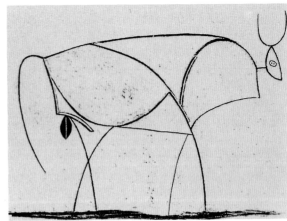

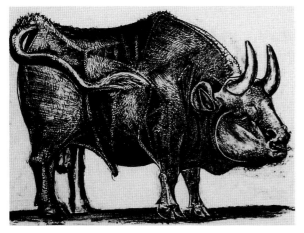
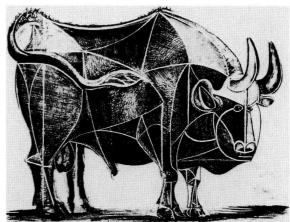
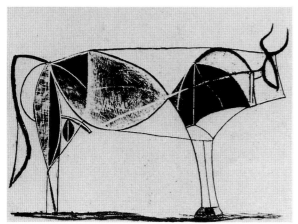
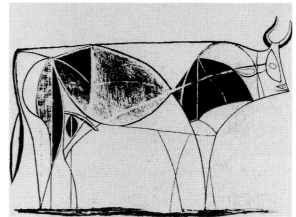
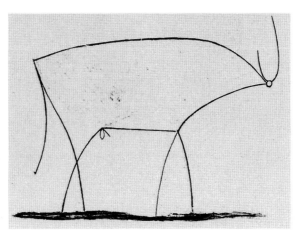

93 Pablo Picasso, *The Bull*, 5 December 1945–17 January 1946. Lithograph (series of 11 progressive states, Mourlot 17, 1–11).

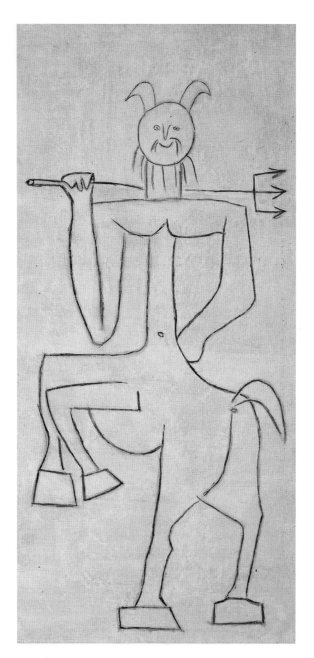

94 *Triptych: Satyr, Faun, and Centaur with Trident* (detail showing panel with centaur), October 1946. Oil and charcoal on fibercement, 248.5 × 360 cm. Antibes, Musée Picasso.

Poussin's *Triumph of Pan*. The cast of characters of fauns and centaurs owes its appearance, as I have mentioned above, to the influence of the Catalan poet Ramón Reventós's mythologizing tales *Dos Contes*.

In August 1944, Picasso's paraphrase of Poussin's *Bacchanal* had been more than just a tribute to the French master; on the eve of liberation it was an homage to France itself and to the survival of its civilization. Once before, at the

end of the First World War, Picasso had paid artistic tribute to the cultural traditions of his adopted country. At that time, Picasso's friend, the German dealer Wilhelm Uhde, surprised by the artist's Ingresque style, had attributed this return to a classical idiom to Picasso's desire to identify himself and his art more closely with the prevailing nationalist sentiments in France.[128] After the end of the Second World War, the debates on national identity, in which Picasso was a reluctant protagonist, inspired a different reaction. These debates led the artist to reconsider his own ties both to his home country and his adopted country, and may have influenced his decision to return to the "neutral" territory of the Mediterranean—the "latin sea"—whose shores were common to both France and Spain. Ultimately, however, the "Picasso controversy" helped initiate the process by which he re-assessed and re-affirmed his Spanish roots and his special allegiance to Catalonia. This process culminated a few years later, in a series of painterly dialogues with his artistic forebears.[129]

During the Occupation, when Picasso had gone to the Bibliothèque Nationale and copied by hand the text of Reventós's *Dos Contes*, he seems to have been seeking comfort from the grim realities of wartime Paris in the Catalan *mediterranisme* of his friend's mythologizing fables, which evoked an Arcadia, unsullied by recent history. The stories reflected faith in the enduring values of the Mediterranean tradition, and for Picasso they resounded with recollections of long-lost friends, of youth and innocence.[130]

Ramón Reventós had been a fervent devotee of Eugenio d'Ors's *Noucentisme*, a nationalistic program for the cultural revival of Catalonia in the early years of the century, and had conceived of *Dos Contes* as a sort of literary illustration of d'Ors's *mediterranisme*.[131] The main protagonists of his nostalgic visions of a waning Arcadia are a faun and a centaur, caught in conflict with the exigencies of the modern world. Both would reappear in Picasso's oeuvre in Antibes. Picasso instinctively reacted to some of the nationalistic nostalgia of Reventós's tales, which inspired him to become involved with the publication of a Catalan and a French edition of his friend's work in 1947, for which he drew the illustrations (figs. 95, 96).

In Reventós's story, *El centaure picador*, the centaur, the last surviving descendant of his species, was adopted at birth by a Catalan poet and brought from Greece to Catalonia. Although the centaur shared his mentor's dedication to classicism, their views on politics diverged widely; the poet was conservative, whereas the centaur adopted the ideas of the Left.[132] Like Picasso, whose political and artistic inclinations he shared, Reventós's centaur is the incarnation of the cultural and spiritual affinities between Catalonia and ancient Greece. In Picasso's oeuvre he also provides the conceptual bridge between the Mediterranean as locus, on the shores of which Picasso was born and where he was going to retire, and its role as harbinger of civilization. Among the mythical characters of his Antibes drawings and paintings, it is clearly the centaur with whom Picasso identified. After his affinity with the Minotaur in the 1930s, Picasso had once again found a fitting alter ego: half man, half beast, an eternal exile.

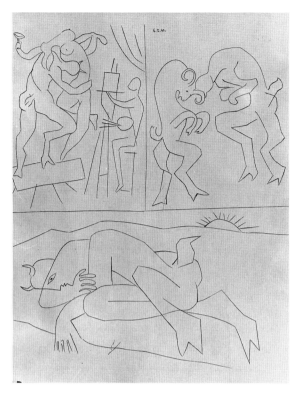

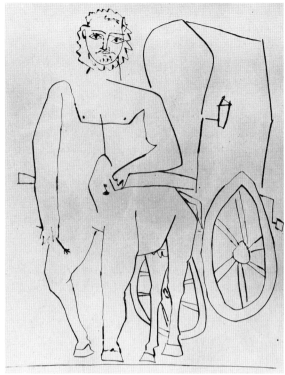

95 (above left)
Illustrations for Ramón
Reventós's *Dos Contes*
(Catalan edition), February
1947. Etching, 33.6 ×
26.4 cm. Barcelona, Museu
Picasso.

96 (above right)
Illustrations for Ramón
Reventós's *Dos Contes*
(French edition), 1947.
Etching, 31 × 24 cm.
Barcelona, Museu Picasso.

Picasso had alluded to his feeling of being an exile. He had revealed that his decision to join the French Communist party had been motivated, in part, by his desire to find a family and a home until Spain, once again under a democratic government, could receive him.[133] It may be no coincidence that one of the paintings of the Antibes cycle, one of the few to carry a title and to refer to a specific myth, is called *Ulysse et les sirènes*, with its inherent theme of the longing to return home.[134] Now that the wartime restrictions on travel had been lifted, Picasso must have felt his self-imposed exile with particular poignancy. A committed supporter of the Republican cause, and sworn opponent of Franco, Picasso had vowed not to return to Spain until democracy had been reinstated.[135] In the meantime, Vallauris, where he settled with Françoise for the next years, became a kind of surrogate Spanish village.[136]

"I am Spanish," Picasso asserted emphatically in a 1954 interview, and "I have the documents to prove it."[137] He had in fact retained his Spanish nationality, despite the annual effort of renewing his residency card. His contacts with Spanish Republicans continued to be strong; he kept in touch with the Republican government in exile and actively backed the clandestine Spanish Communist party.[138] Picasso was as generous in his support of the Republican cause as he was diligent in following the French Communist party's demands for his art, money, and time. He did however complain repeatedly about the resulting

interference with his work schedule.[139] Picasso was on the board of several refugee and relief organizations[140] and contributed to exhibitions with his fellow countrymen,[141] as well as to innumerable charities.[142] He was frequently surrounded by a coterie of young Spanish artists, several of whom owed to him their freedom from refugee internment camps in south-west France. Picasso's painting, *Monument aux Espagnols morts pour la France*, his memorial to a sad chapter in French-Spanish relations during and after the Spanish Civil War, had paid tribute to other, less fortunate Republican refugees, who had lost their lives in the French Resistance.[143] Indeed, Picasso apparently considered himself to be something of an official representative of Republican Spain in exile. In 1946, he flew into a rage at the mere suggestion that he should adopt French nationality.[144]

Many exiles, particularly in their later years, experience a powerful impulse to return to their roots and reaffirm their origins, and so it was with Picasso. It is also arguable that the nature and intensity of the nationalistic polemic in which Picasso was caught up contributed to the urgency of his quest. This impassioned, at times ill-tempered, debate had shown that the old rifts, which had recently torn the world apart, had not healed. Picasso's critical attitude about this state of affairs and his despair over the degeneration of human values in the war and post-war society are known to us from numerous testimonies of the time.[145]

In its Virgilian intermingling of humans from the here and now with mythological creatures, *La Joie de Vivre* belongs to the realm of Arcadian imagery, with its contingent intimations of loss. Representations of Arcadia in art and literature could imply either the fragility of a blissful existence in a threatened earthly paradise or else a lost golden age of which Arcadia is only a reflection.[146] In either case depictions of Arcadian existence translate the nostalgia for a haven "not only from a faulty reality but also, and even more so, from a questionable present."[147] Similarly, the retreat to prehistoric and pre-rational forms of expression implies a critique of the present and a yearning for the lost territories of the past. No wonder, then, that in this hostile climate of debate the *Antipolis* series embodied Picasso's nostalgic dream of Arcadia. Stimulated by the traditions of both his native and his spiritual home, Picasso's dream of escape was expressed in an idiom which had survived from prehistorical times and was inspired by the spontaneity of children's art.[148] As his old friend, Josep Palau i Fabre once wrote, "having plumbed the depth of the human soul, he [Picasso] reached both the child and the caveman in himself. He reinvented man's history and then turned it into legend."[149] This attempt to recover vanished youth and purity also informed Picasso's decision to move to the Mediterranean. Like Reventós's centaur the artist was destined to remain in exile. Vallauris became for him a cultural and geographical outpost for the lost territory of the imagined innocence of prehistorical societies and for his native Spain, which history had rendered unattainable.

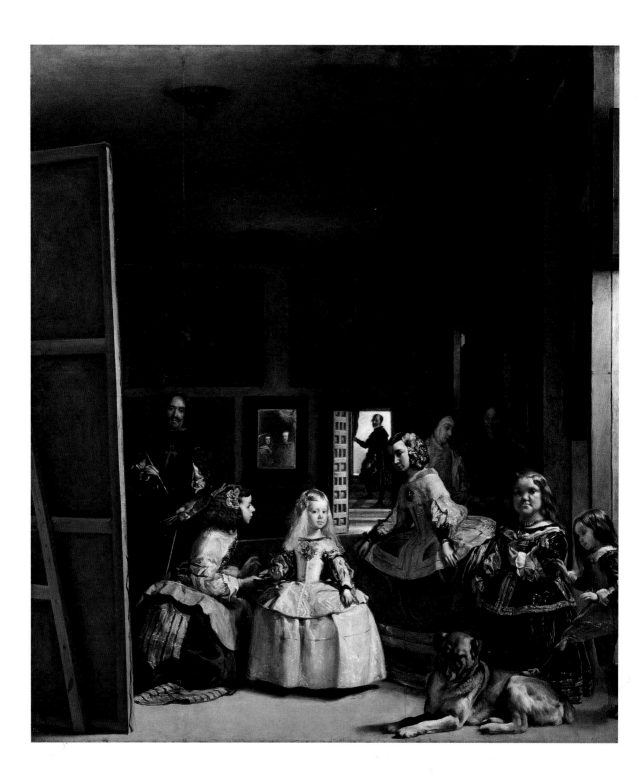

5　Picasso in the Studio of Velázquez

SUSAN GRACE GALASSI

In the mind of the artist a sort of chemical reaction is set going by the clash of the individual sensibility and already existing art. He does not find himself alone in the world; in his relation to the world there always intervenes, like an interpreter, the artistic tradition.

José Ortega y Gasset[1]

PICASSO'S VARIATIONS ON Velázquez's painting *Las Meninas* are a compelling record of the artistic interchange between an old master and a modern one forged in the same tradition.[2] Painted in a studio set up on the deserted top floor of Picasso's Villa La Californie in Cannes over a four-month period in 1957, this suite of forty-five paintings based directly on *Las Meninas*, and an additional thirteen related works, lays out the process of absorption and transformation of the capital of the past which is central to his artistic enterprise as a whole, and to modernism. One of the most iconoclastic artists of his century, Picasso was at the same time deeply rooted in tradition and highly conscious of his place in it, as is attested by his repeated recourse to the art of his predecessors in copies, references, and allusions in works executed throughout his life. Nowhere, however, is Picasso more revealing of his obsession with the history of art as a living process than in his variations on painting of the past. Through them, he not only reflects on history, and his place in it, but encloses himself within it. In his variations the creative and the historical processes meet, and Picasso makes history as he makes art.

No painting of the past was more imbued with personal and historical meaning for Picasso than *Las Meninas*, which he first saw as an adolescent. Picasso's variation of 1950 after El Greco's *Portrait of a Painter* (his first after an artist of his native land) heralded his so-called Spanish decade.[3] The overtly Spanish character of much of Picasso's work of these years expresses, I believe, a longing for connection with a personal and irreplaceable world, and for the very notion of a national tradition.[4] The Spanish characters, which return with a vengeance—the swaggering bullfighters, the blind Celestinas, and young courtesans with their duennas—are freighted with nostalgia. Like the

97　Diego de Velázquez, *Las Meninas (The Maids of Honor)*, 1656. Oil on canvas, 321 × 181 cm. Madrid, Museo del Prado.

119

voluptuous nudes of the following decade, they mask, sometimes in a self-mocking way, the loss of a significant part of himself: this is expressed most poignantly in Picasso's dialogue with Velázquez.

It was perhaps inevitable that at some point Picasso would be lured into the labyrinthine depths of the greatest of all Spanish paintings (fig. 97). Throughout his life, Picasso had submitted paintings of the past to intensive analysis, recreating them in his own style, but his interest in this artistic process increased as he reached old age. What other work could present so significant a challenge to Picasso as his forebear's masterpiece, which was once displayed at the Prado with a placard bearing the inscription *"obra culminante de la pintura universal"* ("culminating work of world art")?[5] In *Las Meninas*, nine nearly life-size, identifiable figures from the court of Philip IV are captured in the act of responding to something or someone beyond the frame of the picture. The scene is depicted with such startling realism that, at first glance, the figures appear to be in an extension of our own space. At the center stands the five-year old infanta of Spain, María Margarita, daughter of King Philip and Queen Mariana. She is flanked by her *meninas* (or handmaidens), María Agustina Sarmiento on the left, who offers her water in a clay vessel, and Isabel de Velasco on the right. Further to the right are two dwarfs, Maribárbola and Nicolás Pertusato, and a large dog lying in the foreground. Behind this group are two chaperons, and standing at the top of a short flight of stairs in an open doorway is José Nieto, chamberlain to the queen, who glances back at the group. At the left, stepping out from behind a large canvas that has its back to us, is Velázquez himself, brush in mid-air. He looks out at a point beyond the space of the room directly in front of the painting, presumably at his model. In his biography of Velázquez of 1724, Antonio Palomino de Castro (to whom we are indebted for the names of the cast of characters) also offered the first published opinion as to what the painter is painting on the hidden face of the canvas—a riddle that has obsessed generations of viewers: "Velázquez proved his great genius because of the clever way in which he reveals the subject of what he is painting. He makes use of the mirror at the back of the gallery to show us the reflection of our Catholic kings, Philip and Mariana."[6] Palomino concludes his description of the master's "most illustrious work" with the assertion that "it is impossible to overrate this painting because it is truth, not painting."[7]

The apparent realism of the scene, however, is only a cover for Velázquez's ingenious perspectival sleights-of-hand, which, as Jonathan Brown has noted in chapter one above, rupture the picture's narrative coherence and leave "gaps in the story . . . wide enough to accommodate numerous interpretations."[8] Velázquez's subtle departures from the conventions of classical representation epitomize what Brown has referred to as the indigenous counterclassical tendency of Spanish art, which sets itself apart from the "grand manner" that originated in the Italian Renaissance.[9] At the end of the nineteenth century, however, when Picasso first became acquainted with *Las Meninas*, the work was appreciated for its naturalism or "truth"—a view summed up in Théophile

Gautier's witty quip, "Où est, donc, le tableau?"[10] In the self-reflexive spirit of twentieth-century art, however, the painting's paradoxical nature was brought to the fore, giving rise to myriad iconographic interpretations.[11] By the second half of the century, the picture that had stood for "truth and not painting" came to represent "painting and not truth" (or painting as truth), reflecting modernism's reductive focus on the nature of representation itself and the reciprocal relationship of the objective world with the subjective experience of the viewer. The "tableau vivant" of the late nineteenth century became by the later twentieth a "network of feints." In his influential essay of 1966, the French philosopher Michel Foucault described the work as:

> A mere confrontation, eyes catching one another's glance, direct looks superimposing themselves upon one another as they cross. And yet this slender line of reciprocal visibility embraces a whole complex network of uncertainties, exchanges, and feints. The painter is turning his eyes towards us only in so far as we happen to occupy the same position as his subject. We, the spectators, are the additional factor. Though greeted by that gaze, we are also dismissed by it, replaced by that which was always there before we were, the model itself. But inversely, the painter's gaze, addressed to the void confronting him outside the picture, accepts as many models as there are spectators; in this precise and neutral place the observer and the observed take part in a ceaseless exchange.[12]

Foucault's structuralist interpretation has spawned numerous articles by both philosophers and art historians, which take up the issue of whether the mirror reflects the implied figures of the king and queen in front of the canvas, or their painted images from the front of the painting within the picture, or both.[13] "Truth" came to be intimately connected with the spectator's point of view. A spatial analysis by Martin Kemp of the room in the Alcázar palace in which the scene depicted in *Las Meninas* takes place (and where Velázquez in fact executed the painting) demonstrates that, as Palomino first stated, it is the painted image of the king and queen from the front of the large canvas on which the artist is working which is reflected in the mirror.[14] Yet no empirical evidence can obviate the elusive interchange of illusion and reality embedded in the very structure and meaning of *Las Meninas* through which Velázquez questions the complex nature of the relationship between representations and real things.

While the pre-eminent position of *Las Meninas* in the history of art, as well as its theme of the artist at work and the questions it raises concerning representation, were more than sufficient to make it an obvious target of Picasso's emulation, there are also specific formal qualities of the work—for example, the compelling outward thrust of the composition toward the spectator—which would have seized his imagination. In *Las Meninas*, however, the viewer does not merely complete the narrative as the displaced focal point of the composition. The viewer tries to situate himself by taking up the point of view before the painting which is assigned him explicitly by its composition and by its implicit

demand for narrative completion. At the same time, his desire for resolution is denied through the interplay of perspectival viewpoints, and the fact that he must compete for his place with unrepresented members of the cast of characters—the king and queen, and Velázquez himself, who occupied the same general area when painting the picture. Furthermore, the play of the real and illusory in the painting's narrative structure is reinforced on another level. The variety of images depicted in the scene, including paintings within the painting, figures reflected in the mirror, windows, a door, and characters from real life, represent, as Karl Birkmeyer has noted, "different pictorial realities," with the painter as "the physical and spiritual pivot from which the synthesis of different visual realms originate . . . and around which they turn."[15] These various representational modes vie with one another for dominance and contribute to the painting's questioning of the problematic connection between appearance and reality, and of the possibility of any absolute truth.

To Picasso, the co-founder of Cubism, these exchanges between real and pictorial space, the represented and the implied, and the interplay of structural systems were undoubtedly among the primary attractions of the work.[16] Through the framework of the quintessential Spanish masterpiece, he continues to investigate an issue at the core of his own art: the irresolvable gap between the painted sign and symbolic meaning.[17] It is in this fissure that Picasso finds connection with his predecessor (and the Spanish tradition that the work epitomizes) and discovers meaning of his own, thus renewing one of the most familiar works in the history of art and reconnecting with his artistic roots. The ground on which Picasso sets himself in front of *Las Meninas* is dynamic and shifting; his challenge is to establish his position within the ongoing history of interpretations of the painting and make it his own by merging the roles of viewer and author.

Yet another powerful attraction to *Las Meninas* for Picasso would have been the layers of association and unconscious memory embedded in a work he had known over his entire life. Picasso's first encounter with *Las Meninas* took place in the spring of 1895 in the company of his father and first teacher, Don José Ruiz, an academic painter of little talent. En route from La Coruña to Málaga, the family stopped for a day in Madrid so that Don José could take his son, then fourteen, to the Prado.[18] The year was a watershed for Picasso and his family. In January the youngest of the three Ruiz children, María de la Concepción (Conchita), a blond-haired girl of seven, died of diphtheria. As John Richardson has shown, Picasso mourned her throughout his life, and his father never fully recovered from the loss.[19] In the fall the family moved to Barcelona, where Don José took on a new teaching post at the local academy, La Llotja. There Picasso would soon establish his own path in more-or-less direct opposition to that of his father, and to the naturalism that Velázquez's art then epitomized. The visit to the Prado took place just before the young Picasso emancipated himself fully from his father's influence. Looking back on *Las Meninas* from a perspective of sixty or more years, Picasso's first view of the "obra culminante" at his father's

98 Pablo Picasso, studies for *Self-Portrait with a Palette*, autumn, 1906. Pencil on paper, 31.5 × 48.3 cm. Paris, Musée Picasso.

side could not but have been deeply imprinted on his memory, and become fused with the work itself. Over the course of his career, Picasso turned from time to time to *Las Meninas* for inspiration, often in indirect form. In one of his own first masterpieces, the *Demoiselles d'Avignon* of 1907 (fig. 24), as Leo Steinberg has suggested, the intensity of address with which the eyes of the figures in the painting are directed on a spot in front of the picture plane, in the viewer's space, may well derive from *Las Meninas*.[20] Furthermore, in a study for his *Self-Portrait with a Palette* of a year earlier, Picasso had represented himself in the pose of Velázquez in *Las Meninas*, a revealing moment of identification, suppressed in the final version (fig. 98).[21] In the late 1920s, some of Picasso's Synthetic Cubist studios reflect *Las Meninas* at a distance.[22] As I have discussed elsewhere, Picasso may also have used the painting as something of an unconscious model in another major work, *Guernica* (fig. 99) painted in 1937.[23] In his struggle to give expression to the spirit of the Spanish people in *Guernica*, Picasso appears to have absorbed aspects of Velázquez's composition and the combination of drama and detachment of that most enduring of national monuments.

The critical fortunes of Velázquez are yet another dynamic process which enters into and shapes Picasso's dialogue with the master. As a youth in Spain, Picasso had witnessed Velázquez's artistic apotheosis. In the last two decades of the nineteenth century, the only extended period of his life that Picasso spent in Spain, Velázquez was the focus of intensive scholarly study in the Peninsula. British, German, and French scholars had been among the first to lay the foundations for a critical assessment of Velázquez's oeuvre, establishing him as

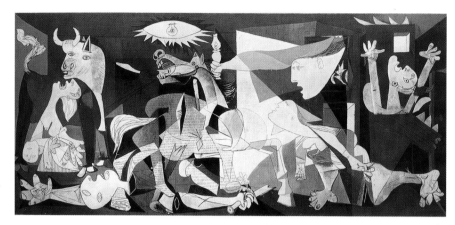

99 Pablo Picasso, *Guernica*, 1937. Oil on canvas, 349.3 × 776.6 cm. Madrid, Museo Nacional, Centro de Arte Reina Sofia. On permanent loan from the Museo del Prado.

a "universal master" on a par with Rembrandt and Raphael.[24] In the 1880s and 1890s, Spanish historians rushed to reclaim Velázquez from the outsiders, and to establish his position as Spain's premier artist. "We have the main thing," one writer complained, "the paintings, but lack the interpretation. . . . Outside Spain, our art counts for little, and if they discover an artist like Velázquez's, they do not realize that he is Spanish."[25] The first Spanish monographs on Velázquez appeared in the last two decades of the nineteenth century, and in 1899, marking the tricentennial of his death, a large retrospective of his work was held at the Prado.[26] *Las Meninas* was set up in a special room, a sort of simulacrum of the work itself, "with the light admitted from the left, in the same way as was the case when the picture was painted."[27] During the celebration, the bronze statue of Velázquez was set in front of the Prado, where it remains today. There could be no further doubt about his status as the standard bearer of the national tradition.

As Robert Lubar discusses in chapter two above, during his years in Barcelona Picasso allied himself with the burgeoning Catalan movement of *Modernisme*, the members of which participated in the rediscovery of El Greco, whom they anointed as the prophet and patron of their anti-naturalistic art.[28] The "realism" of Velázquez, in fact, had considerably less appeal to the Catalan group. It may well have been, as Palau i Fabre notes, that "the modernists' irreverence for such sacrosanct national monuments as *Las Meninas* played a role in bringing about Picasso's integration into the group."[29] For the young Picasso, Velázquez was clearly a presence, though not a direct influence, as was El Greco. His interest in Velázquez appears to be laced with ambivalence, as revealed in the subtle changes he introduces in his copy of the portrait of Philip IV in the Prado, made in the fall of 1897, while a student in Madrid.[30] The combination of intense admiration for great artists of the past with his natural tendency to rebel against authority and officially sanctioned art, which is evident in Picasso's student copy, emerges in a far more exaggerated form in his dialogue with Velázquez sixty years later.

Once he was established in France, Picasso's appreciation for Velázquez's naturalism grew, while his early enthusiasm for El Greco's mysticism diminished. "We cannot conceive of a Philip IV in any other way than Velázquez painted him. . . . He convinces us by his right of might," he remarked to Marius De Zayas in 1923.[31] Although El Greco continued to interest Picasso throughout his life, it was his realism that he later esteemed, especially his "magnificent heads."[32]

It is no coincidence that Picasso turned to Velázquez's immortal painting at a time when he was becoming increasingly isolated behind the wall of his fame and his influence on younger artists was waning. Picasso took on the so-called "obra culminante" when he was past the period of producing masterpieces of his own and was preoccupied with looking back on his life and art, though he remained intensely productive and innovative. As Palau i Fabre has noted, it was also a period of adjusting to a number of losses in his personal and professional life.[33] Three years before he launched his *Meninas* series his companion of the past decade, Françoise Gilot, left him with their two young children, Claude and Paloma. In 1955, Picasso's estranged wife Olga Koklova died, thus severing a vital link to his productive post-First World War years and to his fruitful collaboration with Serge Diaghilev's Ballets Russes. (Olga, in fact, had once danced the role of one of the *meninas* in a one-act ballet based on *Las Meninas*.[34]) Throughout the fifties, several painters with whom Picasso had launched the modernist movement died, among them Henri Matisse, André Derain, and Fernand Léger. The younger generation of Abstract Expressionists had little or no interest in Picasso's current work or sympathy with his commitment to representation, while they plundered the paintings of his Cubist and Surrealist periods. By his mid-seventies, the towering figure of twentieth-century art had arrived at a problematic relationship with the present, not uncommon in long-lived artists. As the art historian Kurt Badt has noted, "the late works of great masters, which come about at the period style of a subsequent generation, tower over the flow of history as solitudes, inaccessible to the context of time."[35] It was in the 1950s that variation, through which past and present merge into simultaneity, became central to Picasso's artistic program.

Although Picasso had discussed redoing *Las Meninas* with his lifelong friend Jaime Sabartés in the early 1950s (as he entered his seventies), he undertook the project only at seventy-five, the age at which his father had died. Reaching this significant marker undoubtedly triggered Picasso's morbid fear of death and concern with securing a place among the immortals. As the "father" of Spanish art, Velázquez would have been an unavoidable measure of his own stature, and *Las Meninas* the ultimate test of his inventive powers.

When Picasso executed his variations in 1957, *Las Meninas* had recently passed its three-hundredth anniversary. Was it once again time to claim it for the Spanish and to reassert his own identity?

* * *

THE MENINAS VARIATIONS

> Suppose one were to make a copy of *The Maids of Honor*; if it were I, the moment would come when I would say to myself: suppose I moved this figure a little to the right or a little to the left? At that point I would try it without giving a thought to Velázquez. Almost certainly, I would be tempted to modify the light or to arrange it differently in view of the changed position of the figure. Gradually I would create a painting of *The Maids of Honor* sure to horrify the specialist in the copying of old masters. It would not be *The Maids of Honor* he saw when he looked at Velázquez's picture; it would be *my Maids of Honor*.

> Picasso to Sabartès, ca. 1950[36]

Overture

VARIATION NO. 1, 17 AUGUST 1957

In the first variation (fig. 100), Picasso boldly propels the image forward by three centuries, in his largest canvas since *Guernica*, and the largest by far of the entire series. The first variation, which was left unfinished, announces the themes he will develop, and immediately fulfills his intention of making it "*my Maids of Honor*." He will paint another thirty-two paintings before he returns again to the ensemble.

If *Las Meninas* did, in fact, enter into Picasso's pool of associations while he was painting *Guernica*, the connection appears to be reflected in his choice of a horizontal format for the first variation (in opposition to that of Velázquez), in the grisaille palette, and in the overall composition in which a centralized triangle and two upright flanking panels are used. Picasso attempts to challenge Velázquez's authority at the outset by taking a place beside him, lodging his reconstruction not only in his predecessor's masterpiece but in one of his own, which may, in turn, echo *Las Meninas*. The "retour éternel" is manifest in his initial painting, and belies the intensity of the struggle that Picasso will wage with his forefather to claim a place for himself.[37]

The receding space of the palace room has been compressed in the Picasso into a Cubist layering of planes that retains a strong echo of the depth of the original. Picasso seizes on the perspectival ambiguities of his theme and develops them in a new direction in a modern, reductive vocabulary, while demonstrating both his appreciation of and his distance from Velázquez's own iconoclasm. Within Picasso's Cubist box—the sides of which have been pushed back—figures, released from perspective, shift places (as he predicted) or shoot up and out of scale with the rest. The head of Velázquez with its double-profiled face, overlapped by a single nose, brushes the top of the ceiling, and he holds not one, but two palettes.[38] Yet the towering giant of Spanish art is curiously insubstantial: his profiles face inward, isolating him from the rest of the group, and

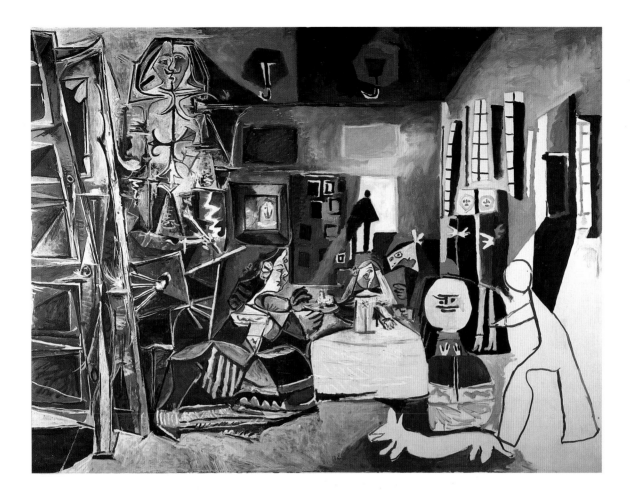

his faceted body melds into the space around him. He is in the process of dissolution, about to be expelled from the company of the *meninas*. In the next forty-three paintings, the figure of Velázquez will reappear only three times, and then merely as an insignificant player. Picasso has already taken his place.

The rest of the figures, with the exception of the chaperons, are drawn into a triangle as in the original, although in a more compact and central one; it is on them—the infanta and her retinue—that Picasso will focus his attention in the next months. Velázquez's major figure, the Infanta María Margarita, remains Picasso's focus as well. A change is seen, however, in the increased significance Picasso places on José Nieto, the *aposentador*, or queen's chamberlain, who is framed in the doorway on the steps at the back of the picture, presumably holding open the door for the royal couple's passage through the room. Though Nieto is the smallest and most distant figure in the original, his importance is underlined by his position at the perspectival center of the work, located in his bent arm. Poised on the stair and looking back on the assembled group in the room, he alone shares with the painter within the picture a view of both the royal

100 Pablo Picasso, *Las Meninas, after Velázquez* 1 (full view), 17 August 1957. Oil on canvas, 194 × 260 cm. Barcelona, Museu Picasso.

Pablo Picasso. *The Shadow* (*L'Ombre*). 1953. Oil and gouache on canvas, 129.5 × 96.5 cm. Paris, Musée Picasso.

couple standing beyond the limits of the work, and their painted image on the canvas, both of which are denied to the viewer's sight. A surrogate for the artist, he rounds out the view of the scene from behind.[39]

Picasso shifts Nieto to the apex of the triangle, directly over the infanta. Given the strong emphasis he placed on the act of looking throughout his art, as seen in his many depictions of lovers watching over their sleeping mates, artists studying their models, and scenes of bawdy voyeurism, it is not surprising that the *aposentador* takes on special significance. Furthermore, Nieto's role as "door opener" undoubtedly reverberated with Picasso's long fascination with doors, windows, and mirrors, frequently presided over by a shadow figure, often a symbolic representation of Picasso himself, as seen for example in *L'Ombre* of 1953 (fig. 101).[40] As Lydia Gasman has shown, these rectangular architectural elements (with their superimposed shadow figures) are often surrogates for the painting and play a key role in Picasso's concept of art as a form of magic.[41] In shifting the position of Nieto to the left, Picasso imposes a new structure over the original work: two of the main focal points of *Las Meninas*— the physical center of the canvas, located in the eyes of the infanta, and the vanishing point of the painting in the bent arm of Nieto, which compete for

dominance and create tension in the original work[42]—are locked into a more rigid composition in the variation. In representing himself as large and central to the scene, towering over the phantom figures of the king and queen in the mirror, Velázquez had already taken considerable license with the social order.[43] Picasso pushes this element further by placing the courtier directly over the infanta, in a world of his own in the making. Nieto stands out from the rest of the cast not only by his position at the apex of the triangle of figures, but by his small scale and flat, disk-like, featureless head and blank body. Neither coming nor going, he appears to be stamped on the canvas like the stenciled letters or numbers in Picasso's Cubist paintings.

The most significant change, however, is in the level of abstraction at which Picasso represents reality. By carrying Velázquez's play with the laws of perspective well beyond realistic representation, and introducing an anti-naturalistic figure style made up of angular facets and geometric lines, Picasso severs the vital connection between the pictorial space of the painting and the spectator, and the reciprocity of "direct looks superimposing themselves upon one another as they cross."[44] It is in this relationship of viewer to viewed that the meaning of the original work lies. In the variation, the onlooker does not enter into the space of the painting as a seamless extension of his own, but into an historical continuum—an interplay of two structural and symbolic systems separated by 300 years. Picasso's compressed space and flattened forms, which absorb and recast his predecessor's illusionistic idiom, is but an overlay of one code upon another, neither of which has any greater claim to representation as a "valid intentional act."[45] Picasso's painting begins and ends with the surface; the illusion of the external world is replaced with a "truth" of Picasso's own—his own subjective response to Velázquez's depiction of the real world sifted through memory and translated through his fragmented contemporary idiom.

As if to underline his infiltration of the sacred precinct of Velázquez's studio, he replaces Velázquez's noble mastiff with his own dachshund, Lump, and throws open the windows on the right to let the light flood through modern mullions into the dark recesses of the room.[46]

I

VARIATION NO. 2, 20 AUGUST 1957

Selecting a moderate-size upright rectangular canvas, Picasso rivets his attention on the infanta, the central figure of the canvas (fig. 102); in the next two weeks he devotes all but one of the next fifteen paintings to her. With her pale golden hair, radiant clothing, and direct outward glance, the infanta is the most visually compelling figure in the work by Velázquez, and its linchpin. Picasso launches his series in an analytic spirit, exploring the connections and differences between Velázquez's formal language and his own through careful observation, though he does not refrain from, often ruthless, parody.

102 Pablo Picasso, *Las Meninas, after Velázquez* 2 (infanta, bust), 20 August 1957. Oil on canvas, 100 × 81 cm. Barcelona, Museu Picasso.

One of the salient features of Velázquez's painting as a whole—its sense of arrested motion—is made explicit in the "peculiar dislocations between the infanta's glance and the position of her head."[47] Picasso seizes immediately on the child's quizzical regard and dynamic expression, transposing her soft flesh into a modern vocabulary of flat, angular, and curved shapes set into a triangular framework of rods. Velázquez's subtle dislocations are transposed into a vocabulary of ruptured Cubist planes. Where the infanta's head pulls gently right and her eyes abruptly left in the original, Picasso responds with a fusion of two interlocking opposing profiles: the top eye, mouth, and chin face right (following the direction of her head), while the bent back profile nose (with frontal

nostrils) points to the left, in the direction of her gaze. As if to heighten the points of contrast and continuity between his representational system and that of Velázquez, Picasso appropriates certain elements, such as the triangles of light and dark on the princess's neck, directly into his canvas. In the variation, however, these shapes reinforce the child's two-dimensionality and dynamic aspect, and serve as a transition from her complex geometric head to her flat, sandwich-board body. The ragged black line along the neckline of the Infanta's dress in the Velázquez is likewise appropriated almost unchanged. Picasso, however, mimics the "loaded brush" of Velázquez's painterly style through exaggeration, and continues the black border off the edge of her bodice, so that it overruns its representational function to become an abstract element in the design. Picasso's Cubist infanta is opened up to inspection from multiple points of view, marking his symbolic entry through this key figure into the painting as a whole. The transformation from flesh to lines and planes, furthermore, reveals Picasso's irreverent and witty approach to appropriation, in which he fits one of the most famous figures in the history of art, frozen in time, to his Cubist template. Yet it is not only form but subject matter that is blatantly altered in translation. To the left of the infanta, who has been placed slightly off-center, Picasso includes the disembodied hand of the adjacent figure—María Agustina—holding a small clay vessel, known as a *búcaro*, on a tray. The exaggerated size of the *búcaro* and the proffering, cut-off hand create a secondary focus within the work. Not only does this intrusive fragment remind the viewer of the infanta's relation to the context from which she has been momentarily excised, but it reverberates with images of the *búcaro* throughout Picasso's art, a quintessentially Spanish object which he often imbued with sexual connotations. The thrusting, phallic fingers of the maid and the vessel's swelling form wittily suggest similar meaning here.

VARIATION NO. 3, 20 AUGUST 1957

The attendant, María Agustina, appears in a bust-length portrait in the next canvas (fig. 103). Not only was her appearance predicted in the previous work by her arm and hand, but the infanta's rightward facing profile with parted lips, and receding chin, suggest that Picasso was taking a sidelong glance at the serving girl while painting her mistress, incorporating aspects of the former into the latter. The overlay of one figure upon another, a process which will continue throughout the series, reveals the concision of Picasso's analytic powers.

Changing models, Picasso changes approaches as well: here he rapidly sketched out the adolescent maid in an expressionistic style reminiscent of Van Gogh, warming his palette with blue, yellow, and terra cotta. The disembodied figure of the infanta is exchanged for one of flesh and blood. Picasso appears to be indulging for a moment in the tantalizing beauty of this dark-haired Spanish girl, but almost immediately he returns to the nucleus of the composition. As its linchpin, the infanta poses a greater challenge: more than any other

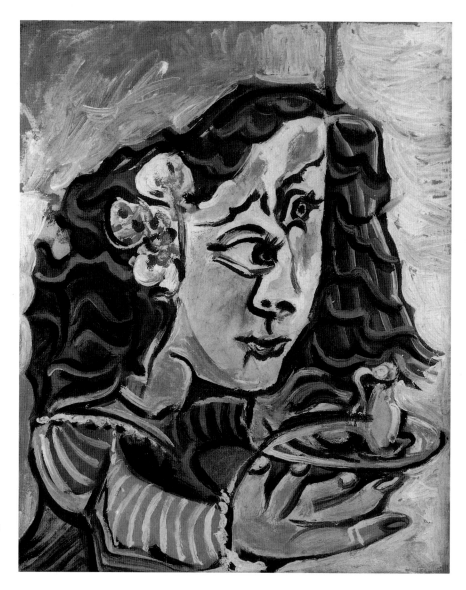

103 Pablo Picasso, *Las Meninas, after Velázquez* 3 (María Agustina, bust), 30 August 1957. Oil on canvas, 46 × 37.5 cm. Barcelona, Museu Picasso.

character, she embodies the whole, and ties together the two sides of the composition.[48]

104 (facing page) Pablo Picasso, *Las Meninas, after Velázquez* 4 (infanta), 21 August 1957. 100 × 81 cm. Barcelona, Museu Picasso.

VARIATIONS NOS. 4–8, 21–27 AUGUST 1957

Picasso returns to the grisaille palette and Cubist idiom and continues to analyze the infanta in alternating standing- and bust-length portraits. In the first of these (fig. 104), the flattened forms of the full-length figure are projected into low relief and set off by simplified geometrical shapes based on careful scrutiny

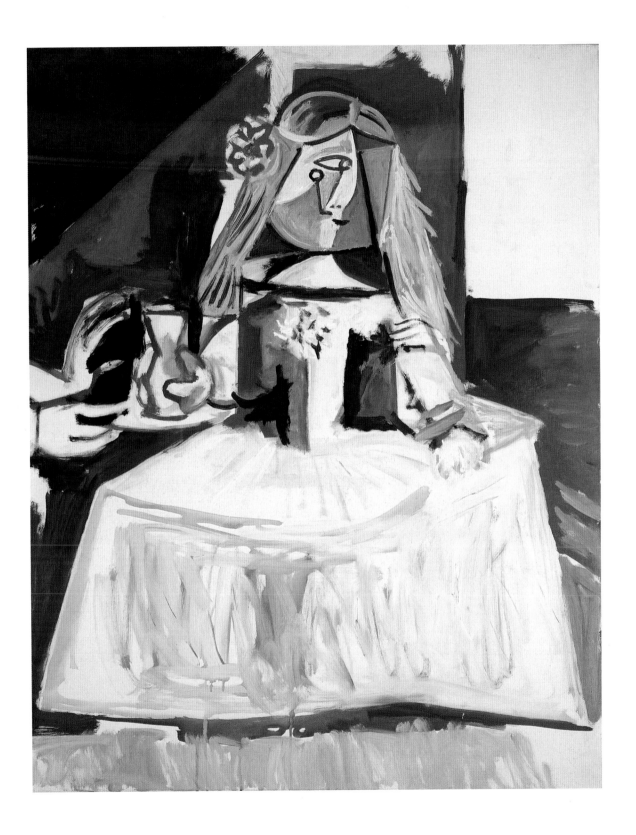

of the setting as depicted by Velázquez. The presence of Isabel de Velasco, the *menina* to the right of the painting, is suggested by a few stripes from her skirt which overlap the infanta's. Here, as in the previous depiction of the infanta, Picasso exaggerates Velázquez's shadows, particularly around the left side and hem of her dress, and in the dark areas between her arms and body. The master's brush technique, in which "irregular deposits of pigment float on the surface of rich colors"[49] is noted and parodied in Picasso's exaggerated free-hand stokes, mere abstractions which lie on the surface—perhaps they are also an irreverent reference to the "empty" gesture painting of the fifties, which he despised. As the series progresses, Picasso focuses on different elements of Velázquez's illusionistic code—his use of perspective, chiaroscuro, brushstroke, and, later, color and the space of the room itself, holding each up for inspection through the filter of his modern sensibility.

VARIATION NO. 8, 27 AUGUST 1957

The eighth canvas (fig. 105) represents a moment of synthesis. Picasso throws off the grisaille palette and breaks into color, zooming in on the infanta's face and shoulders in a highly economical and harmonious work. Reduced to the fundamental elements of visual representation—primary and secondary colors, line and plane, darkness and light—this diagrammatic figure, with its interlocking profiles, challenges the naturalism of his predecessor with its economy of means and distance from reality, yet with a completeness and complexity of its own. Here, a perfect balance of tradition and modernity is achieved. Velázquez portrays an individual captured in a moment. Picasso's ideogram spans (and compresses) a broad range of historical styles, yet the figure retains the recognizable features of her counterpart.

VARIATIONS NOS. 9–11, 27–28 AUGUST 1957

The powerful gestalt of the previous work is violently disrupted in the next (fig. 106). A black wedge is driven down the center of the child's face, and the eyes are brought close together, giving her a look that is more simian than human. Wholeness is shattered, and parts begin to drift away. Mobility is restored to the series, which had come to a stasis in the previous work: in the next two canvases, no larger than the span of a hand, her face fades, like an after-image.

VARIATIONS NOS. 12–17, 4–6 SEPTEMBER 1957

Picasso resumes the series after a week's absence with a bust-length portrait of the infanta (fig. 107), and launches a new approach. Lines and planes dissolve

105 Pablo Picasso, *Las Meninas, after Velázquez* 8 (infanta, bust). 27 August 1957. Oil on canvas. 33 × 24 cm. Barcelona, Museu Picasso.

into luminous, painterly fields of yellow and white. The infanta radiates outward into bordering areas of intense red and blue—pure energy. The emphasis on parts in her previous incarnations gives way to a greater sense of wholeness, yet the two opposing profiles remain visible and in discord. A change takes place here from an analytic to an Expressionist approach.

In No. 13 (fig. 108), the princess is transformed into a fiery virago set off by

106 Pablo Picasso, *Las Meninas, after Velázquez* 9 (infanta, bust), 27 August 1957. Oil on canvas. 33 × 24 cm. Barcelona, Museu Picasso.

the red steps behind her. Picasso has swerved from the re-definition of a single figure to a quick take of the group as a whole, without the artist. As if to capture the immediacy of his powerful response, Picasso shifts to a crude, almost sub-representational mode, where empty circles stand for heads, and a few, heavy, black lines suffice to define bodies which do not entirely correspond to forms underneath. The figures reflected in the mirror are reduced to something threatening, resembling crossbones, while above it an empty black frame enclosing an area of white tilts towards us—perhaps a repetition of the mirror. There is a

136

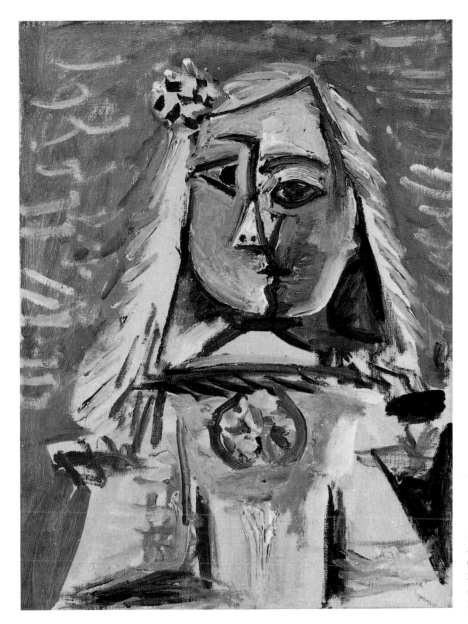

107 Pablo Picasso, *Las Meninas, after Velázquez* 12 (infanta/Isabel), 4 September 1957. Oil on canvas, 35 × 27 cm. Barcelona, Museu Picasso.

strong feeling of compression and claustrophobia in this small work: the infanta is hemmed in by her courtiers on both sides, while the prominent doorman pauses at the top of the step, his arm uplifted, as if he is about to descend. The charged, raw energy of this confining and primarily female domain is reminiscent of the *Demoiselles d'Avignon*, while the male entering at the top of the step recalls the medical student stepping into the brothel in an early study for that painting (fig. 26).[50] The crudeness and virulence of the work signals a new level of engagement with the theme. Is it perhaps Picasso himself standing at the

108 Pablo Picasso, *Las Meninas, after Velázquez* 13 (partial group), 4 September 1957. Oil on canvas, 35 × 27 cm. Barcelona, Museu Picasso.

doorway, his arm raised as if painting the picture, about to descend into the scene below to take possession of it. The brothel/studio equation is familiar in Picasso's oeuvre. As his encounter with Velázquez continues, the analytic process which propelled Picasso through the first twelve paintings towards increasing abstraction gives way to a more associative one. Links with his own paintings, and those of other artists, as well as autobiographical material embedded in layers of memory now emerge with greater force.

The first part of the series comes to a close with three more portraits of the

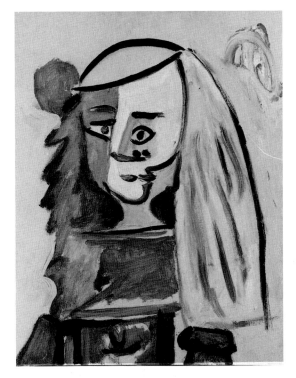

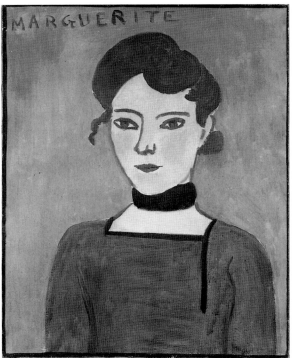

infanta, each one distinctly different from the previous one. This group of three portraits marks a movement toward greater subjectivity and competition with his counterpart. Identities become increasingly fluid and open to manipulation. In No. 16 (fig. 109), for example, the fall and color of her hair, the juxtaposed flowers, and bemused expression belong to the infanta, while the three-quarter view of her face looking left and its strong division at the nose into areas of light and dark, as well as the green of her dress are taken from Isabel de Velasco; the lips and chin facing left may belong to her counterpart, María Agustina. A painting Picasso owned and greatly esteemed, Matisse's portrait of his daughter of 1907, may be remembered here as well. The oval face, almond eyes, tiny mouth, square neckline of her dress, and simple manner of drawing recall Matisse's bust-length portrait of Marguerite, who had the same name as the infanta (fig. 110).[51]

The last of the infanta portraits, No. 17 (fig. 112), is the most naturalistic. The apparent realism, however, conceals another ingenious weaving together of different figures from the painting and from Picasso's life. The sweep of her hair over her forehead, the juxtaposed flowers on her head and bodice, the straight neckline of her dress remain the infanta's identifying markers. But her quizzical expression, delicate features, and cocked head are replaced by the veiled, blunted visage of the dwarf Maribárbola, who confronts the viewer head-on with open, staring eyes, which seem to look inward as well as out. In *Las Meninas*, the

109 (above left) Pablo Picasso, *Las Meninas, after Velázquez* 16 (comb. infanta/Isabel), 6 September 1957, 41 × 32.5 cm. Barcelona, Museu Picasso.

110 (above right) Henri Matisse, *Portrait of Marguerite*, 1907. Oil on canvas, 65 × 54 cm. Paris, Musée Picasso. Donation Picasso.

111 Pablo Picasso,
Paloma, 1952. Colored
pencil on paper, 66 ×
50.5 cm. Paris, Musée
Picasso.

112 (facing page) Pablo
Picasso, *Las Meninas, after
Velázquez* 17 (infanta/
dwarf), 6 September 1957.
Oil on canvas, 46 ×
37.5 cm. Barcelona, Museu
Picasso.

infanta and her dwarf, approximately the same height, represent poles of beauty
and ugliness, perfection and aberration, youth and age, and high and low social
position. Picasso reconciles these antitheses, and introduces a third likeness into
the blend, that of his daughter Paloma as she looked a few years earlier, when she
would have been the same age as the infanta (fig. 111). The full, round cheeks
and deep, dark eyes—as much his own as his daughter's—bear her stamp. Or
could this hybrid figure from art and life also evoke his blond-haired sister,
María de la Concepcion? When he stood with his father in front of Velázquez's
canvas sixty years before, just months after her death, the small blond-haired
princess could not fail to have reminded them of their very recent loss. This is
a summarizing work in which Picasso fuses observation with memory and
invention.

* * *

113 Pablo Picasso, *The
Pigeons* (*Los Pichones*) 19, 6
September 1957 III. Oil on
canvas, 100 × 80 cm.
Barcelona, Museu Picasso.

Interlude

THE PIGEONS, NOS. 18–26, 6–12 SEPTEMBER 1957

On the same day on which he painted his last two infantas, Picasso turned
abruptly to another subject, the view framed by his window of a pigeon roost
and cage which stood on the balcony overlooking the Mediterranean in the
brilliant late summer light; over the next six days he painted nine canvases of
the scene (No. 19, fig. 113). The need for diversion after the intensity of his
involvement with Velázquez is understandable; what is less clear at first is why
Picasso saw the pigeon paintings as integral to the series. When he donated the

114　Henri Matisse, *The Open Window*, 1905. Oil on canvas, 55 × 46 cm. New York, Collection, Mr. and Mrs. John Hay Whitney.

Meninas suite to the Museu Picasso in Barcelona in 1971, Picasso included the pigeon paintings, and they remain on display together.

In this sub-set of pictures within the *Meninas* series, Picasso keeps his major theme in evidence, however: he continues to explore the problematic relationship of art and truth (or the painted image and its counterpart in the physical world) in a more contracted focus—through the familiar painting/window analogy. Furthermore, the pigeon scenes, like the *Meninas* paintings are also variations on a theme, though in these paintings the "frame" remains fixed on the scene as a whole, while Picasso responds creatively to the natural changes imposed on his living tableau by different weather conditions and times of day.

Yet Picasso's preoccupation with the Velázquez is such that even in these scenes from life, aspects of *Las Meninas* are overlaid in a light-hearted way. There is an echo of the squared-off back of Velázquez's huge canvas here in the large upright pigeon-cote at the far left. The pigeons align themselves along the floor of the balcony in something of a parody of the infanta and her group, while in several of the paintings a solitary black pigeon (in a flock of white) perches on the top of the swung-open gate of the pigeon cote in a witty reference to the *aposentador* (Nos. 19–22).

There are deeper connections as well. Mary Mathews Gedo was the first to point out the link between Picasso's father and the pigeon paintings.[52] Don José specialized in "fur-and-feather" paintings, with pigeons being his favorite

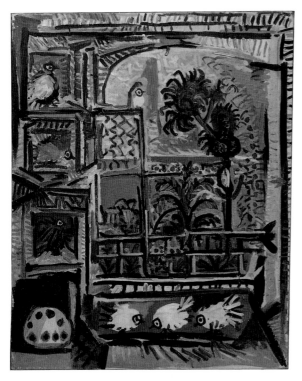

115 (above left) Pablo Picasso, *The Pigeons (Los Pichones)* 24, 12–14 September 1957 I. Oil on canvas, 100 × 80 cm. Barcelona, Museu Picasso.

116 (above right) Henri Matisse, *Interior with Egyptian Curtain*, 1948. Oil on canvas, 116 × 89 cm. Washington D.C., The Phillips Collection.

subject. As a child, Picasso helped him paint in the legs of the birds. Gedo saw the *Meninas* series as a means by which Picasso reunited with his father.[53] It is notable that Picasso moved directly to the pigeon paintings on the day that he painted the last infanta with its possible evocation of his dead sister. The pigeons point to another lost relationship as well, though a more recent one. Pigeons and doves are also a subject of Matisse; he not only painted them but raised them and gave some to Picasso. Furthermore, the window scene is a classic Matisse subject dating back to the early years of the century (fig. 114).[54] Picasso's first window scenes of the twenties pay homage to those of his rival. Some of the pigeon paintings evoke works by Matisse: No. 24, for example, is reminiscent of Matisse's *Egyptian Curtain* of 1948 (figs. 115, 116). Matisse, furthermore, admired Velázquez profoundly, and his studio paintings undoubtedly acknowledge the quintessential work on this theme. Having taking up residence in Velázquez's studio, Picasso discovered his old rival's presence there, as well as his father's.

VARIATION NO. 27, 14 SEPTEMBER 1957

Like communicating vessels, one series pours back into the other. On the same day that he completed the most ornate of the pigeon paintings, Picasso picked

up where he left off in the *Meninas* suite—with a portrait of the infanta. She is full length, and the vivid Mediterranean colors from his window scenes flood over her as she once again reaches for her *búcaro* from the disembodied hands of María Agustina. The figure's head is large in relation to the body—the dwarf/infanta combination lingers on. With this painting, a synthesis of aspects of several previous versions of her, Picasso retires her from the series.

2

VARIATIONS NOS. 28–30, 15–16 SEPTEMBER 1957

This view of Velázquez's canvas as a whole begins the second part of the series with a change of direction (fig. 117). Over the next two weeks, Picasso would paint six large canvases, measuring $50^3/_4 \times 63^3/_8$ in. (some vertical and some horizontal) on the *Meninas* ensemble, though not all the characters are present in each one. Picasso's interest in the central character, the infanta—so potent that she pulled others into herself—gives way to an interest in the nature of Velázquez's mysterious, atmospheric space.

Picasso's new attack begins with a change of format: he turns his sizable canvas in the horizontal direction for the first time since the initial painting, allowing the space to circulate freely. Regathering the full cast of characters, with the conspicuous absence of Velázquez himself, Picasso takes to the extreme the painterliness of his predecessor's atmospheric space in the most schematic work to date. Figures and architectural elements are reduced to outlines which float weightlessly in a silvery-green space. Matisse's entry through the pigeon pictures now seems prophetic. The nearly monochromatic color scheme, sense of compressed interior space, and the schematic treatment of solid forms recall Matisse's revolutionary studios of 1910–20. The rivalry appears to have shifted for the moment from his predecessor to his contemporary, or perhaps Picasso has called on his friend for reinforcements in his battle with Velázquez. With this painting, Picasso's dialogue with Velázquez widens from the issue of the representation of form to that of the artist's studio as the locus of creation.

It is not only the reverberations of Matisse's studios that are evoked, but of earlier, highly conceptual works by Picasso himself on the theme, such as *The Studio* of 1927–28 in the Museum of Modern Art (perhaps based on *Las Meninas*, fig. 118), of which this variation may be seen as a late pastiche.[55] Though painted in a Synthetic Cubist style in flat, opaque planes, it shares with this work a spare linearity and ambiguity of signifiers. Lydia Gasman has described *The Studio* as central to Picasso's conception of painting as a magical object in which he creates an "almost-confusion" between art and life through numerous formal analogies.[56] The artist, for example, can be read as both a figure in front of his canvas in the act of painting it, or as the image on the canvas; the canvas

117 Pablo Picasso, *Las Meninas, after Velázquez* 28 (partial view), 17 September 1957. Oil on canvas, 129 × 161 cm. Barcelona, Museu Picasso.

118 Pablo Picasso, *The Studio*, winter 1927–28. 149.9 × 231.2 cm. New York, The Museum of Modern Art. Gift of Walter P. Chrysler, Jr.

also can be seen as a radiant door, etc. A similar play of levels of reality takes place here which draws on Velázquez's own ingenious weaving together of truth and artifice. The vacant mirror floats forward, like an abstract painting or—in fifties' terms—a television set; it is linked with the red door which also can be seen as a canvas on which Nieto is painting; Nieto is framed by the open door, but also can be seen as an enlarged keyhole in a closed white door; and the windows to the right both puncture the wall, and can be read as geometric paintings hung on it.

A new geometric, cartoon-like figural style appears in this painting. Heads expand into an enormous triangle (María Agustina's), or shrink to a small empty disk on a large body (the infanta's), or wave like a flag on a pole (Isabel de Velasco's). As willfully bizarre as Picasso's figures appear, they have, in fact, been created through careful observation of the models, by extending lines from the figures to enclose the space between them. Writing of the *Meninas* variations just after they were painted, Roland Penrose recalled Charles Baudelaire's characterization of Spanish humor as "well-endowed with the comic . . . They are quick to arrive at the cruel stage and their grotesque features usually contain a somber element."[57] As Picasso paints, the elements of humor, irreverence, and shock increase, as he continues to reinvent his theme, attempting to keep it alive.

VARIATIONS NOS. 31–32, 15–16 SEPTEMBER 1957

In No. 31, the full cast is now submerged into a colorful web of lines and planes in a decorative Cubist idiom that resembles stained glass (fig. 119). Picasso returns here, for the first time since his initial painting, to Velázquez's canvas as a whole. In this painting and the following three canvases, Picasso mirrors—in his refracted Cubist idiom—Velázquez's own act of mirroring his world, and reaches the peak of intensity of his dialogue with his fellow countryman. Here space is primary and the figures conform to it, in opposition to the first work in the series in which the characters dominated their environment. From the multi-aspect figures that absorbed his attention throughout the first part of the series, Picasso now concentrates on translating Velázquez's chamber of vision, criss-crossed by lines of sight, into a "simultaneous space," a transition from figure to figure and ground, which also occurred in Picasso's previous series of variations after Delacroix's *Women of Algiers*.[58] Velázquez's painterly illusionism and Picasso's abstract geometric vocabulary are successfully integrated as overlay and underlay. A temporary harmony between artistic idioms and eras has been reached.

In the following work (No. 32, fig. 120), executed the next day, Picasso recast the group in a flat Synthetic Cubist style. With its figures painted in bright, primary colors and set against a black ground, the painting recalls his masterpiece of 1921, *Three Musicians* (fig. 121) and, more generally, his work as a set designer for the Ballets Russes during that period. (The stage-like space of *Three*

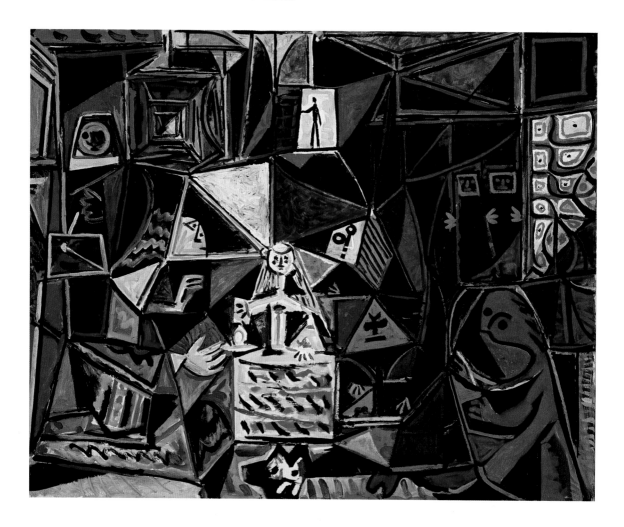

119 Pablo Picasso, *Las Meninas, after Velázquez* 31 (full view), 18 September 1957. Oil on canvas, 129 × 161 cm. Barcelona, Museu Picasso.

Musicians, its dark background, the frontal arrangement of figures, and the large shepherd dog lying down, suggest a somewhat remote connection to *Las Meninas* as well.)

VARIATIONS NO. 33, 2 OCTOBER 1957

In the third of a series of paintings based on the image as a whole (fig. 122), harmony is again disrupted. A lively biomorphic Cubism replaces the geometric order of Nos. 31 and 32. The welter of small, swelling shapes and bending lines pull into depth as if by magnetic force, while the palette of shrill, primary colors and overall surface patterning contribute further to an almost unbearable sense of claustrophobia. Here Picasso seems to give poignant expression to his sense of entrapment in Velázquez's irrational space; yet at the center of the canvas, the doorman/painter enclosed in a rectangle of radiant yellow (a confla-

148

120 Pablo Picasso, *Las Meninas, after Velázquez* 32 (full view), 19 September 1957. Oil on canvas, 161 × 129 cm. Barcelona, Museu Picasso.

121 Pablo Picasso, *Three Musicians*, 1921. Oil on canvas, 200.7 × 222.9 cm. New York, The Museum of Modern Art. Mrs. Simon Guggenheim Fund.

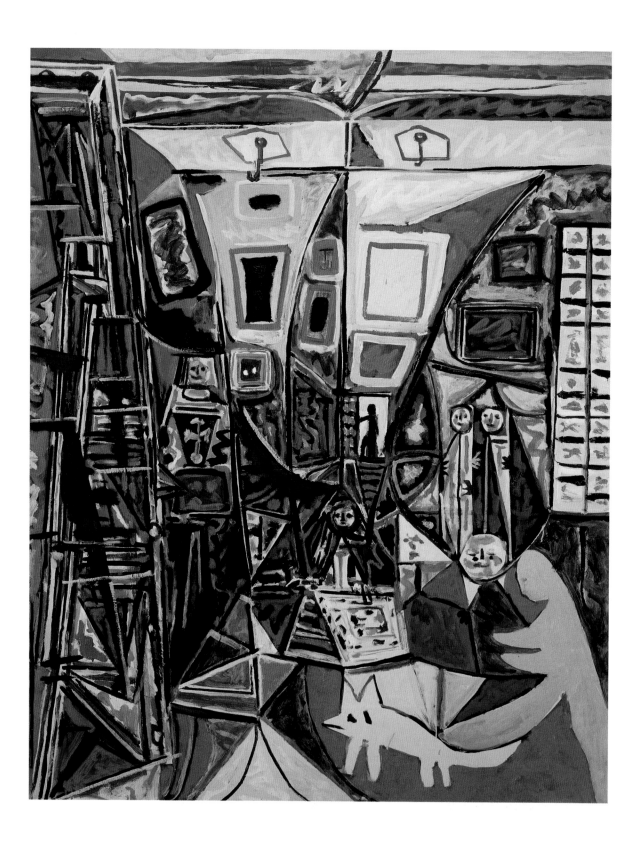

tion perhaps of the door and mirror) remains undisturbed in his duties—a symbol of endurance.

VARIATION NO. 34, 9 OCTOBER 1957

In the next painting (fig. 123), Picasso turned back to the more stable horizontal axis; the vibrating colors and converging lines and shapes are banished. In a reprise of No. 32, he returns to somber tones of brown and black for the background, which sets off the child-like figures of the infanta and her retinue in bright, primary colors. A relative sense of stability and depth returns which parodies the old master's own spatial play. The figure of Velázquez re-emerges for the first time since the initial work in the series, now shrouded in a black costume resembling that of a monk or domino. *Three Musicians* is evoked again in the spare geometric style and coloration of the painting. With the re-instatement of Velázquez in the studio, the door at the back guarded by the shadowy figure of the *aposentador* opens up into a vortex-like tunnel, and out through the passageway the diminutive guard/painter disappears.

With this canvas, Picasso broke his self-imposed solitude of the previous six weeks, and invited some friends to see the ensemble. This painting marks the end of the most intensive part of Picasso's dialogue with Velázquez. The series would continue, but the focus of his endeavor diminishes.

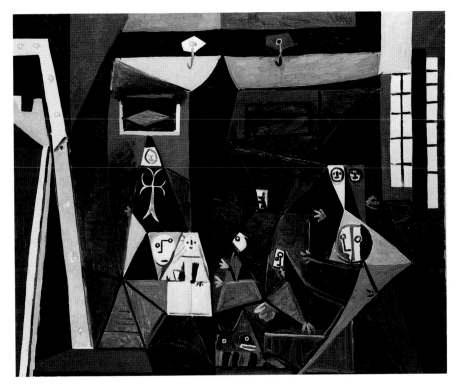

123 Pablo Picasso, *Las Meninas, after Velázquez* 34 (full view), 3 October 1957. Oil on canvas, 129 × 161 cm. Barcelona, Museu Picasso.

122 (facing page) Pablo Picasso, *Las Meninas, after Velázquez* 33 (full view), 2 October 1957. Oil on canvas, 161 × 129 cm. Barcelona, Museu Picasso.

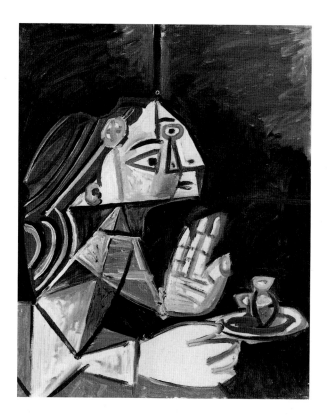

124 Pablo Picasso, *Las Meninas, after Velázquez 36* (María Agustina), 9 October 1957. Oil on canvas, 65 × 54 cm. Barcelona, Museu Picasso.

Coda

VARIATIONS NOS. 35–58, 9 OCTOBER–30 DECEMBER 1957

In the subsequent twenty-four works, many of which are small in scale, Picasso returns to studies of individual figures and small groups, concentrating now on the handmaidens and dwarfs. Executed in series of three or four paintings, with increasingly long intervals between them, these sets of paintings become more schematic toward the end, until they merely fade away.

Some of these later works can be seen as reprises of earlier canvases in the series. In No. 36 (fig. 124), and the next three paintings, for example, Picasso returns to María Agustina, the infanta's rival for his attention at the outset of the suite. The offering of the *búcaro*, which was touched on in several of the earlier studies, is more fully developed in later paintings. In No. 37, the scene evolves into a kind of comic annunciation.

The element of the bizarre erupts into the surreal in No. 40, *The Piano* (fig. 125). In the series as a whole *The Piano* stands out for its degree of departure from the theme, becoming an almost independent painting; it exemplifies in more exaggerated form, however, Picasso's working method throughout the suite, as his comments about it to Roland Penrose reveal:

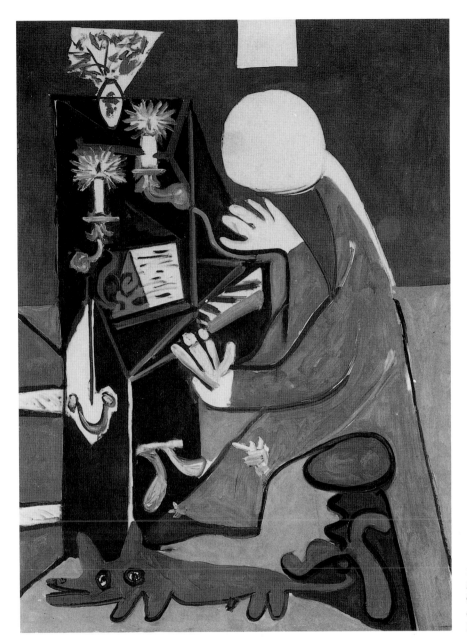

125 Pablo Picasso, *The Piano* (*El Piano*) 40, 17 October 1957. Oil on canvas, 130 × 96 cm. Barcelona, Museu Picasso.

I saw the little boy with a piano. The piano came into my head and I had to put it somewhere. For me he was hanged, so I made him hang. Such images come to me and I put them in. They are a part of the reality of the subject. The Surrealists in a way were right. Reality is more than the thing itself. Reality lies in how you see things. A parrot is also a green salad and a parrot. He who makes it only a parrot diminishes its reality. A painter who copies a

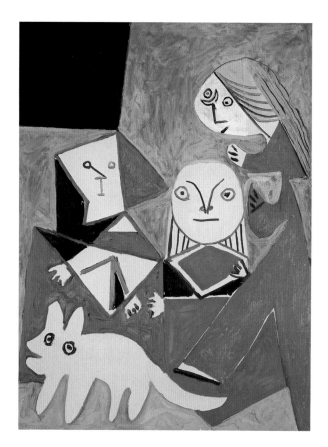

126 Pablo Picasso, *Las Meninas, after Velázquez* 44 (three figures and a dog). 24 October 1957. Oil on canvas. 130 × 96 cm. Barcelona, Museu Picasso.

tree blinds himself to the real tree. I see things otherwise. Don Quixote can come into *Las Meninas*.[59]

The Piano is followed by a bust-length portrait of Nicolás Pertusato (No. 41) and six large paintings in a vertical format, all of the same dimensions, executed over a three week period (Nos. 42–45). In these paintings, Picasso focuses on the group to the right of Velázquez's painting: Isabel de Velasco, Maribárbola, and Nicolás Pertusato, as well as the dog, executed in bright primary colors in a style of child-like simplicity (No. 44, fig. 126). *Three Musicians* lingers as a reference. Picasso's repetitions of groupings of children recall the fact that the earliest title for Velázquez's painting was *The Family Picture*. They may also be wishful recreations of his own fractured family, with his children by Françoise Gilot— Claude and Paloma—then aged ten and eight, accompanied by, perhaps, Jacqueline's adolescent daughter Cathy, in the role of the *meninas* and dwarves. In No. 47 (fig. 127), the last large canvas of the series, painted on a flat red ground, the two *meninas*, the Infanta, Nicolás, and the dog are joined by an enlarged Nieto in his rectangular doorway, his arm uplifted like Velázquez in his self-portrait. The "painter" goes on working with his family gathered around

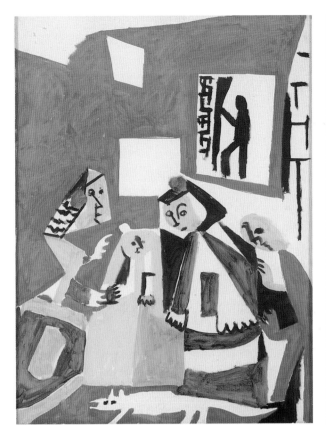

him in his studio. The rectangle of light of the doorway also can be seen as the mirror at the back of Velázquez's studio in which Picasso casts his own reflection as a symbol of possession. The painting also evokes Matisse's *Large Red Interior* of 1948 (fig. 128). In the final sizable painting of his series, one of the most radical in its deconstruction of the apparatus of illusionism, Picasso places himself in a continuum that links the rich heritage of his Spanish past with the modern French tradition, within a theme shared by all three—the artist's studio.

The series comes to a close in December with small, delicately painted canvases depicting the *meninas*, individually or with a dwarf, in a style that recalls the energetic brushwork of Goya. As Picasso's interest in Velázquez's painting fades, the world outside his studio once again intrudes: three small painterly views of his garden seen from his studio window were rapidly executed on 3 December (Nos. 54–56), and they were followed by a portrait of Jacqueline in a painted frame (No. 57, fig. 129), Picasso's actual companion in the studio and witness to the unfolding project. In the final canvas (No. 58, fig. 130), no larger than a postcard, painted on 30 December in delicate brushstrokes and somber tones of brown and green, the infanta/*menina* figure returns to take a bow as the year ends. Through this diminutive figure, one of the most enduring

127 (above left) Pablo Picasso, *Las Meninas, after Velázquez* 47 (partial view), 15 November 1957. Oil on canvas, 130 × 96 cm. Barcelona, Museu Picasso.

128 (above right) Henri Matisse, *Large Red Interior*, 1948. Oil on canvas, 146 × 97 cm. Paris, Musée National d'Art Moderne, Centre Georges Pompidou.

129 Pablo Picasso,
Portrait of Jacqueline 57, 3
December 1957. Oil on
canvas, 115 × 89 cm.
Barcelona, Museu Picasso.

characters in the history of art, Picasso reaches back through Goya to Velázquez,
inscribing himself in the chain of great Spanish masters, and, metaphorically,
travels home.

* * *

Picasso's journey in *Las Meninas* relies on an essential quality of Velázquez's
work, its instability. The painting's open-ended scenario, shifting perspectives,

130 Pablo Picasso, *Las Meninas, after Velázquez* 58 (infanta/Isabel), 30 December 1957. 33 × 24 cm. Barcelona, Museu Picasso.

and ambiguity provide fertile ground for Picasso's transformation of the theme along new structural and narrative lines. The *modus operandi* that Picasso uses in his attack is to surround his model on all sides, submitting it to a multivalent Cubist analysis. Multiplicity replaces unity, and Picasso takes his predecessor's critique of the classical system of representation and his plurality of meaning one step further. Throughout the series, he exploits the "chemical reaction" between his own art and tradition to explore his own unconscious and the mystery of the creative process.

Velázquez's naturalism encompasses a range of styles, from the finely rendered face of the infanta to the veiled features of Maribárbola, to the almost abstract image of the king and queen in the mirror, and the ghostly presence of the paintings on the back wall; these different representational approaches are reconciled, however, in a unified whole through his loose brushstroke and the atmospheric space that envelops them. While Velázquez's varied modes challenge stylistic unity, Picasso embraces discontinuity. The series consists of abrupt transitions of style from one set of paintings to another: painterly Analytic Cubism, Expressionism, Surrealism, decorative and Synthetic Cubism, and a mode of child-like simplicity, united only by their common origin in Picasso, constituting something of an anthology of his idioms. Each of these modes takes Picasso deeper into his journey, though not necessarily in a progressive fashion.

Velázquez takes liberties with the unity of time and space by bending the rules of linear perspective. What Velázquez condensed into an instantaneous scene, however, Picasso opens up into a series of separate moments or impulses. In Velázquez, pictorial and physical space are brought into sharp juxtaposition through the relationship of the painted figures and those implied in front of the painting. Picasso's series extends into real space and time, creating an environment which physically surrounds the viewer.

Velázquez defies the principle of narrative unity by leaving gaps in the logic of his story that invite multiple interpretations. Picasso disrupts narrative itself. Within the series there are peaks and lulls, but the paintings do not build to a climax or a definitive statement. They are, rather, a record of the path of his explorations as he shifts his attention from the whole to the parts and back to the whole again. The paintings simply come to an end as he exhausts his interest.

Picasso also exploits the tension between fact and allegory in his theme. In *Las Meninas* Velázquez literally depicts his workroom and the figures themselves. The painter, however, subverts the convention of group portraiture through carefully calculated relationships among the depicted figures on the canvas, the implied royal figures, and the viewer, to express private meaning—perhaps, as Jonathan Brown has proposed, to comment on his personal status at court and the nobility of his art, although many other interpretations have been offered.[60] After all, the painting is, among other things, a self-portrait of Velázquez in his world. Picasso likewise bends the subject to express meaning of his own; the variations are also a portrait of himself as an artist in the very act of creation. The essential link between the two works is the studio. In *Las Meninas*, the artist's studio is not simply a neutral backdrop to the action, but central to the meaning of the work as a whole, for it is on his own ground that Velázquez demonstrates art's triumph over reality, and his privileged relation to his monarch. A studio is also a container not only of each artist's individual output but of the flow of the history of art. Velázquez himself alludes to this through the inclusion of dimly lit paintings by other artists on the back wall of his studio. Palomino identified these paintings as a series of copies by Juan del Mazo after some of

Rubens's pictures for the Torre de la Parada which represent subjects from Ovid's *Metamorphoses*,[61] a theme which underscores the notion of continuous transformation at play within *Las Meninas* itself. Earlier in his career, Picasso had illustrated scenes from the *Metamorphoses* in a suite of etchings in 1930.[62] The *Meninas* series, however, is itself a form of metamorphosis through which a work of art becomes, in Picasso's words "something else entirely."[63] The notion of continuous change throughout the creative process, linking the activity of the artist with that of the viewer, and the past with the present, was at the very heart of Picasso's aesthetics, as he made clear in a conversation with Christian Zervos in 1935:

> A picture is not settled beforehand. While it is being done it changes as one's thoughts change. And when it is finished, it goes on changing according to the state of mind of whoever is looking at it. A picture lives a life like a living creature, undergoing the changes imposed on us by our life from day to day. This is natural enough, as the picture lives only through the man who is looking at it.[64]

Through his suites of variations, Picasso capitalizes on his conviction that in art the only "truth" is the spectator's fluid, subjective responses.

Picasso draws on the theatricality of Velázquez's painting as well. The frozen poses of the figures, their outward orientation to an "audience," the deep receding, stage-like space that faces the viewer frontally, the make-shift "props," and dramatic spotlighting all contribute to a strong sense that we are witnessing a moment from a play. Picasso inserts himself into the gap between arrested and potential motion and sets the "play" in motion again in suites of improvisations. Some of the *Meninas* variations suggest painted decor or costume studies and recall his involvement with the theater in the late teens and 1920s, an experience to which he alludes in a number of references. Picasso converts his studio into a metaphorical stage on which he enacts the drama of his creative response to the masterpiece, with the variations themselves forming both the substance of the interchange and the backdrop to his ongoing performance (his own version of "action painting"). In his extended series of variations of his late years, Picasso's involvement with the theater is revived in new form. Here, as in his work for the stage, he continues to expand boundaries of art beyond the limits of the individual canvas, while observer becomes creator, process becomes product, past becomes present, and the self an other.

It is in the paradoxical locus of the artist's studio—part workshop, part theater, and part metaphor for the space of imagination and creativity—that Picasso realizes most profoundly his connection and competition with his predecessor. In confronting the quintessential masterpiece on the theme of the artist at work, Picasso's own most important subject, he opens up the archive of his art, and re-examines the nature of artistic representation, and the forces of the historical past, his own personal past, and the creative process itself, which act upon it. The *Meninas* series as a whole may be seen as the content of an

SUSAN GRACE GALASSI

Ur-studio which embraces Picasso's entire artistic endeavor, merging past and present into simultaneity.

Las Meninas is Velázquez's *summa*, painted at the height of his career. Through it Velázquez expressed his confidence in his conquest of reality, and ability to surpass it, and staked his claim to immortality. Picasso's variations, however, are rooted in loss. An essential aspect of the meaning of the series lies in the form itself: through variation Picasso frankly acknowledges the modern artist's loss of belief in the power of painting to fully represent the world and ability to speak in an individual voice, and mourns the passing of his own period of producing masterpieces. The serial form of the *Meninas* variations, in which each work supersedes the next, posits an absence of certainties. Picasso's repetitions of other artists' paintings are the painted analogue to his remarks to a friend on the nature of truth in art: "What truth? Truth cannot exist. If I pursue a truth on my canvas, I can paint a hundred canvases with this same truth. Which one, then, is the truth? And what is the truth—the thing that acts as my model, or what I am painting? No, it's like everything else. Truth does not exist."[65]

It is in keeping with the nature of Picasso's artistic enterprise, however, that he made use of this "second-hand" art form to revitalize his art and himself. The detachment of variation offered a perspective through which he could renew his longstanding themes through an historical lens and inscribe himself in tradition. Variation also afforded Picasso the opportunity to reassert his commitment to subject matter at a time when abstraction ruled, while remaining true to his Cubist frames of reference. Furthermore, the exploration of great monuments known over a lifetime allowed Picasso to revisit significant figures and experiences and, in the most important of his themes, *Las Meninas*, to re-immerse himself in his Spanish past, both immediate and historical. In the *Meninas* suite, his children Paloma and Claude, his dead sister and father, and his experience as a designer for the Ballets Russes, and perhaps Olga, and several of his own culminating works—the *Demoiselles d'Avignon*, *Three Musicians* and *Guernica* (all of which suggest some connection with *Las Meninas* and thus its power over him as the very "model" of the masterpiece) surface as allusions. He also carries on his competition with his most serious contemporary rivals—the recently deceased Matisse, whose work he "continues," and perhaps with the still-living Georges Braque, whose series of important late works on the theme of the studio between the years 1948 and 1956 undoubtedly was a goad to Picasso's competitive spirit.[66] Members of his immediate household, Jacqueline and perhaps her daughter Cathy, as well as his dog, Lump, may be reflected as well. Picasso himself presides over it all, the blank figure suspended in the door/mirror, guardian of the gate hovering between two spatial realms and historical periods, and perhaps between life and death—who goes on painting.

As he entered old age, variation became Picasso's primary weapon in confronting and resisting the encroachment of the past, even as he attempted to situate himself in the historical continuum in which he wished his life's work to be viewed by successive generations. Yet, in submitting himself at last to the *ne*

160

plus ultra of painting, Picasso could not escape the fact that Velázquez had already anticipated his own penchant for destabilizing the old certainties. Not only had many of the ideas that Picasso explored over the course of his career already been taken up by his predecessor, but his very presence in front of Velázquez's masterpiece and his participation in its enigmatic scenario were written into the script some three hundred years earlier. Velázquez, like Picasso himself, knew only too well that the artist does not "find himself alone in the world," and he deliberately left his studio door ajar, inviting future generations to challenge his authorial role, and thus keep his art alive. Picasso could only take up his assigned place and hold up his multi-faceted mirror to Velázquez's world. Yet even in that act of mirroring, he was anticipated.

Notes

1 Picasso and the Spanish Tradition of Painting

1 For the sake of convenience, "Spain" is used here instead of the more historically accurate "Castile."

2 The data on Picasso's biography are drawn from John Richardson (with the collaboration of Marilyn McCully), *A Life of Picasso,* vol. 1, *1881–1906* (New York: Random House, 1991). For the 1895 visit to the Prado, see p. 57.

3 For detailed accounts of Picasso's activities in Madrid in 1897–98 and 1901, see Javier Herrera, "Tradición y modernidad: ideas estéticas y artísticas del joven Picasso," *Anuario del Departamento de Historia y Teoría del Arte de la Universidad Autónoma de Madrid* 5 (1993), pp. 98–107, and "El joven Picasso en el Museo del Prado," *Boletín del Museo del Prado,* no. 33 (1994), pp. 59–70.

4 Richardson, *op. cit.,* p. 95. On 19 October 1897, Picasso registered as a copyist at the Prado, with the expressed intention of copying works by Velázquez. See Alfonso E. Pérez Sánchez, "Picasso y la pintura 'antigua,'" *De pintura y pintores: La configuración de los modelos visuales en la pintura española* (Madrid: Alianza Editorial, 1993), p. 162. Herrera, "El joven Picasso," marshals the evidence for Picasso's working sessions at the Prado.

5 Manuel B. Cossío, *El Greco* (Madrid: Suárez, 1908). For the reception history of El Greco in the nineteenth century, see José Álvarez Lopera, *De Ceán a Cossío: La fortuna crítica del Greco en el siglo XIX,* vol. 11, *El Greco: Textos, documentos y bibliografía* (Madrid: Fundación Literaria Española, 1987).

6 Salvador Viniegra, *Museo Nacional de Pintura y Escultura: Catálogo ilustrado de la exposición de las obras de Domenico Theotocopuli, llamado El Greco* (Madrid: Museo del Prado, 1902).

7 For Picasso's visits to Toledo in 1897–98, and again in 1901, see Richardson, *op. cit.,* pp. 93 and 178.

8 For these events, see Santiago Alcolea Blanch, *The Prado* (New York: Harry N. Abrams, Inc., 1991), pp. 72–73.

9 For the critical fortune of Goya, see Nigel Glendinning, *Goya and His Critics* (New Haven and London: Yale University Press, 1977). The relationship of Picasso to Goya during the stays in Madrid is outlined by María Teresa Ocaña, "1897–98. La période goyesque—Madrid," in *Picasso: Toros y toreros* (Paris: Réunion des Musées Nationaux, 1993), p. 92, and Herrera, "El joven Picasso," pp. 66–68.

10 Richardson, *op. cit.,* p. 191.

11 *Ibid.,* p. 497 n. 14.

12 *Ibid.,* p. 75.

13 *Ibid.,* p. 430.

14 There is still no comprehensive study of Berruguete's life and career.

15 For Picasso's engagement with the myth and art of El Greco, see John Richardson, "Picasso's Apocalyptic Whorehouse," *New York Review of Books* 34, no. 7 (23 April 1987), pp. 40–47, and Pérez Sánchez, *op. cit.,* pp. 159–64.

16 Fernando Marías and Agustín Bustamante, *Las ideas artísticas de El Greco (Comentarios a un texto inédito)* (Madrid: Cátedra, 1981), and *El Greco y el arte de su tiempo: Las notas de El Greco a Vasari* (with studies by Xavier de Salas and Fernando Marías) (Madrid: Real Fundación de Toledo, 1992).

17 Richard G. Mann, *El Greco and His Patrons: Three Major Projects* (Cambridge: Cambridge University Press, 1986), pp. 1–45.

18 Sarah Schroth, "Burial of the Count of Orgaz," in *Figures of Thought: El Greco as Interpreter of History, Tradition and Ideas,* Studies in the History of Art 11 (1982), pp. 1–17.

19 Jonathan Brown and Richard L. Kagan, "View of Toledo," in *Figures of Thought,* pp. 19–30.

20 Letter from Manet to Fantin-Latour, Madrid, 3 September 1865; see Juliet Wilson-Bareau, ed., *Edouard Manet: Voyage en Espagne* (Caen: Echoppe, 1988), p. 44.

21 For a critique of several interpretations, see Jonathan Brown, *Velázquez: Painter and Courtier* (New Haven and London: Yale University Press, 1986), p. 303 nn. 43, 57, 58, 62. The definitive analysis of the perspective is by Martin Kemp, *The Science of Art: Optical Themes in Western Art from Brunelleschi to Seurat* (New Haven and London: Yale University Press, 1990), pp. 104–08. A small but telling point is made by Thomas L. Glen, "Should Sleeping Dogs Lie? Once Again, *Las Meninas* and the Mise-en-scène," *Source: Notes in the History of Art* 12, no. 3 (1993), pp. 30–36.

22 See Brown, *Velázquez,* pp. 252–53, and Jan B. Bedaux, "Velázquez' *Fable of Arachne (Las Hilanderas)*: A Continuing Story," *Simiolus* 21 (1992), pp. 296–305.

23 Jonathan Brown, *Images and Ideas in Seventeenth-Century Spanish Painting* (Princeton, N.J.: Princeton University Press, 1978), pp. 70–71.

24 Jeannine Baticle, *Goya* (Paris: Fayard, 1992), p. 282.

25 Translation by Enriqueta Harris, *Goya* (London: Phaidon, 1969), pp. 28–29. For a recent discussion of this crucial document, see Andrés Úbeda de los Cobos, "De Antón Rafael Mengs a Francisco de Goya," in *Renovación, Crisis, Continuismo: La Real Academia de San Fernando en 1792* (Madrid: Real Academia de San Fernando, 1992), pp. 57–81.

26 Reva Wolf, *Goya and the Satirical Print in England and on the Continent, 1730–1850* (Boston: David R. Godine, 1991).

27 Ilse Hempel Lipschutz, *Spanish Painting and the French Romantics* (Cambridge, Mass.: Harvard University Press, 1972).

28 Jeannine Baticle and Cristina Marinas, *La Galerie Espagnole de Louis-Philippe au Louvre, 1838–1848* (Paris: Réunion des Musées Nationaux, 1981).

29 Cited by Lipschutz, *op. cit.*, 137. The anonymous author published the comment in the *Journal de Artistes* 11 (1873), pp. 39–40.

30 Richardson, "The Apocalyptic Whorehouse."

31 For instance, see Kenneth E. Silver, *Esprit de Corps: The Art of the Parisian Avant-Garde and the First World War, 1914–1925* (Princeton, N.J.: Princeton University Press, 1989), pp. 315–21.

2 Narrating the Nation: Picasso and the Myth of El Greco

I am grateful to Robert Wohl, Linda Nochlin, Marilyn McCully, Irving Lavin, William Rubin, Judith Cousins, Leslie Jones, and especially Patricia G. Berman for their astute criticisms of this text. Unless otherwise indicated, all translations from the Catalan, Castilian, and French are my own.

1 Picasso to Gertrude and Leo Stein, undated letter, summer 1909 (Stein archive, Beinecke Rare Book and Manuscript Library, Yale University); as cited by Judith Cousins, "Documentary Chronology," in William Rubin, *Picasso and Braque: Pioneering Cubism* (New York: The Museum of Modern Art, 1989), p. 361. Excerpts from the letter first appeared in Marilyn McCully, ed., *A Picasso Anthology: Documents, Criticism, Reminiscences* (Princeton, N.J.: Princeton University Press, 1982), pp. 64–65. In the letter Picasso describes the countryside as "splendid," clearly indicating that he had arrived in Horta. In a letter to Alice Toklas dated 15 June (Cousins, *op. cit.*, p. 361), Fernande writes: "We have been here ten days already."

2 No explanation is given in the correspondence from Horta. However, in late July–early August, Fernande informed the Steins of her continuing ill health: "I've been in Spain for two months, and have not yet had an entire day to rest. . . . I most certainly would be better off in Paris, where I could receive treatment." It is likely that Fernande's weak physical state precluded a trip to Madrid.

3 For a discussion, see John Richardson (with the collaboration of Marilyn McCully), *A Life of Picasso*, vol. 1, *1881–1906* (New York: Random House, 1991), pp. 57, 89–97, and 177–89. Additionally, Rolf Laessoe has speculated that Picasso traveled to Madrid once again in 1902 to visit an important El Greco exhibition. William Rubin, following up on Laessoe's suggestion, sees this trip as probable, although he notes the lack of concrete evidence to confirm this assertion. Rolf Laessoe, "A Source in El Greco for Picasso's *Les Demoiselles d'Avignon*," *Gazette des Beaux-Arts* 110, no. 1425 (October 1987), pp. 131–36; cited by William Rubin, "The Genesis of *Les Demoiselles d'Avignon*," in *Les Demoiselles d'Avignon*, Studies in Modern Art 3 (New York: The Museum of Modern Art, 1994), p. 139ff.

4 Museu Picasso, Barcelona, no. 110.678. Reproduced in *Museu Picasso: Catàleg de pintura i dibuix* (Barcelona: Ajuntament de Barcelona, 1984), p. 463. Other El Greco style heads, all dated ca. 1899, are inventoried and reproduced as follows in the catalog of the Museu Picasso, Barcelona: 110.034, p. 438; 110.316R, p. 444; 110.370, p. 449; 110.571, p. 454; 110.641, p. 460; 110.671, p. 462; 110.671R, p. 463; 110.729, p. 471; 110.435R, p. 520. Sketch 110.675, p. 534, is dated ca. 1899–1900 in the catalog.

5 Rolf Laessoe, *op. cit.*, and John Richardson, "Picasso's Apocalyptic Whorehouse," *New York Review of Books* 34, no. 7 (23 April 1987), pp. 40–47.

6 Ron Johnson, "Picasso's *Demoiselles d'Avignon* and the Theatre of the Absurd," *Arts Magazine* 55, no. 2 (October 1980), pp. 102–13. In 1973, well in advance of Johnson's, Lassoe's, and Richardson's arguments, Santiago Amón had proposed El Greco's *Apocalyptic Vision* as a source for the *Demoiselles*, noting many of the same shared formal structures between the two paintings. Santiago Amón, *Picasso* (Madrid: Editorial Cuadernos para el Diálogo, 1973), pp. 44–54. Rubin, "The Genesis of *Les Demoiselles*," pp. 138ff, discusses Amón's observations in depth, noting as well that the comparison between the *Demoiselles* and the *Apocalyptic Vision* seems first to have been made by Gustav René Hocke, *Die Welt als Labyrinth: Manier und Manie in der Gegenwart* (Hamburg: Rowolt Taschenbuch Verlag, 1968), p. 35; and subsequently by Tom Prideaux, "The Terrible Ladies of Avignon," *Life* 65, no. 26 (27 December 1968), p. 52.

7 For more on the spatial compression of Picasso's visual field, and on the unusual format of the *Demoiselles* in relation to the Greco, see Rubin, "The Genesis of *Les Demoiselles*, pp. 98–101, and notes.

8 Although both Richardson and Laessoe assert that El Greco's *Apocalyptic Vision* was in Zuloaga's Paris studio at this time, Rubin (*ibid.*, pp. 139ff) casts a shadow of doubt concerning the precise whereabouts of the painting. For a full discussion, see the entry for 14 June 1907 in the chronology by Judith Cousins and Hélène Seckel, in *ibid.*, pp. 151–52.

9 Laessoe based his reading on Leo Steinberg's ground-breaking interpretation of the *Les Demoiselles d'Avignon* (Leo Steinberg, "The Philosophical Brothel," *Art News* 71, no. 5 [September 1972], pp. 22–29 [part 1]; and *Art News* 71, no. 6 [October 1972], pp. 38–47 [part 2]). Taking exception with Steinberg's interpretation of the painting as a "trauma of sexual encounter," Rubin has preferred to read the *Demoiselles* in relation to a single "embracing idea," focusing on the artist's fear of death and disease and on Picasso's "darkening insights into the nature of feminity." Rubin first advanced his position in "From Narrative to 'Iconic' in Picasso: The Buried Allegory in *Bread and Fruitdish on a Table* and the Role of *Les Demoiselles d'Avignon*," *Art Bulletin* 65, no. 4 (December 1983), pp. 615–49. The argument is reprised and expanded in "The Genesis of *Les Demoiselles*."

10 Richardson, "Picasso's Apocalyptic Whorehouse," p. 40. The source for Picasso's quote is Romauld Dor de la Souchère, *Picasso in Antibes* (New York: Pantheon Books, 1960), p. 14. The full text reads: "It has been said that *Les Demoiselles d'Avignon* was the first picture to bear the mark of Cubism; it is true. You will recall the affair in which I was involved when Apollinaire stole some statuettes from the Louvre? They were Iberian statuettes.... Well, if you look at the ears of *Les Demoiselles d'Avignon*, you will recognise the ears of those pieces of sculpture! Furthermore it is the realisation that counts. From this point of view it is true that Cubism is Spanish in origin and that it was I who invented Cubism. . . ." It should be noted, however, that Picasso's text is a second-party quotation, recounted by Dor de la Souchère, who undoubtedly embellished Picasso's language.

11 Salmon admitted El Greco into a genealogy of Cubism that included Poussin, Chardin, Ingres, Seurat, and Cézanne on at least two occasions: in his 1920 book *L'Art vivant* (Paris: Éditions G. Crès et Cie), and in a 1926 essay "L'Anniversaire du cubisme," *L'Art vivant*, Paris, no. 36 (15 June 1926), pp. 444–45. Excerpts from these essays appear in *Les Demoiselles d'Avignon* (Barcelona: Museu Picasso, 1988), pp. 675–82.

12 Robert Rosenblum, "The *Demoiselles d'Avignon* Revisited," *Art News* 72, no. 4 (April 1973), pp. 45–48. For a discussion of Picasso's links to nineteenth-century art, see also Norma Broude, "Picasso: Artist of the Century," *Arts Magazine* 55, no. 2 (October 1980), pp. 84–86.

13 In contrast to earlier critics (among them Alfred Barr and John Golding), Rubin has minimized the role of Cézanne in the genesis of the *Demoiselles*, arguing that Picasso's formal assimilation of Cézanne was sporadic and partial in the period preceding his work on *Three Women*. Rubin does, however, admit a thematic connection with Cézanne in relation to the mood of sexual anxiety that permeates the artist's *Temptation of St. Anthony* and *Luncheon on the Grass* ("The Genesis of *Les Demoiselles*," pp. 97–98). For an earlier, polemical debate between Rubin and Leo Steinberg concerning Cézannism and early Cubism, see William Rubin, "Cézannism and the Beginnings of Cubism," in *Cézanne: The Late Work* (New York: The Museum of Modern Art, 1977), pp. 151–202; Leo Steinberg, "Resisting Cézanne: Picasso's *Three Women*," *Art in America* 66 (November/December 1978), pp. 114–33; *idem*, "The Polemical Part," *Art in America* 67 (March/April 1979), pp. 115–27; and William Rubin, "Pablo and Georges and Leo and Bill," *Art in America* 67, no. 2 (March–April 1979), pp. 128–47. Rubin's position is restated with changes in "Picasso and Braque: An Introduction."

14 To these comments may be added a recent observation by Irving Lavin that one of the preparatory drawings for the *Demoiselles d'Avignon*, in which Picasso emphasizes the harmonic proportions of a nude, bears an affinity with Albrecht Dürer's Dresden sketchbook, which was published in 1905 (Irving Lavin, "Picasso's Lithograph(s) 'The Bull(s)' and the History of Art in Reverse," in *Past–Present: Essays on Historicism in Art from Donatello to Picasso* [Berkeley, Los Angeles, and Oxford: University of California Press, 1993], pp. 253–54).

15 Rubin, "The Genesis of *Les Demoiselles*," pp. 96–97.

16 Picasso's image of five prostitutes crowded into a shallow space carries numerous political and social implications. The specter of an uncontrollable, irrational mob haunted Third Republic France as the personification of its fears. Against a backdrop of concerns over mental illness, criminal delinquency, sexual deviance, alcoholism, venereal disease, feminism, and the increasingly militant posture of anarcho-syndicalism, crowd psychologists viewed the mob as savage, proletarian, and most importantly for my reading of the *Demoiselles*, feminine—a clear threat to the patriarchal social order. Although there is no evidence to argue for this interpretation programmatically in Picasso's painting, it is clear that the *Demoiselles* radically overturned conventions governing the representation of the female nude in *fin-de-siècle* French painting. For a discussion of crowd psychology, see Susanna Barrows, *Distorting Mirrors: Visions of the Crowd in Late Nineteenth-Century France* (New Haven and London: Yale University Press, 1981), pp. 73–92, 149. For a consideration of Picasso's transgression of the idealized classical nude in relation to concerns about degeneration and social pathology in *fin-de-siècle* France, see David Lomas, "A Canon of Deformity: *Les Demoiselles d'Avignon* and Physical Anthropology," *Art History* 16, no. 3 (September 1993), pp. 424–46.

17 For a broad examination of the relationship between respectability (bourgeois morality and the control over sexuality) and nationalism, see George L. Mosse, *Nationalism and Sexuality: Middle-Class Morality and Sexual Norms in Modern Europe* (Madison, Wisconsin: The University of Wisconsin Press, 1985); and Andrew Parker, Mary Russo, *et al.*, eds., *Nationalisms and Sexualities* (New York and London: Routledge, 1992). For a discussion of this question in relation to the *Demoiselles*, see

James D. Herbert, *Fauve Painting: The Making of Cultural Politics* (New Haven and London: Yale University Press, 1992), pp. 174–76.

18 For a discussion of Freud's writings on the Medusa and castration anxiety in relation to the conflict between Eros and Thanatos in the *Demoiselles*, see Yve-Alain Bois, "Painting as Trauma," *Art in America* 76, no. 6 (June 1988), pp. 130–41. Rubin, "The Genesis of *Les Demoiselles*," p. 115, observes that as early as 1970, in an unpublished radio lecture for the BBC, John Nash had characterized the squatting figure in the lower right corner as a Medusa, thereby emphasizing the general thanotopic content of the painting.

19 Salmon, "Histoire anécdotique du cubisme"; excerpted and translated in Edward F. Fry, *Cubism* (New York and Toronto: Oxford University Press, 1966/1978), p. 82. See also Herbert, *op. cit.*, p. 176.

20 For a discussion of this association with Black Africa in French painting and cultural criticism, see Marianna Torgovnick, *Gone Primitive: Savage Intellects, Modern Lives* (Chicago: The University of Chicago Press, 1990 and 1991).

21 In a recent article, Anna Chave remarks on the persistence of a 'certain masculinist vision of sexuality" in the literature on the *Demoiselles d'Avignon*, one that she asserts "inevitably debases women." In attempting to clear a space for "unanticipated viewers"—women, people of color, and sex workers—she largely disregards the question of Picasso's intentions as revealed in the hundreds of preparatory sketches for the painting, and concentrates on the discursive excesses of his (mostly white, male, and heterosexual) critics. Whether the "unauthorized perspectives" she proposes for viewing the painting are relevant to a discussion of Picasso's intended audience is an open question. In raising the issue, Chave locates her discourse outside the frame of the painting and positions her reading in the field of contemporary cultural criticism: "If the demoiselles can never function successfully as models of empowerment, they have, nonetheless, already functioned effectively as lightning rods for *fear* of the empowerment of women and peoples of color. One story *Les Demoiselles* and its reception teaches is how 'a crisis in phallocentric culture was turned into one of its great monuments,' as [Hal] Foster aptly puts it" (Anna C. Chave, "New Encounters with *Les Demoiselles d'Avignon*: Gender, Race, and the Origins of Cubism," *The Art Bulletin* 76, no. 4 [December 1994], pp. 597–611).

22 The term is taken from Hans Robert Jauss, "Literary History as a Challenge to Literary Theory," in *Toward an Aesthetic of Reception*, trans. Timothy Bahti (Minneapolis: University of Minnesota Press, 1982), p. 28.

23 Leo Stein purchased the *Bonheur de Vivre* several weeks after the opening of the 1906 Salon des Indépendants, where it was exhibited. The painting subsequently hung in the Stein's apartment at 27 rue de Fleurus in Paris. Rubin, "The Genesis of *Les Demoiselles*," pp. 35 and 128–

29, asserts that Picasso is likely to have first seen Matisse's painting at the Indépendants.

24 The references to Ingres, whose art had just been shown in a retrospective at the Salon d'Automne of 1905, are particularly numerous, as Matisse quotes from the nineteenth-century artist's *Turkish Bath*, his *Odalisque with Slave*, and from his celebrated *Golden Age* of 1862, the likely source for the dance motif.

25 Herbert, *op. cit.*, p. 116, writes, "Matisse's paintings . . . never force a choice between the eternal and the contemporary. . . . they actively blur the line of demarcation between the two temporal realms."

26 *Ibid.*, p. 144.

27 Matisse's replication of Arcadian imagery emerges most clearly in a comparison between the *Bonheur* and Agostino Carracci's *Love Reciprocated* of ca. 1589–95 (Baltimore Museum of Art). For a discussion, see J.B. Cuno, "Matisse and Agostino Carracci: A Source for the *Bonheur de Vivre*," *Burlington Magazine* 122 (July 1980), pp. 503–05. For an extended consideration of classical "staging" devices in Matisse's Fauve paintings, see Roger Benjamin, "The Decorative Landscape, Fauvism, and the Arabesque of Observation," *Art Bulletin* 75, no. 2 (June 1993), pp. 295–316. In contrast to Herbert's position concerning Matisse's use of Impressionist devices to identify his Arcadian vision politically with Third Republic France, Benjamin asserts: "the Fauve modernists recuperated classicism . . . as a means of resisting Impressionist culture. Along this primarily diachronic axis, the dimension of cultural memory is active, being embodied in specific compositional structures like that of the *paysage composé*" (p. 296).

28 Paul de Man "The Rhetoric of Temporality," in *Blindness and Insight: Essays in the Rhetoric of Contemporary Criticism* (Minneapolis: University of Minnesota Press, 1971–1983), pp. 187–228.

29 Rubin, "From Narrative to 'Iconic' in Picasso," p. 635.

30 I am following Paul de Man's discussion of Hans-George Gadamer's definition of the symbol in modern literature: "In *Wahrheit und Methode*, Hans-Geory Gadamer makes the valorization of symbol, at the expense of allegory, coincide with the growth of an aesthetics that does not distinguish between experience and the representation of this experience. The poetic language of genius is capable of transcending this distinction and can thus transform all individual experience directly into general truth. The subjectivity of experience is preserved when it is translated into language; the world is then no longer seen as a configuration of entities that designate a plurality of distinct and isolated meanings, but as a configuration of symbols ultimately leading to a total, single, and universal meaning" (*op. cit.*, p. 188).

31 For a discussion, see Margaret Werth, "Engendering Imaginary Modernism: Henri Matisse's *Bonheur de vivre*," *Genders* 9 (November 1990), pp. 49–74. To the extent that Matisse calls into question a unified subject/object relationship, the rhetorical mode of the *Bonheur* is sus-

pended between symbol and allegory. It is, to borrow Craig Owens's term, an "allegory *in potentia*" (Craig Owens, "The Allegorical Impulse: Toward a Theory of Postmodernism, Part 2," *October*, Spring 1980, pp. 59–80).

32 De Man, *op. cit.*, p. 222.

33 De Man offers a critique of the traditional interpretation of irony as a rhetorical mode in which "the sign points to something that differs from its literal meaning and has for its function the thematization of this difference" (*op. cit.*, p. 209). For de Man, irony involves a "reflective disjunction," a self-critical activity in which the subject "knows himself by differentiating what is not" (p. 213), but which offers no possibility of future synthesis, no "preliminary movement toward a recovered unity" (p. 219). Irony, de Man continues, "reveals the existence of a temporality that is definitely not organic, in that it relates to its source only in terms of distance and difference and allows for no end, for no totality" (p. 222).

34 See Hélène Seckel's cautionary remarks in *Les Demoiselles d'Avignon* (Barcelona: Museu Picasso, 1988), pp. 650–52.

35 Gelett Burgess, "The Wild Men of Paris," *Architectural Record* 27, no. 5 (May 1910), pp. 401–14.

36 The term is James Herbert's. Herbert does not discuss Burgess's article, although he makes the point that Picasso's contemporaries registered their dismay before the *Demoiselles*.

37 For a discussion of the full implications of this process, see Roland Barthes's classic essay "Myth Today," in Barthes, *Mythologies* (New York: The Noonday Press, 1957/1990), pp. 109–59.

38 Jonathan Brown, "Introduction: El Greco, the Man and the Myths," in *El Greco of Toledo* (Boston: Little, Brown, & Co., 1982), pp. 15–33; and José Álvarez Lopera, *De Cean a Cossío: La fortuna Crítica del Greco en el siglo XIX* (Madrid: Fundación Universitaria Española, 1987).

39 "Nuestros grabados: Retrato por Domenico Theocopuli (El Greco)," *Luz*, Barcelona 1, no. 1 (15 November 1897), p. 8.

40 "Celebrado en sus días, en los nuestros y sin duda en los venideros, pueden aspirar sus obras a la serena inmortalidad de los que se mantienen constantemente modernos" (Miquel Utrillo, *Domenikos Theotokopulos "El Greco"* [Barcelona, 1906], reprinted in Álvarez Lopera, *op. cit.*, p. 546). Scholars have long assumed that Picasso, who had known Utrillo since their days at the Quatre Gats café, would have seen a copy of Utrillo's book on the occasion of his trip to Barcelona and Gósol in the summer of 1906. John Richardson has gone so far as to view Utrillo's book as re-igniting Picasso's interest in El Greco during his Gósol sojourn (Richardson, *A Life*, p. 435).

41 See, for example, Sebastià Junyent, "Els pintors joves," *Joventut*, no. 204 (January 1904), pp. 7–10, reprinted in Álvarez Lopera, *op. cit.*, p. 537. For a discussion of Picasso's friendship with Junyent, see Josep Palau i Fabre,

Picasso i els seus amics catalans (Barcelona: Editorial Aedos, 1971); and Richardson, *A Life*.

42 Picasso's Catalan colleagues in turn commented on the artist's affinity for El Greco. An unsigned, handwritten review of Picasso's exhibition at Els Quatre Gats in February 1900 reads: "Each stroke of the pencil, charcoal or paintbrush reveals a profound faith in art and a kind of inspired fever which immediately reminds us of the best works by El Greco and Goya, the sole, undisputed masters or divinities for Picasso." The text is reproduced in *Picasso and Els 4 Gats: The Key to Modernity* (Barcelona: Museu Picasso, 1995), p. 318.

43 Santiago Rusiñol, "La Comissió: El Monument al Greco" (1897), in *Obres completes* (Barcelona: Edicions Selecta, 1956), pp. 559–60, reprinted in Álvarez Lopera, *op. cit.*, pp. 377–78.

44 Santiago Rusiñol, "Impresiones de arte," *La Vanguardia*, 1897, reprinted in Álvarez Lopera, *op. cit.*, pp. 407–12.

45 One of the paintings is now attributed to the artist's studio. For a discussion of Rusiñol's friendship with Zuloaga in Paris and his acquisition of the two paintings, see Enrique Lafuente Ferrari, *The Life and Work of Ignacio Zuloaga* (Barcelona: Editorial Planeta, 1972/1991); Marilyn McCully, "Els Quatre Gats and Modernista Painting in Catalonia in the 1890s," unpublished Ph. D. thesis, Yale University, 1975, pp. 47–52; Richardson, "Picasso's Apocalyptic Whorehouse," pp. 41–42; and Álvarez Lopera, *op. cit.*, pp. 72–78.

46 For a description of the ceremonies, see "La fiesta de Sitges," parts 1 and 2, *La Vanguardia*, 6 November 1894, pp. 4–5, and 7 November p. 5, in Álvarez Lopera, *op. cit.*, pp. 358–65.

47 "La inauguración (de la estatua del Greco por Reynés)," *La Vanguardia*, 30 August 1898, p. 5, in Álvarez Lopera, *op. cit.*, pp. 423–26.

48 Javier Herrera Navarro, "El pensamiento noventayochista y el joven Picasso," *Goya*, no. 231 (November–December 1992), pp. 151–60, makes an important distinction between what he terms the "'españolismo' exacerbado y [la] falta de curiosidad por lo de fuera" that characterized Picasso's circle in Madrid in 1901, and the European, cosmopolitan air at the Quatre Gats, where Symbolist painting and the ideas of Wagner, Schopenhauer, Maeterlinck, and Ruskin, among others, were discussed.

49 The other two painters accorded this honor were Bresdin and Monticelli.

50 "C'est une réhabilitation toute récente que celle du Greco dans la gloire. Le goût de la nouveauté y a prêté concours et peut-être, en outre, l'apparition de Cézanne et les expositions posthumes de Van Gogh ont-elles aidé chez nous le public à se placer au point de vue qu'exige, pour être compris, l'un de ceux que le souci de plaire a le moins préoccupés" (Pierre Hepp, "Le Greco," *Catalogue des Ouvrages de Peinture, Sculpture, Dessin, Gravure, Architecture et Art Décoratif*, Société du Salon d'Automne [Paris, 1908], p. 258).

51 Susan Grace Galassi, "'Games of Wit': Picasso's Variations on the Old Masters," Ph.D. thesis, New York University, Institute of Fine Arts (February 1991), pp. 13–14.

52 *Ibid.*, pp. 28–29.

53 Galassi discusses the disputed dating of the sketch, in *ibid.*, pp. 60–62.

54 For a discussion of the "primitive" sexual body, see Torgovnick, *op. cit.*, p. 102. On the persistence of this trope in recent Western criticism, see Chave, *op. cit.*

55 Marilyn McCully, "Picasso and the Catalan Artistic Community in Paris Before the Great War," in *Paris, The Center of Artistic Enlightenment*, Penn State University Papers 4 (1988), p. 228.

56 Richardson, *A Life*, pp. 153–54, 163. According to Richardson, four of Picasso's bullfight scenes had been exhibited at the Quatre Gats café in July 1900, prior to his first trip to Paris.

57 Félicien Fagus, "Gazette d'art: L'Invasion espagnole, Picasso," *Revue blanche* 25 (15 July 1901), pp. 464–65 (review of Picasso/Iturrino exhibition at the Galeries Vollard, 25 June–14 July 1901), translated in Pierre Daix and Georges Boudaille, *Picasso: The Blue and Rose Periods* (Greenwich, Conn.: New York Graphic Society, Ltd., 1966), p. 333. For a discussion and hypothetical reconstruction of the Vollard show, see Josep Palau i Fabre, *Picasso: The Early Years, 1881–1907* (Barcelona, Ediciones Polígrafa, 1985), pp. 228–59; and Richardson, *A Life*, pp. 193–203.

58 Gustave Coquiot, "La Vie artistique: Pablo Ruiz Picasso," *Le Journal*, 17 June 1901, in McCully, *A Picasso Anthology*, pp. 32–34.

59 Because of his focus on Picasso's dialogue with modern art as an "alternative heritage" to the French classical tradition, James Herbert does not address the broader implications of this review. The term "grand ancêtres," within the context of Fagus's discussion of "gongorisme," points to the Spanish as much as the French tradition. While Fagus presents Picasso as a friendly neighbor of French artists, the review in fact challenges the rigid binary oppositions through which cultural difference is enforced, rather than affirming "the existing categories of what constituted French art" as Herbert asserts (James Daniel Herbert, "Fauvism and After: The Politics of French Cultural Unity," Ph.D. thesis, Yale University, 1989, pp. 341–42).

60 Félicien Fagus, "Gazette d'art," *Revue Blanche*, 1 September 1902, translated in Daix and Boudaille, *op. cit.*, p. 334. The group show of works by Louis Bernard-Lemaire and Picasso, organized by Pere Manyach for the Galerie Berthe Weille, ran from 1–15 April 1902.

61 For a consideration of the French republican attitude toward constructing a national tradition and identity, see Herbert, *Fauve Painting*, pp. 128–29. On the broad implications of this process of historical invention, see Benedict Anderson, *Imagined Communities: Reflections on the Origin and Spread of Nationalism* (London and New York: Verso, 1983/1987).

62 For a discussion of Guillaume Apollinaire's investment in the idea of Picasso as protean genius, see Herbert, *Fauve Painting*, pp. 177–78.

63 Charles Morice, "L'Art moderne: Exposition de MM. Picasso, Launey, Pichot, et Girieud," *Mercure de France*, modern series 44 (December, 1902), p. 804, in Daix and Boudaille, *op. cit.*, pp. 334–35.

64 T. J. Clark, *The Painting of Modern Life: Paris in the Art of Manet and his Followers* (New York: Alfred A. Knopf, 1985); and Jerrold Seigel, *Bohemian Paris: Culture, Politics, and the Boundaries of Bourgeois Life* (New York: Viking Press, 1984).

65 M. Utrillo, "Paris por dentro," *La Vanguardia*, 27 April 1890, in McCully, "Els Quatre Gats," p. 16.

66 For a full discussion, see McCully, "Els Quatre Gats and Modernista Painting," pp. 18–24, and chapter 4; and Richardson, *A Life*, pp. 129–42.

67 Richardson, *A Life*, p. 372.

68 *Ibid.*, p. 427.

69 For an excellent discussion of Nietzschian anti-historicism, see Hayden White, "The Burden of History," in *Tropics of Discourse: Essays in Cultural Criticism* (Baltimore and London: The Johns Hopkins University Press, 1978/1990), pp. 27–50. For a broader examination of Picasso's inversion of notions of historical progression see Lavin, *Past-Present*, pp. 203–60.

70 Ron Johnson, "The *Demoiselles d'Avignon* and Dionysian Destruction," *Arts Magazine*, October 1980, pp. 94–101. For additional Nietzschean interpretations of Picasso's early work, see Mark Rosenthal, "The Nietzschean Character of Picasso's Early Development" *Arts Magazine*, October 1980, pp. 87–91; Anthony Blunt and Phoebe Pool, *Picasso: The Formative Years* (New York: New York Graphic Society, 1962); and Patricia Leighten, *Re-Ordering the Universe: Picasso and Anarchism, 1897–1914* (Princeton, N.J.: Princeton University Press, 1989).

71 See, for example, the following editorial commentary in *Arte Joven*, no. 1 (31 March 1901), celebrating a shared faith in cultural and social renewal among intellectuals in Catalonia and Castile: "A los redactores de *Joventut*, de Barcelona, manda un cariñoso abrazo. *Arte Joven* ha sido acogido allí con entusiasmo; nosotros, que no tenemos compromisos con nadie y poseemos suficientes energías para despreciar á los que, solapadamente, tratan de hacernos fracasar en nuestra obra de regeneración, vemos con admiración un periódico que sustiene ideales similares á los nuestros y que sabe seguir su camino, á pesar de las burlas de los ignorantes y de las zancadillas de los envidiosos."

Javier Herrera Navarro has discussed the importance of social commentary in Picasso's drawings for *Arte Joven* in relation to the literary work of the Generation of 1898. Emphasizing Picasso's links to Madrid intellectual circles above the impact of the artist's first trip to

Paris in October 1900, Herrera's work nonetheless represents an important rereading of this obscure journal (Javier Herrera Navarro, "La revista *Arte Joven*: una documentación sobre el Picasso azul, el modernismo y el 98," *Esopo* 3 (April 1991), pp. 11–36; *idem*, "Picasso y los escritores del 98: la revista *Arte Joven*," *La balsa de la Medusa*, no. 24 (1992); and *idem*, "El pensamiento noventayochista y el joven Picasso."

72 See, for example, an article by Camilo Bargiela on the Catalan anarchist writer Pompeyo Gener (an early translator of Nietzsche in Spain) in *Arte Joven*, no. 2 (15 April 1901). For a discussion of Nietzsche's impact on the formation of a specifically Catalan cultural nationalism and its conservative and authoritarian implications by 1906, see Vicente Cacho Viu, ed., *Els Modernistes i el nacionalisme cultural (1881–1906)* (Barcelona: Edicions de la Magrana, 1984).

73 For a brief discussion of the interpretation of Nietzsche in Spain, see Gonzalo Sobejano, "Nietzsche y el individualismo rebelde," in José-Carlos Mainer, ed., *Modernismo y 98* (Barcelona: Editorial Crítica, 1980), pp. 36–41. Sobejano emphasizes the Nietzschean themes of moral revolution and the "trasmutación de los valores éticos" in the works of the *Modernista* poets in Madrid (Rubén Darío, Valle-Inclan, *et. al.*) in relation to the "individualismo anarcoaristocrático de los hombres del '98" (Unamuno, Ganivet, Pío Baroja, Azorín, Maeztú). On the relationship between *Modernismo* and the Generation of 1898 in Spain, see note 89, below.

74 "No es nuestro intento destruir nada: es nuestra misión más elevada. Venimos á edificar. Lo viejo, lo caduco, lo carcomido ya caerá por sí sólo. . . . Virgilio, Homero, Dante, Goette [*sic*], Velázquez, Ribera, el Greco, Mozart, Beethoven, Wagner . . . éstos son los jóvenes eternos, cuantos más años pasan más grandes son, crecen en vez de perecer y mientras el mundo exista existirán ellos: Son los inmortales" (Editor's statement, *Arte Joven*, número preliminar [10 March 1901]). For a related discussion of the idea of Poussin's "enduring youth" in French criticism, see Theodore Reff, "Cézanne and Poussin," *Journal of the Warburg and Courtauld Institutes*, 23, nos. 1–2 (January–June 1960), pp. 150–74; and Herbert, *Fauve Painting*, pp. 120–23.

75 See, for example, "Nuestra Estética: Ideas de Goethe," *Arte Joven*, no. 1 (31 March 1901). The text, an excerpt from one of Goethe's writings of 1826, reads: "Un hombre de talento no viene al mundo para aprenderlo todo por sí propio, sino para volverse del lado del arte de los buenos maestros, susceptibles de hacerle apto para algo."

76 Francisco de A. Soler, "!!Toros!!," *Arte Joven*, no. 2. (15 April 1901): "Confiamos edificar sobre las ruinas de un pueblo caído por sus visios, un pueblo grande, noble, amante del Trabajo, del Arte y de la Ciencia."

77 "No queremos redimirnos: levantamos nuevas plazas de toros en vez de crear escuelas; bromeamos, reímos siempre, nos divertimos á todas horas y no procuramos regenerar á la industria, al comercio y á la agricultura, que están dando las últimas boqueadas . . .

Lo hemos perdido todo: la dignidad y la vergüenza.

!Bien, pueblo, bien! Sigue tu camino, ve á los toros y satisface tus instintos crueles viendo correr la sangre . . ." (*ibid.*).

78 As Patricia Leighten has argued (*op. cit.*, chapter 1), modern art in *fin-de-siècle* Madrid was charged with a redemptive social role among authors associated with the anarchist movement. The following opposition by José Martínez Ruiz (Azorín) between politics and aesthetics is characteristic of this position. Commenting on the recent elections in Spain, Azorín wrote: "Votar es fortalecer la secular injusticia del Estado. . . . El arte es libre y espontáneo. Hagamos que la vida sea artística. Propulsores y generadores de la vida, los artistas no queremos ni leyes ni fronteras. Nuestra bohemia libre, aspriamos á que sea la bohemia de la humanidad toda" (J. Martínez Ruiz, "La Vida," *Arte Joven*, no. 2 [15 April 1901]). While a link between the language of cultural renewal and Spanish anarchist literature is undeniable, Leighten's attempt to read into this relationship a specific political intent in Picasso's work is questionable. For a discussion, see my review of Leighten's book in *Art Bulletin* 62, no. 3 (September 1990), pp. 505–10.

For more on the "decadent" aspects of the bohemian protest in *fin-de-siècle* Spanish literature, see Manuel Aznar Soler, "Bohemia y burguesía en la literature finisecular," in Mainer, *op. cit.*, pp. 75–82. Aznar Soler makes the important observation that the bohemian attitude was "violently censored" by writers of the Generation of 1898, dedicated to the spiritual and moral regeneration of Spain. Nonetheless, the fact that both decadent and regenerationist elements within Spanish literature are present in *Arte Joven* points to a common antagonism among the Modernistas and the Generation of 1898 toward *ochocentista* art and literature and the society of Restoration Spain.

79 Pincell [Miquel Utrillo], "Dibuixos d'en Picasso," *Pèl & Ploma*, no. 77 (June 1901), translated in Daix and Boudaille, *op. cit.*, p. 333. Palau i Fabre translates this portion of the review slightly differently: "In Madrid, he and the writer Soler founded the periodical *Arte Joven*, which in a few issues aroused interest, precisely because of the freshness seen in the young Andalusian artist's drawings" (Palau, *op. cit.*, p. 514). The occasion for the review was an exhibition of pastels that Utrillo had organized in June 1901 at the Sala Parés in Barcelona.

80 Significantly, the editor of *Arte Joven*, Francisco de Asís Soler, had collaborated regularly on *Luz* beginning with its first issue.

81 "Los que espontáneamente nos hallamos agrupados entorno de *Luz* somos jóvenes, y en ello ciframos tanta fuerza y esperanza, que todos nuestros deseos van encaminados á imprimir perpétua joventud á lo que

podamos producir ahora, mañana, más tarde y siempre. . . .

"No fiándonos aún en nuestras fuerzas, contamos con el apoyo decidido de los espíritus jóvenes; de todos aquellos que aspiran a la juventud del Arte hacia el ocaso de la vida, como sucede con Puvis de Chavannes; con Whistler, y con Degas, como sucede con Burne-Jones, con William Morris, Wagner y los Goncourts. Estos y otros muchos, hallaron la verdadera fuente de *Jouvence*, rejuveneciéndose más y más por medio del Arte, á medida que los años les alejaban de los ardorosos tiempos juveniles" (A.L. de Barán [Miquel Utrillo], "Arte Joven," *Luz* [2nd week of October 1898], as translated in McCully, "Els Quatre Gats and Modernista Painting," p. 209).

82 *Luz*, no. 6. (3rd week of November 1989); no. 8 (1st week December 1898); no. 10 (3rd week of December 1898); no. 11 (4th week of December 1898); no. 12 (5th week of December 1898). Verhaeren's text had originally appeared in the Belgian journal *L'Art moderne*.

83 After a period of study with the innovative landscape painter Carlos de Haes in Madrid, Regoyos traveled to Brussels in 1879. He was a founding member of the group *L'Essor* in 1880, and joined its radical splinter organization *Les XX* in 1883. Through friendships with Verhaeren, Constantin Meunier, August Rodin, James Ensor, Théo Van Rysselberghe, Paul Signac, Fernand Khnopff, and Jan Torrop, among others, Regoyos was positioned at the vanguard of art and literature in Europe. For Regoyos's activities in Belgium and Paris, see *Darío de Regoyos: 1857–1913* (Madrid: Fundación Caja de Pensiones, 1986). On the significance of Brussels as a model for Catalan culture, see McCully, "Els Quatre Gats and Modernista Painting," pp. 210–11.

84 A.L. de Barán (Miquel Utrillo), "Arte Nuevo: Darío de Regoyos," *Luz*, no. 8 (1st week of December 1898).

85 On the highly mediated image of Spain in nineteenth-century French art and literature, see Alisa Luxenberg, "Over the Pyrenees and through the Looking-Glass: French Culture Reflected in Its Imagery of Spain," in *Spain, Espagne, Spanien: Foreign Artists Discover Spain 1800–1900* (New York: The Equitable Gallery in association with The Spanish Institute, 1993), pp. 11–31.

86 For a partial accounting of works in the Regoyos exhibition, see the "Fichas técnicas," in *Darío de Regoyos: 1857–1913*: pp. 281–303. The complete text of *España negra* is reprinted.

87 Darío de Regoyos and Emile Verhaeren, *España negra*, 1st edition (Barcelona: Imprenta Pedro Ortega, 1899), as cited by Angeles Pardo, *La literatura del casticismo* (Madrid: Editorial Moneda y Credito, 1973).

88 Lily Litvak has discussed the burgeoning industrialization of Spain after mid-century in textile and cork manufactures, mining and heavy metals, ship building, the rapid expansion of the railroads, and in the wine and chemical industries. Spain's economic boom ended with the onset of an agricultural depression in the late 1880s.

As a deep sense of economic pessimism set in, a prelude to the devastating economic and political consequences of the Spanish-American War, the widespread failure of industrialization to ameliorate the conditions of workers and peasants in Spain had become apparent (Lily Litvak, *A Dream of Arcadia: Anti-Industrialism in Spanish Literature, 1895–1905* [Austin and London: University of Texas Press, 1975], particularly the author's introduction).

89 For a critical differentiation of the ethical posture of the Generation of 1898 from Castilian *Modernismo*, see Guillermo Díaz-Plaja's seminal study, *Modernismo frente a noventa y ocho: Una introducción a la literatura española del siglo XX* (Madrid: Espasa-Calpe, 1979), and Pedro Salinas, "98 Frente a Modernismo," in Mainer, *op. cit.*, pp. 53–56. Of particular interest is the direct confrontation with reality by members of the Generation of 1898, and their view of literature as a manifestation of conscience, in contrast to the aestheticism and emphasis on the interior life of the senses that characterize the writings of Rubén Darío and Ramón Valle-Inclán. In this context, it is also important to distinguish *Modernismo* from Catalan *Modernisme*, which Joan Lluís Marfany defines as "the process of transformation of Catalan culture from a traditional and regional culture into a modern and national culture" (*Aspectes del modernisme* [Barcelona: Curial, 1975], p. 34). While the two movements share certain characteristics, especially in relation to the broader panorama of European Symbolism, their cultural agendas are entirely distinct.

90 The literature on the Generation of 1898 is extensive. For two excellent studies, see Donald L. Shaw, *The Generation of 1898 in Spain* (London: Ernest Benn Limited, 1975); and H. Ramsden, *The 1898 Movement in Spain* (Manchester, England: Manchester University Press, 1974). In his discussion of texts by Unamuno and Ganivet, Ramsden makes the important observation that the regenerationist ideology of these authors was shaped in the years *preceding* the National Disaster.

91 Lily Litvak defines *intrahistoria* as the "permanent storehouse of common tradition." By this term, she explains, "[Unamuno] means the silent daily lives of the common people who continue unchanged in their secular workaday worlds beneath the exciting, though ephemeral, events of public history" (Litvak, *op. cit.*, pp. 115, 31). For the writers of the Generation of 1898, a recognition of Spain's immutable character represents the *a priori* condition for the spiritual regeneration of the nation.

92 Ernest Gellner, *Nations and Nationalism* (Ithaca: Cornell University Press, 1983).

93 *Ibid.*, p. 46.

94 As Eric Hobsbawm observes, "It is the contrast between the constant change and innovation of the modern world and the attempt to structure at least some parts of social life within it as unchanging and invariant, that makes the 'invention of tradition' so interesting for historians

of the past two centuries." In Hobsbawm's analysis, the invention of tradition "is essentially a process of fomalization and ritualization, characterized by reference to the past, if only by imposing repetition" Eric Hobsbawm and Terence Ranger, eds., *The Invention of Tradition* (Cambridge: Cambridge University Press, 1983), pp. 2, 4. See also Eric Hobsbawm, *Nations and Nationalism Since 1780: Programme, Myth, Reality* (Cambridge and New York: Cambridge University Press, 1990).

95 As Benedict Anderson explains, nationalism does not represent an ideology, although nationalist discourses exist in relation to ideologies. The difficulty one encounters in defining nationalism, Anderson writes, "is that one tends unconsciously to hypostasize the existence of Nationalism-with-a-big-N . . . and then to classify 'it' as *an* ideology. . . . It would, I think, make things easier if one treated it as if it belonged with 'kinship' and 'religion,' rather than with 'liberalism' or 'fascism'" (Anderson, *op. cit.*, pp. 5–7).

96 Anderson considers the great extent to which the "imagined community" of the nation is constituted through print-language. Other constitutive forces that structure the "imagined community" include already existing models of the independent national state, and the institutions of knowledge represented by the census, the map, and the museum. Anderson explains: "We can summarize the conclusions to be drawn from the argument thus far by saying that the convergence of capitalism and print technology on the fatal diversity of human language created the possibility of a new form of imagined community, which in its basic morphology set the stage for the modern nation." Elsewhere, Anderson cautions against the tendency of nationalist idealogues to treat specific languages as *emblems* of nation-ness, like flags, costumes, folk-dances, and the rest," emphasizing that "Print-language is what invents nationalism, not *a* particular language per se" (Anderson, *op, cit.*, pp. 46, 133–34).

97 Describing the transformation of El Greco's style into a new and personal idiom in Castile, Lefort writes: "C'est dans ce milieu d'exaltation mystique et de naturalisme religieux, que le Greco se transforme jusqu'à dépouiller toute sa belle harmonie vénetienne" (Paul Lefort, "Dominico Theotocopuli, surnommé le Greco," in *Histoire des peintres de toutes les écoles. Ecole Espagnole* (Paris, 1869), reprinted in Álvarez Lopera, *op. cit.*, pp. 257–63. See also Brown, 'El Greco: The Man and The Myths," p. 21).

98 Maurice Barrès, *Greco ou Le Secret de Tolède* (Paris: Plon-Nourrit et Cie., 1912/1923). Barrès writes: "La Castille étonna, domina le Greco. Il arrive souvent qu'un étranger surpris par un milieu nouveau en saisit les nuances et le peindre mieux que ne feraient les indigènes de talent" (pp. 116–17). For a discussion of Barrès's text and the positioning of El Greco as a proto-Expressionist ("dans son oeuvre Greco manifestera ce

que est le propre de l'Espagne, la tendence à l'exaltation des sentiments" [p. 121]), see Brown, "El Greco: The Man and the Myths," p. 27.

99 "Malgré son origine, ce peintre, dont la carrière artistique s'écoula presque tout entière en Espagne, sut interpréter mieux que tout autre le génie propre de la race ibérique . . ." (A. de Beruete, "Corréspondance d'Angleterre. Exposition d'oeuvres de peintres espagnols en Guildhall de Londres," *Gazette des Beaux-Arts* 26, no. 531 (September 1901), pp. 251–60, reprinted in Álvarez Lopera, *op. cit.*, p. 497.

100 Manuel B. Cossío, "El Greco, Velázquez, y el arte moderno," *Boletín de la Institución Libre de Enseñanza* 31 (1907), pp. 336–46 and 373–81, reprinted with slight revisions as chapter 12 of Manuel B. Cossío, *El Greco* (Madrid, 1908): "halló un mundo por él nuevo, que había de ser forzosamente visto en alto relieve por ojos extranjeros, penetradores siempre de algo más, y de algo más típico, que quizás escapa a los ojos de los naturales, que nunca salieron de su tierra, y que había de ser traducido con un espíritu como el suyo, de otra raza y pueblo, no embotado por el hábito de la diaria contemplación de aquel medio.

"Porque este pintor, extranjero como los arquitectos y escultores que vinieron a España y fueron reabsorbidos por el arte local, es el que entona más que ningún otro en nuestro país, y todos convienen en que lo representa y como español se le trate. A unos, les absorbe el *arte*, mientras que el Greco ha despreciado el arte y los artistas y dado arte él; arte genuino nacional, porque fue absorbido por la montaña entera de tierra y raza; por la naturaleza, por lo humano. Y huyendo de lo sensible y lo concreto buscó lo único que en el arte como en todo nos *hace libres*: lo que no es perecedero."

101 Brown, "El Greco. The Man and the Myths," pp. 21–26.

102 For an analysis, see María del Carmen Peña, *Pintura de paisaje e ideología: La generación del '98* (Madrid: Taurus, 1982); and Ramsden, *op. cit.*

103 On the question of origins, see Michel Foucault, "Nietzsche, Genealogy, History," in Paul Rabinow, ed., *The Foucault Reader* (New York: Pantheon Books, 1984), pp. 76–100. Of Nietzsche's concept of genealogy, Foucault writes: "Genealogy does not pretend to go back in time to restore an unbroken continuity that operates beyond the dispersion of forgotten things; its duty is not to demonstrate that the past actively exists in the present, that it continues secretly to animate the present, having imposed a predetermined form on all its vicissitudes. Genealogy does not resemble the evolution of a species and does not map the destiny of a people. On the contrary, to follow the complex course of descent is to maintain passing events in their proper dispersion; . . . it is to discover that truth or being does not lie at the root of what we know and what we are, but the exteriority of accidents."

104 For a discussion, see Hayden White, "The Historical Text as Literary Artifact," *op. cit.*, pp. 81–100.

105 Walter Benjamin, "Theses on the Philosophy of History," in Benjamin, *Illuminations* (edited and with an introduction by Hannah Arendt) (New York: Schocken Books, 1969/1977), pp. 253–64. For an interesting application of Benjamin's theses to the concept of the nation, see Anderson, *op. cit.*, pp. 22–26. The analogy to calendrical time is Anderson's.

106 For a discussion of Unamuno's *En torno al casticismo* and Ganivet's *Idearium español* in this regard, see Ramsden, *op. cit.*

107 José Ortega y Gasset, *El espectador* (Madrid: Suárez, 1946); as cited in Litvak, *op. cit.*, pp. 135–36.

108 Benjamin, "Theses," p. 261. On Benjamin's Messianism, see Richard Wolin, *Walter Benjamin: An Aesthetic of Redemption* (Berkeley, Los Angeles, and London: University of California Press, 1994), pp. 49–63.

109 Benjamin's project is clearly stated in the following excerpts from sections XIV, XV and XVI of the Theses: 'History is the subject of a structure whose site is not homogeneous, empty time, but time filled by the presence of the now [*Jetztzeit*]. Thus, to Robespierre ancient Rome was a past charged with the time of the new which he blasted out of the continuum of history"; "The awareness that they are about to make the continuum of history explode is characteristic of the revolutionary classes at the moment of their action"; "A historical materialist cannot do without the notion of a present which is not a transition, but in which time stands still and has come to a stop. For this notion defines the present in which he himself is writing history. Historicism gives the 'eternal' image of the past; historical materialism supplies a unique experience with the past" (Benjamin, "Theses," pp. 261–62).

110 For a discussion, see Díaz-Plaja, *op. cit.*, pp. 218, 226–27, 235–36.

111 According to Álvarez Lopera, *op. cit.*, p. 91, Azorín and Pío Baroja visited Toledo in December 1900, during a period of maximum immersion "en un ambiente en el que la admiración por el Greco era casi religión." Álvarez Lopera provides an excellent account of the changing critical fortunes of El Greco among writers of the Generation of 1898 (pp. 89–101).

112 "El genio pictórico castellano, que se inicia definido en Theotocopuli, va formándose en la generación sucesora, hasta florecer espléndido en la paleta de D. Diego Rodríguez de Silva Velázquez" (José Martínez Ruiz, "El Museo. Una sala para el 'Greco,'" *La Correspondencia de España*, 18 December 1901, p. 1, reprinted in Álvarez Lopera, *op. cit.*, pp. 502–04.

113 "Velázquez es el desarrollo al máximo de ciertas facultades pictóricas del Greco. De un Ticiano, quizá menos pintor, pero más exaltado y más poeta al sentir el espíritu de las llanuras castellanas, nació el Greco; el Greco, más pintor y menos poeta, es Tristán. Tristán, en su última hipostasis, en su *devenir*, es Velázquez" (Pío Baroja. "Cuadros del Greco. Tierra castellana. En Santo Tomé," *El Globo*, 9 July 1900, p. 2, reprinted in Álvarez Lopera, *op. cit.*, pp. 460–64.

114 Aureliano de Beruete, *Velázquez* (Paris: Henri Laurens Editeur, 1898), as cited by Fernando A. Marín Valdés, "Textos biográficos y críticos en torno a Aureliano de Beruete," in *Aureliano de Beruete: 1845–1912* (Madrid: Fundación Caja de Pensiones, 1983), pp. 85–101. For a discussion of Beruete's landscape painting in relation to generational ideology, see María del Carmen Peña's essay in the same exhibition catalogue, "Aureliano de Beruete y Moret, personaje y paisajista español de fin de siglo," pp. 12–23.

115 In Pío Baroja's novel *La busca*, the Guadarrama *sierra* is used as a symbol of the pristine beauty of the eternal Castilian landscape, in contrast to the urban desolation of modern industrial Madrid. For a discussion, see Litvak, *op. cit.*, pp. 89–90, 183.

116 Robert Wohl, *The Generation of 1898* (Cambridge, Mass.: Harvard University Press, 1979).

117 *Ibid.*, p. 38.

118 *Ibid.*, p. 207.

119 For an examination of the avant-garde's "agonistic sacrifice to the future" as a particular function of its historical consciousness, see Renato Poggioli, *The Theory of the Avant-Garde* (Cambridge, Mass.: Harvard University Press, 1968), p. 60–77.

120 Wohl, *op. cit.*, p. 38.

121 For a discussion, see Poggioli, *op. cit.*, pp. 86–92.

122 *Ibid.*, p. 87.

123 For a discussion of the intellectual in *fin-de-siècle* Spain, see E. Inman Fox, "Al Año de 1898 y el origen de los 'intelectuales,'" in Mainer, *op. cit.*, pp. 31–36.

124 Michael Leja, "'Le vieux marcheur' and 'les deux risques': Picasso, prostitution, venereal disease, and maternity, 1899–1907," *Art History* 8, no. 1 (March 1985), pp. 66–81. Patricia Leighten is particularly insistent on this point. See her *Re-Ordering the Universe* and, in relation to the *Demoiselles d'Avignon*, "The White Peril and *L'Art nègre*: Picasso, Primitivism, and Anticolonialism," *Art Bulletin* 72, no. 4 (December 1990), pp. 609–30. For a more nuanced reading of the role of women in Catalan politics and society, see Temma Kaplan, *Red City, Blue Period: Social Movements in Picasso's Barcelona* (Berkeley, Los Angeles, and Oxford: University of California Press, 1992).

125 Gellner, *op. cit.*, pp. 4–5.

126 There is no clear consensus on the politics of the Generation of 1898. Litvak, *op. cit.*, pp. 241–43, cautions against interpreting the 1898 writers as escapists or reactionaries, noting that their "dream of Arcadia" registered a deep social commitment. Emphasizing their utopian faith in a better world, Litvak does, however, acknowledge that they were "bourgeois at heart." More sensitive to the class position of the individual members of the Generation of 1898 and their subsequent move to the political right is Donald Shaw, *op. cit.*, who notes in his introduction Unamuno's, Azorín's, and Maeztú's

progressive disillusionment with the class struggle. Rosa Rossi, "El 98. Crisis de la conciencia pequeñoburguesa," in Mainer, *op. cit.*, pp. 17–20, defines the petty-bourgeois attitude of the Generation of 1898 in its nostalgia for pre-industrial modes of production, static social relations, and in its essentialist nationalism. Most of the writers of the Generation of 1898 came from the ranks of shopowners, merchants, and small businessmen, although Azorín was the son of a prosperous vineyard owner from the province of Alicante.

127 André Malraux, *Picasso's Mask*, trans. June and Jacques Guicharnaud (New York: Holt, Reinhart, and Winston, 1976), pp. 10–11.

128 Rubin, "The Genesis of *Les Demoiselles*," pp. 99–100, questions whether Picasso would have known in 1907 that Manuel Cossío was about to retitle El Greco's *Sacred and Profane Love* as *The Opening of the Fifth Seal*, thereby casting a shadow of doubt on Richardson's interpretation of the *Demoiselles* as an "Apocalyptic Whorehouse."

129 Roger Allard, "Sur quelques peintres," *Les Marches du Sud-Ouest* (Paris), June 1911, cited in Edward Fry, *Cubism* (New York and Toronto: Oxford University Press, 1966/1978), p. 64. In this text, Allard sought to distinguish the work of Picasso from that of the Salon Cubists, despite connections that their contemporaries perceived among them. In a 1919 article that has been attributed to Allard, the author suggests that Picasso's relation to the Spanish tradition is a question of intuition and temperament, rather than of form and style: "It may well be thought that the air of Paris has saved M. Picasso from the common fate of Spanish painters of his generation, who subsist as best they can on the appearance and outward form of a tradition no longer sustained by custom or belief. Our changing sky prompts him to change his own manner and style as often as necessary, while the clothing has never disguised the material quality of his temperament, which is of the highest order" ("Picasso," *Le Nouveau Spectateur*, no. 4 [25 June 1919], pp. 61–62, 68–70, excerpted and translated in McCully, *A Picasso Anthology*, pp. 132–33, 135).

3 The Spanishness of Picasso's Still Lifes

The Spanishness of Picasso and the national flavors of Cubism are topics that have long fascinated me and that I first approached in my *Cubism and Twentieth-Century Art* (New York: Harry N. Abrams, Inc., 1960). I was happy, therefore, to have the opportunity to rework this material in a more focused way for a slide lecture first presented on 29 February 1992 at a symposium occasioned by the opening of the exhibition *Picasso and Things* at the Cleveland Museum of Art. As it turned out, Jean Sutherland Boggs's magisterial catalogue, which greeted me at the opening, proposed and often amplified richly many of the Spanish connections I offered in my lecture. If her essays and copious catalogue entries rendered some of my points redundant, at least they confirmed my own view of the impor-

tance of Spain for Picasso's art. I hope my indebtedness to her work is apparent in the notes that follow.

1 *Exposition Chardin et Fragonard*, Paris: Galerie Georges Petit, 1907.

2 See Jean Sutherland Boggs, *Picasso and Things* (Cleveland: The Cleveland Museum of Art, 1992), no. 11.

3 See William Rubin, *Picasso in the Collection of the Museum of Modern Art* (New York: Museum of Modern Art, 1972), p. 48.

4 For more on this inevitable eighteenth-century comparison, see Eleanor Tufts, *Luis Meléndez: Eighteenth-Century Master of the Spanish Still Life* (Columbia: University of Missouri Press, 1985), pp. 48–49. Further connections between Picasso's *Fruit and Glass* and Spanish still-life painting are suggested by Boggs (*op. cit.*), who compares it with a detail of two pears on a table in Zurbarán's *Holy House of Nazareth* (Cleveland Museum of Art).

5 On this painting, see William Jordan, *Spanish Still Life in the Golden Age, 1600–1650* (Fort Worth: Kimbell Art Museum, 1985), p. 125, no. 12.

6 The comparison with Zurbarán was made even by Picasso, who, on seeing Gris's portrait of his wife, Josette (1916), remarked, "It's far more beautiful than Zurbarán." See John Richardson, "Juan Gris en Suisse," *XXe Siècle*, no. 6 (January 1956), p. [64].

7 Especially in the years 1916–17. For the fullest treatment of this period. see Ramón Favela, *Diego Rivera: The Cubist Years* (Phoenix: Phoenix Art Museum, 1984).

8 I have elaborated on this Spanish populist color in Gris's work in "Cubism as Pop Art," in Kirk Varnedoe and Adam Gopnik, eds., *Modern Art and Popular Culture* (New York: Harry N. Abrams, Inc., 1990), p. 124.

9 William Rubin, *Picasso and Braque: Pioneering Cubism* (New York: The Museum of Modern Art, 1989), p. 419.

10 *Ibid.*, p. 399.

11 For the most detailed account of this painting, including its date, see now Boggs, *op. cit.*, no. 30, as well as Pierre Daix and Joan Rosselet, *Picasso: The Cubist years, 1907–1916* (Boston: New York Graphic Society, 1979), no. 476.

12 On these three oval paintings, see Daix and Rosselet, *op. cit.*, nos. 463–65; and Boggs, *op. cit.*, no. 28.

13 In Nochlin's important article, "Picasso's Color: Schemes and Gambits," *Art in America* 68, no. 10 (December 1980), pp. 105–23, 177–83.

14 *Ibid.*, pp. 115ff.

15 To my knowledge, Boggs (*op. cit.*, no. 30) was the first to discern this as a paint brush, although Daix and Rosselet (*op. cit.*, no. 476) read it as a pen with a nib, which would relate it to the letter written to Picasso's father on the table (left center). In either case, brush or pen, this object is associated with a personal signature and handwriting.

16 See Rubin, *Picasso and Braque*, p. 399.

17 This glossy enamel commercial paint, as pointed out by Daix and Rosselet (*op. cit.*), produces a flat, opaque effect,

analogous to collage. As Picasso reported on 17 June 1912, one of his earliest supporters, the German critic and collector Wilhelm Uhde, did not like these "recent paintings where I use Ripolin and flags" (Rubin, *Picasso and Braque*, p. 395). For Uhde they must have marked an abrupt shift from the flickering chiaroscuro style which Picasso had used for his portrait some two years earlier (Winter 1909–10).

18 On the *Fêtes de Céret*, see Daix and Rosselet, *op. cit.*, no. 473; and also Nochlin, *op. cit.*, pp. 112–13, who links this with the *Spanish Still Life* as an indication of Picasso's symbolic bi-nationalism at this time.

19 To my knowledge, the presence of this Catalan flag, the more regional counterpart of the Spanish flag on the ticket to the bullring, has not been noticed before. It offers a precocious example of the welling Catalan nationalism that would soon become conspicuous in Miró's work.

20 A very early use of the pattern of the Catalan flag joined to the French tricolor is found in Miró's poster project of 1919 for the Paris–Barcelona review *L'Instant* (reproduced in color in *Homage to Barcelona*, London: Hayward Gallery, 1985, fig. 274); but this reaches more personal dimensions in *The Tilled Field* (1923–24; New York, Solomon Guggenheim Museum), with its profusion of Catalan, Spanish, and French flags. As for the red-and-yellow color scheme in Miró, it is ubiquitous, especially in the combination of a yellow ground and a strong red sun, but can be found in its most abstract form in the untitled painting of January–April 1930 in the Menil Collection, Houston.

21 As disclosed in the pivotal article by Theodore Reff, "Picasso's *Three Musicians*: Maskers, Artists & Friends," *Art in America* 68, no. 10 (December 1980), pp. 125–42.

22 For example, Boggs, *op. cit.*, nos. 91–93.

23 I pointed out this color symbolism in "Picasso's *Girl before a Mirror*: Some Recent Reflections," *Source* 1, no. 3 (Spring 1982), pp. 1–4.

24 Most conspicuously in *The Dream*, 24 January 1932, New York, Collection Ganz.

25 See Boggs, *op. cit.*, no. 101.

26 For the fullest account of this painted memorial, see Elizabeth Cowling and John Golding, *Picasso: Sculptor/Painter* (London: Tate Gallery, 1994), no. 114.

27 These drawings are illustrated in Boggs, *op. cit.*, figs. 30a and 30b.

28 See *ibid.*, p. 44.

29 For this information, I am indebted to my student Margaret Oppenheimer, who, luckily for me, was working in the ceramic collection of the Hispanic Society of America when my question came up.

30 See Boggs, *op. cit.*, no. 3. A third example of a still life with *porrón* is Zervos 32:342. It should be added that Picasso's choice of a *porrón* might also be interpreted as part of the beginning of his long rivalry with Matisse, who, in two still lifes of 1904, had included a *purro*, the Provençal version of this drinking vessel. See Jack Flam, *Matisse, the Man and his Art, 1869–1918* (Ithaca and

London: Cornell University Press, 1986), pp. 110 and 121.

31 The phallic character of the *porrón* in these scenes of male and female nudes was first explored by Leo Steinberg in "The Philosophical Brothel, Part 1," *Art News* 71 (September 1972), pp. 25–26, reprinted, with revisions, in *October* 44 (Spring 1988). Steinberg also points to the *porrón* in *Three Nudes*, a gouache of 1906 which again presents this drinking vessel as a male attribute in an erotic context (Zervos 32:340).

32 For the fullest account of the painting's title, with its layers of allusion, from Avignon itself to Barcelona, see William Rubin, "The Genesis of *Les Demoiselles d'Avignon*," in *Les Demoiselles d'Avignon*, Studies in Modern Art 3 (New York: The Museum of Modern Art, 1994).

33 I have discussed the analogies between these still lifes by Ingres and Picasso in "The 'Demoiselles d'Avignon' Revisited," *Art News* 72 no. 4 (April 1973), pp. 45–48.

34 This particularly Spanish symbolism is fully treated in Suzanne L. Stratton, *The Immaculate Conception in Spanish Art* (Cambridge: Cambridge University Press, 1994).

35 "Picasso's Apocalyptic Whorehouse," *New York Review of Books* 34, no. 7 (23 April 1987), pp. 40–47.

36 In *Picasso: Fifty Years of His Art* (New York: The Museum of Modern Art, 1946), p. 256.

37 For the provenance, see Harold E. Wethey, *El Greco and His School*, vol. 2 (Princeton, N.J.: Princeton University Press, 1962), p. 5.

38 See, for example, John Richardson (with the collaboration of Marilyn McCully), *A Life of Picasso*, vol. 1, *1881–1906* (New York: Random House, 1991), chapter 5 (on Picasso's early religious paintings) and chapter 23 (on Jarry's influence).

39 For an account of these misidentifications and reproductions of Picasso's explanatory drawings, see Rubin, *Picasso in the Collection of the Museum of Modern Art*, pp. 62, 204; and more recently, Boggs, *op. cit.*, no. 19.

40 Robert Lubar kindly called my attention to the *botijo* in Miró's *Nord-Sud* (1917). For this and other Miró still lifes of 1916–17 with Spanish motifs, including a *porrón*, see Jacques Dupin, *Miró* (New York: Harry N. Abrams, Inc., 1994), figs. 53–55.

41 See Ramón Favela, *Diego Rivera: the Cubist Years* (Phoenix: Phoenix Art Museum). A bottle of Anis del Mono turns up, too, in two later Rivera still lifes of 1915 (*ibid.*, pp. 82, 103).

42 See Douglas Cooper, *Juan Gris: Catalogue Raisonné*, vol. 1 (Paris: Berggruen, 1977), no. 104.

43 See, for example, his *Kiosko de Canaletas* (1918), illustrated in Waldo Rasmussen, ed., *Latin American Art of the Twentieth Century* (New York: The Museum of Modern Art, 1993), p. 181.

44 See Boggs, *op. cit.*, nos. 62, 63.

45 The mysteries of this still life, one of the most symbolically charged from the Cubist years, have begun to be disclosed in Boggs's discussion (*ibid*), but need further elucidation. I disagree with her identification of the

form at the left as a bottle and scallop shell, and see it rather as a bunch of grapes (with the silhouette of the stem above). Moreover, I believe the glass at the right is topped by an absinthe spoon with a sugar cube, as in the famous sculpture of 1914. The French laws of 1914–15 banning absinthe (a menace to the nation's health, especially that of its male youth at the beginning of the First World War) may be woven into this pervasively lethal imagery. The blue silhouette of a bird, incidentally, is a remarkable preview of the phantom birds that float through Braque's late work.

46 For more on this, see Mark Rosenthal, "Juan Gris, en la ventana abierta," in *Juan Gris {1887–1927}*, (Madrid: Biblioteca Nacional, 1985), p. 59.

47 I originally pointed out this generic source in *The Sculpture of Picasso* (New York: The Pace Gallery, 1982), p. 6, and later expanded the point in "Cubism as Pop Art," p. 126.

48 On this bronze *Bouquet of Flowers*, which includes two commercial tin molds transformed into flowers, see Boggs, *op. cit.*, no. 134.

49 The connection between this story by Nicolás María López and Picasso's metamorphic guitars is made by John Richardson, *A Life*, p. 186.

50 See Boggs, *op. cit.*, no. 84.

51 For more illustrations of these *trompe l'oeil* still lifes, see Ramón Torres Martín, *La naturaleza muerta en la pintura española* (Barcelona, 1971), pls. 46–52.

52 In *Cubism and Twentieth-Century Art*, p. 94.

53 This identification is fully treated in Lewis Kachur, "Picasso, popular music and collage Cubism (1911–12)," *Burlington Magazine* 135, no. 1081 (April 1993), pp. 252–60.

54 *Ibid.*, fig. 7.

55 It first appears in autumn 1911, at the same time as Picasso's *Man with a Clarinet* (see *ibid.*, fig. 6), suggesting that Braque, like Picasso, had a *tenora* at hand for his works of the next few years.

56 On this painting, see *Pintura española de bodegones y floreros de 1600 a Goya* (Madrid: Museo del Prado, 1983–84), no. 47, where its earlier attribution to Alonso Vázquez (see Torres Martín, *op. cit.*, p. 65) is disputed.

57 On this Pereda, see the full discussion in Jordan, *op. cit.*, no. 41.

58 On Cézanne's skulls, see especially Theodore Reff, "Cézanne: The Severed Head and the Skull," *Arts Magazine* 58, no. 2 (October 1983), pp. 84–100.

59 For a selection of these late paintings and watercolors of skulls, see William Rubin, ed., *Cézanne: The Late Work*, (New York: The Museum of Modern Art, 1977), pls. 152–59.

60 The richest treatment of this topic is found in Leo Steinberg, "The Skulls of Picasso," *Art News* 70, no. 6 (October 1971), pp. 26–8, 73–6, reprinted in *idem, Other Criteria: Confrontations with Twentieth-Century Art* (New York: Oxford University Press, 1972), pp. 115–23.

61 In the famous painting in the Iglesia de la Santa Caridad, Seville.

62 See Boggs, *op. cit.*, no. 7, for a full discussion of the dating and the speculations about the origins of this still life. She also suggests a Spanish source for it, a still-life detail of skull and books in Zurbarán's *Bishop Gonzalo de Illescas* (1639).

63 I have elaborated on this visual play of skull and words in "Picasso and the Typography of Cubism," in Roland Penrose and John Golding, eds., *Picasso 1881/1973* (London: Elek, 1973), p. 52.

64 Boggs, *op. cit.*, no. 44.

65 There is one odd exception, which may even have triggered Picasso's Cubist *Vanitas*, namely, André Derain's *Still Life with Skull* (1912; St. Petersburg, Hermitage), reproduced in *André Derain: Le Peintre du "trouble moderne"* (Paris: Musée d'Art Moderne de la Ville de Paris, 1994–95), p. 192.

66 Such correlations are suggested *ibid.*, no. 102.

67 Of the infinite allusions in *Guernica*, some of the most important point to Goya's *Executions of May 3, 1808* and Delacroix's depictions of the Greek Wars of Independence and the July 1830 Revolution.

68 "The Skulls of Picasso," p. 74.

69 See Cowling and Golding, *op. cit.*, no. 102. Boggs retains the traditional date, 1943, in her full discussion of the sculpture (*op. cit.*, no. 114).

70 See Françoise Gilot and Carlton Lake, *Life with Picasso* (New York, Toronto, and London: McGraw-Hill, 1964), p. 17. Gilot recounts this story again in her revealing article occasioned by the *Picasso and Things* exhibition, "From Refuse to Riddle," *Art and Antiques* 9, no. 6 (Summer 1992), p. 60.

71 First pointed out by Gilot in *Life with Picasso*, p. 120.

72 In "From Refuse to Riddle," p. 60.

73 See Pierre Gassier and Juliet Wilson, *Goya: His Life and Work* (London: Thames & Hudson, 1971), nos. 903–13. No. 913, a skinned calf's head at the Statens Museum for Kunst, Copenhagen, is noted there as being different from the others; and, in fact, Olaf Koester, the curator, kindly informs me that this is now attributed to an Italian painter, Felice Boselli.

74 I suggested this in 1960 in *Cubism and Twentieth-Century Art*, p. 289.

75 On this painting, see Marilyn McCully, *Picasso: a Private Collection* (London: Cacklegoose Press, 1993), pp. 164–66. Its first owner, Douglas Cooper, referred to the painting as "my Goya."

76 See Boggs, *op. cit.*, no. 105.

77 See McCully, *op. cit.*, p. 166.

78 On this bronze, often dated 1944, see Cowling and Golding, *op. cit.*, no. 105, in which it is pointed out that Picasso himself rejected an overtly religious reading of the sculpture.

79 This telling comparison was made by Boggs, *op. cit.*, no. 104.

80 On the particular brutality of this still life, see my *Cubism and Twentieth-Century Art*, p. 102; and Boggs, *op. cit.*, no. 78, in which the Chardin comparison is made. The motif of animal sacrifice is provocatively treated in

Willard Misfeldt, "The Theme of the Cock in Picasso's Oeuvre," *Art Journal* 28, no. 2 (Winter 1968/69), pp. 146–54, 165.

81 See José López-Rey, *Velázquez: A Catalogue Raisonné of his Oeuvre*, (London: Faber and Faber, 1963), no. 167, in which the similarity to the work of Alejandro de Loarte is pointed out. A more recent attribution of this painting is to Giovanni Battista Recco, a Neapolitan still-life painter who worked in a strongly Spanish mode. See *Painting in Naples 1606–1705: From Caravaggio to Giordano* (London: Royal Academy of Arts, 1982), p. 219; and *Civiltà del Seicento a Napoli* (Naples: Electa, 1984), vol. 1, p. 386.

82 See Boggs, *op. cit.*, no. 142.

83 On the *Charnel House*, see Rubin, *Picasso in the Collection of the Museum of Modern Art*, pp. 166–69, 236–41, in which my suggestion of the Goya source is also illustrated (p. 238, no. 7).

4 *Picasso and the French Post-war "Renaissance"*

This paper would not have been possible without the support of the co-authors of this volume. I thank Susan Galassi, Robert Lubar, and Robert Rosenblum for their comments, and I am particularly indebted to Jonathan Brown for his untiring editorial advice. The research for this project is part of the work for my forthcoming doctoral thesis, *Picasso and the Parti de la Renaissance Française: The Artist as a Communist, 1944–1953*, for the Institute of Fine Arts, New York University. I want to thank Kirk Varnedoe, my thesis advisor, and William Rubin for their continuing support, help, and encouragement. And I am indebted to Tony Judt for significantly enlarging my perspective on the historical and cultural background of the 1940s and '50s in France by permitting me to follow his seminars in European history at New York University. I want also to express my gratitude to the librarians and curators of the Musée Picasso in Paris—and in particular to Brigitte Léal—for their invaluable help and friendship. And I owe special thanks to the librarians of the Museum of Modern Art and the Metropolitan Museum in New York for their nurturing assistance.

1 The *Antipolis* series is housed today at the Château Grimaldi, which has been renamed Musée Picasso. For the story of Picasso's involvement with the museum, see: Romuald Dor de la Souchère, *Picasso à Antibes* (Paris: F. Hazan, 1960); *idem*, *Picasso in Antibes* (London: Lund Humphries, 1960), and "Picasso, Antibes," *Little Library* 47 (New York: Tudor Publishing, 1962), n.p. For the catalogue of its collection of works by Picasso: Danièle Giraudy, *L'Oeuvre de Picasso à Antibes* (Antibes: Musée Picasso, 1981). See further: Paul Eluard, Jaime Sabartés, Michel Sima, *Picasso à Antibes* (Paris: R. Drouin, 1948).

2 Jean Leymarie quoted in Marilyn McCully, "Picasso's Approach to Drawing: The Antipolis Series," *Drawing* 12, no. 3 (September–October 1990), p. 50.

3 Picasso's quotation: "les oeuvres naissent selon les moments, les lieux et les circonstances" is cited in Jean Leymarie, *Picasso: Métamorphoses et unités* (Geneva: Skira, 1971), p. 141.

4 For accounts of Picasso's life during the post-Second World War period and the Occupation, see Françoise Gilot and Carlton Lake, *Life with Picasso* (New York, Toronto, and London: McGraw-Hill, 1964); Michèle Cone, *Artists under Vichy: A Case of Prejudice and Persecution* (Princeton, N.J.: Princeton University Press, 1992); Mary-Margaret Goggin, *Picasso and his Art during the German Occupation, 1940–1944* (Ann Arbor, Michigan: University Microfilms International, Dissertation Information Service, 1988; doctoral thesis for Stanford, University, 1985); Laurence Bertrand Dorléac, *Histoire de l'Art 1940–1944: Ordre National, Traditions et Modernités* (Paris: Publications de la Sorbonne, 1986), now published as *L'Art de la défaite 1940–1944* (Paris: Éditions du Seuil) 1993. My notes relate to the earlier version. See also Siegfried Gohr, ed., *Picasso im Zweiten Weltkrieg 1939 bis 1945* (Cologne: Museum Ludwig, 1988); Ludwig Ullmann, *Picasso und der Krieg* (Bielefeld: Karl Kerber Verlag, 1993); as well as the relevant chapters in Pierre Daix, *Picasso Créateur: La vie intime et l'oeuvre* (Paris: Éditions du Seuil, 1987), in translation by Olivia Emmet, *Picasso: Life and Art* (New York: Harper Collins Publishers, 1993); Pierre Cabanne, *Le Siècle de Picasso*, vol. 3, *Guernica—la guerre*, and vol. 4, *La gloire et la solitude* (Paris: Denoël/Gonthier, 1975), in translation by Harold J. Salemson, *Pablo Picasso: His Life and Times* (New York: William Morrow and Co., 1977); Roland Penrose, *Picasso: His Life and Work* (Berkeley and Los Angeles: University of California Press, 1958, 1962, 1971, 1981); and the chronology by Jane Fluegel in William Rubin, ed., *Pablo Picasso: A Retrospective* (New York: Museum of Modern Art, 1980).

5 Picasso had visited Matisse, who had spent the war years in the hills behind Nice, earlier that year.

6 Ramón Reventós, with engravings by Pablo Picasso, *Dos Contes* (Paris, Barcelona: Editorial Albor, 1947). See John Richardson, "Picasso y Ramón Reventós: El orígen Catalán de Antipolis," in *Picasso Clásico* (Málaga: Palacio Episcopal, 1992), pp. 155–71. See also Sebastien Goeppert, Herma Goeppert-Frank, and Patrick Cramer, *Pablo Picasso: Catalogue Raisonné des Livres Illustrés* (Geneva: Patrick Cramer, 1983), nos. 43, 44, 45.

7 See, in particular, Kenneth E. Silver, *Esprit de Corps: The Art of the Parisian Avant-Garde and the First World War, 1914–1925* (Princeton: Princeton University Press, 1989); and his "Der politische Bezug in Picasso's Neoklassizismus," in Ulrich Weisner, *Picassos Klassizismus: Werke 1914–1934* (Bielefeld: Kunsthalle Bielefeld and Stuttgart: Edition Cantz, 1988), pp. 77–88; Marilyn McCully, "Noucentisme: Picasso, Junoy und der Klassizismus von Barcelona," in Weisner, *op. cit.*, pp. 43–50; Robert S. Lubar, review of Patricia Leighten, *Re-Ordering the Universe: Picasso and Anarchism, 1897–1914*, in *Art Bulletin* 72, no. 3 (September 1990), pp. 505–10.

8 Picasso was a subscriber to the clipping service "Lit Tout," the files for which can be found in the archives of the Musée Picasso in Paris. For James Lord's recollections, see James Lord, *Picasso and Dora: A Memoir* (New York: Farrar Strauss Giroux, 1993), p. 58.

9 Gertrude Stein, *Picasso* (London: B.T. Batsford Ltd., 1938, and New York: Dover Publications, Inc., 1984), p. 20; Wilhelm Uhde, *Picasso et la tradition française: Notes sur la peinture actuelle* (Paris: Édition des Quatre Chemins, 1928), p. 24; Jean Cocteau, *Picasso* (Paris: Stock, 1923), p. 11; *Entre Picasso et Radiguet* (Paris: Hermann, 1967), p. 115: "Picasso est de chez nous. Il a mis toutes les forces, toutes les ruses de sa race à l'école, au service de la France." James D. Herbert, *Fauve Painting: The Making of Cultural Politics* (New Haven and London: Yale University Press, 1992), p. 212, says that "chez nous" does not mean being one of us, but Cocteau says "de chez nous" and that means precisely one of us.

10 Herbert *Fauve Painting, op. cit.*, p. 181; and his "Matisse without History," *Art History* 11, no. 2 (June 1988), pp. 297–302.

11 Tony Judt, *Un Passé Imparfait: Les Intellectuels en France 1944–1956* (Paris: Librairie Arthème Fayard, 1992), chapter 12, "Le libéralisme, voilà l'ennemi," pp. 272, 273, 297; published in English as *Past Imperfect: French Intellectuals 1944–1956* (Berkeley and Los Angeles: University of California Press, 1992). Citations from Judt in this chapter are from the French edition. Nicholas Hewitt, "Les Lettres Françaises and the Failure of the French Postwar 'Renaissance,'" in *The Culture of Reconstruction: European Literature, Thought and Film, 1945–1950* (London: Macmillan, 1989), p. 120; Pascal Ory and Jean-François Sirinelli, *Les Intellectuels en France de l'Affaire Dreyfus à nos Jours* (Paris: Armand Colin, 1986). According to Kirk Varnedoe, the same occurred after the Franco-Prussian war of 1870–71.

12 Martin Brionne, "La Peinture: de quelques équivoques," *Esprit*, no. 1 (1945), p. 134: "Si profondément a été remué cette nation, qu'elle ne parvient pas à isoler des évènements politiques les aventures spirituelles ou artistiques qu'elle découvre en même temps." See also André Lhote, "Un éternel malentendu," *Les Lettres Françaises*, 28 October 1944.

13 P.V., "Peinture et Politique," *L'Éclair*, 19 February 1946: "Notre aimable confrère *La Nation*, dans un papier où, déballant tout son arsenal de bataille, se trouvent curieusement mêlés la peinture, 'les trusts,' *L'Aurore*, *L'Époque*, le Vatican, Pétain, les 'fascistes portugais', Clément Vautel, Camille Mauclair, et la propagande de Goebbels, s'en prends à nous parce que nous avons, parait-il, mal parlé de Picasso. . . ."

14 Already during the Occupation the lines of demarcation between Right and Left had been blurred in the cultural field, inasmuch as Resistance fighters and Vichy supporters alike had claimed the continuity of the past and had based their ideas for the future on the French cultural tradition. See Hewitt, *op. cit.*, p. 120.

15 André Fermigier, *Picasso* (Paris: Librairie Générale Française, 1969), p. 157; quoted in Linda Nochlin, "Picasso's Color: Schemes and Gambits," *Art in America*, no. 10 (December 1980), p. 117.

16 Paul Eluard wrote to Roland Penrose that Picasso was "un des rares peintres à se conduire comme il faut . . . ," cited in Cabanne, *op. cit.*, vol. 3, p. 142; Brassaï, *Conversations avec Picasso* (Paris: Gallimard, 1964), p. 209; Louis Parrot, "Hommage à Picasso, qui vécut toujours de la vie de la France," *Les Lettres Françaises*, 9 September 1944, p. 8; *idem*, "Homage to Pablo Picasso", *Tricolor* 2, no. 10 (January 1945), pp. 78–80: "By his mere presence among us, he restored hope to those who were coming to doubt our chances of salvation." Jean Weinberg, "Peintres Étrangers, Peinture Française", *Unir*, 28 October 1944: "La France libre a répondu simplement en faisant du peintre de *Guernica* le symbole de la peinture sans chaines". According to all accounts—contemporary reports as well as recent scholarship—Picasso had distinguished himself through uncompromising behavior. Any rumors casting doubt on Picasso's behavior during the Occupation, referring in particular to his relations with the Germans, have never been substantiated, except for three rather innocent encounters. For references, see my note 4, above.

17 For the after-life of the spirit of the Resistance, the development of the "myth," and its identification with France, see Henry Rousso, *Le Syndrome de Vichy de 1944 à nos jours* (Paris: Éditions du Seuil, 1987).

18 For the Communists' self-assigned role in the post-war revival of France, see Georges Cogniot and Roger Garaudy, *Les Intellectuels et la Renaissance Française* (Paris: Éditions du Parti Communiste français, 1945); and Roger Garaudy, *Le Communisme et la Renaissance de la Culture Française*, (Paris: Éditions Sociales, 1945). According to the historian Annie Kriegel, the Communists were the first fully to seize upon the political power of culture. For the relations between the French intellectuals and the Communist party in the post-Second World War era, see her *Ce que j'ai cru comprendre* (Paris: Robert Laffont, 1991); Judt, *op. cit.*; David Caute, *Communism and the French Intellectuals 1914–1960. Western Europe* (New York: Macmillan, 1964); Ariane Chebel d'Apollonia, *Histoire Politique des Intellectuels en France 1944–1954* (Paris: Éditions Complexe, 1991). More specifically on the role art played in Communist party politics: Jeannine Verdes-Leroux, "L'Art de Parti. Le Parti Communiste et ses Peintres 1947–1954," *Actes de la Recherche en Sciences Sociales* (Paris), no. 28 (June 1979); *idem, Au service du Parti* (Paris: Fayard/Minuit, 1983); Dominique Berthet, *Le P.C.F., la culture et l'art* (Paris: La Table Ronde, 1990); Sarah Wilson, "Art and the Politics of the Left in France, ca. 1935–1955" (unpublished Ph.D. thesis, Courtauld Institute of Art, University of London, 1992).

19 Judt, *op. cit.*, pp. 283–88: "francité, une identité à laquelle on prêtait une supériorité morale qui

compensait les aspects les plus ténébreux de l'histoire récente." See also his chapter on *francité*, "Gesta Dei per Francos. La francité des intellectuels français," pp. 291–324.

20 See photos of Picasso surrounded by members of the Front nationale des intellectuels at the Père-Lachaise cemetery in *Le Patriote* (15 October 1944) and with the Front national universitaire at a memorial for the victims of Fascism in October 1944 (photo Roger-Viollet, in *L'Histoire*, October 1988, p. 75). Picasso was also seen among those who presided at the party's reception for Marcel Prenant, eminent member of the Resistance, at his liberation from German captivity (*Humanité*, 22 June 1945).

21 This album, entitled *Florilège des Poètes et Peintres de la Résistance*, had gathered contributions from the most representative personalities of French intellectual life and of the Resistance (*Ce Soir*, 9 October 1944).

22 Alain Giry, "La Nouvelle Abstraction et la critique de l'Humanité, 1945–1951," in Université de Saint-Étienne, *Art et Idéologies, l'art en occident 1945–1949* (Saint-Étienne: Centre Interdisciplinaire d'Études et de Recherche sur l'Expression Contemporaine, 1976), p. 136.

23 André Fougeron in a conversation with the author. Fougeron, who was the General Secretary of l'Union des arts plastiques, became the Communist party's most devoted and most sectarian adherent of Socialist Realism. For information on Fougeron, see Anatole Jacovsky, "Quelques mots sur quelques tableaux d'André Fougeron," *Le Point*, no. 36 (1947); Louis Aragon, Introduction, *Album de dessins* (Paris: Édition 13 épis, 1947); J. Rollin, *André Fougeron* (Berlin: Hentschel, 1972); Simone Flandin, "André Fougeron: Le parti-pris du réalisme 1948–1953" (Clermont-Ferrand, unpublished M.A. thesis, University of Clermont-Ferrand, 1982); Galérie Jean-Jacques Dutko, *André Fougeron; pièces détachées 1937–1987* (Paris: Éditions Person, 1987); Boris Taslitzky, *Fougeron; de 1936 à aujourd'hui* (Gentilly, Val-de-Marne: Musée de la Résistance Nationale, 1992); see also Dorléac, *op. cit.*, pp. 280, 382, and Wilson, *op. cit.*, *passim*.

24 The political motivations behind the selection for their exhibitions did not escape public attention; see, for example, René Guilly, "Résistance et art officiel," *Juin*, 23 July 1946, who accused the organization of claiming to present the true face of French art but of showing instead a rather grotesque mask.

25 On the Union des arts plastiques and the Front national des arts, see Dorléac, *op. cit.*, pp. 279, 280, and Wilson, *op. cit.*, pp. 267, 280. The Front national des arts was superseded in 1946 by the Union des arts plastiques and was a branch of the Communist-run Union nationale des intellectuels.

26 Like most of the exhibitions destined to show French art abroad, the *Picasso and Matisse* exhibition in December 1945 at the Victoria and Albert Museum, London, was organized by the Association française d'action artistique. Subsidized by several ministries, such as Les Affaires étrangères (State Department), it was in charge of propagandizing French theater, music, and art outside France. Other official exhibitions in which Picasso participated in 1945 and 1946 were a showing of contemporary French painting in Brazil; *La Peinture française de David à Picasso* in Liège, Belgium (*Le Parisien Libéré*, 20 June 1946); and *Peintres français d'aujourd'hui* in Venice, Rome, and Milan. For an exposé of the aims of this organization, see *Ce Matin*, 13 May 1947. When the UNESCO organized an international exhibition of contemporary art in November–December 1946, Jean Cassou, the newly reinstated director of the Musée National d'Art Moderne, requested Picasso's presence within the French section of the show. Picasso was, however, shown among the Spaniards of Paris within the French section.

27 Jean Cassou, *Une Vie pour la liberté* (Paris: Éditions Robert Laffont, 1981).

28 As member of the board of directors of the *Encyclopédie de la Renaissance Française*, Picasso attended the official announcement of the project. Roger Garaudy, member of the Central Committee of the French Communist party, in his role as Secretary General declared the aims: 'Nous voulons prouver la continuité de la grandeur spirituelle de la France" (*Les Étoiles*, 24 July 1945); Noel Sabord, "Émule de Diderot, M. Langevin annonce l'Encyclopédie de la Renaissance Française," *Ici Paris*, 20 June 1945.

29 The Maison de la Pensée française had developed from the pre-war concept of the Maison de la Culture. According to Solange Bouvier-Ajam ("Picasso et la Maison de la Pensée," *Europe*, special edition, "Picasso," April–May 1970, pp. 71–75), La Maison de la Pensée française could not have survived without the moral, artistic, and financial support of Picasso. Picasso exhibited in its space five times between the years 1948 and 1958. During those years the organisation occupied a beautiful building opposite the Elysée palace but had no money for installation, lighting, let alone a catalogue. In fact, the exhibitions were published in the *Cahiers d'Art*. For one of his exhibitions there in 1954, *Oeuvres des Musées de Leningrad et de Moscou*, Picasso managed to obtain the release of his paintings from the Soviet Union, from the Hermitage and the Pushkin Museum. The show however was short-lived. Sergei Shchukin's daughter claimed her rights to the collection and the government recalled the paintings to the Soviet Union.

30 One of Cassou's lectures, entitled "C'est tout l'esprit français qui anime et explique la peinture française," took place on Thursday, 12 February 1946 in Montbrison, Loire. See also the series of lectures on Picasso by the Abbé Morel given throughout France, as well as abroad. The most famous of those lectures, at the Sorbonne in February 1946, took place with Picasso and Eluard on the platform (Jean d'Esme, "Propagande à

31 rebours," *Ce Matin*, May 1947; V.M.S., "Clefs de Picasso," *Confluences*, no. 10 [April 1946]).

31 Lucien Schultz, "En écoutant Jean Cassou," *L'Essor de Saint-Etienne*, 20 February 1946.

32 See n. 33, below; see also Wilson, *op. cit.*, pp. 260, 278, n. 122. On the post-war purge of collaborators, see Rousso, *op. cit.*, pp. 66, 346, and, more particularily, his "L'épuration en France, une histoire inachevée," *Vingtième Siècle* January–March 1992; Pierre Assouline, *L'Épuration des intellectuels* (Brussels: Édition Complexe, 1985); Jean-Pierre Rioux, *The Fourth Republic* (Cambridge and New York: Cambridge University Press, 1987); Anne Simonin and Hélène Clastres, *Le Débat: Les idées en France, 1945–1988. Une chronologie* (Paris: Gallimard, 1989). The Communist contemporary press is full of the heated debate surrounding the issue; see, for example, *L'Humanité* and *Les Lettres Françaises* and the polemic in February 1945 between Albert Camus in *Combat* and François Mauriac in *Le Figaro*.

33 The meeting took place on 3 October 1944, the eve of Picasso's official admittance into the French Communist party ("Épuration dans les Arts," *Franc-Tireur*, 6 October 1944; "Arrêtera-t-on les sept pèlerins?" *France Libre*, 5 October 1944). The related documents are in the archives of the Musée Picasso in Paris. See also Wilson, *op. cit.*, p. 264. André Fougeron, the group's General Secretary, told me in an interview that he did not recall whether Picasso was actually present at the meeting. It is known, however, from a number of published interviews in late 1944 and early 1945, that Picasso gave free rein to his call for retribution (Peter Whitney, *San Francisco Chronicle*, 3 September 1944; Lee Miller, *Vogue* 104, no. 7 [15 October 1944], p. 149).

34 In 1947, when the French Embassy in London protested Dunoyer de Segonzac's nomination to the Royal Academy in London, because of his pro-German wartime record, Picasso was suspected to be the originator of the accusations (Léon Gard, "Les Artistes de France ont-ils la parole", *Apollo*, 1 May 1947; "Fallait pas qu'il y aille. . . . Et Dunoyer de Segonzac accuse Picasso," *Aurore*, 6 May 1947).

35 In the literature on Picasso it is often asserted that Picasso was the first foreign artist to have been singled out for a retrospective in the *cadre* of the Salon d'Automne. However, at least two previous examples can be found in the 1908 retrospective of El Greco's work and of the work of Sir Francis Seymour-Haden in 1907. I thank Robert Lubar for having drawn my attention to the El Greco exhibition.

36 Brionne, *op. cit.*, p. 135.

37 Paul Eluard, "Promesse inoui," and "Le plus grand des peintres aujourd'hui vivants, Picasso a apporté son adhésion au Parti de la Renaissance française," *l'Humanité*, 5 October 1944, p. 1; L.P. "Picasso au Salon," *L'Humanité*, 7 October 1944, p. 1; Louis Parrot, "Picasso au Salon," *Les Lettres Françaises*, 7 October 1944, claiming once again that it was "only fitting that the artists of Paris who helped liberate the capital should have thought to honor the painter who most efficiently had symbolized the spirit of the Resistance"; Jacques Gabrile, who reports on the exhibit for *Ce Soir*, exults that Picasso's true place is not in a temporary exhibition, however prestigious, but in the Louvre amongst his peers (9 October 1944).

38 For the details on the scandal surrounding Picasso's presence at the Salon, see: "Un essai de sabotage absurde au Salon d'Automne," *Le Parisien Libéré*, 10 October 1944; "Scandale au Salon," *Libération*, 10 October 1944; "A 'Tokio' Picasso provoque une insurrection," *Aurore*, 10 October 1944; J.B., "Au Salon d'Automne on avait volé trois Picasso," *Ce Soir*, 10 October 1944; Sherry Mangan, "L'Affaire Picasso", *Time Magazine*, 30 October 1944, p. 78; G.H. Archambault, "Picasso. The painter who defied the Germans finds himself the hero of a revolutionary mood," *New York Times Magazine*, 29 October 1944, pp. 18,19,39; Alfred H. Barr, Jr., "Picasso 1940–1944. A digest with notes," *Museum of Modern Art Bulletin* 12, no. 3 (January 1945), p. 6; Gwen Harrison, "L'affaire Picasso," *Maelström* 1, no. 2 (Summer 1945), pp. 13–15; Gilot and Lake, *op. cit.*, p. 61; André Fermigier, "La gloire de Picasso", *Revue de l'Art* 1–2 (1968), pp. 114–22.

39 Weinberg, "Peintres Étrangers, Peinture Française."

40 P.L. Pamelard, "Est-ce une fesse ou un macaron?" *Nouvelle Jeunesse*, 13 October 1944.

41 J.B., "Au Salon d'Automne on avait volé trois Picasso," *Ce Soir*, 10 October 1944; André Lhote, "Quand les 'collaborateurs' se font critiques d'art," *Les Lettres Françaises*, 14 October 1944; Aspirant Campouro, "Mon camarade Picasso," *En avant F.F.I.*, 4 November 1944: "Le chahut du Salon d'Automne nous rappele trop certaines pillages de magasins juifs et l'épuration 'intelligente' de l'art, trop la conception hitlérienne de la liberté, pour que notre attention ne soit éveillé."

42 "Picasso et le C.N.E.," *Les Lettres Françaises*, 21 October 1944, p. 7, equates the action of the anti-Picasso protesters with the "procédé de la brutalité physique et d'intimidation qui sont ceux des hitlériens . . . ," and he adds: "de telles manifestations ne peuvent être que le vestige de l'occupation allemande. . . . Nous tenons à dire que directement ou indirectement nous les considerons comme le fait de l'ennemi." (One notable non-Communist among the signatories was François Mauriac.)

43 Hewitt, *op. cit.*, p. 120.

44 Fontanel, "Picasso. . . . J'ai quelques réactions," *Gavroche*, 20 October 1944; Brionne, *op. cit.*, p. 137; "Pablo Picasso au Salon d'Automne," *Fraternité* (Lyon), 18 November 1944: "si c'est d'être fasciste de ne pas aimer cette peinture, et bien je suis fasciste." See also Waldemar George, "L'affaire Picasso," *Opéra*, 17 April 1946: "Il suffit aujourd'hui pour être qualifé de membre de la cinquième colonne, voir d'agent nazi, de mettre en doute le génie transcendant de Picasso!"

45 André Lhote ("Les attractions du Salon d'Automne," *Carrefour*, 30 September 1944) had started the defense before the attack: "Cette nouvelle presse, si elle fait, au nom de la sensibilité française, des réserves sur le cas Picasso, ne pourra nier que le fameux Espagnol joua exactement le role opposé à celui qu'assumait une certaine critique asservie. Il réalisait le contre poison type, le rappel à l'ordre le plus efficace à l'usage des égarés. . . ." Germain Bazin in an article in *L'Amour de l'art* followed the same reasoning when he wrote: "Qui dira pourquoi les 'collaborateurs' se recruitent uniquement parmi les fauves et les réalistes? . . . N'est-ce pas parce que l'abstraction est une position de liberté, qui engage tout l'homme et n'admet aucun pacte avec les puissances?" (in Gérard Monnier, *Des Beaux-Arts aux Arts Plastiques: Une histoire sociale de l'art* [Paris: Éditions la Manufacture, 1991], p. 243). Waldemar George protested: "assimiler l'art abstrait à l'esprit de Résistance est une sinistre duperie" ("Le Salon d'Automne ouvrira le 6 Octobre sans les pèlerins de Munich," *Résistance*, 28 September 1944, pp. 1, 2).

46 Fernand Perdriel, "Portraits Français", *Le Monde Illustré*, 11 August 1945, discussed the exhibition of the same title in the Galerie Charpentier: "Comme nous voici loin de Picasso, de son artificielle et desséchante fantaisie! Comme un Picasso nous apparait en contradiction flagrante avec la lignée de l'art français depuis des siècles! Comme François Mauriac a raison dans sa préface de dénoncer l'art 'déhumanisé'!" See also Jean Texier, "Arlequin révolutionnaire," *Gavroche*, 20 June 1946, pp. 1, 2; *Toujours Paris*, 10 April 1946.

47 *Toujours Paris*, 10 April 1946.

48 Michel George-Michel, "Défense et Illustration de Picasso Monstre Cosmique," *La France au Combat*, 18 April 1946.

49 *Le Monde* quoted in "Les Arts à travers la Presse," *Apollo*, 1 February 1946; see also "Sans-gêne," *Aux Écoutes*, 29 November 1946; Léon Gard, "L'art présenté comme français à l'étranger n'est pas l'art français," *Apollo*, 1 December 1947; Elie Bertrand, "Le spectre nazi a bon dos . . .", *Apollo*, 1 August 1946; Louis Gielly, *Corieux* (Geneva), no. 16 (1946).

50 "D'origine espagnol, on veut en faire le plus grand peintre français de l'époque, voir en lui la synthèse de toutes les qualités de notre art" (*Toujours Paris*, 10 April 1946).

51 Texier, *op. cit.*

52 Gard, "L'art présenté comme français à l'ètranger."

53 George Besson, "La Peinture, Prestige de la France", *Les Étoiles*, 8 July 1946: "C'est au cris 'La France aux Français' que certains quittent l'exposition Picasso [in the Galerie Louis Carré]." The author of the article "Picasso-Braque. Sur la sellette" (*Spectateur*, 18 June 1946) queries why Braque, "peintre français," does not receive the same attention and publicity as Picasso, the Spaniard.

54 Waldemar George, quoted in Herbert, "Matisse without History." See also Bernard Dorival, *Les Etapes de la peinture française contemporaine* (Paris, 1946), pp. 321,322. Gaston Diehl, "Matisse le Classique," *Comœdia*, 12 June 1943, p. 1; Philip James, "Picasso et Matisse à Londres," *L'Arche*, no. 1 (1946), pp. 141-44; *Toujours Paris*, 10 April 1946; Bernard Dorival, "Le Cubisme," *Les Nouvelles Littéraires*, 31 May 1945; *Conférencia*, no. 11, p. 469; Claude Morgan, "Picasso et l'École de Paris," *La Pensée*, 1, no. 1 (Spring 1945), p. 52.

55 Louis Aragon, "Matisse ou la peinture française," *Arts de France* 23-24 (1947), pp. 11-23. See Laurence Bertrand Dorléac on similar attitudes in Aragon's discourse on Matisse during the Occupation (*op. cit.*, p. 281).

56 Besson, *op. cit.*: "Je ne sais si Picasso est Espagnol, Italien, Arabe ou Patagon, juif ou chrétien catholique ou parpaillot. Je sais qu'il est Picasso. Et je ne me suis jamais posé la question: Son oeuvre est-elle française, espagnole, judéo-maçonnique ou soviétique?" I should add here that there was, however, some very astute writing on Picasso's Spanishness that lacked any trace of xenophobia, as, for example, in the texts of Jean Cassou.

57 George-Michel, "Défense et Illustration de Picasso"; Léon Degand, "Les Problèmes de la peinture," *Les Lettres Françaises*, 29 September 1945; *idem*, "Arts Nationaux," *Les Lettres Françaises*, 13 June 1947; *idem*, "L'Explication raciale," *Les Lettres Françaises*, 14 July 1945.

58 Degand "Arts Nationaux"; *idem*, "L'Explication raciale."

59 Bertrand, "Le spectre nazi a bon dos"; *Toujours Paris*, 10 April 1946; "Stimmen gegen Picasso," *Die Tat* (Zürich), 8 June 1946.

60 Waldemar George, "L'Art de Picasso n'est pas français," *Opéra*, 13 March 1946, and the reply by Georges Huisman, "Mais si, Picasso est un peintre français," *Opéra*, 27 March 1946.

61 Christopher Green, "Classicisms of Transcendence and of Transience: Maillol, Picasso and de Chirico," in Elizabeth Cowling and Jennifer Mundy, *On Classic Ground. Picasso, Léger, de Chirico and the New Classicism 1910-1930* (London: Tate Gallery, 1990), p. 269.

62 Lhote, *op. cit.*; Huisman, *op. cit.*

63 Huisman, *op. cit.*: "Prétendre que Picasso n'est pas un artiste français, c'est exclure de notre communeauté artistique, comme au temps de Pétain et d'Hitler, tant de peintres et de sculpteurs de l'École de Paris qui sont venus de quatre coins de l'Europe chercher l'inspiration à Montmartre ou à Montparnasse et qui font rayonner la culture de la France sur leur pays d'origine."

64 Lhote, *op. cit.*, quotes an earlier text by Waldemar George, in which he wrote: "Les conditions morales et politiques d'une nouvelle renaissance artistique ont été réalisées par l'Italie fasciste. La France ne peut tarder à les réaliser."

65 "Maurice Vlaminck vient attaquer dans leurs repaires Parisiens Picasso et Jean-Paul Sartre" (*Samedi Soir*, 11 January 1947).

66 George, "L'affaire Picasso." See also Dorival, "Le Cubisme."

67 George, "Le Salon d'Automne ouvrira le 6 octobre," p. 1.

68 Green, *op. cit.*, p. 279.

69 George, "Le Salon d'Automne ouvrira le 6 octobre," pp. 1, 2; *idem*, "La jeune Peinture Française est-elle vouée à devenir l'art d'un monde sans âme?" *Le Littéraire*, 24 August 1946; idem, "L'art de Picasso n'est pas Français."

70 *Le Journal Officiel*, 19 September 1946, p. 3791.

71 Dorival, *Les Étapes de la Peinture Française Contemporaine*, in particular p. 319: "tous les faits donnent l'impression que l'occident est de nouveau battu par une marée déferlant de l'Est, comme il avait été au premier siècle de notre ère". For his assessment of Picasso as "oriental," see his "Le Cubisme."

72 Herbert, *Fauve Painting*, p. 175.

73 Lucien Farnoux-Reynaud, "Les Fourriers de la Décadence, Pablo Picasso ou La Mort du Scorpion," *Concorde*, 29 August 1946, pp. 1, 5: "puisque le slave et l'espagnol ont mille points communs."

74 The author of an article in *Arts–Beaux Arts* ("Quelques peintres et sculpteurs espagnols de l'École de Paris," 29 June 1945) speaks of the compulsion of some writers on Picasso to point out his "sémito-méditerranéennes" origins: "on a l'habitude de qualifier son cubisme d'espagnol en opposition à celui de Braque reconnu français, mais cet espagnolisme a toujours caché trop d'individualisme pour prétendre être un symbole nationale, et ce n'est guère là qu'une façon détournée de rappeler des origines sémito-méditerranéennes."

75 David Wingeate Pike, *Les Français et la Guerre d'Espagne* (Paris: Presses Universitaires de France, 1975), p. 374.

76 Waldemar George, "Aut César aut nihil, en marge de l'exposition Picasso aux galeries Georges Petit," *Formes*, 25 May 1932, p. 268.

77 Expressionism was seen as the artistic expression of Jews, Slavs, and Spaniards. (Jean Weinberg, "Peintres Étrangers, Peinture Française," *Unir*, 28 October 1944: "Slaves, Espagnols et Juifs s'abandonnent à un plus âpre expressionism.") On the xenophobic attitudes towards the École de Paris between the wars see Romy Golan, "The *Ecole Française* vs. the *Ecole de Paris*: The Debate about the Status of Jewish Artists in Paris Between the Wars," in Kenneth Silver and Romy Golan, *The Circle of Montparnasse: Jewish Artists in Paris 1905–1945* (New York: The Jewish Museum, 1985).

78 Bernard Dorival, *Les problèmes de la peinture française contemporaine*, quoted in Dorléac, *op. cit.*, p. 156.

79 *Ibid*. Picasso himself had been the target of anti-semitic attitudes and remarks. See, for example, René Huyghe, who called Picasso "un Israelite sans attaches" in his *Histoire de l'Art Contemporain* in 1935; cited in Herbert, *Fauve Painting*, p. 180.

80 Waldemar George had published that accusation in 1931 in a two-part article "Ecole Française ou Ecole de Paris," in his magazine, *Formes* and in his book *L'Esprit français et la peinture française*. See also Golan, *op. cit.* Some French critics were ready to recognize the valuable contribution that French painting had received from the foreign painters of the École de Paris. Henri Laugier has called the École de Paris "une de plus grandes gloires de la France," in "Faire l'impossible pour répandre le français dans le monde", *Les Étoiles*, no. 4, 1945. The art critic of the *Franc Tireur* spoke of the "Magnifique affirmation de la vitalité de la peinture française—française même quand elle a pour auteurs le Malagene Picasso, le Bulgare Pascin, le Russe Soutine, l'Italien Modigliani . . ." (30 May 1946). See also Jean Cassou, "La Critique d'Art et la Tradition Française," *Arts/Beaux Arts*, no. 178 (20 August 1948), pp. 1, 5.

81 Louis Gielly, "Les Folies de la Peinture," *Corieux* (Geneva), no. 16 (1946); Michel Florisoone, "L'école de Paris," *France Intérieure*, 16 June 1946: "La cosmopolitisation d'une civilization et sa fixation en un point sont les premiers signes de sa décadence. . . ." The exhibition of School of Paris painters in the gallery Charpentier coincided with an International Conference on Peace in May–June 1946 and has been viewed as a conscious effort to demonstrate the good will of the French towards the people of other nations (Maximilien Gauthier, "Misère et Grandeur de la Saison de Paris," *Gavroche*, 30 May 1946).

82 George, "L'affaire Picasso". Speaking of School of Paris artists he wrote: "C'est parce qu'ils s'initièrent à la culture française que ces peintres ont atteint l'universalité. Mais initiation n'est pas synonyme de *gallicisation*," and he adds: "Picasso est lié par son hérédité ibérique et arabe. Les sources orientales de son art ont été décélées par plusieurs spécialistes."

83 Bernard Dorival, "Existe-t-il un expressionisme juif?" *Art Présent*, no. 1 (1945), pp. 52, 53; Germain Bazin, "Existe-t-il un art expressionniste an France?" *Art Présent*, no. 1 (1945), pp. 42–46. For the exhibition "Quelques peintres juifs et le pathétique dans l'art", curated by Waldemar George, see the review by Degand, "Arts Nationaux."

84 George, "La jeune Peinture Française": "Pour confectionner des jeux de construction, des monstres ou des colosses, le monde peut se passer de nous." *Idem*, "L'Art de Picasso n'est pas Français." Even Picasso's classicism was too subjective for George and failed to achieve the universal quality of a Maillol. (Green, *op. cit.*, p. 269). For a critic of Picasso's subjective expressionism, see also Frank Elgar, "Des Arts. Léon Gischia," *Carrefour*, 16 May 1946.

85 Jean Loisy, "Peinture abstraite et peintres chrétiens," *France Catholique*, 9 August 1946; René Domergue, "Vers un renouveau de l'humanisme plastique," *L'Aube*, 14 January 1946, quotes Claude-Roger Marx: "Tous les arts, en définitif, ne nous intéressent que dans la mesure où ils nous parlent de l'homme et de son destin." Picasso was held responsible for spreading a "humanisme décadent" (Farnoux-Reynaud, "Les Fourriers de la Décadence," pp. 1, 5) and an art that was "obstinément inhumain" (Texcier, *op. cit.*, p. 1).

86 Claude-Roger Marx, "Tous les arts, en définitif, ne nous

interessent que dans la mesure où ils nous parlent de l'homme et de son destin" is quoted in Domergue, "Vers un renouveau de l'humanisme plastique."

87 Huisman, "Mais si, Picasso est un peintre français."

88 Waldemar George, "Le néo-humanisme", *L'Amour de l'Art* no. 12 (1934); reprinted in Pontus Hulten, *Les Réalismes 1919–1939* (Paris: Centre Georges Pompidou, 1981), p. 200. See also Dorléac, *op. cit.*, p. 142.

89 François Mauriac quoted in Judt, *op. cit.*, p. 309: "notre pays est le plus humaniste par excellence . . . Nos moralistes ont porté à sa perfection la science de l'homme qui vaut pour nous tous chrétiens et incroyants." Georges Cogniot, in Cogniot and Garaudy, *op. cit.*, called France "humanism's own chosen country." On the importance of the humanist ideology in France at the time, see Michael Kelly, "Humanism and National Unity, the Ideological Reconstruction of France," in Hewitt, *op. cit.*, p. 113.

90 Kelly, *op. cit.*, pp. 103, 115. Henri Rode wrote in his column "Revue des Revues" in *Poesie 45*, in May 1945, that most magazines published that month had appeared under the theme of a new humanism. "Comme il fallait s'y attendre, c'est sous le signe d'un nouvel humanisme que se présentent la plupart des revues parues ces mois-ci."

91 Waldemar George, "Renaissance de l'art français et mission de la France", *Résistance*, 26 Septembre 1946; *idem*, "La Jeune Peinture Française": French art "est probablement une des dernières barrières d'une civilisation humaniste chrétienne". See also Georges Cogniot in his address to the Communist Party Congress in 1945: "Communist Intellectuals we continue France and civilization," in Cogniot and Garaudy, *op. cit.*, p. 23 (cited in Caute, *op. cit.*, p. 212).

92 George, "La Jeune Peinture Française."

93 Pierre-Henri Simon, "De la représentation spirituelle", *Le Monde*, 5 June 1946: "Les peuples attendent de nous, . . . une leçon d'humanisme, un example de santé. . . . Choisissons bien nos représentants spirituels: j'ose écrire qu'il est plus urgent aujourd'hui d'envoyer à l'étranger des Poussin et des Corots que des Picasso et des Matisse".

94 George, "Le néo-humanisme": "donner un sens plus pur aux mots de la tribu" (reprinted in Pontus Hulten, *op. cit.*, p. 200).

95 Judt, *op. cit.*, pp. 283, 284; Gérard de Puymège, *Chauvin, le soldat-laboureur. Contribution à l'étude des nationalismes* (Paris: Éditions Gallimard, 1993), p. 278.

96 Michel Winock, *Nationalisme, antisémitisme et fascisme en France* (Paris: Éditions du Seuil, 1982), p. 38 *passim*; see also Eric J. Hobsbawm, *Nations and Nationalism since 1780* (Cambridge: Cambridge University Press, 1990); Benedict Anderson, *Imagined Communities: Reflections on the Origin and Spread of Nationalism* (London, New York: Verso, 1987), pp. 122, 140.

97 Grosser is cited in Judt *op. cit.*, pp. 302, 303. François Mitterand, in his *L'Abeille et l'Architecte*, expressed his post-war disillusionment: "Mon sentiment d'apartenir à un grand peuple (grand par l'idée qu'il se faisait du monde et de lui, et de lui dans le monde, selon un code de valeurs qui ne reposait ni sur le nombre, ni sur la force, ni sur l'argent) avait subi quelques entailles. J'ai vécu 1940: inutile d'en dire d'avantage" (cited in René Girault and Robert Frank, *La Puissance Française en Question (1945–1949)* [Paris: Publication de la Sorbonne], p. 137).

98 Simonin and Clastres, *op. cit.*, pp. 28, 60–62. See also Girault and Frank, *op. cit.*, pp. 138, 412: "La fissure décisive . . . dans les certitudes françaises . . . se situe moins en 1940 ou en 1945, deux moments où le dynamisme national dispose encore de deux "recours" mythiques, qu'entre 1946 et 1948. . . ."

99 François Mauriac, quoted in Waldemar George, "Rayonnement de l'art français," *Voix de Paris*, 6 September 1945, and in *idem*, "L'association française d'action artistique défend dans le monde entier l'art et l'esprit français," *Ce matin*, 13 May 1947.

100 For just a sampling of those voices, see François Mauriac and Raymond Aron in Judt, *op. cit.*, p. 308; in 1945 François Mauriac said that never before in its history has France, this great nation having become so small, been so keenly aware of its mission. See also George, "Rayonnement de l'art français"; Dorival, "Existe-t-il un expressionisme juif?", pp. 52, 53; Degand, in *Les Lettres Françaises*, 6 December 1946, p. 4. See also Pierre Francastel in his review of the Salon d'Automne 1944, cited in Dorléac, *op. cit.*, p. 164. A proclamation of the Union nationale des intellectuels in 1945 starts with those words by Victor Hugo and by Michelet: "France sans toi le monde serait seul", "[notre patrie] est le pilote du vaisseau de l'humanité" (*Les Étoiles*, August 1945). Several speakers addressed the issue of French cultural hegemony at the Congrès de la Pensée Française au Service de la Paix in July 1946; see, in particular, Jean-Richard Bloch and Léon Moussinac, quoted in *Les Étoiles*, 9 July 1946.

101 André Chastel, "'L'art du vingtième siècle a deux capitales: Paris et New York' nous dit M. Monroe Wheeler, directeur du Museum of Modern Art de New York," *Une Semaine dans le Monde*, 3 May 1947, p. 1. Louis Aragon and George Cogniot are quoted in Caute, *op. cit.*, p. 214. In the spring of 1947 the first exhibition of American painting at the Galerie Maeght provided the French critics with the opportunity to stress, once again, the supremacy of French painting. See Gérard Monnier, *Des Beaux-Arts aux Arts Plastiques. Une histoire sociale de l'art* (Paris: Éditions la Manufacture, 1991), p. 252.

102 See Judt, *op. cit.*, pp. 305, 306. Fears of cultural invasion, exacerbated in particular after the unfavorable Blum-Byrnes accords and the acceptance after 1947 of the Truman doctrine and the Marshall Plan, intensified the insistence on the French cultural heritage. Despite the fear of becoming a third-rate country, modernization

and the attending dependence on foreign influence were just as dreaded.

103 Although the Right had been discredited in intellectual circles after the war, and despite the purges, from 1945 on a nostalgic extreme Right started to re-emerge in France (Rousso, *op. cit.*, pp. 42, 43). Despite the strong support for the Communists, the weakened position of the Socialists, which became apparent during the summer of 1946, encouraged the Right and center and deprived the Communist and Socialist Left of its majority. This was compounded in May 1947 by the dismissal of the Communists from the government. See Jean-Pierre Rioux, *La France de la Quatrième République. L'ardeur et la nécessité, 1994–1952* (Paris: Éditions du Seuil, 1980), in particular the chapter "Le tournant de l'été 1946," pp. 148–153.

104 Dorléac, *op. cit.*, pp. 155, 156. There were a few, however, who recognized the danger that this exaggerated pursuit of balance and harmony could lead to "fadeur," to insipidity (Jean Grenier, "Au Salon d'Automne. Peinture baroque, sculpture classique," *Combat*, 13 October 1994).

105 Bernard Dorival, in *Les Problèmes de la peinture française contemporaine*: "Jamais l'idée de la peinture pure n'aurait mûri ailleurs qu'entre les Alpes et la Manche, le Rhin et les Pyrénées. . . . Peinture pure, peinture logique, et par là, peinture de chez nous." Quoted in Dorléac, *op. cit.* p. 157. See also Dorival's *Étapes de la Peinture française contemporaine*, pp. 321, 322; Frank Elgar, "Des Arts. Léon Gischia," *Carrefour*, 16 May 1946 and in innumerable articles in *Arts de France*.

106 There existed, of course, a parallel strain to that lineage which included such painters as Fouquet, Clouet, the brothers Le Nain, Chardin, and Courbet, and which had been stressed for its social consciousness by the French Left already during the *querelle du réalisme* in the thirties. (I thank Robert Lubar for having reminded me of the relevance of that alternative story.) After the war, however, it was only after 1947, with the dogmatization of Zdhanovism in art and literature by the French Communist party, that the emphasis on those artists recurred. For the famous "retour à Courbet," for example, see: Louis Aragon, *L'Exemple de Courbet* (Paris: Éditions Cercle d'Art, 1952). For the artistic policies of the French Communists see Jeannine Verdès-Leroux, Dominique Berthet, Laurence Bertrand Dorléac, and Sarah Wilson, as cited above.

107 For the existence and attitudes of French artists during the war and the Occupation see Cone, *op. cit.* and Dorléac, *op. cit.* For further reference, see my note 4, above.

108 Elizabeth Cowling, Introduction to Cowling and Mundy, *op. cit.*, p. 18.

109 Waldemar George, "Le Salon d'Automne qui ouvre ses portes demain sera le Salon de la Libération," *Résistance*, 5 October 1944. See Silver, *Esprit de Corps*, pp. 247, 249, for the previous incarnation of this French dream of being the rightful heir to the Greek classical tradition.

110 Dore Ashton, ed., *Picasso on Art. A Selection of Views* (New York: Plenum Publishing Co. 1972), p. 148; Daix, *op. cit.*, p. 278.

111 Zervos 14:35; whereabouts unknown, dated 24–29 August 1944.

112 Ashton, *op. cit.*, p. 152.

113 The drawing is dated 31 October 1946, III, 1 November 1946, IV. Yet, as has always been the case with manifestations of classicism in Picasso's oeuvre, works with classicizing elements in Antibes appear side by side with other forms of expression. Picasso had always protested against a teleological reading of his different styles and insisted on the fact that style for him was never connected to development or evolution but rather to the content of what he wanted to express (Pablo Picasso, "Picasso Speaks. A Statement by the Artist," *The Arts*, May 1923, p. 323).

114 Theodor Reff, "Picasso am Scheideweg, Skizzenbuch Nr. 59. von 1916," in *Picassos Klassizismus*, p. 187.

115 Otto Brendel, "Classic and Non-classic Elements in Picasso's Guernica," in Whitney J. Oates, ed. *From Sophocles to Picasso: The Present-day Vitality of the Classical Tradition* (Bloomington: Indiana University Press, 1962).

116 Johann Joachim Winckelmann, *Gedanken über die Nachahmung der griechischen Werke in der Malerei und Bildhauerkunst* (Dresden, 1755); reprint. in C.L. Fernow, ed., *Winckelmanns Werke*, vol. 1 (Dresden, 1808), p. 31.

117 Elizabeth Cowling, Introduction to Cowling and Mundy, *op. cit.*; Green, *op. cit.*, pp. 267–82.

118 In an article in the 1940–44 issue of *Cahiers d'Art* its editor, Christian Zervos, praised the virtues of pre-hellenic art as inspiration for modern artists, while deriding the dogmatic devotion to Greek art of the classical period, which he held responsible for dead-end academicism—what Dubuffet has mocked as the "Greekeries of the Western humanist tradition" (Christian Zervos, Pour une évaluation des valeurs esthétiques," *Cahiers d'Art* pp. 15–19 [1940–1944], pp. 9–19). Jean Dubuffet, in a lecture of January 1945, published in *Prospectus et tous écrits suivants* 1 (1967), pp. 31–53. Braque, too, had been inspired by Cycladic art at about the same time; see Christian Zervos, "Braque et la Grèce Primitive," *Cahiers d'Art* pp. 15, nos. 1–2, 3–4, (1940), pp. 3–6. Equating the archaic period with the childhood of man, Zervos praised in particular the instinctual over the reasoned approach to art.

119 According to Jean Leymarie, the war had destroyed whatever faith there was in the machine and the technological society. See Bernard Ceysson, *L'Art en Europe: Les années décisives 1945–1953* (Saint-Étienne: Musée d'Art Moderne, 1987), p. 9. The rebirth of the crafts belongs to the contemporary aspiration to replace the dehumanizing machine with the honesty of the artist-craftsman, a movement that had been promoted by Pétain, but now was shared by the Right and the Left. See in that respect

Henri Raynaud (secretary of the C.G.T.), "L'ouvrier et l'art," *Art de France*, no. 1, (1945), pp. 5, 6. Jean Cassou, "Les poteries de Picasso," *Art et Décoration*, no. 12 (1949), pp. 13–21; "Les mains au travail," *Arts de France*, nos. 21/22 (1948), p. 49. Léon Moussinac, "Picasso, ouvrier de la terre et du feu," *Les Lettres Françaises* 8, no. 236 (2 December 1948), pp. 1, 7. See also Jean Laude, "Problèmes de la Peinture en Europe et aux États-Unis," in Université de Saint-Étienne, *Art et Idéologies: L'art en Occident, 1945–1949* (Saint-Étienne: Centre Interdisciplinaire d'Étude et de Recherche sur l'Expression Contemporaine, 1976), pp. 33, 39, 46.

120 H. Hubert, *Étude sommaire de la représentation du temps dans la réligion et la magie* (Paris, 1905), pp. 3–4, quoted in Herbert, *Fauve Painting*, pp. 113, 139, 140.

121 Herbert, *Fauve Painting*, pp. 112–18.

122 Jean Gras, "Picasso a passé l'hiver à décorer le Musée d'Antibes," *Liberté de Nice*, 24 May 1947. Gras compared Picasso's work in Antibes to primitive masks in the Musée de l'Homme in Paris, "qui font penser aux premiers balbutiements de l'art humain faits surtout d'une émotion fugitive et peu analysée," and he queried how those can "s'allier à la plus insondable et la plus moderne, . . . des 'cérébralités'?" The underlying interconnectedness between the primitive and the classical, as posited by the late nineteenth-century anthropologist Sir James Frazer, had informed Picasso's work since early in the century. We recognize it, for example in his powerful *Two Nudes* of 1906 in the Museum of Modern Art in New York, where the indebtedness to Iberian and archaic Greek sources blends with the inspiration from a Greek stele of the classical period. On Frazer's impact for the arts, see Brendel, *op. cit.*, p. 86. See also Cowling and Mundy, *op. cit.*, p. 202.

123 Charles Étienne, "Quand Picasso délaisse la peinture pour la céramique," *Combat*, 7 April 1948: ". . . mener les jeux du primitif et de l'enfant sans rien renier d'une des plus prodigieuses aventures poétiques et plastiques de l'époque n'est peut-être pas donné à tout le monde."

124 Irving Lavin, "Picasso's Bull(s): Art History in Reverse," *Art in America*, no. 3 (March 1993), pp. 76–93, 121–23.

125 Lavin, *op. cit.*, p. 86.

126 We know from Hélène Parmelin that Picasso could be hurt by such public criticism (*Voyage en Picasso* [Paris: Éditions Robert Laffont, 1980], p. 84).

127 This was revealed in 1947, when Picasso took a selection of his paintings to the Louvre to compare them with the old masters.

128 Uhde, *op. cit.*, p. 24. For earlier returns to classicizing idioms and references to the French tradition in Picasso's oeuvre, see Silver, *op. cit.*, *passim*; Weisner, *op. cit.*; Christopher Green, "Pablo Picasso," in Cowling and Mundy, *op. cit.*, pp. 200–23.

129 See Susan Galassi's essay, chapter 6, below.

130 All my information on Reventós and his *Dos Contes* derives from Richardson, "Picasso y Ramón Reventós."

131 Eugeni d'Ors's theories, which he had launched in 1906 under the name of *Noucentisme* in a series of essays entitled *Glosari*, promoted the return to a classicizing artistic tradition. The influence of d'Ors's *mediterranisme* had been recognized in Picasso's oeuvre as early as 1906 in his work from Gósol and again as a result of his summer in Barcelona in 1917. For Eugeni d'Ors's *Noucentisme*, see Robert S. Lubar, "Cubism, Classicism, and Ideology: the 1912 *Exposició d'Art Cubista* in Barcelona and French Cubist Criticism," in Cowling und Mundy, *op. cit.*, pp. 309–23; and Marilyn McCully, "Noucentisme: Picasso, Junoy und der Klasizismus von Barcelona," in Weisner, *op. cit.*, pp. 43–50.

132 This antagonism was curiously echoed in Picasso's recent adherence to communism, while Eugeni d'Ors's initial conservative trends had led him to become a supporter of Franco. Eugeni d'Ors and his theories were also likely to have been revived in Picasso's memories at the time by d'Ors's 1946 publication of his essay on Picasso, which he had written 16 years earlier. See José López-Rey, "La guerre est finie. Picasso and Spain," *Art News* 81, no. 9 (November 1982), p. 144.

133 Pablo Picasso, "Why I became a Communist," *New Masses* 53, no. 4 (24 October 1944), p. 11: "While I wait for the time when Spain can take me back again, the French Communist party is a fatherland for me." The article appeared in French, "Pourquoi j'ai adhéré au Parti Communiste," *Humanité*, 29/30 October 1944, pp. 1, 2. On joining the party Picasso apparently told Marcel Cachin, "Maintenant j'ai trouvé ma vraie patrie," in R.M., "Peintre–Poète–Parti," *Les Lettres Françaises*, 1 May 1945.

134 See Yvonne Jehenson and Natalie Joy Woodall, "Parody and the Character of Ulysses," in Jürgen Kleist and Bruce A. Butterfield, eds., *Mythology From Ancient to Post-Modern* (New York, Bern, Berlin, Paris: Peter Lang, 1992), pp. 17–27.

135 In November 1946 Picasso once again joined a group of Spanish intellectuals in expressing his opposition to Franco's regime in Spain ("Les intellectuels espagnols contre Franco," *La Défense*, 15 November 1946). When the New York Buchholz Gallery wanted to open its Madrid branch with an exhibition of Picasso lithographs, he protested that he had not painted *Guernica* to be then exhibited in Franco's capital (Dominique Desanti, "Picasso contre l'exposition de ses oeuvres à Madrid," *Libération*, 3 June 1949) His continued allegiance to communism should probably be seen, at least in part, in light of this opposition to the fascist regime in Spain.

136 Vicente Marrero Suárez, "Picasso: 'Soy español y tengo documentación española,'" *Informaciones del Sabado* (Madrid), 20 March 1954, supplement, p. 1.

137 *Ibid.*, p. 1.

138 François Lachenal, "Instantanés Picasso," in *Picasso* (Ingelheim/Rhein: Museum, 1981), p. 36.

139 Jean Cocteau, *Journal 1942–1945* (Paris: Gallimard, 1989), p. 580; Brassaï, *op. cit.*, pp. 210, 228.

140 Picasso presided over the Comité d'aide aux républicains and was the honorary chairman of the Joint Anti-Fascist Refugee Committee. He was on the Comité d'honneur of Solidaridad Española and was actively involved with the grouping of Spanish intellectuals in Paris, the Union Nacional de Intelectuales, and with the Comité France Espagne, whose members met in Picasso's studio. (This is derived from documents in the archives of the Musée Picasso in Paris; see also my forthcoming doctoral thesis.) On the Spanish Communist party during its exile in France, see David Wingeate Pike, *Jours de Gloire, Jours de Honte. Le parti communiste d'Espagne en France depuis son arrivée en 1939 jusqu'à son départ en 1950* (Paris: SEDES, 1984).

141 Many of those exhibitions benefited Spanish republican charities, for example the exhibition at the Galerie Louis Carré in June–July 1945 (R.J., "Artistes Espagnols," *Le Monde*, 3 July 1945; "Quelques peintres et sculpteurs espagnols de l'Ecole de Paris," *Arts—Beaux Arts*, 29 June 1945; Léon Degand, "Le don d'invention," *Les Lettres Françaises*, 30 June 1945); the exhibition at the Galerie Visconti in March 1946 for the benefit of interior resistance in Spain (Lo Duca, "Hommage à l'Espagne," *Le Monde Illustré*, 2 March 1946, p. 279; José Maria Quiroga Pla, "Exposition franco-espagnole," *Arts de France*, 15 March 1946, p. 5); and the exhibition of Catalan art at the Galerie Reyman in November 1946.

142 Among the recipients of his contributions was the gala to benefit the families of the Spaniards fallen for the liberation of France (*Populaire*, 19 October 1944; *Combat*, 19 October 1944), the Spanish Refugee Relief (Harriet and Sidney Janis, "Picasso. The Recent Years," *Arts and Architecture* 63 [November 1946], p. 56); and the social works of the Spanish Red Cross. Picasso also helped finance the hospital Varsovie in Toulouse. Officially a hospital for all Spaniards wounded in the civil war, it became increasingly a Communist front organization funneling funds to the Communist underground in Spain (Pike, *Jours de Gloire*, pp. 173–83).

143 On the internment camps and the fate of the Spanish republicans in France, see Louis Stein, *Beyond Death and Exile: The Spanish Republicans in France, 1939–1955* (Cambridge, Mass. and London: Harvard University Press, 1979); Pike, *Les Français et la Guerre d'Espagne*.

144 Gilot and Lake, *op. cit.*, p. 199.

145 Picasso confided his pessimistic views to André Dubois (Daix, *op. cit.*, p. 290), to Christian Zervos ("Picasso. Figures entre deux charniers," *America* 2 [1945], p. 54), and to Jean Cocteau (Cocteau, *op. cit.*, p. 598).

146 Variably interpreted as a moralizing vanitas image or a contemplative absorption in the idea of mortality, Poussin's painting *Et in Arcadia Ego* has become the paradigm for Arcadian representations and their definition. See Erwin Panofsky, "Et in Arcadia Ego: Poussin and the Elegiac tradition," in *Meaning in the Visual Arts* (Chicago: The University of Chicago Press, 1955), pp. 295–314.

147 *Ibid.*, p. 303.

148 It is interesting to note in this connection that Picasso used similar arcadian imagery in his mural *Peace* in the chapel in Vallauris, and in his posters for the peace movement. See René Hirner, *Picassos Arkadien; Friedens- und Paradiesdarstellungen in Pablo Picassos Plakatkunst* (Heidenheim: Kunstmuseum Heidenheim, 1993).

149 Palau i Fabre, *Child and Caveman: Elements of Picasso's Creativity* (New York: Rizzoli, 1978), p. 5.

5 Picasso in the Studio of Velázquez

This article (which appears in a slightly different form in my book *Picasso's Variations on the Masters: Confrontations with the Past*, New York: Harry N. Abrams, Inc., 1996) is derived from a chapter of my doctoral dissertation on Picasso's variations on the old masters, which I completed in 1991 at the Institute of Fine Arts, New York University, under the direction of the late Professor Gert Schiff; to him I owe profound thanks. I am likewise grateful to Jonathan Brown for his guidance on the critical reception of *Las Meninas* and comments on the paper. I also thank Robert Rosenblum, Robert Lubar, and Gertje Utley, for their insightful suggestions; their scholarship on Picasso is reflected throughout these pages. I extend my heartfelt thanks to Gillian Malpass for her design and editing of this book.

Dedicated to the memory of my brother, J. Thomas Grace.

1 José Ortega y Gasset, *The Dehumanization of Art* (1948), exerpted in Walter Jackson Bate, ed., *Criticism, The Major Texts* (New York: Harcourt, Brace and Jovanovich, 1970), p. 663.

2 Picasso's forty-five paintings in oil on canvas based on *Las Meninas* were executed between 17 August and 30 December 1957. These paintings, and an additional thirteen paintings executed during the same period, are reproduced in color in Jaime Sabartès, *Picasso's Variations on Velázquez' Painting "The Maids of Honor" and Other Recent Work* (New York, 1959). The numbering of the variations, all of which are dated, follows the order of the plates in the Sabartès book. (My plate numbers, however, are different from the Sabartès numbers). For the first critical book on this series, see Josep Palau i Fabre, *El Secret de les Menines de Picasso* (Barcelona: Ediciones Polígrafa, S.A., 1981). Velázquez's *Las Meninas*, oil on canvas, was executed in 1656, and is housed in the Museo del Prado in Madrid.

3 Citations of paintings by Picasso refer to the standard catalogue: Christian Zervos, *Pablo Picasso*, 33 vols. (Paris: Éditions Cahiers d'Art, 1933–78), hereafter cited as Zervos. *Portrait of a Painter*, oil on plywood, Collection Angela Rosengart (Zervos, 15:165). El Greco's *Portrait of a Painter*, oil on canvas, ca. 1600, is housed in the Museo Provincial de Bellas Artes, Seville.

4 For an extended discussion of Picasso's exile from Spain, see Gertje Utley's essay, chapter 4, above.

5 Noted in Leo Steinberg, "Velázquez' *Las Meninas*," *October* 19 (1981), p. 45.

6 Antonio Palomino de Castro, "Life of Velázquez," section 7 in *El museo pictorico y escala óptica*. Part 3: *El paranaso español pintoresco laureado* (Madrid, 1724). Translated from the edition published by M. Aguilar (Madrid, 1947), in Robert Enggass and Jonathan Brown, *Sources and Documents, Italy and Spain, 1600–1750* (Englewood Cliffs, N.J.: Prentice-Hall, 1970), pp. 193–94.

7 *Ibid.*, p. 194.

8 Jonathan Brown, chapter 1, p. 15, above.

9 *Ibid.*, p. 3.

10 Cited in Carl Justi, *Velázquez and His Times*, trans. A.H. Keane (London: H. Grevel and Co., 1889), p. 418.

11 For a summary of some of these interpretations and his own notable contribution to the subject, see Jonathan Brown, "The Meaning of *Las Meninas*," in *Images and Ideas in Seventeenth-Century Spanish Painting* (Princeton, N.J.: Princeton University Press, 1978), pp. 87–110.

12 Michel Foucault, "Las Meninas," in *The Order of Things: An Archaeology of the Human Sciences* [translated from the French, *Les Mots et Les Choses*], (New York: Random House, Vintage Books Edition, 1970), pp. 3–16. See Karen Kleinfelder's insightful critique of Foucault's essay in her discussion of the *Meninas* variations in *The Artist, His Model, Her Image, His Gaze* (Chicago: Chicago University Press, 1993), pp. 57–67.

13 On this point, see John Searle, "*Las Meninas* and the Paradox of Pictorial Representation," *Critical Inquiry* 6 (1987), pp. 477–88; Joel Synder and Ted Cohen, 'Critical Response on *Las Meninas*, Paradox Lost," *Critical Inquiry* 7 (1980), pp. 429–47. See also Steinberg, *op. cit.* A year after the Searle and the Synder and Cohen articles, Steinberg came to a similar conclusion as the latter, asserting that the mirror's image comes from two sources—both the actual king and queen in front of the painting and their painted likeness on the front of the canvas in the picture. The conflation, he argues, pays tribute to the mimetic power of painting, "as if to grant that the masterpiece on the canvas mirrors the truth beyond any mirror's capacity to surpass it." See also Jonathan Brown, *Velázquez: Painter and Courtier* (New Haven and London: Yale University Press, 1986), p. 259.

14 Martin Kemp, *The Science of Art: Optical Themes in Western Art from Brunelleschi to Seurat* (New Haven and London: Yale University Press, 1990), pp. 108–09.

15 Karl M. Birkmeyer, "Realism and Realities in the Paintings of Velázquez," *Gazette des Beaux-Arts* 52 (1958), p. 70.

16 See Roland Penrose, *Picasso: His Life and Work* (New York: Harper and Row, 1959), pp. 371–72. In a conversation about *Las Meninas* with Penrose shortly after he executed the variations, Picasso commented: "Look at it, and try to find where each of these is actually situated. Velázquez can be seen in the picture, whereas in reality, he must be standing outside it. He is shown turning his

back to the Infanta who at first glance we would expect to be his model. He faces a large canvas on which he seems to be at work but it has its back to us and we have no idea what he is painting. The only solution is that he is painting the king and queen, who are only to be seen by their reflection in the mirror at the far end of the room. This implies, incidently, that if we can see them in the mirror, they are not looking at Velázquez, but at us."

17 For a discussion of this point in *Las Meninas*, see Ann Hurley, "The Elided Self: Witty Dis-Locations in Velázquez and Donne," *The Journal of Aesthetics and Art Criticism* 44 (Summer 1986), pp. 357–69.

18 For a detailed account of this period of Picasso's life, see John Richardson (with the collaboration of Marilyn McCully), *A Life of Picasso* vol. 1, *1881–1906* (New York: Random House, 1991), pp. 57–89.

19 *Ibid.*, pp. 47–51.

20 Leo Steinberg, "The Philosophical Brothel," part 1, *Art News* 71 (1972), p. 22. Steinberg's observation is corroborated by the appearance of a reference to Velázquez's dog in one of the studies for the *Demoiselles*. See Werner Spies, *Pablo Picasso: Eine Ausstellung zum hundersten Geburtstag. Werke aus der Sammlung Marina Picasso* (Munich: Prestel Verlag, 1981), p. 25, fig. 16.

21 Spies, *op. cit.*, fig. 17. Zervos 25:5, *Self-Portrait with a Palette*, Zervos 1:375.

22 See, for example, Picasso's *The Studio* of 1927–28 in the Museum of Modern Art, New York (Zervos 7:142). William Rubin, in *Picasso in the Museum of Modern Art* (New York: The Museum of Modern Art, 1971), p. 123, notes a connection between this painting and *Las Meninas*.

23 See S.G. Galassi in "The Arnheim Connection: *Las Meninas* and *Guernica*," *The Journal of Aesthetic Education* 27, no. 4 (1993).

24 Justi, *op. cit.*, p. 10. Carl Justi, author of an important monograph on Velázquez, summarizes Velázquez's critical fortunes on pp. 10–15. See also José Ortega y Gasset, "Velázquez and his Fame," in *Velázquez* (New York: Random House, 1953). In 1983, I participated in Jonathan Brown's seminar at the Institute of Fine Arts, N.Y.U., on Velázquez's fame; I am grateful to him and fellow students for the background material for this section.

25 Angel Gavinet, "La pintura española juzgada en el extranjero," 1895, in *Varia Velázqueña, homenaje a Velázquez en el III centenario de su muerte, 1660–1960* (Madrid: Ministerio de educación national, Direccion general de bellas artes, 1960), pp. 200–02. Gavinet was a member of the so-called "Generation of 1898." For a discussion of this literary and philosophical group's attitude towards the issue of national identity, see Robert Lubar's essay, chapter 2, above.

26 The first Spanish monograph was Gregorio Cruzada Villaamil's *Anales de la vida y los obras de Diego de Silva Velázquez, con ayuda de nuevos documentos* (Madrid: Miguel

Guijarro, 1885). The author published numerous other works on the artist over the next twenty years.

27 Aureliano de Beruete, *Velázquez* [translated from the Spanish], (London: Methuen and Co., 1906), p. xxx.

28 See Lubar, pp. 34ff., above.

29 Josep Palau i Fabre, *Picasso: The Early Years, 1881–1907* [translated from the Spanish], (New York: Rizzoli, 1981), pp. 124.

30 Velázquez, *Philip IV*, oil on canvas, 1651–52, Madrid, Museo del Prado. Picasso, *Philip IV, after Velázquez*, oil on canvas, 1897–98, Barcelona, Museu Picasso. Palau i Fabre, in *Picasso, The Early Years*, notes that in his *Meninas* variations, Picasso "seems to be still rebelling against ancient servilitudes" (p. 138). Picasso's first visual reference to *Las Meninas* also dates from this period in Madrid as well, in the form of a sheet of sketches that includes two of the central characters—the infanta and María Agustina Sarmiento—who would later play dominant roles in the variations. The drawing is in the Museo Picasso in Barcelona and is reproduced in Palau i Fabre, *El Secret de Les Menines*, p. 8.

31 Statement to Marius de Zayas of May 1923, excerpted in Dore Ashton, ed., *Picasso on Art: A Selection of Views* (Harmondsworth, Middlesex: Penguin Books, 1974), p. 165.

32 Picasso to Kahnweiler, 1955, in *ibid.*, pp. 168–69.

33 This point is explored in depth by Palau i Fabre in *El Secret de les Menines*. The author posits a connection between Olga's death in 1955 and the *Meninas* variations, noting that the series is a testament to the crisis and upheavals in Picasso's life during the early 1950s.

34 Palau i Fabre, *El Secret de les Menines*, p. 10. The ballet was first performed in the Teatro Eugenia Victoria, San Sebastián, on 21 August 1916 with music by Gabriel Fauré, choreography by Leonid Massine, and costumes designed by José-María Sert. The connection between the ballet and the *Meninas* variations was first proposed by Palau i Fabre.

35 Kurt Badt, *Das spätwerk Cezannes* (1971), cited in Rudolf Arnheim, "On the Late Style," in *New Essays on the Psychology of Art* (Berkeley and Los Angeles: University of California Press, 1986), p. 291.

36 Sabartès, *op. cit.*, Introduction, n.p.

37 On the Oedipal struggle with the artistic forefather, see Harold Bloom, *The Anxiety of Influence: A Theory of Poetics* (New York, Oxford: Oxford University Press, 1973).

38 Gert Schiff, Introduction, in *Picasso in Perspective* (Englewood Cliffs, N.J.: Prentice-Hall, 1976), p. 25.

39 See Leo Steinberg, "The Algerian Women and Picasso at Large," in *Other Criteria: Confrontations with Twentieth-Century Art* (London, Oxford, New York: Oxford University Press, 1972), pp. 125–234. This connection was made in Steinberg's essay on Picasso's previous series of variations executed in 1954–55, in which he noted that Velázquez is evoked though a reference to the *aposentador* whose glance "rounds out the scene. Thanks to him our

visual knowledge seems less confined to the perspective of aspects." p. 136.

40 Zervos 16:100, Paris, Musée Picasso. Picasso commented to a friend that the shadow was his own, thrown across the bedroom he had until recently shared with Françoise Gilot. See David Douglas Duncan, *Picasso's Picassos* (New York: Harper Row, 1961), p. 145.

41 On the subject the magical significance of windows and doors in Picasso's art, see Lydia Gasman, "*The Three Dancers*: The Skull's Teeth and the Door-Ajar," chapter 10 in "Mystery, Magic and Love in Picasso, 1926–1936: Picasso and the Surrealist Poets (unpublished dissertation, Columbia University, 1981), pp. 661–756.

42 Steinberg, "Velázquez' *Las Meninas*," pp. 51–52, discusses the "scatter effect" brought about by the picture's multiple centers. A third center, Steinberg notes, is the centerline of the painting, marked by the looking glass. These three centers, he notes, are subordinated to yet another centrality outside of the picture, the royal couple.

43 See John Anderson, "Faustus/Velázquez/Picasso," in Schiff, *op. cit.*, pp. 158–162. Anderson discusses the subversive aspects of *Las Meninas*.

44 Foucault, *op. cit.*, p. 4.

45 Hurley, *op. cit.*, p. 357.

46 Sabartès, *op. cit.*, Introduction, n.p.

47 Brown, "The Meaning of *Las Meninas*," p. 91.

48 I would like to acknowledge here my debt to my former teacher, Rudolf Arnheim. My close reading of his exploration of the artistic process in Picasso's art in *The Genesis of a Painting: Picasso's Guernica* (Berkeley and Los Angeles: University of California Press, 1962) was not only an inspiration in undertaking a study of the *Meninas* suite, but it contributed greatly to my understanding of the relationship of each of the individual variations to the series as a whole.

49 Brown, *Velázquez*, p. 261.

50 Zervos 2:19, Basel, Kunstmuseum.

51 Matisse, *Portrait of Marguerite*, oil on canvas, 1906, Paris, Collection Musée Picasso. This painting was chosen by Picasso in an exchange of works with Matisse and remained in his collection throughout his life.

52 Mary Mathews Gedo, *Picasso: Art as Autobiography* (Chicago: University of Chicago Press, 1980), pp. 235–36.

53 *Ibid.*, p. 235.

54 *The Open Window*, oil on canvas, 1905.

55 See n. 23, above.

56 Gasman, *op. cit.*, part 3, p. 1130.

57 Roland Penrose, *op. cit.*, p. 374, citing Baudelaire, *Oeuvres* (Paris, 1939), vol. 2, p. 171.

58 Steinberg, "The Algerian Women and Picasso at Large," p. 230. See Canvas O, the last work in the *Algerian Women* series, Zervos 16:360.

59 Penrose, *op. cit.*, p. 374.

60 See Brown, "The Meaning of *Las Meninas*."

61 Palomino de Castro, cited in Enggass and Brown, *op. cit.*, p. 194.

62 Picasso executed thirty etchings for Ovid's *Metamorphoses*, published by Albert Skira in Lausanne in 1930.

63 Picasso was speaking of his variations of 1932 after Grünewald's *Crucifixion* in a conversation with the photographer Brassaï: "Do you know the Crucifixion of Mathias Grünewald, the central panel of the Isenheim altarpiece? I love that painting and I began to interpret it. But as soon as I began to draw, it became something else entirely." It was in his drawings after Grünewald that Picasso first explored the potential of serial variation. See Brassaï, *Picasso and Company*, trans. Francis Price (Garden City, New York: Doubleday, 1966), p. 24.

64 Picasso to Zervos, 1936, Ashton, *op. cit.*, p. 27.

65 Spoken to Hélène Parmelin, *ibid.*, p. 22.

66 I thank Robert Rosenblum for suggesting this connection.

Photograph Credits

© Succession Picasso/DACS 1996: frontispiece, 23, 26, 28, 29, 30, 31, 32, 33, 34, 35, 36, 40, 41, 43 (photo courtesy the Metropolitan Museum of Art), 44, 53, 55, 56, 57, 58, 59, 60, 61, 62, 63, 65, 66, 67, 68, 76, 77, 78, 79, 81, 82 (photo courtesy Galerie Jean Krugier, Geneva), 84, 85, 86, 88, 89, 90, 91 a–d, 92, 93 a–k, 94, 95, 96, 98, 99, 100, 101, 102, 103, 104, 105, 106, 107, 108, 109, 110, 111, 112, 113, 115, 117, 118, 119, 120, 121, 122, 123, 124, 125, 126, 127, 129, 130; Alinari, Florence: 3 Mas, Barcelona: 4, 7, 9, 15, 16, 17, 20, 37, 46, 54, 69, 74, 97, 99; Photo © RMN, Paris: 18, 50, 51, 62, 80, 89, 92, 97, 98, 101, 110, 111; © Succession H. Matisse/DACS 1996: 27, 110, 114, 116, 128 (photo Philippe Migeat); Institut Municipal d'Historia, Barcelona: 38; Roger-Viollet © Harlingue-Viollet: 39; Courtesy of the Hispanic Society of New York: 47; © ADAGP, Paris and DACS, London 1996: 48 (Photo Archives Laurens).

Index